Paolo Lazzarin

ONE HUNDRED & ONE
Beautiful SMALL TOWNS *in Italy*

New York · Paris · London · Milan

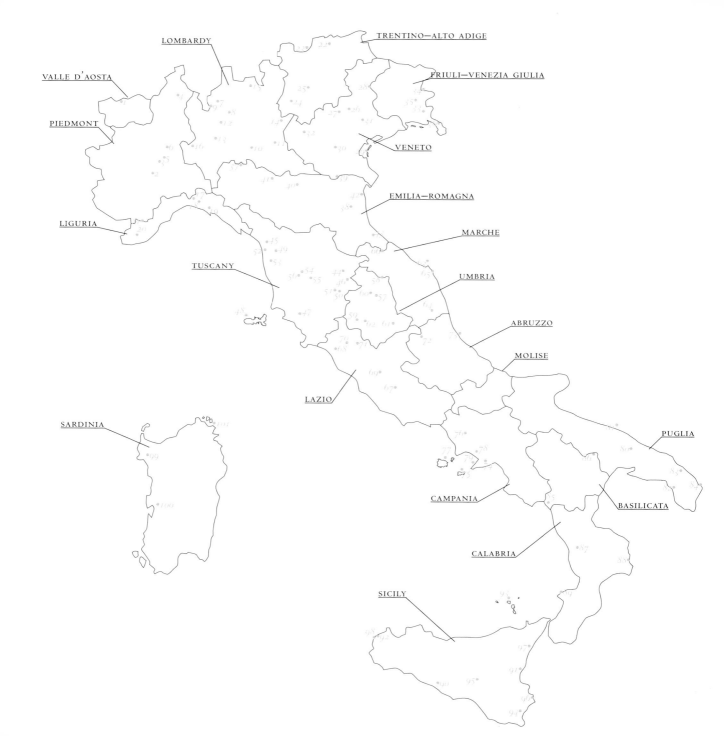

VALLE D'AOSTA

PIEDMONT

LOMBARDY

TRENTINO—ALTO ADIGE

FRIULI—VENEZIA GIULIA

VENETO

LIGURIA

EMILIA—ROMAGNA

MARCHE

TUSCANY

UMBRIA

ABRUZZO

MOLISE

LAZIO

SARDINIA

PUGLIA

CAMPANIA

BASILICATA

CALABRIA

SICILY

REGIONAL CONTENTS

ALPHABETICAL CONTENTS

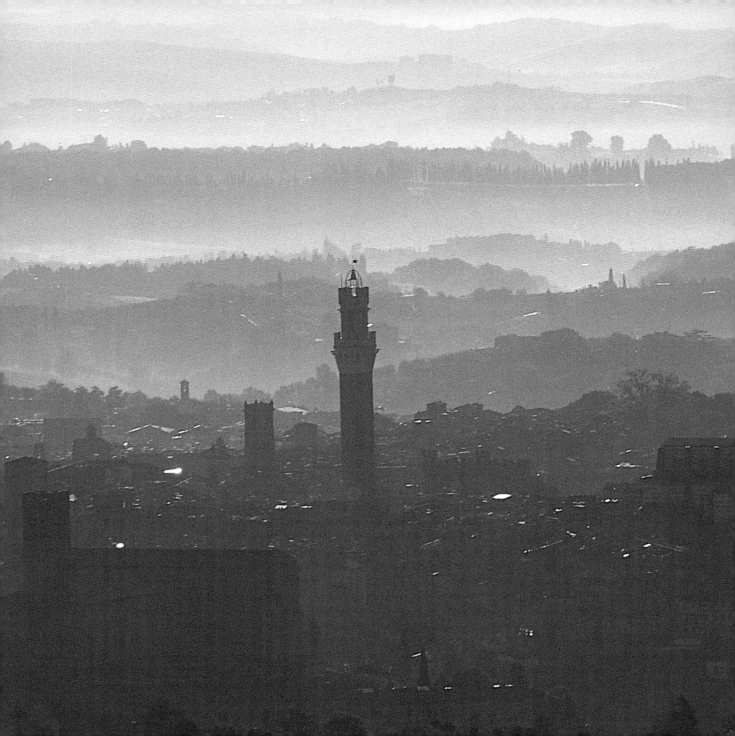

P R E F A C E

Italy has more to offer in the 760 miles between Sicily and the Alps than most countries of far greater expanses can boast. Between Venice and Rome (the same distance that separates Los Angeles from San Francisco), for instance, there is an astonishing variety of places to visit. Italy is home to countless towns of artistic and cultural interest, from the shimmering mosaics in Ravenna's Basilica di San Vitale to the mysterious beauty of Pompeii, Giotto's splendid frescoes in Assisi, and the festive Palio in Siena, as well as numerous nature reserves, including the Po River delta, the Casentino forests, the Tuscan Maremma, the massive Dolomites, and Lazio's volcanic lakes. As of last year, no less than thirty-seven of Italy's natural and architectural treasures were designated UNESCO World Heritage Sites.

Italy's most enduring and inestimably valuable artistic tradition is among the richest in the world. The arc of civilization from prehistoric times to the present is clearly visible and even palpable when visiting ancient ruins or walking along the narrow streets of a medieval town. While incomparable works of art can be seen in museum collections and former private homes now open to the public, there are also entire villages that seem frozen in time (no less than a thousand years ago) and offer an unparalleled glimpse of the past. There is no telling what has yet to be discovered in the countryside or lost among the mountains.

Italy's natural beauty is characterized by endless possibility. Manicured gardens, stupefying cliffs, mountain ranges, sun-kissed coasts, and sparkling lakes dot the countryside from the tip of Italy's boot to the borders it shares with France, Switzerland, Austria, and Slovenia. From the finest desert-like sand of Sicily to the black beaches of Sardinia, azure-blue waters surround the Italian peninsula and one is never more than a few hours from a sunny shore. To the north there are breathtaking glaciers and to the south active volcanoes. From the enchanted forests of Sila to the Ligurian Riviera and the Lombard lakes with their explosion of flowers, there are plenty of options for those wanting to escape the bustle of city life.

Italians are known for their spirit and extraordinary quality of life and there is no better way to experience "La Dolce Vita" than in smaller, off-the-beaten-path towns, where warmth and hospitality are a given—as is exceptional cuisine. The fruits of the land are as diverse as the landscape and Italy is famous both for its gastronomic variety—not to speak of its excellent wines—as well as its extraordinary craftsmanship. Among the traditional artisans are world-renowned ceramicists in Faenza and Capodimonte, goldsmiths in Valenza, and artists who fashion jewelry from red coral in Alghero to name only a few.

Collectively, the 101 towns presented in this book may well stand up to the enormous patrimony of Rome, Florence, or Venice. The towns selected are intended to propose a beginning, encompassing enough for one to realize that it would take a lifetime to truly discover Italy and that, no matter how often or extensively one visits, there are hundreds of reasons to keep going back.

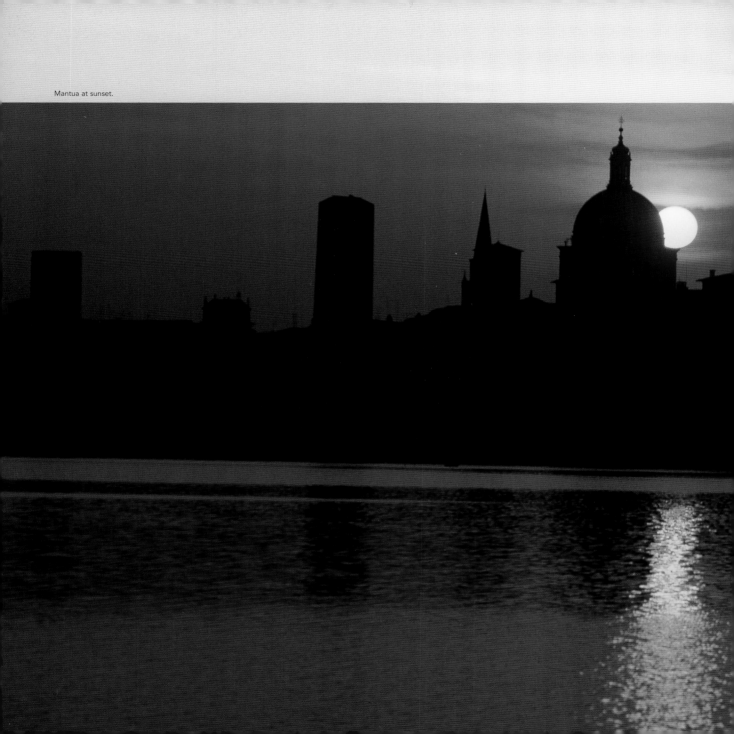

Mantua at sunset.

NORTHERN *Italy*

AOSTA
ROMAN RUINS IN THE ALPS

ONE DOES NOT CHANCE UPON AOSTA, hidden away as it is in the Italian Alps. Nor does one decide to stay here by chance. Whether one stays or leaves depends on which of the town's two souls prevails. The sublime nature of the countryside beckons visitors to challenge the tallest Alps, both magnificent and feared, while the course of the Rhône River will lead those who follow it to the international crossroads of Italy, France, and Switzerland. Aosta is sometimes discovered by accident, and almost always with difficulty, coming across places that are enveloped in an otherworldly silence. The Celtic Salassi tribe, a mysterious people whose origins are unknown, were the ancient inhabitants of the valley. They lived by banditry, which made it difficult for explorers to traverse the territory. The Roman Empire gathered all its determination—and a large part of its army—to secure the transit of their caravans between the Piedmont plains and Gaul. Emperor Caesar Augustus subdued the Salassi—all 26,000 of them—and sold their general, Terenzio Varrone, in the slave market at Ivrea. The emperor then built roads and a city along the valley bed. In 25 BC, Augustus erected the Arco di Augusto (Arch of Augustus), marking the triumph of the Romans over the barbarian tribe. Other buildings scattered about the city bear witness to Aosta's heritage: the Roman walls and the Porta Pretoria (one of the town's best-preserved gates); the Roman Forum, the Teatro Romano, which could seat up to 3,500 spectators in its first-century BC amphitheater; and the Cryptoporticus, an impressive covered gallery. Aosta continued to prosper for many centuries, and time's changing modes of architecture are evident in its most important structures. The early-Christian church of San Lorenzo dates back to the fifth century and is late Gothic in style, while the tenth-century Romanesque Duomo represents the main expression of Christian art and architecture in Aosta. The Collegiata di Sant'Orso was originally a sixth-century church but was altered and adorned with Gothic, and later Baroque, embellishments. The nineteenth-century Piazza Chanoux is the city's public square and heart.

Even if one is only passing through Aosta, it is impossible to ignore the song of the Sirens. There is a sense, upon arriving in Courmayeur, of being held back. One voice prompts you to turn toward the Mont Blanc tunnel leading to the other side of the Alps, while another tempts you to begin the dramatic ascent up the mountain, crossing the great glacier of the Vallée Blanche to arrive in Chamonix.

Gondola service on Mont Blanc.

facing page
The ruins of the Teatro Romano.

Each year, on the last two days of January, the Sant'Orso Fair is held in the historic center of Aosta. While the origins of the fair are unknown, it is certain that there has always been a gathering of shepherds and farmers in the main town of the valley. They would offer their hand-carved objects in exchange for the tools necessary for the coming year's harvest. Useful materials associated with agriculture, cooking, and other pastimes can be found at the fair. More than a thousand exhibitors offer a plethora of items, including sleds, baskets, handmade lace, bowls, clogs, wooden goblets for aromatic wine, snuffboxes, crucifixes, toys, and statuettes. Today the fair takes place on August 15.

There are many secluded places in Aosta where one can enjoy the serenity of the mountains, such as the village of Valnontey at the foot of the Gran Paradiso. La Barme is a small, charming hotel with a cozy restaurant transformed from an old Alpine hut and is found along the narrow Cogne Valley. The beautiful aqueduct bridge of Pondel, one of the vestiges of the Roman occupation, is worth a visit. Take the consular road to Donnas to see the bridges of Saint-Martin, Chatillon, and Saint-Vincent. The hills of the Valle d'Aosta are dotted with castles, mostly medieval in origin and well preserved. Among those that can be toured are Issogne, Verrès, Fénis, Bramafan, Sarriod de la Tour, Graines, and Quart.

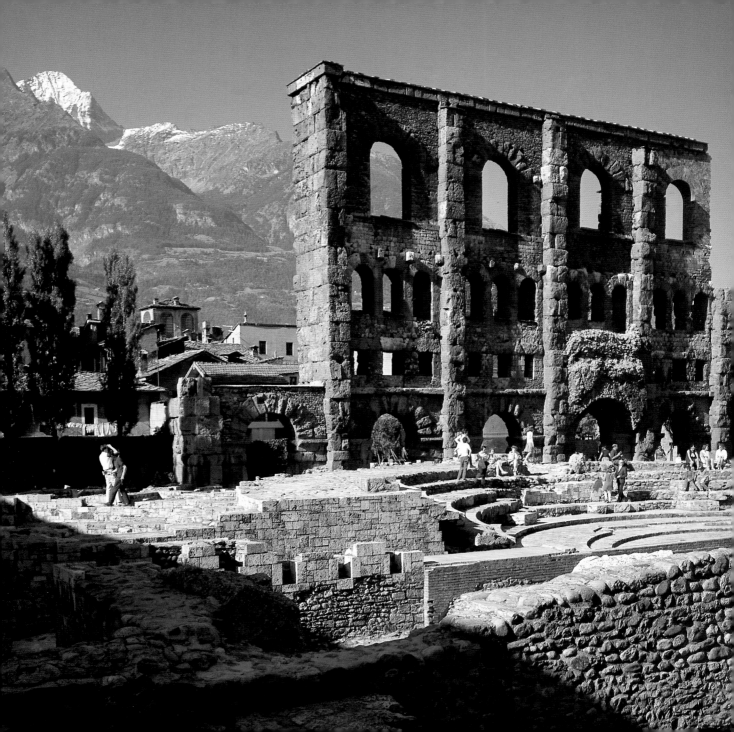

ALBA
GATEWAY TO THE LANGHE

ALBA IS THE CAPITAL OF THE LANGHE, a land dedicated to wine and, for the last century, to the *tartufo bianco* (white truffle), a precious tuber valued since ancient times and used in the Middle Ages as a coin of exchange among the noble families of Piedmont. Alba first became well known after World War II, when the town's Ferrero pastry company began manufacturing Nutella (a creamy spread made from cocoa and hazelnuts). After pizza, Nutella is perhaps one of the most widely recognized Italian products in the world, with fan clubs located in countries as diverse as Japan and Russia.

Alba's Nutella fame, however, comes second only to the renowned Order of the Knights of the Wine and Truffles of Alba, an association established by its twenty-one founding members in 1967 to preserve the town's culinary and oenological traditions. Perhaps it was Alba's pre-Indo-European name that would foretell its foremost position in history. The Grand Master of the Order, its most important representative, enjoys a stature that not even the kings of Savoy could match. Today, there are delegations of the Order in all of the major cities of Italy, as well as America and Asia. In only a few years the organization has been responsible for a series of initiatives that have brought even greater prestige to the Langhe, a region already highly regarded for its pleasant landscape (which changes with every season), numerous hilltop castles surrounded by orderly avenues of vineyards, fine wine, and a cuisine suited for the most elegant of tables, especially in the fall, when truffles ennoble otherwise ordinary dishes. The Order has done everything possible to enhance Alba's natural beauty and spread its reputation. For instance, the organization set up a Regional Piedmont Wine Collection in the medieval castle of the Count of Cavour at Grinzane, where choice wines are subject to the strict control of the National Order of Wine Tasters. The knights also organized the Itinerary of the Wines of Alba, which can be found in cellars where wine is sold and in restaurants where the Order guarantees the quality of Alba's traditional cuisine.

A truffle hunter at work with his faithful companion.

facing page
Shoppers at the National Truffle Fair.

Giacomo Morra, owner of the Hotel Savona, initiated the Fiera del Tartufo (National Truffle Fair) in 1929. The event was to complement the National Exposition held in Alba at the beginning of the twentieth century and designates exhibition awards to the famous truffles of the Langhe. The fair takes place every year from September to October in the historic center of town and is organized with the cooperation of the Trifolao (truffle hunters), who exhibit their prized merchandise. Visitors can participate in truffle, wine, and even chocolate tastings (the town is one stop along the Chocotour, a traveling show entirely dedicated to that most famous of indulgences). There are expositions of wine and food, dinners followed by concerts, donkey races, and courses dedicated to "sensorial analysis," how to recognize the distinct fragrance of the truffle.

The trattoria in the wine cellar of the thirteenth-century Grinzane Cavour Castle is perhaps the best place to sample Alba's wonderful cuisine and taste the wines of Piedmont. Count Camillo Benso, architect of the unification of Italy, spent his childhood here. To reach Grinzane Cavour, pass through Gallo d'Alba at the foot of the hill, from where it is a pleasant walk to the castle.
The Sebaste factory for *torrone* (nougat candy), has been in business since 1885, and apart from their traditional *torrone*, they make nougat covered in chocolate and flavored with rum. Excellent restaurants in Alba's historic center, such as the intimate Il Vicoletto, Daniel's at Pesco Fiorito, Osteria dell'Arco, or Osteria Vento di Langa offer the perfect setting for fine dining. As far as hotels go, I Castelli on Corso Torino is said to be the best in Alba.

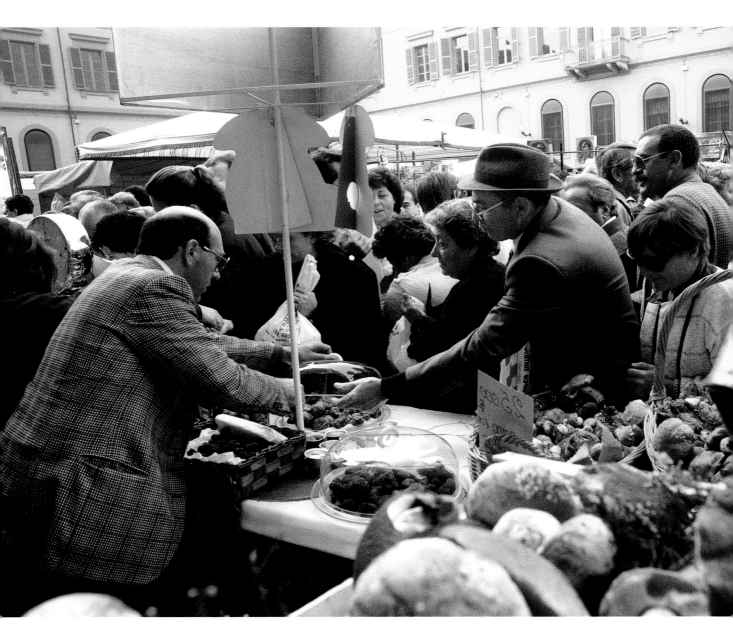

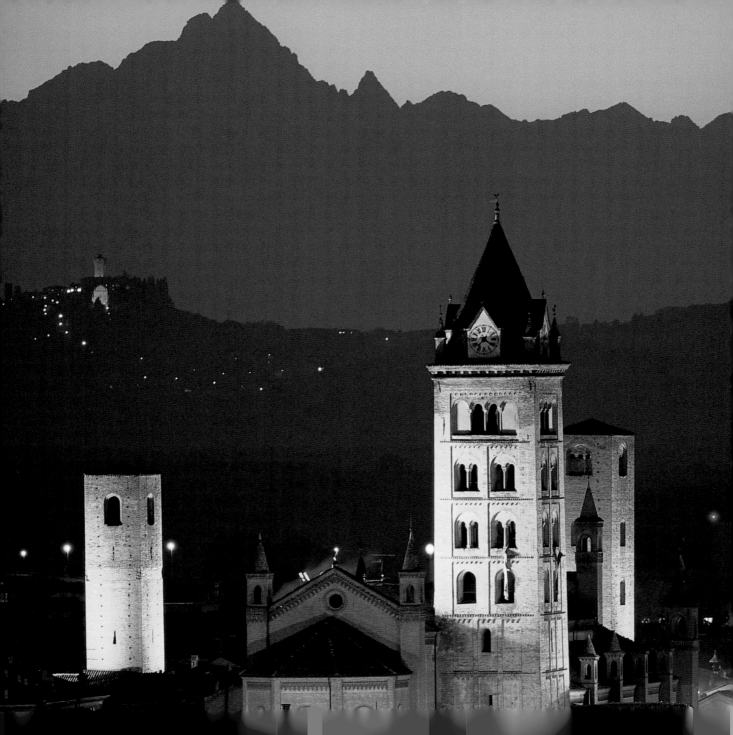

Alba is characterized above all by medieval towers and tower-houses and its historic center is surrounded, in some parts, by the Roman walls of the ancient Alba Pompeia, founded by Cneo Pompeo Strabone in the first century BC. Not to be missed are the Sineo and Astesiano towers, the Loggia dei Mercanti (Merchants' Bazaar), the fifteenth-century manor houses (Diretti, Fontana, and Serralunga), and the Gothic Duomo. Outside of Alba, there are many villages dotted with Roman ruins, such as nearby Pollenzo, whose piazza—one of northern Italy's largest squares—mimics the shape of the ancient amphitheater that once stood at its center.

Sbandieratori (flag tossers) dressed in medieval garb at the Palio degli Asini (a donkey race that opens the Truffle Fair).

below
A wine cellar at the Serralunga manor house.

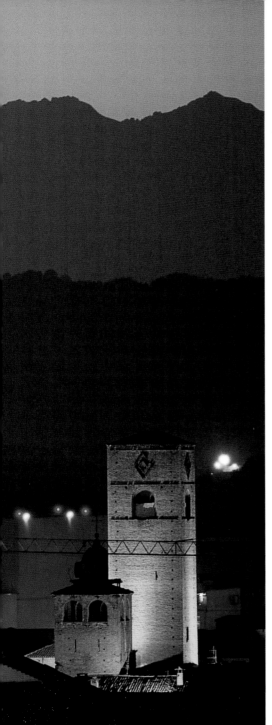

left
Alba's towers cast a magical medieval atmosphere over the town.

15

A S T I
S P U M A N T E V I N E Y A R D S

ASTI WAS AN ANCIENT SETTLEMENT FOUNDED BY THE LIGURIANS. In 89 BC, during the rule of Augustus, it became a Roman colony called Hasta Pompeia, a name derived from the measuring rods that were planted on properties belonging to debtors to the public treasury. Asti was subject to many incursions by the Saracens in the eleventh century and was, as a result, entirely rebuilt. Citizens began erecting towers to protect themselves from future invasions and Asti soon became known as the "city of 100 towers." Only the first-century Torre Rossa (Red Tower) remains from those built during Roman times, although a large number of the towers dating from the eleventh to thirteenth centuries, among the tallest in Piedmont, are still in good condition. These include the clock towers of San Bernardino, the Guttuari, the Solara, and the towers of the Bridge of Lombriasco.

In 1095 Asti became one of Italy's first free communes, and in 1140 it was granted the right to mint coins. The influence of medieval and flowering Renaissance styles can be seen in the city's many architectural gems. Fortified palazzos embellished by ogival windows belonged to the city's noble class. The Rotonda di San Pietro is a glorious Roman monument. The Gothic Duomo was restructured and houses a treasury and a series of frescoes and paintings of great historical significance. The Gothic Collegiate Church of San Secondo was begun in 1256 and finished in 1462 and houses a sixth- or seventh-century crypt.

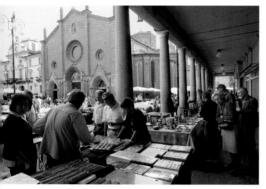

An antiques market on Piazza San Secondo.

facing page
A vineyard where Barbera grapes are grown on a gentle incline.

Asti's vineyards arabesque over the hills of the *Sinus asticus,* a branch of an ancient sea that was the basin upon which the town's foundations were built. Even more famous than its towers is the wine that is made in Asti. Wine is the principal resource of the town, and residents dedicate body and soul to its production. The Wine Making School of Asti produces master wine makers who teach their art all over the world. The famous Piedmont carnival mask takes its name from the *douja*, the traditional wooden measure used by cellar masters. Gianduja chocolate derives its name from "*Gian da la douja*," which describes the severe but humorous workman, a prickly but convivial character. One of the many wine festivals in Italy is the Douja d'Or National Wine Festival held each September. The festival awards the best wine of the year and includes tasings, art exhibitions, and a ceremonial procession. It is a wonderful opportunity to sample and purchase the wines and local specialties of Piedmont.

The art of tapestry making is enjoying a renaissance in Piedmont, where tapestries are created using the traditional "ad alto liccio" technique employed by the great textile manufacturers of the past, from the French in the fourteenth century to the Flemish in the fifteenth century, the Italians in the sixteenth century, and the Gobelins in the seventeenth century. The Museum of the Scassa Tapestries in the monastery of Valmanera was founded in 2002 by the Scassa family and holds an important and extensive collection of wall coverings that have been wonderfully conserved. Examples include tapestries woven from drawings by some of art history's most recognized figures, such as Giorgio de Chirico, Salvador Dalí, Max Ernst, and Henri Matisse.

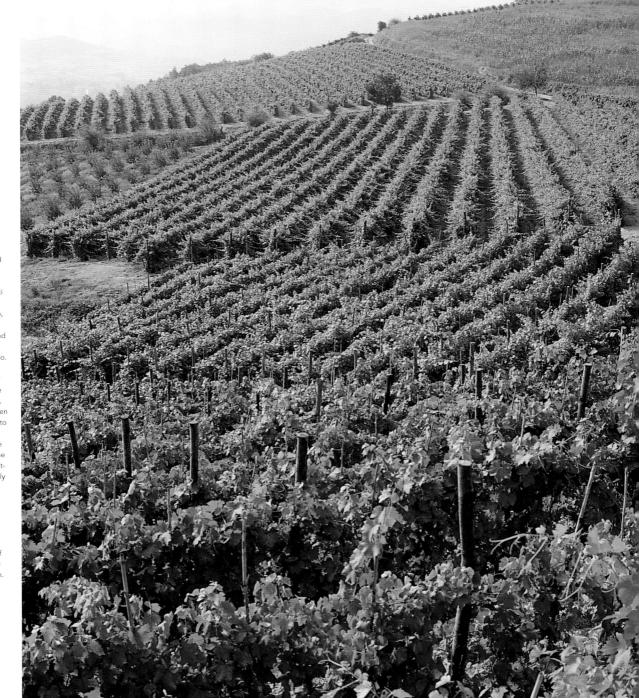

The Barbera wines of Asti are characterized by a deep red color and full body, and are often imitated. Wines from the Asti region include the delicate Grignolino, the sweet and sparkling Freisa, and the Dolcetto, Nebiolo, and Barolo. Barolo is without a doubt the "king of wines and the wine of kings." Recently, the scepter has been passed from hand to hand but Barolo remains among the noblest wines of the peninsula. The best-known grape in Italy is the small, extremely sweet, and golden-hued moscato used to produce Asti Spumante, the mandatory glass of "bubbly" for every important occasion.

STRESA

THE ELEGANCE OF ART NOUVEAU

STRESA IS CENTRALLY LOCATED ON THE WESTERN SHORE OF LAKE MAGGIORE, one of the most beautiful lakes in the region. The curvaceous Mottarone Mountain in the background and the elegant villas with their gardens of lush and exotic plants complete the natural allure of this stretch of lakeside riviera. A visit to some of the town's luxurious villas is an ideal way to experience the verdant environment of Stresa.

The park on the grounds of Villa Pallavicino.

facing page
Isola Bella, one of the three Borromean Islands.

Villa Ducale once belonged to the philosopher Antonio Rosmini, while the writer Alessandro Manzoni frequently stayed at Villa Stampa. Villa Carlotta is called the "queen of the villas" for its enchanting gardens and sumptuous interiors. On the property of the nineteenth-century Villa Pallavicino, wildlife can be observed in a vast park. In the springtime the botanical garden on the grounds of Villa Taranto, a couple of miles north of Stresa, is an explosion of azaleas, rhododendrons, camellias, magnolias, and roses. In the eighteenth and nineteenth centuries, English and German travelers paused on these shores to admire the villas and their gardens and explore the three gemlike Borromean Islands. The first stop would be in Arona, where there is a panoramic view through the eyes of the statue of San Carlone, a colossal 106-foot-high bronze sculpture dedicated to Saint Carlo Borromeo, second in size only to the Statue of Liberty in New York.

Although this slice of land pushes into the foothills of the Alps, the climate is pleasantly mild. Stresa was first chosen as a relaxing vacation destination by the nobility of Milan, the Borromean dukes, and the upper classes from nearby Switzerland and Central Europe, who adorned their houses with works by the greatest artists of the Art Nouveau period.

Stresa, similar to other towns along the shores of Lake Maggiore, has adapted well to its given geography and the relaxed attitude of its visitors. The landscape invites leisurely walks along the lakeside promenade, strolls through the village streets past well-tended homes and craft shops offering hand-embroidered articles and ceramics, and window-shopping at the more expensive clothiers or jewelers, which is a feast for the eyes. Afterward, stop at a confectioner's for a cup of tea and a *margheritine*, Stresa's own star-shaped sweet biscuits.

The Borromean Islands, just north of Stresa, are an integral part of a trip to this area. Each of the three islands are wonderfully different and can be reached in a few minutes by steamboat from the mainland. The islands once belonged to the Borromeo family, who, from the seventeenth century on, built opulent homes on Isola Bella (Beautiful Island), the nearest of the three. They even extended the island and beautified it with an extravagant Italian garden. Terraced and full of statues, rare flora, and even a population of white peacocks, the garden is an impressive expression of the Baroque. A trip to the nearby Isola dei Pescatori (Island of the Fishermen), with its tiny colonnades and old-fashioned homes reminiscent of the nineteenth century, is a picturesque excursion. Isola Madre, the largest of the islands, boasts a palazzo owned by the Borromean dukes and a splendid botanical garden.

To stay on the shores of Lake Maggiore is to go back a hundred years in time. The best-known of the great hotels here is the Grand Hotel des Iles Boromées on Stresa's shores, where a magnificent park overlooks the lake and rooms are lavishly decorated in gold leaf and furnished with inlaid chests. Three miles south at Belgirate, a charming village of aristocratic residences, one can stay at the Villa dal Pozzo d'Annone, a beautiful nineteenth-century building with furnishings and paintings dating from the fifteenth through the nineteenth centuries and a park of over ten acres with rare trees and tumbling waterfalls. Gignese lies behind Stresa and is known for its umbrella-making industry—the town is home to a Museum of Umbrellas and Parasols, a collection of 1,500 examples of this indispensible accessory that was invented in the eighteenth century.

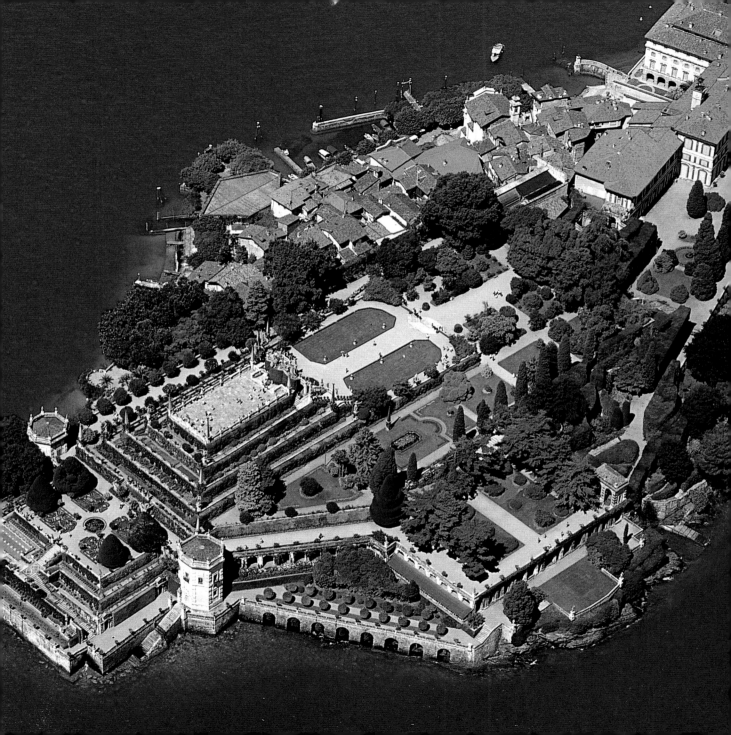

VALENZA
A THOUSAND GOLD WORKSHOPS

VALENZA IS A SMALL CITY CENTER SPECIALIZING IN JEWELRY fashioned from gold and precious stones. The city has become one of the most important manufacturers of jewelry in Italy and the world. There is no exact information as to when Valenza first became active in jewelry making, but it was certainly a long time ago. Legend has it that in Roman times there were four gold mines around the city, while another tells of hundreds of slaves who were made to pan the sands of the Po River for gold nuggets, which were then taken to artisans locked inside the fortress and ordered to work by the Emperor Valens.

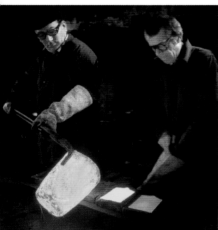

In centuries past, adornments made from gold and precious metals were widespread in the provinces of Vercelli and Alessandria, perhaps because there were many noble families in the area and the Savoy court was then in power. Gold-working activity was resumed with vigor in Valenza in the middle of the nineteenth century. Traditionally, skills were handed down from father to son, resulting in an unparalleled level of craft and consistency that cannot be compared to any form of industrial technology. To this should be added the inexhaustible creativity of the gold craftsmen of Valenza, which has made this village on the banks of the Po the so-called "world capital of the jewel." In Valenza there are more than a thousand small workshops where fashionable jewelry is created from gold and gemstones. The secrets of the artisans lie in their ability to turn their craft into a complete cycle of production. The process starts with the design, then the fusion of the gold, the cutting of the stones, and finally the setting. Valenza's goldsmiths are true masters of their craft, perhaps due to the Fascist regime of the last century, which forbade the working and importation of gold, forcing artisans to employ baser metals in their creations. In order to justify the high cost of labor in contrast to the modest cost of materials, they made elaborate jewelry. After the Fascist regime crumbled, their professional ability was transferred to more precious metals, and Valenza became known as the "city of gold." The Gold Show is organized by the Valenza Gold Workers' Association, which was established in 1945 to revitalize the region. The event is held in March and October and helps to supply the market and promote Valenza's status as a center for jewelry production.

An intense moment at a goldsmith's workshop.

facing page
The grand stairway of the Palazzo Pellizzari.

Valenza was the seat of the noblemen of the Marca Aleramica, which had been instituted by Berengario II in the second half of the tenth century. It then became the seat of the marquisate of Monferrato, a much-contested land of vineyards, castles, monastic centers, and great natural beauty. The natural reserve, Garzaia di Valenza, can be found at the gates of the city and is best toured accompanied by a park guide. The nature reserve Bosco delle Sorti della Partecipanza in Trino is one of the Po Valley's rare examples of a forest of planiziario wood, the product of oaks and poplars. The regional park of Crea is home to Il Sacro Monte del Crea (Sacred Mount of Crea), a sanctuary that, according to legend, was founded in the fourth century by Sant'Eusebio, who is said to have traveled from the East carrying three statues of the Virgin Mary, leaving one behind in Crea. Toward the end of the sixteenth century the Gonzagas, nobles of Mantua, built a holy mount here, including five hermitages and twenty-three chapels entirely frescoed and decorated with sculptures.

The nature reserve along the Po River and the Orba Stream is an ideal place for bird-watching. Most of the birds (migratory, local, and many nesting couples) are aquatic: red and white herons, gray chickens, coots, bitterns, and sea swallows. Nocturnal birds of prey can also be observed here, such as brown, barn, and hoot owls. In the areas of the park that cross the Vercelli and Alessandria provinces, over 5,000 acres of land have been turned into a nature reserve. In 1990 the Garzaia di Valenza (Valenza Heronry) was created to protect Piedmont's only red heron colony. The bird sanctuary encompasses ninety acres and can be reached from Cascina Belvedere at Frascarolo, less than a mile past the bridge spanning the Po. Set out on foot, by bicycle, or with a guide.

VERCELLI
RICE FIELDS AND RISOTTO

VERCELLI HAS HAD A COLORFUL ROMAN AND CIMBRI PAST. In the twelfth century it was a glorious commune of the Lombard League, distinguished for its culture and painting school, for the spires of the church of Sant' Andrea, and for the frescoes by the Piedmontese painter Guadenzio Ferrari (ca. 1475–1546) in the church of San Cristoforo. For miles and miles the town is completely surrounded by rice paddies and has earned the moniker, "land of water." Rice was introduced here in the fifteenth century and was first planted by the Cistercian monks in the Baraggia to the north of the town, between the Elvo and Sesia rivers. At one time it had been wild, infertile moorland, but rice cultivation spread throughout the lowlands with the help of one of the greatest irrigation systems in the world. The proliferation of rice paddies deeply affected the environment and the economy of the area. The Ecomuseum of Water and Land details the history of rice in Vercelli and offers visits to places such as the hydrometric station at Santhìa, the castle of Albano, the mill at Boscherina, and the port at Fontanetto on the Po River.

Vercelli's flat landscape undergoes remarkable changes with every season and can best be enjoyed while riding a bicycle or walking along paths and through sheep meadows. In the spring Vercelli becomes a hive of activity as machines level the land in order to reshape the landfills and canals that will become immense expanses flooded with water. These efforts are all geared toward creating classic rice fields. The water's surface reflects a landscape of farmhouses and poplar trees and is a favorite resting spot for the silent and immobile figures of the ibis, gray heron, and egret. In summer this sea of water becomes bright green as the young rice appears, a prelude to the warm season. In September the fields change to carpets of warm gold, the color of the tufts of young rice, and the harvest frenzy begins. During the winter months the rice fields lie dormant, enfolded in the mists that hide boundaries and roads. It is the ideal season to find refuge in an old inn—and there are several of them—and taste the local salami and other specialties such as goose and cabbage. The story of the rice fields was told by Giuseppe De Santis in his film, *Bitter Rice* (1949), starring Silvana Mangano. It is a story about women laborers, called *mondine*, who toil in the fields pulling out weeds and transplanting healthy shoots upright. Water up to their calves, feet in the mud, their backs bent for many hours, all traces of femininity are erased. The invention of weed killers replaced them, but the chemicals drove out most of the inhabitants of the paddies, such as frogs and salamanders, and even to a certain extent, the ibis, heron, egret, and snipe. However, the old traditions are beginning to return, and the natural cultivation of rice is once again in practice.

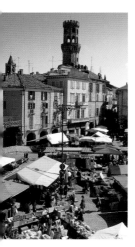

A bustling market on Piazza Cavour.

facing page
Rice fields of Vercelli with the Alps in the background.

There are at least three hundred recorded recipes based on rice, but in reality there are an infinite number depending on the inventiveness of the cook. Rice can be prepared with almost everything, from fish and meat to strawberries and nettles. Basic risotto rice is called Baldo and is used in baked dishes; Arborio, the most common rice in Italy, is for risotto *all'onda* (of the perfect consistency); Maratelli and Carnaroli rice make delicate and refined risottos; and Sant'Andrea rice is used in soups or for preparing cakes or fritters. Risotto is the typical dish of the Pianura Padana, the plain of the Po River. In Vercelli and the surrounding area risotto is prepared with cosset (small frogs' thighs) or with beans, chopped pork fat, and salami *d'la duja* (preserved in suet) and is a staple of the peasant dish *panissa*.

In the mountainous region of Vercelli, the old art of *puncetto*, a fine cotton lace that requires cleverness and patience to make, continues to this day. The lace consists of a delicate net held together by a slipknot and was traditionally worn on Sundays. Today the lace is used more as a decoration for centerpieces or for elegant women's clothing. *Puncetto* can be found in the town of Valsesia at the foot of Monte Rosa. It is worth a visit to see the work of the painter Gaudenzio Ferrari, as well as the fifteenth-century Sacro Monte di Varallo, one of the largest holy mounts in the Alps. The area consists of forty-five chapels, about one thousand life-size terra-cotta figures, and hundreds of breathtaking frescoes.

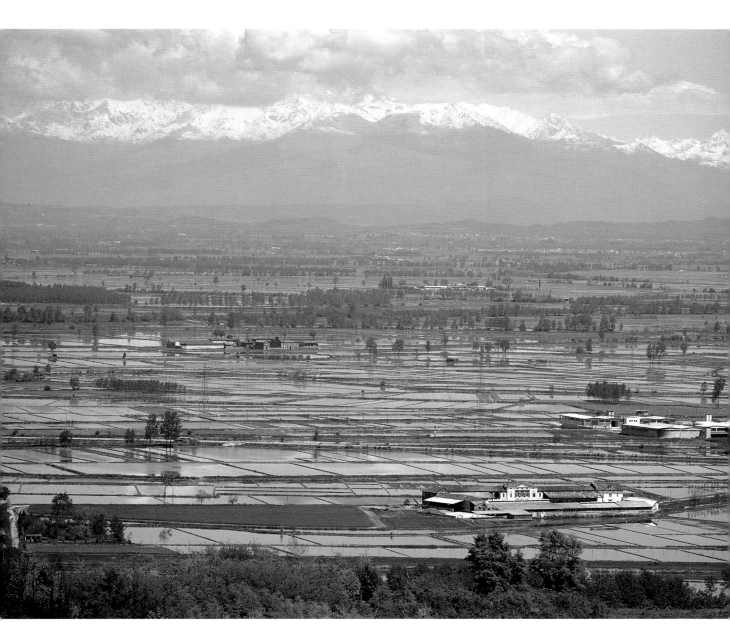

BELLAGIO
THE LAKE GARDEN

BELLAGIO IS KNOWN AS THE PEARL OF LARIO ("Lario" is another name for Lake Como). The town is not easily reached, one must be firm of purpose and not tire of the narrow roads that rim the lake, or of climbing the mountains of the Larian Triangle. After a couple of miles of woodland, a well-tended garden appears, stretching toward the lake and the Punta Spartivento park that separates Lake Como from Lake Lecco. It is easier to arrive by the boats that connect the principal centers around the lake, offering a better view of the promontory, the villas, and the gardens that characterize the port of Pescallo. Centrally located on the shores of Lake Como, Bellagio's geography is unique, with a temperate climate and hearty vegetation.

The city has been inhabited since prehistoric times and was once the summer retreat for Roman patricians. It was eventually discovered by aristocrats from Milan, but it wasn't until the end of the nineteenth century that luxury hotels began to crop up and the area became a vacation idyll for the European elite. Bellagio's location, far from the main roadways, enables it to preserve its natural seclusion. The town center, known as the Borgo, is a pleasant nucleus with narrow streets on flights of steps accented by elegant shops where locally produced silk and lace, blown and decorated glass, and hand-worked leather items are sold. At the heart of the city are lively piazzas and the Romanesque church of San Giacomo, which dates to the beginning of the twelfth century and features a beautiful fifteenth-century triptych above the altar. From the busy harbors along the promenade, the opulent villas climb toward the top of San Primo Hill, from which there is an exceptional vista of the Alps.

Among the sights in Bellagio are the many villas and their romantic gardens. The sixteenth-century Villa Serbelloni, once home to the Roman author Pliny the Younger (ca. AD 61–113), was built on the promontory above the town and includes a vast park overlooking the lake. The villa is now owned by the Rockefeller Foundation, which maintains the property as a retreat for artists and researchers. (The villa is open to the public from April to October.) The Neoclassical Villa Melzi d'Eril was built between 1808 and 1813 by Duke Francesco Melzi d'Eril, an acquaintance of Napoleon. It is rich in frescoes and stucco decoration and has a splendid garden and terrace. The Neoclassical Villa Giulia dominates the lake. Villa Trivulzio has an extravagant English-style park that boasts a small Romanesque church.

The garden at Villa Melzi.

facing page
The division of the lake with the Bellagio promontory seen from Monte Grona.

Artists and scholars, politicians and statesmen, all came to the shores of Lake Como in search of repose and tranquility. Among them were Czar Nicholas II of Russia, German Chancelor Konrad Adenauer, novelists and poets such as Mark Twain, Percy Bysshe Shelley, Stendhal, Gustave Flaubert, Alessandro Manzoni, and Giuseppe Parini, the conductor Arturo Toscanini, and the composer Franz Liszt. However, Bellagio was prized more for its natural beauty and harmony than for its fashionable society. Artists of all kinds discovered inspiration here that might have been impossible to find elsewhere. The English community was so numerous that the first Anglican church in Italy was built in 1891 at Cadenabbia. The American poet Henry Wadsworth Longfellow dedicated a few verses of *The Fight of the Fourth* to this particular place.

One of the best places to stay in Bellagio is the Grand Hotel Villa Serbelloni, a nineteenth-century aristocratic villa fitted out with period hangings, Persian carpets, glass chandeliers from Murano, Empire, Neoclassical, and Art Deco–style furniture; and decorated with stuccowork and frescoes. Guests have access to a lush park on the hotel grounds, a health center, and a restaurant offering excellent dining possibilities. Facing the opposite shore of the lake along the Regina road stands the Grand Hotel Tremezzo, a Belle Epoque–style establishment. Since its founding in 1910 the hotel has welcomed noble families from all over Europe. Italy has a strong glasswork tradition and the production of blown glass balls is a specialty in Bellagio. The extremely delicate balls are hand-painted by artists and often sold as Christmas ornaments.

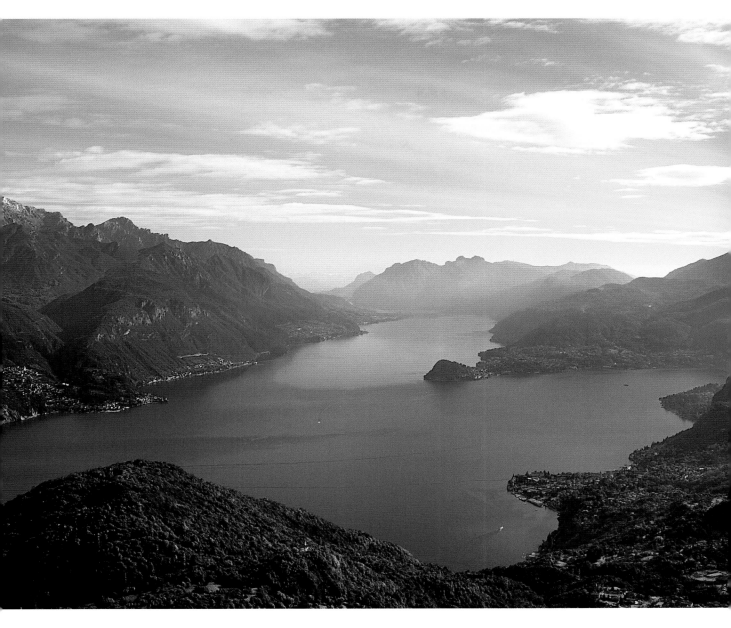

BERGAMO
THE RENAISSANCE CITADEL

BERGAMO CONSISTS OF UPPER BERGAMO AND LOWER BERGAMO, two vastly different social and urban entities. The former is of Celtic origin, whereas the latter developed thousands of years later and continues to grow to this day. Bergamo's name is derived from the German *Berg,* meaning "mountain," a designation that reflects Upper Bergamo's sixteenth-century towering Venetian walls. Upper and Lower Bergamo have two ideals in common: freedom and work. The inhabitants of "de hota" (the local dialect for Upper Bergamo) are proud of their city. It could be said that constructing houses is part of their DNA. It was they who rebuilt Milan after it was destroyed by bombings during World War II. Teams of laborers traveled to the capital of Lombardy to work from dawn until dusk on the construction sites. On weekends they laid brick upon brick in the fields in such a short time that soon each worker had built their family a "villa."

If one takes the funicular from Lower Bergamo, which is modern and efficient, to Upper Bergamo, you will find yourself deep in the Renaissance. The funicular station is in a fourteenth-century building and, from there, through the narrow streets and ancient palazzos, one reaches the Piazza Vecchia, defined by the architects Le Corbusier and Frank Lloyd Wright as one of the most beautiful in the world. To the northeast the piazza is closed in by Palazzo Nuovo, which was begun toward the end of the year 1500 and finished in 1928. Facing it is the Torre del Campanone, a bell tower that tolls 180 times every evening, marking the closing of the city gates. The eleventh-century portico of the Palazzo della Ragione was reworked in the sixteenth century and opens onto a narrow piazza where a few Renaissance architectural masterpieces can be seen, such as the Cappella Colleoni, a chapel built by the architect Giovanni Antonio Amadeo between 1472 and 1476 to house the votive chapel of Bartolomeo Colleoni, a soldier of fortune. Colleoni was in the service of "La Serenissima," or the "Most Serene," Republic of Venice and, among other feats, transported the Venetian fleet from the Adriatic Sea up the Adige River, leading the ships through the mountains as far as Lake Garda, where he faced the Duchy of Milan in a naval battle. The Baptistery was built inside the church in 1340 and then moved to the piazza in 1898. The Duomo was begun in the mid-1400s and finished four centuries later. The Basilica di Santa Maria Maggiore dates to the twelfth century. A little farther away stands the fourteenth-century Citadel, from where a funicular ascends to San Virgilio, the highest point in the city, where the former twelfth-century monastery of Astino can be visited, as well as a castle and a terrace café offering sweeping views of the plains below.

Every Friday from June to September, a tour group meets at nine in the evening in front of the church of Sant'Agostino. Come equipped with comfortable shoes, a light, weatherproof jacket, and a flashlight, and prepare to enter the bowels of Upper Bergamo. One must be ready to hear stories both historical and fictional (and often embellished by the guides of the Archaeological Group of Bergamo, who tell of men employed to remove bodies after the plague, of thirty-five witches burnt at the stake on Piazza Grande, and of soldiers who threw themselves over battlements rather than go to war). In the Citadel, in a room that was once home to a cult, there is a secret passageway leading to an underground corridor where, among stalactites and bats, the exploration begins. The mystery tour concludes at the Pozzo di San Francesco (Well of Saint Francis), where the chill of the outing is eased by a slice of local salami and a glass of wine.

Upper Bergamo is known for its famous soldier of fortune Bartolomeo Colleoni, who was born in Solza and lived in the castle of Malapaga. Bergamo honored (and at the same time feared) allowing Colleoni to demolish part of the Basilica di Santa Maria Maggiore to erect the Colleoni Chapel, which was to hold his mortal remains. The composer Gaetano Donizetti lived in the first half of the nineteenth century and was born just outside the palace walls at Borgo Canale in 1797. A museum housing his mementos is located on the Via Arena and his tomb is on view in the basilica. Donizetti died in 1848 at the Palazzo Scotti. A theater dedicated to him is found in Città Bassa (Lower Bergamo), where one can visit the Accademia Carrara, one of the most important art collections in Italy, where works by Raphael, Diego Velázquez, Lorenzo Lotto, Pisanello, Andrea Mantegna, and Jacopo Bellini are displayed.

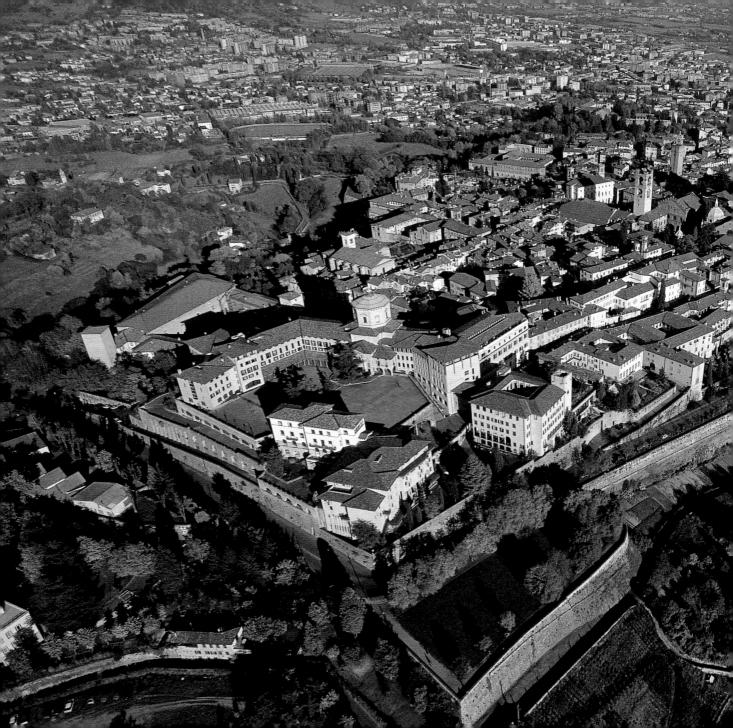

The Adamello glaciers are wedged into the Valle Camonica on Lake Iseo to the east of Bergamo. The Valle Camonica is crossed by the Oglio River and is certainly the most important valley of the Alpine Lombard foothills. The area is rich with artifacts from the past, from remains of a thriving iron industry to palazzos, medieval castles, and Roman ruins, which are everywhere to be found. However, the valley's most valuable asset, and for which it was designated a UNESCO World Heritage Site, consists of more than 200,000 rock carvings from the Camuna civilization, which are scattered along the valley from Breno to Cividate Camuno and from Capo di Ponte to Remedello. The engravings were made over a long period, from prehistoric times until the Roman era, and vary so greatly in style that scholars were able to date and classify them on the basis of their artistic evolution. Many of the rock inscriptions depict prayers or magic rites through which the ancient Camuni attempted to communicate with the cosmos.

A flea market in
Upper Bergamo.

left
An aerial view of
Upper Bergamo.

below
Inlay work in Santa
Maria Maggiore:

The Flood, from a
cartoon by
Lorenzo Lotto.

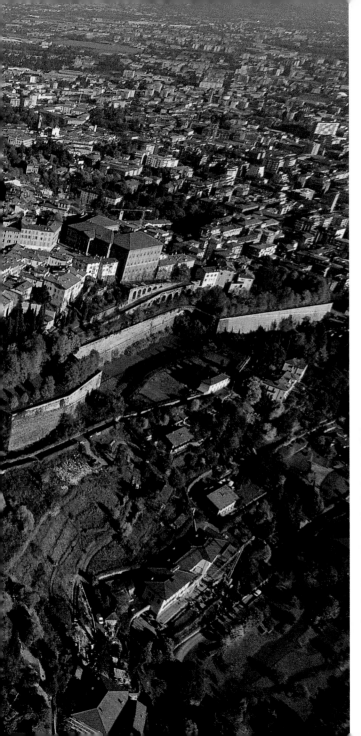

29

C O M O
ANCIENT CAPITAL OF SILK

TOWARD THE END OF THE FIFTEENTH CENTURY, silk was brought to the lakeside town of Como by Duke Ludovico il Moro Sforza of Milan, who imported silkworms from the East and fattened them on mulberry leaves grown in his garden at the castle in Vigevano. The duke's nickname, "il Moro," comes from the Latin *Morus alba*, meaning "mulberry tree." Silk was woven by hand for the nobles of Milan until the early nineteenth century, when mechanical looms were introduced, providing a strong boost for Como's workforce. After World War II further developments took place in the textile industry, and today eighteen thousand people scattered throughout a large number of factories work the silk threads, which are in large part imported. Como exports 50 percent of its silk products. The most fashionable storefronts are located along Via Vittorio Emanuele, but bargains can be found at company outlets.

The artistic heritage of Como's monuments have made the city an important tourist attraction. Among the most significant are the breathtaking fifteenth-century Duomo, the splendid fourteenth-century Palazzo Broletto, the medieval church of San Fedele, the palazzos Rusca and Natta (both marvelous examples of Romanesque–Lombardian architecture), and the Renaissance architecture of the Piazza San Fedele. For those interested in taking to the water, the paddle steamboat Concordia departs from the pier at Piazza Cavour and sails across Lake Como. The English poet Percy Bysshe Shelley described Lake Como in 1818 as a "long, narrow lake that seems like an immense river flowing between the mountains and the forests." The steamboat is sometimes used for special events such as galas or wedding parties. Centuries ago the noble families of Milan crossed the lake from Varenna to Bellagio and Menaggio more than once a day to reach their luxurious villas and gardens along the water's edge.

The shores of Lake Como, or the Lario, as it is sometimes called, have been inhabited since ancient times. The Roman scholar Pliny the Elder and his nephew Pliny the Younger, resided here. At the end of the port stands the Neoclassical Villa Olmo, and, in Cernobbio, the nineteenth-century Villa Erba, which once belonged to the renowned film director Luchino Visconti. The sixteenth-century Villa d'Este has been transformed into one of the most exclusive hotels in Europe; its garden is adorned with whimsical statues, foun-

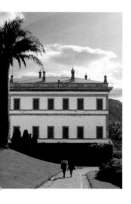

facing page
A view of Lake Como from Villa Balbianello.

below
The Villa Melzi.

tains, and grottos. On the western shore of the lake atop a promontory in Lenno stands the eighteenth-century Villa Balbianello, furnished with period pieces and now managed by the Fund for the Italian Environment. At Tremezzo, the eighteenth-century Villa Carlotta houses works by the sculptor Antonio Canova and paintings by Pieter Bruegel the Elder.

There are many lavish hotels in Como but few can be called grandiose. However, the Villa d'Este (transformed into a hotel in 1873) is one of these by way of its gorgeous setting and the services it offers: two swimming pools, three restaurants, a sports club, and a health center. The villa dates to 1568 and was a project of Cardinal Tolomeo Gallio's. It is found on the western shore of the lake, three miles from the city. Notwithstanding its enormous size (130 rooms), the building preserves the atmosphere of a private residence, and is surrounded by a park and Italian gardens decorated with marble statues and playful fountains.

Only a few miles separate Como from the Swiss canton of Ticino, a natural bridge between northern and southern Europe and a radical departure from traditional Alpine culture, climate, and landscape. The capital of Ticino is Bellinzona, a graceful town at the crossroads between several busy Alpine routes. Three imposing citadels (recently declared World Heritage Sites by UNESCO) bear witness to Bellinzona's pivotal role over the centuries. Castelgrande, the most impressive of the three medieval fortresses, was built to defend important Alpine passages such as the famous Gotthard Pass. Renovations to the Castelgrande have revealed traces of an earlier, perhaps Neolithic, settlement. The castle of Montebello is the most extensive fortification and the Sasso Corbaro Castle stands on its own to the southeast of the city and dates to 1400.

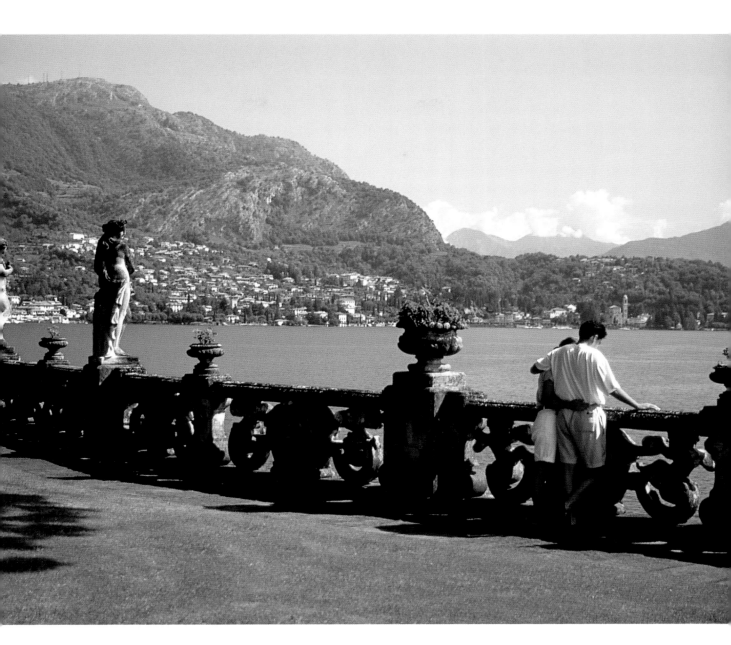

CREMONA

DREAMING OF STRADIVARI

CREMONA IS NESTLED ON THE LOWER LOMBARD PLAIN and was founded in 218 BC to defend the fords across the Po River from Hannibal and the Gauls. It was subjected to incursions, but always emerged unscathed, so much so that today it is considered an artistic center of rare beauty. Visit the Piazza del Comune where graceful palazzos and the Duomo can be seen. The elegant bell tower, called the Torrazzo (Big Tower), is the

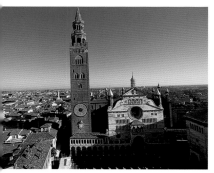

The Romanesque Duomo and the proud Torrazzo seen from the Civic Tower.

facing page
The workshop of a lute maker.

highest in Italy at over 300 feet tall. It was so beautiful upon completion that the architect was said to have been thrown off it to prevent him from erecting another to challenge the tower's grace. The 487 steps up to the Torrazzo's spire are well worth the climb.

The most famous violin in the world, the Stradivarius, is made here, as are the Amati and Guarnieri violins. Cremona boasts one of the greatest schools in Europe for the production of stringed instruments. Andrea Amati (ca. 1515–80) was the master violin maker who defined the form and dimensions of the violin at the end of the sixteenth century. A century later, Antonio Stradivari (1644–1737) raised the technique of making stringed instruments to an art, and in the eighteenth century the Guarnieri family was able to produce an extraordinary sound from violins made from pinewood, which grows in Paneveggio. The difference between the three could not have been great since Nicolò Paganini, perhaps the greatest violinist of all time, began his career not with a precious Stradivarius, and not even with an Amati, but with a less valuable instrument made in 1743 by Bartolomeo Guarnieri del Gesù. This violin was called "the cannon" for the purity and power of its sound.

Cremona is also noted for its *torrone*, a nougat candy of ancient and uncertain origin. Some say its name comes from the Arabic *turun*, a sweet made of available ingredients, easily preserved and transported. Others maintain that it was first served in 1441 at the wedding of Duke Francesco Sforza and Bianca Maria Visconti. For the occasion this compact mixture of almonds, honey, and egg whites, was served in the form of the Torrazzo, but was known as *torrione* at the time. The torrone dedicated at the ducal court became the symbol of the city and was soon exported. By 1500 the commune of Cremona was buying large quantities to donate to the authorities in Milan. The people of Cremona were so addicted to their sweets that a law was passed in 1572 to curb the immoderate consumption of candy. It prohibited indulging in more than two "sugar sweets" a day (with the exception of torrone).

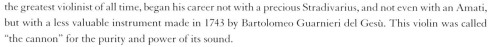

The Po crosses the whole of the plain from the Monviso to the Adriatic Sea, and it is the only real great Italian river. It is navigable for a long distance and crossed by barges carrying goods from Cremona as far away as Venice. From April to October, and particularly on weekends, the Po has in recent years been occupied by small cruise ships carrying a maximum of 100 to 150 persons. The vessels stop at Cremona, Mantua, Ferrara, and Venice, and explore natural oases and artistic hubs. It is also possible to hire a house-boat as it is not necessary to be an expert sailor. This would allow one to move along the river at one's own pace, alternating the sailing with bicycle excursions to the nearest and most interesting centers—Sabionetta is a splendid example. Stop for the night in the coves near the Po Delta or at the landings in the center of town.

For the harmony of its proportions, the elegant Piazza del Comune is one of the most beautiful piazzas in Italy. The square is home to the medieval Palazzo Comunale and the Duomo, the most important monument in Cremona. The Duomo was consecrated in 1190 and the Baptistery in 1167. Beside these two structures rises the bell tower, known as the Torrazzo. Initially intended as a military tower, the Torrazzo has come to symbolize Cremona. The astronomical dial on its clockface still possesses its original mechanism and serves to mark the hours and minutes of the seasons, lunar and solar eclipses, and astral conjunctions. The Loggia dei Militi, built in 1292, is worth visiting for its beauty alone, as is the eleventh-century church of San Michele Vecchio, the oldest in the city. For a history of the violin visit the permanent exhibition on lute making and the Museo Stradivariano (Stradivarius Museum), which houses 1,200 works by Antonio Stradivari. Don't miss the Teatro Scientifico (Scientific Theater), a trompe-l'oeil funhouse founded in 1769.

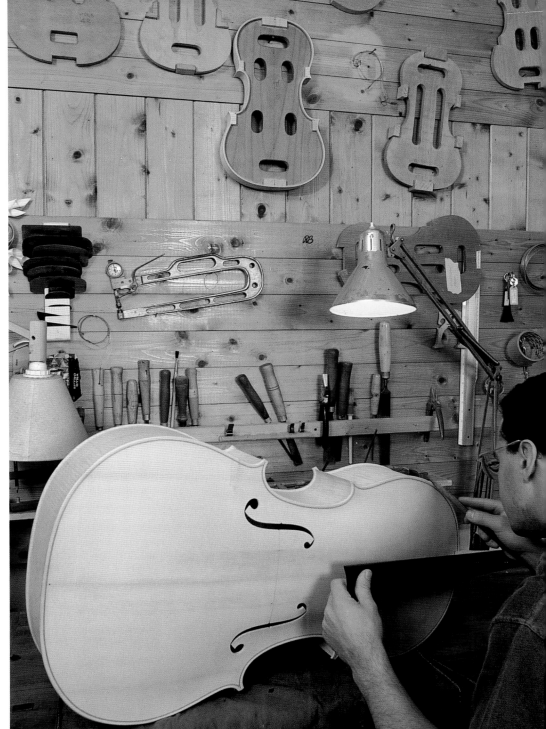

MANTUA

A DUCAL COURT BY THE LAKES

MANTUA IS AN ANCIENT CITY, DEDICATED BY THE ETRUSCANS TO THE GOD MANTU. The Roman poet Virgil was born here in the first century BC, and it is said that his effigy, nicknamed "la vecchia" (the old woman), is carved into the facade of the Palazzo del Podestà. Surrounded by a belt of water composed of three lakes and a tributary of the Mincio River, Mantua was also a powerful municipality. A port enriched the city with commerce. Its walls are now crumbling and the canal has dried up, but the giant lotus leaves covering it remain. The plant was brought from the Far East in the twentieth century and is now the symbol of the city, particularly in the summer when it blooms with pink and white flowers.

Many palazzos graced the city, and at one point Mantua was so stunning that the illustrious Renaissance artists Giulio Romano (1499–1546) and Andrea Mantegna (1431–1506) built their homes here. The medieval Piazza delle Erbe is home to several significant monuments, such as the clock tower, the Palazzo della Ragione, the Rotonda di San Lorenzo, the church of Sant'Andrea (one of the most beautiful in Italy), and the arcades where contracts were once settled with a handshake before going to an inn to warm up with a glass of rustic wine.

Mantua's splendor is owed to the Gonzagas, dukes of Mantua, who ruled from 1328 until the first years of the eighteenth century. The Gonzagas built on the headland between the lakes and erected the fourteenth-century Palazzo Ducale, a sumptuous palace second only to the Vatican. It is a complex of five hundred rooms, fifteen gardens, courtyards, a church, and a theater lying between Piazza Sordello and the lake. The palace was enlarged over the centuries and bears the work of the most famous artists of the time. Almost one hundred of the five hundred rooms of the palace are open to the public. Among the most outstanding are the Camera degli Sposi (Chamber of the Wedded Couple), decorated with frescoes by Mantegna; the Princes' Salon adorned with red-chalk drawings by the early Renaissance painter Pisanello; the Salon of the Rivers; the Riding School courtyard; and the intimate Appartamento del Paradiso (Apartment of Paradise), where the Duchess Isabella d'Este resided. Not to be missed is the jewel-like study with inlaid ceiling. Its walls were once adorned with canvases by the Renaissance painters Pietro Perugino (ca. 1450–1523) and Antonio da Correggio (1494–1534), now preserved in the Louvre in Paris. An island on the property is now united with the mainland, where the duke built the Palazzo del Te, a hunting lodge for the Gonzagas that, thanks to Giulio Romano and other artists, is one of the most elegant structures remaining from the Renaissance.

The ancient, noble, and refined artisanal tradition of Mantua is still alive today. Artisans working in the time-honored metals of gold, silver, and bronze craft medals upon which they inscribe with amazing skill tiny historical characters or events from Italian history. Among the local gastronomical products, and apart from the classic pumpkin dishes, visitors should taste a *torta sbrisolana*, a cornmeal, butter, and almond crumble cake, and *salamella*, a fresh pork sausage used, among other things, for the preparation of *risotto alla pilota* (milner's risotto).

facing page
A detail of a ceiling fresco by Andrea Mantegna in the Camera degli Sposi at the Palazzo Ducale.

below
Palazzo Broletto's internal courtyard.

The *Cucurbita* arrived in Italy from South America with Christopher Columbus. It is cultivated widely in the countryside between Mantua and Ferrara. There are many forms of pumpkin—club-shaped, pear-shaped, bottle-shaped—and colors—white, yellow, green, and variegated. Some are as small as tangerines, others as big as nine feet in diameter. Their flesh is meaty and consistent, or they can unravel like thread and be served with a sauce, similar to spaghetti. The pumpkin is used to prepare many tasty dishes, from soups to risottos to desserts. The *tortelli* at the restaurant Il Cigno are the most famous in Mantua. They are prepared by one of the best cooks in Italy, Nadia Santini, at the Dal Pescatore restaurant. From September to December, an exhibition called "From One Pumpkin to Another" is an invitation to venture on a gastronomic excursion to visit inns and learn about the many varieties of pumpkins that exist.

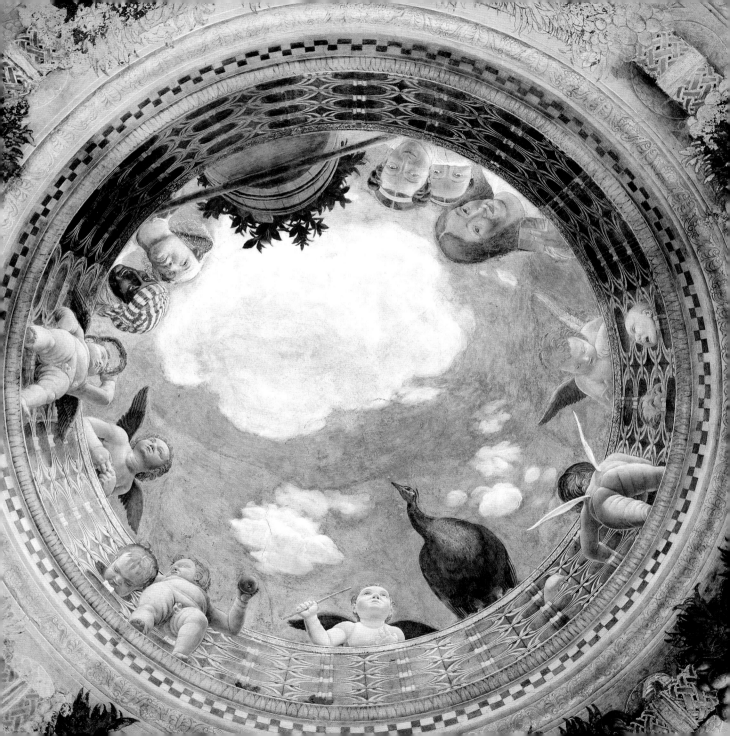

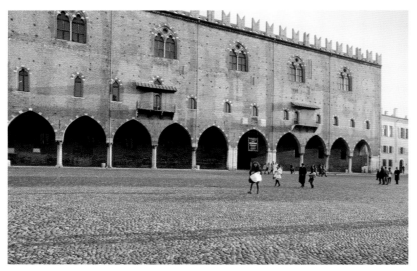

Mantua's historic center is concentrated around three aligned piazzas: Sordello, Broletto, and delle Erbe, alternated by lovely parallel streets graced by ancient palazzos. The Duomo overlooks Piazza Sordello, which is dedicated to Saint Peter. The facade is Baroque in style and the bell tower is Romanesque. Beside it stands the Palazzo Ducale, constituting the San Giorgio Castle, the Corte Vecchia, and the Corte Nuova. The Torre della Gabbia overlooks the Piazza Broletto as does the Palazzo del Podestà with its elegant arcades, called I Lattonai, which lead to Piazza delle Erbe. Here stands the Palazzo della Ragione with its clock tower and, in the background, the Rotonda di San Lorenzo, an eleventh-century church inspired by the Holy Sepulcher in Jerusalem. Casa Boniforte dates to 1455 and is one of the oldest homes in the city. A few steps away is the Basilica di Sant'Andrea, one of the finest examples of Renaissance architecture in Italy. The basilica was designed by the architect Leon Battista Alberti (1404–72) in 1470.

The facade of
Palazzo Ducale on
Piazza Sordello.

right
The central element of
the eastern perspective
of Giulio Romano's
Palazzo del Te.

below
A glimpse of the Piazza
delle Erbe.

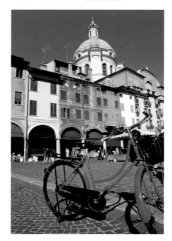

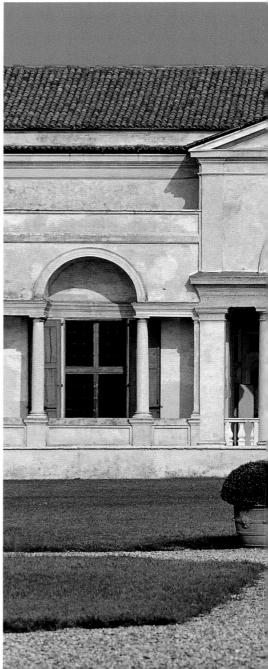

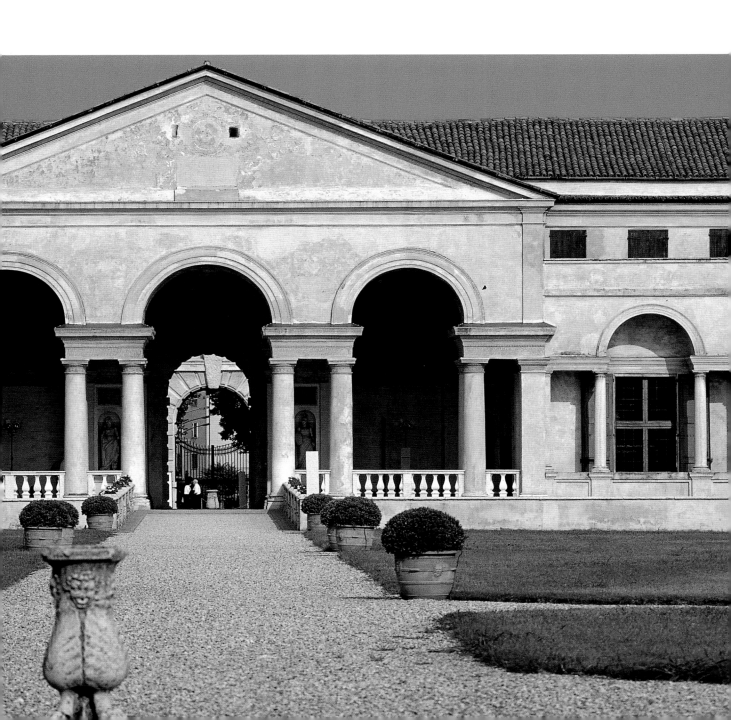

MONZA
THE PARK OF ROYALS AND FERRARIS

Traveling by car between Milan and Monza, one doesn't know where one city begins and the other ends. However, in the not-too-distant past Monza was the capital of Brianza, an historic area where the Milanese vacationed or took day trips. Tourists and residents alike are known to ride bicycles to the hills to collect daffodils.

Monza has since grown in size and become a province, separating itself from the politics of Milan. Brianza is no longer an oasis of green, even if it protects its natural resources and parks. Scattered on the hills are hundreds of villas and gardens that try to preserve their bucolic status. The great park of the Villa Reale thrives as an expanse of woods and fields enclosed within nine miles of walls, the largest enclosed area of its kind in Europe. The grand Neoclassical Villa Reale was built between 1777 and 1780 by the architect Giuseppe Piermarini as a country retreat for Archduke Ferdinand of Austria, son of Empress Maria Theresa. A nearby park was constructed at the beginning of the nineteenth century by Eugenio Beauharnais, viceroy to Napoleon. He enlarged the garden and widened the perimeter to include a farmhouse and two eighteenth-century villas. With the end of royal rule the park had to accept the compromises of progress. During the first decades of the twentieth century, first a racecourse was built, then polo grounds and a golf club.

On the other hand, Monza has a different and much older history and preserves some unique treasures. According to archaeological finds, the area is of Roman origin and reached its greatest splendor under the rule of the Lombard queen Theodelinda. In AD 595 she built a basilica dedicated to Saint John the Baptist in the place indicated to her by a white dove, the symbol of the Holy Spirit, as God was said to have announced to her in a dream. The Corona Ferrea (Iron Crown) is kept in the chapel of the Duomo of San Giovanni and dedicated to the queen. The crown is of fine workmanship (possibly dating to the fifth century) and is set with twenty-four diamonds and twenty-two other precious gemstones. Legend has it that the band of iron inside the crown came from one of the nails used to crucify Christ. The crown was employed during the coronation ceremonies of the Lombard kings and the Holy Roman Emperors from Charlemagne (664) to Charles V (1539), followed by Napoleon in 1805 and Ferdinand I of Austria in 1838. The queen's treasure is kept in the basilica's museum and includes ampoules from the Holy Land, jewels, medieval relics, third-century ivories, and sixteenth-century tapestries.

The Formula 1 race circuit comes to Monza every year.

facing page
The complex of Villa Reale.

The Automobile Club of Milan built a racetrack in 1922 to celebrate the twenty-fifth year of its founding. It was constructed inside the Royal Park of Monza in only 110 days and was, at that time, one of the first in Europe. Even then, an undersecretary of education who was sensitive to environmental issues suspended work on the track because of the "artistic value of the monuments and the conservation of the landscape." He only managed, however, to reduce the dimensions of the original project. Even today, environmentalists protest against the unnatural use of this green oasis. But the racetrack is now an institution that is part of the history of Monza and the sport of motor racing in Italy.

In Monza's Royal Park (the largest enclosed park in Europe), the ancient king's hunting lodge has become the Saint Georges Premier, a refined restaurant where one can spend hours relaxing while sampling the local cuisine. Other restaurants in Brianza also offer excellent fare, such as the Eremo della Priora in Missaglia. Farther north, in Alta Brianza near Lake Lecco, is the San Pietro al Monte, a restaurant that has survived the encroaching crowds, perhaps due to its secluded location. To get there one must embark on a one-hour climb up a mule track. Hidden in a forest on the way is the tiny church of San Pietro, possibly of Lombard origin, and the eleventh-century oratory of San Benedetto.

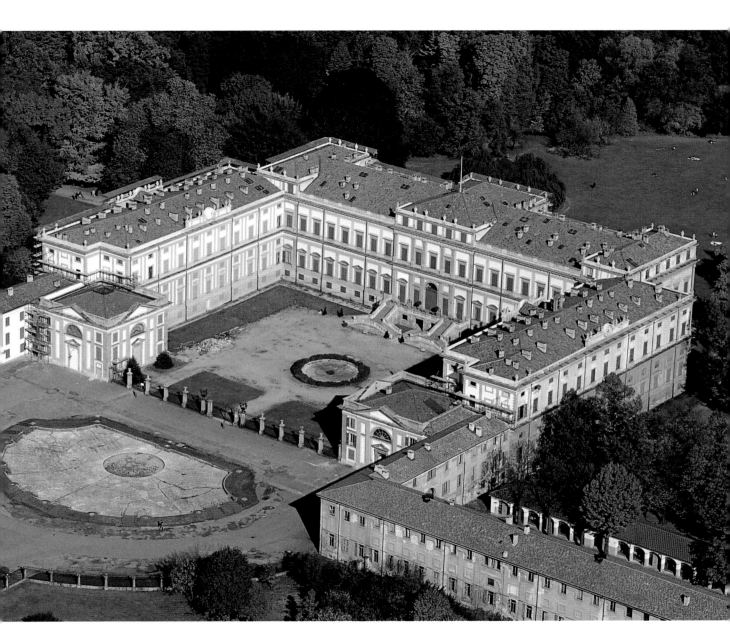

P A V I A
CENTER OF CULTURE AND ACADEMICS

PAVIA IS SPLIT IN HALF BY THE TICINO, the "Blue River" that separates the culturally rich center of the city from the popular Borgo Ticino. Pavia's medieval core was laid out according to the ancient Roman system of right-angled subdivisions from two principal arteries. The *cardo* (the principal road during Roman times) is the modern Strada Nuova, and the *decumano* (the road running perpendicular to the *cardo*) is now the Corso Cavour, from which many smaller streets form the squares of the *insulae* (interior). The sculptor Angelo Galli fashioned a medallion for the municipality that represents the life and history of the city and upon which he depicted a boatman on the *navigli* (canals), a washerwoman, the university, the Duomo, the high towers, representations of nature such as trees and animals, and the monks from the nearby Certosa (the Carthusian monastery).

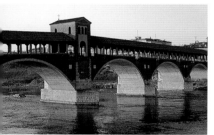

The graceful Ponte Vecchio.

facing page
The Teatro Anatomico in the ancient university.

The University of Pavia is located on the left bank of the Ticino River where Lothario I, king of Italy, founded a law school in AD 825. Five centuries later, in 1361, Emperor Charles IV consecrated the town as a "university city" at the behest of Duke Galeazzo II Visconti (1320–78), the imperial vicar. Several illustrious names studied here, such as the Venetian playwright Carlo Goldoni (1707–93), expelled for his pungent satires against women; the scientist Alessandro Volta (1745–1827), who taught here and held the chair of Experimental Physics in 1778; and the poet Ugo Foscolo (1778–1827), head of the department of Public Speaking. Pavia is a youthful and lively town known for its progressive ideas, and tourists are given free range to explore its past through an impressive array of architectural wonders such as the Duomo, the church of San Michele, the fourteenth-century Castello Visconteo, and the remarkable halls belonging to the ancient university. Not far from the city center stands the fifteenth-century Certosa, one of the largest and best-preserved convent complexes in the world. Visit Pavia on a winter day when the old Borgo seems to float on clouds and the river is covered with a thick coat of fog. The atmosphere invites one to stop in at one of the many taverns, where the furnishings are worn and haphazard but the fireplace is always lit. Order a plate of *arborelle del Ticino* (tiny fish from the Ticino). An ideal companion is a glass of Barbera wine, vivacious in taste, like those who produce it. Sample a *zuppa Pavese* (a clear broth poured over a slice of toast and raw egg), and lis-ten to the story of its origins: In 1525 King Francis I of France had been defeated, and, taking refuge in a farmhouse, asked for food. The *regiora* (lady of the house), embarrassed by her poorly stocked larder, responded by adding everything she could find into the cauldron, including stale bread and eggs. The *zuppa Pavese* was a success and eventually made its way to the court of the king of France.

Pavia has become the Italian capital of fur, thanks to the furrier Annabella, founded in 1960 by Giuliano Ravizza. The shop on the Corso Cavour overlooks Piazza della Vittoria. Inside, the rooms are decorated with gold, stuccowork, and mirrors, and elegantly furnished with antiques. Forty sales assistants present the world's largest assortment of fur pieces, from rabbit to luxurious sable. There is only one fur shop in Italy and it is in Pavia (open from Monday to Saturday and on Sundays during the winter months). Simonettta Ravizza, Giuliano's daughter, has her own shop on the elegant Via Montenapoleone in Milan.

Pavia's Certosa lies halfway between the town and Milan. It is one of the many Cistercian abbeys that arose during the twelfth century on the lower plain of the Po River to reclaim the vast marshes near Milan. Today these abbeys are monuments of great artistic value, but the most famous and magnificent is certainly that of Pavia, built in the fourteenth century by Gian Galeazzo Visconti as a family mausoleum. The Certosa was originally connected by way of a park to the castle in the city, and was about six miles away. The church holds an invaluable treasure that marks the transition from the Gothic style to that of the Renaissance and traces the influence of Lombard art through the centuries. In the small convent shop it is possible to purchase liqueurs and essences prepared by the monks. To enjoy a good meal, go to the nearby Locanda Vecchia Pavia, a comfortable restaurant converted from an old mill.

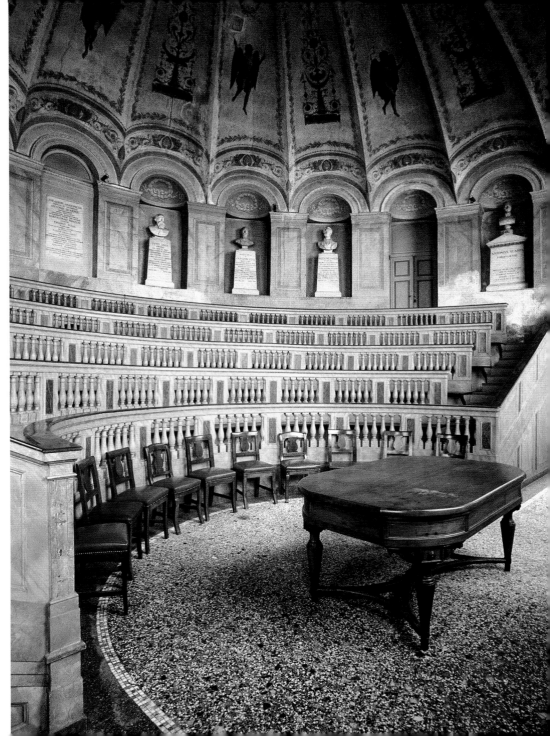

SIRMIONE

PEARL OF THE PENINSULA

THE PENINSULA OF SIRMIONE IS A NARROW STRIP OF LAND extending into Lake Garda and defended by the Castello Scaligero. Strangely, its battlements are half Guelf, squared, and half Ghibelline, swallow-tailed. In addition to the luminosity of the landscape, it provides some important traces of history. Among the silver-green of the olive groves, the Roman poet Gaius Valerius Catullus (ca. 84–54 BC) built a lavish home on the promontory and described it as the "Paene insularum, Sirmio, insularumque ocelle" (the pearl of peninsulas and islands, both). The Grotte di Catullo (Grottos of Catullus) are associated with the great poet and are the best examples of imperial-age building style in Northern Italy. Even though Catullus died in 54 BC, the villa on the grounds is datable to between the late first century BC and the first century AD. Catullus was certainly spellbound by the landscape, as we read in his poetry, and was perhaps inspired by the *trifora del paradiso,* the window of the salon with sweeping views of the Veronese shore of the lake. The grottos and the archaeological museum, which exhibits pottery, historic coins, and stuccowork, is open to the public year-round.

The peninsula is separated from the mainland by a canal. Fishing rights in the waters between Sirmione and the point of San Virgilio were acquired in 1452 at a great cost (1,000 ducats of fine gold). Many unsuccessful attempts (even by Napoleon in 1806) have been made to revoke these rights. Sirmione has given up these privileges, and the fishing grounds of San Virgilio now belong to the towns of Garda and Torri, where the distant past of five centuries ago has been reborn with fish auctions and the distribution of the earnings among the *fuochi* (the fishermen's families).

One enters the town through the thirteenth-century gateway of the Castello Scaligero, a fortress built by the Della Scala family and an excellent example of a harbor citadel. The Castello is surrounded by a moat and connected to the mainland by two bridges. Go beyond the gateway and the shops on the Via Vittorio Emanuele and climb the charming Via Strentelle to the church of Santa Maria Maggiore. Proceed up the Cortine Hill to enjoy a magnificent panorama. Here lie the ruins of the monastery of San Salvatore, founded in the eighth century by Ansa, wife of the Lombard Desiderio. Alongside the thermal baths discovered in 1889, the Passeggiata delle Ricordanze (Memory Promenade) skirts the lake through the canebrake and continues with a scenic walk through parks and villas such as that of the elegant Villa Cortine, now a hotel. The path passes the church of San Pietro in Mavino, built in the eighth century on the ruins of a pagan temple and renovated after the first millennium with a magnificent apse decorated with frescoes.

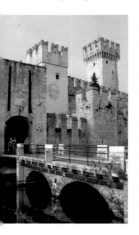

facing page
The Castello Scaligero on the lake and, *below,* one of the bridges spanning its moat.

The extra-virgin olive oil of Garda is one of the best and most sought-after in Italy. Yellow-green in color due to the presence of chlorophyll, it has a delicate scent and a soft, fruity, but distinct taste, with a low degree of acidity. The olives used to make the oil are hand-picked and cold-pressed. They do not undergo any chemical processes to ward off the development of the pesky olive fly as this insect is not indigenous to the region. The oil is sold at big and small farms alike, where wine is often also produced.

Lake Garda is the largest lake in Italy and its waters are traversed by motorboats, ferries, and hydrofoils that connect the main centers of the coast and enable crossings from west to east and east to west. Since 1980 private motorboats have been banned in the Garda Trentino. The Navigation Company launched its first steamship in 1827 and today the Navigarda fleet includes about twenty vessels for various purposes: public transport, tourist excursions, and day and night cruises, from Desenzano to Sirmione and Gardone, for example, or from Desenzano to Peschiera and as far as Riva, spanning the whole lake. Cruises on the old paddle steamers Italia and Zanardelli, launched in 1908 and 1903, respectively, are particularly romantic.

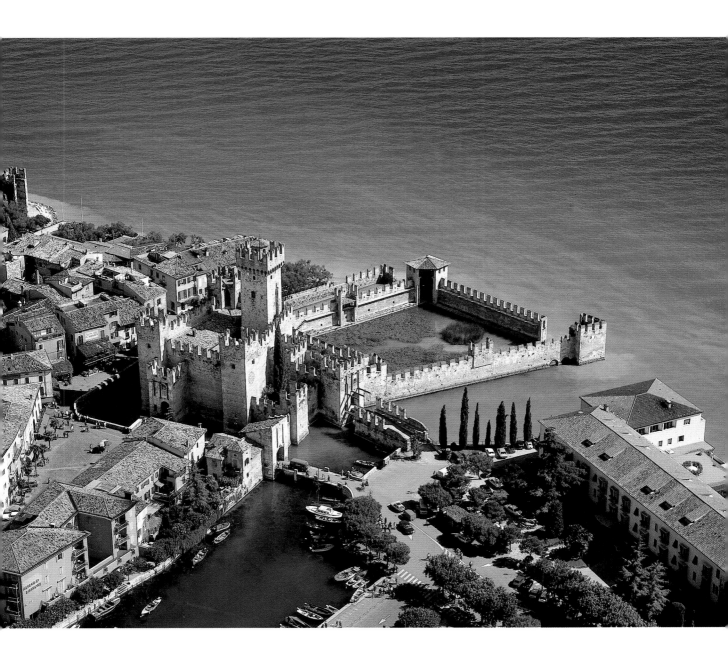

SONDRIO
SPLENDID ISOLATION IN THE ALPS

SONDRIO IS LOCATED IN THE HEART OF THE VALTELLINA (the Upper Adda River valley) and rises from the shores of Lake Como, whose waters provide irrigation for buckwheat fields and vineyards tended to by the inhabitants of the harsh but sun-drenched mountainsides. It is said that he who does not know the mountain cannot understand it. Salvatore Quasimodo, the 1959 Nobel Prize winner for literature wrote, "I don't know how I could adapt to living in this village, that is so silent and squalid, with fields immersed in ice." These were the understandable impressions of a writer transported from the warmth of Sicily to the cold northern climate of Sondrio. Quasimodo spent the years between 1934 and 1937 working here with the State Civil Engineers, and he apparently did not enjoy his isolation, albeit in one of the most beautiful of the Italian Alpine hamlets.

Until a few years ago one would have had to take the snaking State Road 38 along the lake in order to reach Sondrio. The view of the landscape during the ascent is incomparable. Although a major roadway was built, many still prefer the winding road that overlooks the sparkling waters of Lake Como to the innumerable dark tunnels of the highway. At the end of the valley the Stelvio Pass, a climb that reaches an altitude of over nine thousand feet, is the only direct route out of the town and is often closed in winter due to heavy snowfall. The cyclist Fausto Coppi was the first to cross the pass on June 1, 1953, during the Giro d'Italia race. The sportswriter for the popular daily newspaper *Corriere della Sera* described Coppi as "a fragile man struggling, alone, against the terrible giant of nature…."

Because of its natural seclusion, Sondrio is dedicated to protecting its environment. The city's administration has put a large part of the land under protection and created the National Park of the Stelvio. Every October the city organizes an exposition around the park known as the Sondrio Festival. During the event, Sondrio is transformed into a multi-ethnic stage as individuals from all over the world gather at the café on Piazza Garibaldi or in front of the fountain on Piazzetta Quadrivio, their languages mixing with the lilting local dialect. This pleasing cacophony of voices spreads throughout the valley, where groups can tour the *crotti* of Chiavenna (natural caves formed in the mountainside), visit cellars with vats of Valtellina Sforzato or Sfurzat (the valley's prized wine), or taste the different forms of the local Bitto cheese.

The natural caves (*crotti*) of the Val Chiavenna.

facing page
The vineyards reach right up to Sondrio's boundaries.

An article in 1858 declared that "the excellent cheeses are sufficient to demonstrate what the Valtellina can offer," and Bitto, a mild cheese with ancient Celtic origins, is the best of them. Bitto cheese is recognized by the European Union D.O.C. (Denominazione di Origine Controllata) regulation. Bitto cheese is made from the milk of cows and is aged for two to three years (some forms for up to ten years) in deep cellars. The tasty meat called Bresaola is cited in documents from the fifteenth century by a Giovanni Carnesalata ("salted meat"), perhaps the dish's originator. Bresaola is a lean red meat taken from the round or rump (rarely from the shank) of the cow or horse, and is considered nutritious and easy to digest. The meat is first encased in a sheath, then salted and rubbed with spices, and finally left to mature for a year in well-ventilated rooms after which it is eaten raw.

Ancient Sutrium is of Lombard origin and boasts the eleventh-century Masegra Castle and many palazzos: Pretoria, now City Hall; Sassi, a museum for art and history; Sertoli, where wonderful frescoes are displayed; Casa Carbonera, with an elegant spiral staircase; and the Villa Quadrio, now a library. It is worth stopping in Morbengo in the lower valley to see the palazzos, the wine and cheese cellars of the brothers Ciapponi, and the Museo dell' Homo Selvadego at Sacco. Continue through the valley on the scenic Panoramica road, and exit at Tirano. From here, take the Rhätische Bahn, or Die Kleine Rote ("the little red train," as it is quaintly called in German), which travels through the glacier region and into Switzerland by way of the Bernina Pass, ending its journey in picturesque St. Moritz.

VIGEVANO
THE FINE ART OF SHOEMAKING

VIGEVANO IS LOCATED IN THE HEART OF LOMBARDY'S PICTURESQUE TICINO VALLEY, at the crossroads between waterways and artificial canals that bear witness to the city's agricultural core. Vigevano's principal calling, however, is the production of shoes—for every size and price, from the cheapest that end up in flea markets to the custom-made that adorn the most stylish feet in the world. The art of *conzare le scarpe*

The Duomo with its characteristic concave facade creates a dramatic curtain on the piazza.

facing page
Piazza Ducale, one of Italy's most ornate squares.

(shoemaking) in Vigevano can be traced back to a document from 1392 that prohibited the tanning and working of leather on the public square. The first modern shoe factory was born in Vigevano in 1866, and since the beginning of the twentieth century the city has produced more than one third of the shoes made in Italy. In 1952, when Vigevano hosted the International Shoe Fair, it was manufacturing thirty million pairs of shoes a year. Despite the high value placed on the shoe industry, the basic agricultural soul of the city has been preserved. Just beyond the fortifications are rice fields, windmills, and farms that are active to this day.

To enter the historic center of Vigevano is to be transported to another time. The Piazza Ducale was built between 1492 and 1494 by Ludovico il Moro Sforza, Duke of Milan, and is rightly considered one of the most beautiful Renaissance squares in Italy. A perfect rectangle paved with cobblestones taken from the Ticino riverbed, the piazza was cut to fit into the urban fabric of Vigevano. On one side of the square stands the seventeenth-century concave facade of the Duomo, designed by the bishop-architect Juan Caramuel de Lobkowitz. Some believe the facade was renovated because it is not in alignment with the church but is accentuated by four great arches and perfectly integrated into the square. The complex of the Palazzo Ducale is imposing, but hidden from sight by houses, even on the side where once a long ramp connected it with the square; only its high tower betrays its presence. Luchino Visconti, the powerful ruler of Vigevano in 1337, began the transformation of the medieval center to make room for a castle. With the help of Gian Galeazzo Visconti, Galeazzo Maria Sforza, and Ludovico il Moro, the castle became one of the most elaborate residences of the fifteenth century and included stables, the Palazzo delle Dame, and even a falcony. Among the artists and architects who contributed to the project were Leonardo da Vinci (1452–1519) and, arguably the greatest architect of his time, Donato Bramante (1444–1514). The stables appearing in Leonardo's drawings were designed to hold up to three hundred horses.

The famous Museo della Calzatura (Footwear Museum) is a unique institution dedicated to the history and evolution of the shoe in Italy. The museum is divided into three sections: the first is devoted to curiosities of footwear; the second chronicles the historical background of the shoe from the fifteenth century to the present—it displays shoes and slippers belonging to famous individuals such as Beatrice d'Este (the wife of Ludovico il Moro Sforza) and Mussolini—and the third comprises an ethnographic exhibit of shoes from different cultures, such as Dutch clogs, boots worn by the Lapps, African tribal sandals, and wooden and mother-of-pearl slippers worn in India.

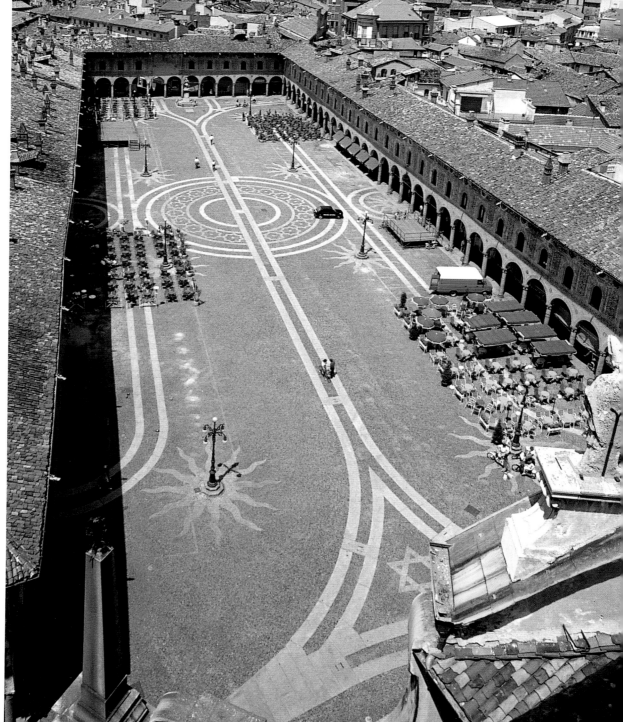

The Ticino River, called the "Blue River," flows a couple of miles from Vigevano. Its surrounding area is one of the most beautiful environments in Italy, with crystal-clear water, thick forests, marshlands, and moorland. Historical churches, villas, castles, and mills abound, and some of them are quite important, such as those once belonging to the ancient civilization of Golaseca. Since the 1970s the banks of the Ticino throughout Lombardy and Piedmont have been designated natural reserves. Parkland begins at the point where the Ticino departs from Lake Maggiore at Sesto Calende and stretches as far as the river's confluence with the Po, near Pavia. In addition to walking, there are bicycle paths along the banks—the most interesting routes lie between Turbigo and Sesto Calendo and Zelata and Bereguardo.

CAMOGLI
FOCACCIA AND OLIVES

At the edge of the Paradise Gulf, Camogli emerges from the green of maritime pines and a rainbow of multicolor houses huddled together on the promontory protecting the twelfth-century church of Santa Maria Assunta from the raging sea. It is said that Camogli gets its name from *Cà a muggi* (houses huddled together) or *cà de mogee* (the wife's house, as the men were always at sea). The most probable

explanation is that its name derives from Camulio or Camulo, the god Mars of the Sabines and Etruscans, or from Camolio, a sun deity of Celtic Gaul. Approached from the sea Camogli resembles an impenetrable wall. But the network of narrow lanes (*carrugi*) at the base of the promontory penetrate inward and outward with stairways covered by vaulted roofs from which dozens of evocations of the Virgin Mary are said to look after those at sea. The *carrugi* come to an end behind the Castello Dragone, a medieval castle built on a precipice.

Camogli was and still is a village of fishermen and sailors forced to band together on a small piece of land in order to defend themselves against the harsh and precipitous coast. In order to shelter themselves from inclement weather, inhabitants have had to devise ingenious ways and invent bold urban solutions by building their houses adjacent to one another—even on top of one another—in a honeycomb pattern. The buildings are often so tall that villagers boast of having built skyscrapers before they were invented in New York.

The people of Camogli are socially aware, too. In fact, Camogli was the first town, in 1853, to institute a Maritime Insurance Fund (Mutua Assicurazione Marittima Camogliese) to guarantee assistance and support in the event that a ship went down. This was at the height of Camogli's economy, when the "city of a thousand white sails," as it was called, managed a fleet of hundreds of merchant ships that were leased to principal European powers. The same community lives on in the salty air that wafts through the *carrugi*. It penetrates the hearts of tourists, together with the welcoming smiles of the people and the sparkling waves seen while strolling down Via Garibaldi eating a piece of classic focaccia. Liguria's focaccia, pressed bread cooked in a wood oven and flavored only with olive oil and salt, is beyond compare. The Italian term *focaccia* first appeared in the Oxford English Dictionary in 1997.

A colorful cluster of houses.

facing page
The gigantic iron pan used during the Sagra del Pesce.

The Sagra del Pesce is a celebration of fish held each year during the Feast of San Fortunato. The festival takes place on the second Sunday in May and is perhaps the most anticipated day of the year. It is said that the inhabitants of Camogli organized the celebration to disprove their stereotypical stinginess, and it seems they've managed to do so. For the first feasts in 1952 six brick ovens were built in the square and fresh fish was fried all day. The following year a gigantic frying pan was constructed, which became the real attraction (today the pan is almost thirteen feet wide). The Sagra del Pesce was recognized by the international press with an article in the *New York Herald Tribune* and a Eurovision television program in 1955.

Nothing could be better than a stay at the Cenobio dei Dogi, a striking sixteenth-century villa transformed into a hotel with a private beach, pool, and terraces overlooking the sea. Visitors should take a trip to the aquarium in Genoa, about twelve miles away. Built in 1992 to celebrate the fifth centenary of the discovery of America by Christopher Columbus, Genoa's aquarium is the largest in Europe and among the most beautiful in the world. The complex includes sixty-one basins asplash with graceful and colorful fish. An additional one hundred tanks are not on public display, but reserved for the care and acclimatization of the animals. Five thousand marine animals from five hundred different species can be seen. Many of them can be observed up close, such as manta rays and sharks. Part of the aquarium is the Great Blue Ship, a vessel inside which the journeys of history's most celebrated explorers are described. Nearby, in what used to be cotton warehouses, is the Pavilion of the Sea and Navigation, an interactive museum where one can relive the adventures of famous seafarers of the past.

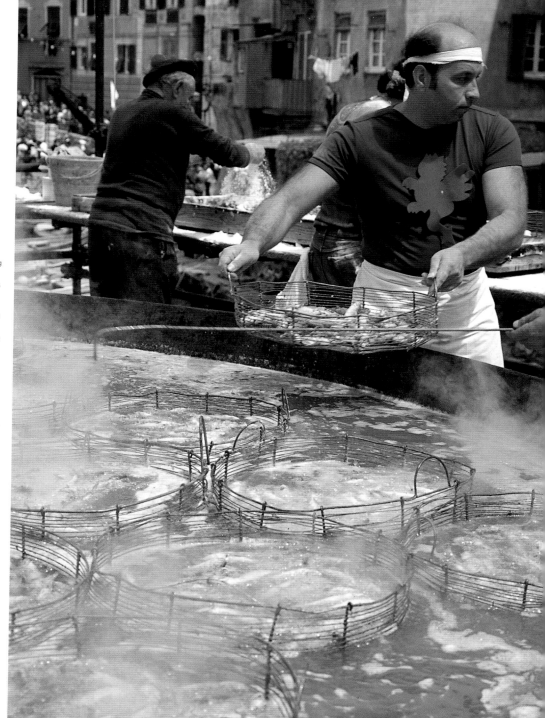

PORTOFINO
LA DOLCE VITA

MOUNT PORTOFINO DRAMATICALLY PROJECTS OUT INTO THE TYRRHENIAN SEA FROM RAPALLO. It is an ecological pocket that has remained almost completely unspoiled due to its isolation. At the foot of the mountain are a few settlements that enjoy its splendid beauty: Santa Margherita, Paraggi, and Portofino. Further on is the small hamlet of San Fruttuoso (accessible by boat only) and the rocks of Punta Chiappa, a meeting place for underwater enthusiasts. This paradise of nature represents an oasis of social and cultural life. The well-known postcard image of the piazza that eases down to the water's edge and is framed by multicolor houses is familiar throughout the world. Behind the houses stands the church of San Martino and the sixteenth-century Castello di San Giorgio, also called Castle Brown after the English Consul in Genoa who transformed it into an elegant residence in 1867. Farther back is the mountain dotted here and there with villas inhabited by celebrities from Europe and across the Atlantic. In fact, many Hollywood stars have been known to take in some summer sun in Portofino, including John Wayne, Glenn Ford, Ava Gardner, and Tom Cruise. Others, such as Humphrey Bogart, Lauren Bacall, Elizabeth Taylor, and Richard Burton, have preferred the fairly isolated Hotel Splendid, where the Belle Epoque atmosphere is a perfect setting for lovers.

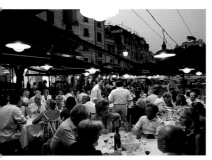

Nightlife unfolds on the little piazza.

facing page
The harbor of Tigullio, the pearl of the Italian Riviera.

Portofino overflows with elegant cafés and restaurants, exclusive shops, luxury yachts, and extravagant hillside villas overlooking the piazza. Close by, however, is a place that is at the opposite extreme. It takes about twenty minutes by boat along the coast to reach the jewel-box-sized San Fruttuoso, a solitary bay where a beautiful Benedictine abbey and cloister can be visited. The abbey was built in AD 711 by Prospero, Bishop of Tarragona, to hide the relics of the martyr Fruttuoso. The medieval watchtower was built by members of the Genoese Doria family. This fishermen's retreat consists of three houses, an inn, and a couple of cafés and eateries that spring up between the rocks during the summer. The nearby monastery was built between the thirteenth and fourteenth centuries and inhabited by monks until the sixteenth cen-

Mount Portofino is a rocky mass of pudding stone. Its original name, *Portus Delphini*, may have derived from the similarity of its shape to the arched backs of the dolphins that leap in the sea. From 1935 this ecological niche of 2,900 acres has been a protected area, and, since 1995, a national park. It is home to the highest concentration of flower varieties in the Mediterranean and a variety of bird species and invertebrates. The mountain can be traversed on foot, following a fine network of paths through the woods, where the scents of the Mediterranean underbrush, called maquis, waft through the trees. Sailing excursions around the tip of the peninsula explore the ancient settlements of Mortola, San Nicolò, Porto Pidocchio, or La Tonnara. It is also possible to go diving in order to observe the fascinating marine life and underwater vegetation.

tury. Toward the end of the sixteenth century the abbey was divided into living quarters by the Bozzo family, who lived here for four hundred years and were involved in the fishing industry. In the second half of the twentieth century the abbey was converted back into a tourist attraction. Few people know of the tranquil village of San Fruttuoso, a place where silence is absolute—shops are closed from six in the afternoon to ten in the morning.

A local specialty found throughout Liguria and not to be missed is *mosciame*, perhaps the most delicious of preserved fish products. *Mosciame* is dried fish meat over which extra-virgin olive oil has been drizzled. It is served in thin slices and accompanied by filet of tuna. The best fish are prepared at the beginning of the summer. The filets are salted for several hours and dried in the sun for a few days, or in special rooms at a temperature of 85 to 90 degrees Fahrenheit. The art of lace making has a longstanding tradition in Portofino and Santa Margherita. It became common in the area during the sixteenth century, but slowly declined toward the end of the nineteenth century.

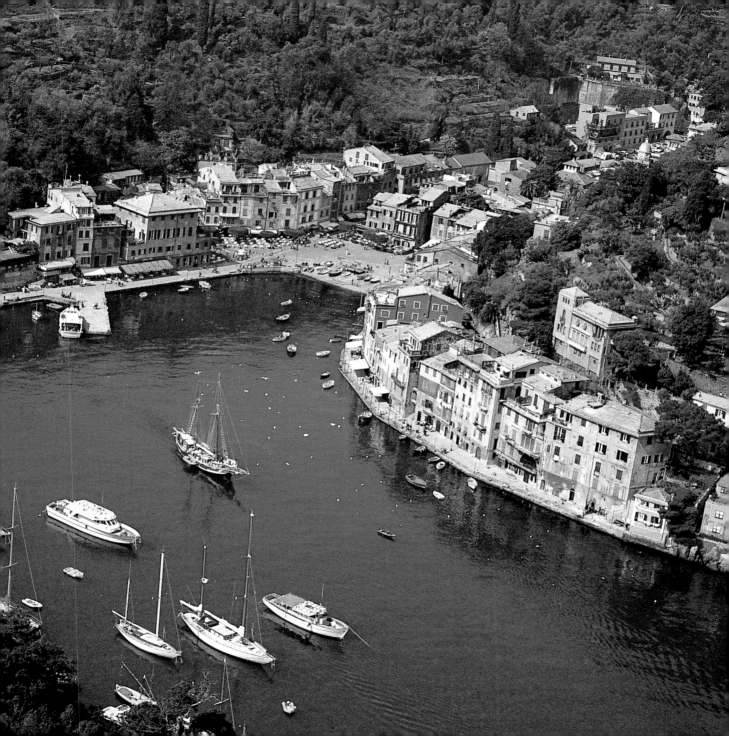

PORTOVENERE AND CINQUE TERRE
BYRON'S RIVIERA

PORTOVENERE STANDS AT THE MOST EXTREME PART OF THE PROMONTORY that closes the Gulf of La Spezia (also called the Poets' Gulf). Thanks to its enviable position, and together with the villages of the Cinque Terre, Portovenere was a favorite destination for romantic tourists in the early nineteenth century (the English poets Lord Byron and Percy Bysshe Shelley often traveled here). The port is dedicated to Venus, the goddess of love, and the ruins of her temple are near the beautiful church of San Pietro, which dominates the open sea beyond the island of Palmaria. It is almost unimaginable that this picturesque and joyously colorful place was, until the fifteenth century, a bastion of defense for the powerful Republic of Genoa, which dominated the Tyrrhenian Sea. An inscription on the gateway leading to the town confirms this—*Colonia Januensis 1113*. The castle built here in the Middle Ages, together with the fortified houses and the surrounding wall, was destroyed and then rebuilt by the Genoese in 1458. Further down stands the Gothic church of San Lorenzo, built between 1118 and 1130.

The collection of villages known as the Cinque Terre begin in the north along the coast. Five miles separate Punta Mesco from Punta San Pietro, and some hundreds of miles of terraces with low sustaining walls where vegetables are grown. The fruits of the earth provided sustenance for the region's indomitable people, descendants of the Celts, who withstood much adversity. It is probably the best-known coastline of the Riviera di Levante and was declared a UNESCO World Heritage Site in 1997. The five villages that make up the Cinque Terre are Riomaggiore, Manarola, Corniglia, Vernazza, and Monterosso. They are connected by the Genoa–Livorno railway line and, until a few years ago, it was the only way to reach them by land. Today, all the villages are linked by a road, which purposely winds to discourage excess traffic. The best way to go from one village to the next, however, is on foot along the paths overlooking the sea, which skirt vineyards, olive groves, and vegetable gardens perfumed with the scent of basil and lemons. The most romantic part of the walk is from Riomaggiore to Manarola. This tranquil path was restored in 1995 and is now called the Via dell'Amore (Lovers' Lane). In the summer, those who are brave enough can dive into the sea from the high cliffs. The most characteristic of the towns is also the most beautiful: Vernazza is nestled around a little port with brightly painted houses (enabling the sailors to see them from afar). The church of Santa Margherita has been built on the port, its one side continually battered by the waves from the sea, creating a dramatic scene. Also of note is its octagonal bell tower and interior columns of black slate.

A crayon-colored array of boats resting in the port of Vernazza.

facing page
A sweeping view of Manarola atop its cliffside abode.

Excellent wines are produced here on terraces sustained by dry walls. The "cinque pampinose terre" (five vine-rich lands) is how the poet Gabriele d'Annunzio described them. Although not much wine is made here (there are less than 346 acres of vineyards), the wine that is produced enjoys a favorable reputation. Amphorae once used to hold Vernaccia of Cornelia were found during excavations in Pompeii. The light and delicate Cinque Terre is the region's typical white wine, the authenticity of which is guaranteed. Sciacchetrà wine is made from the same grapes, hand picked and then dried. The result is a proud dessert wine that is usually accompanied by strong cheeses dressed with herbs. Traditionally, Sciacchetrà is aged in small casks until October 30 of the year following the harvest. The taste is sweet and dry, with a relatively high alcohol content. It can also be *dolce naturale* (naturally sweet) or similar to a liqueur when matured for at least three years.

During the summer season a boat service plies through the villages of the Cinque Terre, but the towns are also connected by a network of trails and mule paths that were once the only existing routes until a railroad was built in 1874. Today the trails have been restored and are marked with signs, parapets in the most dangerous places, and benches to rest on and from which the landscape can be admired. The trails are one of the best ways to discover the territory, away from the tourist invasions during the high season. An easy walk is along pathway number 2, which is nine miles long and connects Monterosso with Riomaggiore. The twenty-five-mile-long pathway number 1, however, extends from Portovenere to Levanto, following the coastal ridge, and is much more strenuous, but can be accomplished in two days if you pack a camping tent.

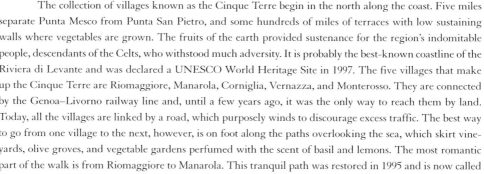

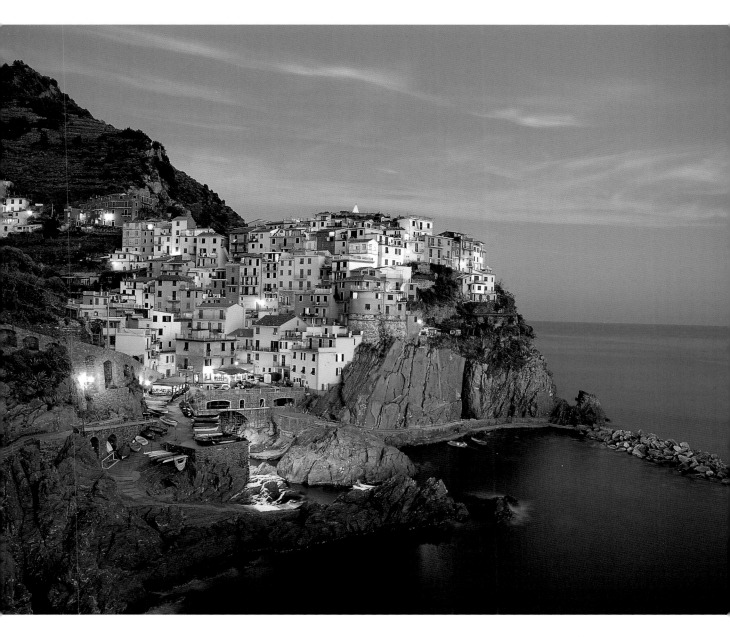

The Gulf of La Spezia was named the Gulf of Poets in 1919 by the Tuscan playwright Sem Benelli in honor of the many poets (mostly English but also Italian) who once lived on this coast. On July 8, 1822, Percy Bysshe Shelley died in the waters of the gulf. He was one of the most important poets of English literature and lived in the Villa Magni near San Terenzo. Shelley was sailing aboard the *Ariel*, named after a character in William Shakespeare's *The Tempest*, when he was overcome by a storm. The poet's body was identified thanks to a couple of verses by John Keats that were in his pocket. He was cremated on the beach in the presence of Lord Byron, among others. In his *A Defence of Poetry*, Shelley wrote: "Poets are the mirror of the gigantic shadows that the future throws upon the present. An immovable force that moves. Poets are the unacknowledged legislators of the world."

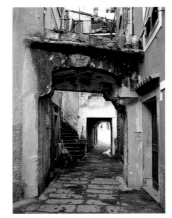

Characteristic views of Riomaggio and, *below*, of Vernazza.

right
The church of San Pietro in Portovenere and ruins of the Old Fort.

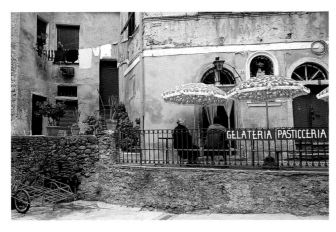

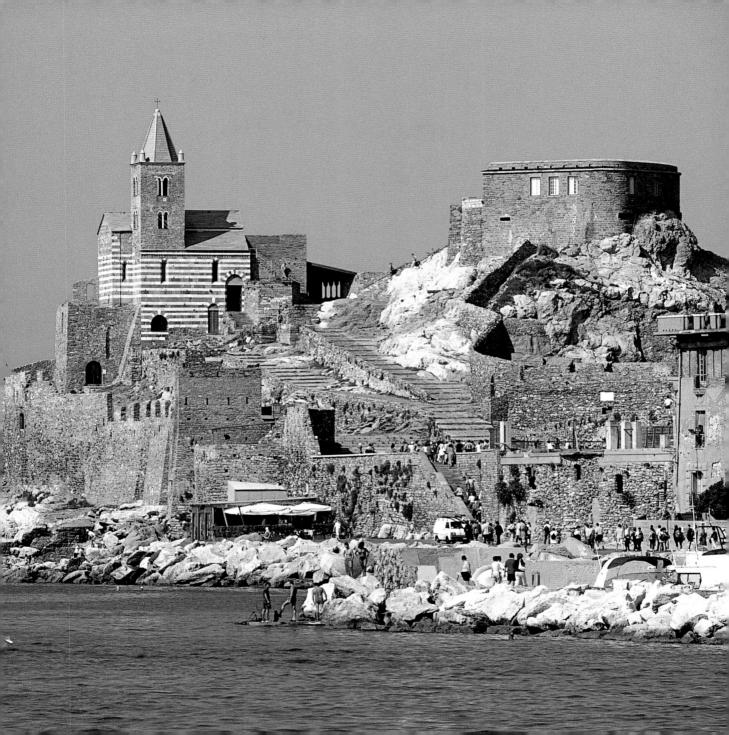

SAN REMO

STAGE SET FOR ITALIAN SONG

SONGS AND FLOWERS SEEM TO BE UNSUBSTANTIAL PILLARS UPON WHICH TO BUILD A FORTUNE, but this is precisely how (with the help of the popular Casinò) San Remo gained its celebrity. The San Remo Casinò has become an emblem of the city, but today it is more famous for its beautiful Art Nouveau architecture than for gambling. In 1951 the annual San Remo Music Festival debuted at the Casinò and now takes place in the Ariston Theater. For a week the festival keeps half the Italian public glued to their television sets. Although it is the sustaining economic factor of the city, the festival is also a significant voice for the nation. The beloved song "Volare" by Domenico Modugno was performed, from 1958 on, in almost every language in the world and became the anthem of Italy abroad—it was even sung by Dean Martin.

San Remo's luck began some time ago in the mid-1800s, when it became a destination place for an elite class of travelers from all over the world. Toward the end of the nineteenth century, it grew into an important center for the cultivation of flowers. Today, the strip of coastline between Capo Nero and Capo Verde resembles a mosaic of greenhouses. Added to this, San Remo is home to the Mercato dei Fiori, a flourishing flower market that is the largest in southern Europe and the Mediterranean basin.

The solid base of San Remo's economy is the mild climate and the beautiful seaside of western Liguria. In the seventeenth century even the queen of Poland was enchanted by the perfume of orange blossoms, which, she said, "pervades over three leagues." The German philosopher Walter Benjamin (1892–1940) wrote upon his arrival in 1934, "The felicity of strolling and writing and collecting one's thoughts in such a wonderful place. San Remo is really very beautiful." Even before he had read the accounts of San Remo's history, when it was a hamlet of rural folk and fishermen, Benjamin was compelled to note its ability to inspire. The antique heart of the town is set high up in La Pigna (the medieval San Remo), where the steep and narrow lanes wind inside the gateway of the twelfth-century portal of San Giuseppe and around the third-century cathedral of San Siro and the sanctuary of the Madonna della Costa, which dates to AD 600. Nightlife entertainment can be found at the old port, and restaurants and fashionable clubs have cropped up between Piazza Bresca and Piazza Sardi, the meeting places for the festival's stars.

The Mercato dei Fiori, one of Italy's most important flower markets.

facing page
The San Remo Casinò, the historical site of the San Remo Music Festival.

The San Remo Casinò was built in 1905 by the French architect Eugène Ferret. Until the mid-twentieth century it was a veritable temple for gambling. Attracted by the green baize tables, it was a gathering place for the nobility and ruling classes, as well as artists and industrialists. Today the Casinò has lost some of its glitter; there are more slot machines than roulette tables, and it attracts a younger crowd. The city's love affair with flowers began at about the same time, when San Remo started cultivating carnations. Because of the mild climate, the flowers could be grown during the winter months. Since then San Remo has been called "the city of flowers" and the whole of the coast of Liguria is known as the "Riviera of flowers."

Visitors to San Remo will have no shortage of luxurious accommodations to choose from. The Grand Hotel Londra, opened in 1861, has hosted guests such as the composer Franz Liszt, the novelist Émile Zola, and Prince Philippe d'Orléans. The Royal Hotel is one of two five-star hotels on the Ligurian coast and was opened in 1872 by Lorenzo Bertolini, one of the most famous names in the Italian hotel business (his family still runs the establishment). Politicians, writers, and actors have also stayed here. The botanical garden contains 130 species of plants from the four corners of the world and is well worth a visit. The Grand Hotel & Des Anglais was established at the end of the nineteenth century. The original furniture is still intact and the hotel also boasts some illustrious former guests, such as Emperor Hirohito of Japan and King Gustav of Sweden.

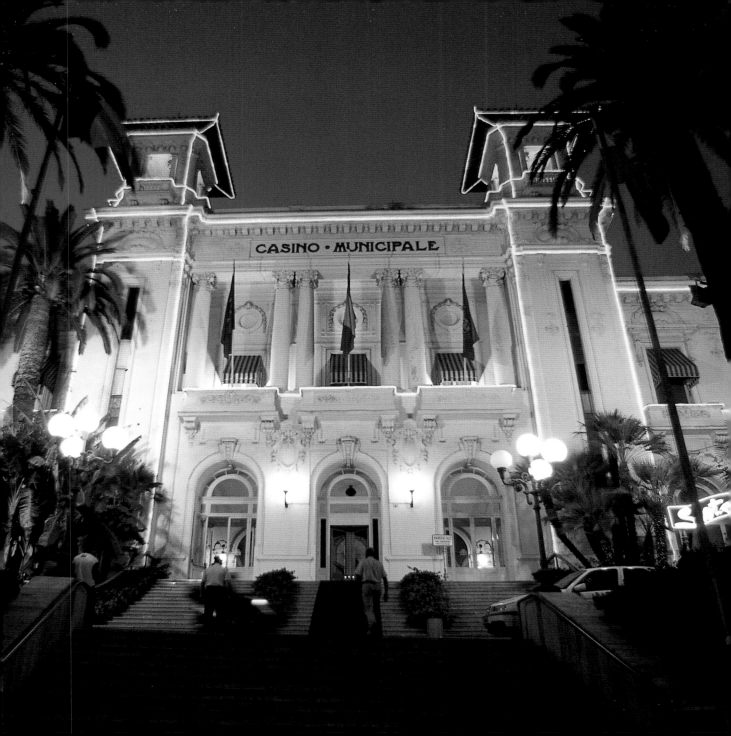

TRIORA
PERCHED ABOVE THE SEA

ALTHOUGH LIGURIA'S COASTLINE INCLINES TOWARD THE SEA, it is one of the most mountainous regions in Italy. Its generous terrain of flowering gardens quickly turns into impassible snow-covered peaks. Villages here are sparsely populated, mysterious, and intriguing. Triora, for example, lies at an altitude of 2,560 feet and is flanked by the Ligurian Alps. To reach the heights of this eagle's nest, one first goes to Molini, where in the thirteenth century there were more water-driven mills than there were houses. On the way one can do some sightseeing and stop at the sixteenth-century Bridge of Santa Lucia.

Interior of a grocery store.

facing page
Via del Borgo Antico in Molino di Triora.

Popular legends tell of witches living in Triora. In fact, in 1587, after two years of famine, villagers began to suspect their spell of bad luck was attributable to the women from Cabotina, who were thought to have been in cahoots with the devil. The village parliament called in a priest and a vicar to investigate and, as a result, many women were either jailed or tortured; thirteen were condemned to death. An ethnographic museum gives ample space to the tales of the witches. The Bridge of Loreto just outside the town is said to be under a curse. However, today the bridge attracts thrill-seekers of another kind: bungee jumpers.

Nearby villages of interest include Dolceacqua, the home of Rossese di Dolceacqua wine, favored by both Napoleon and Pope Julius II. Here one can visit the Doria Castle and the Ponte Vecchio (Old Bridge), which Claude Monet described as "a jewel of lightness." In contrast, Dolcedo is a mountain village with paved roads and crisp air. The proximity of the Riviera is evident in the mild climate and the oil presses along the banks of the Prino River. Badalucco is known for its frescoed houses, while the village of Pigna (pinecone) is so called because of its shape: a series of concentric circles wound around a hill. The Contessa Belloma, a figure clouded in mystery, occupied the nearby castle of the Counts of Ventimiglia in the tenth century. From her origins as a washerwoman she became a spy for Czar Nicholas II of Russia. The village of Bussana Vecchia was built in the eleventh century and suffered an earthquake in 1887, during which it was partially destroyed. It was abandoned to build a new village that, since 1959, has been home to artists from all over Europe who have turned the town into a global center for art. About thirty artists' and sculptors' studios are open to visi-

tors in the summer. Seborga is a principality encompassing about nine miles, with 350 subjects and a prince who was elected in 1963. It mints its own coins and prints stamps. Perhaps it may be just an oversight, but in 1079 the counts of Ventimiglia declared the territory a principality and since then the Italian State has made no formal act of annexation or recognition.

Witches are said to be baited by a plant known as the Madonna's herb, popularly called *strigonella*, or witch's herb, and used to cure ailments ranging from insomnia to stomach-aches to colds. Legendary tales are told at the Bottega di Angelamaria in Molini. It is said that Angelmaria is a descendant of a *bàgiua* (a witch) who was put to trial in 1587. Love potions are prepared with aromatic and medicinal herbs from the Argentina Valley and sold in her shop. For the nonbelievers, we recommend tasting the delicious meats and cheeses. There is another "witch" on the Corso Italia at Triora, and here too, there is a shop selling typical produce from the Ligurian hinterland. The *bruzzo* (goat cheese) and the *cubaita* (almond nougat) are recommended.

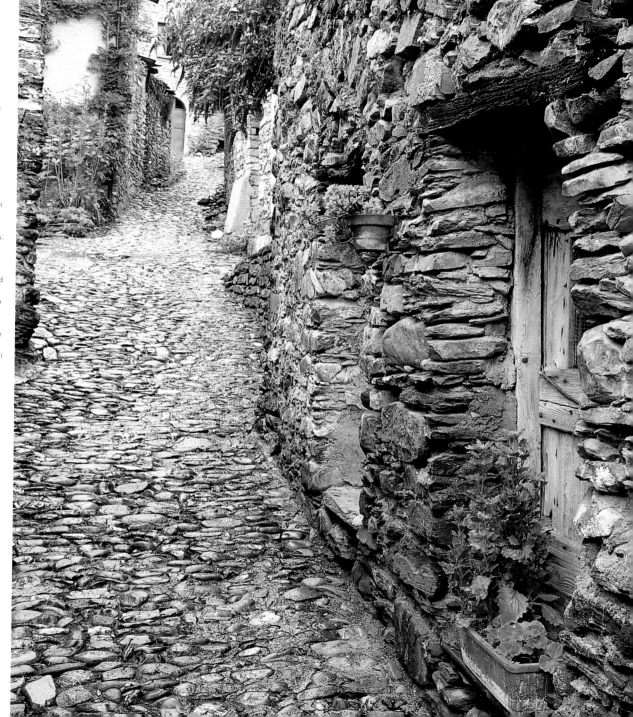

Inland, on the western side of Liguria and within a few miles of the coast, the sea is literally forgotten when it comes to matters of taste. Local restaurants specialize in hearty dishes based on produce grown from the land, with a generous use of wild, aromatic herbs. In Molini di Triora, restaurant Santo Spirito's entrées of snails, wild boar, and mushrooms are washed down with a glass of Rossese di Dolceacqua, a classic red wine. The Capanna da Baci in Apricale offers ravioli stuffed with borage, spinach gnocchi, and rabbit with olives. In Dolceacqua, on the terrace that overlooks the Doria Castle, the restaurant Gastone serves classic *capon magro* (green vegetable salad) with *bottarga* (dried and smoked roe of mullet or tuna) and ravioli stuffed with artichokes. In Seborga, taste the rabbit at Osteria del Coniglio. Surrounded by vineyards in Dolceacqua, visit Terra Bianca, a guest house famous for its game.

BRESSANONE
THE POWER OF THE PRINCE–BISHOPS

BRESSANONE (OR BRIXEN) IS THE SPIRITUAL AND ARTISTIC CAPITAL OF THE TIROL. Approaching the city one is struck by the ordered harmony of the countryside, the sprawling mountains home to enchanted forests and meadows, fields cultivated with a geometric rigor, well-kept villages, castles, and the colorful houses that dot the city streets. It seems to be a picture-perfect postcard contested only by the solemnity of the older buildings, which reflect the power of the prince–bishops who resided here from 1179 to 1803. The composed dignity of the Alto Adige, or Südtirol, arouses admiration even in those who do not know that 80 percent of the territory is considered a natural reserve.

This region, bordered by Austria and Switzerland, bears the markings of a Germanic-inflected culture, especially in its local dialect, which varies greatly from formal Italian. In fact, it wasn't until 1919 that the region became part of Italy. Prior to this date the Alto Adige was a fief belonging to the Hapsburg Empire for many centuries, during which the past influence of Roman rule and barbarian invasions had been forgotten. Bressanone was founded in AD 901 by Zaccaria, bishop of Sabiona, from which the Episcopal See was transferred from Chiusa to Prichsna; in 960 it was again moved to Bressanone by bishop Albuin.

A wood-paneled room in the Palazzo dei Principi Vescovi occupied by a green ceramic stove for heating.

facing page
A detail of a fresco of an elephant in the Duomo.

Both Bressanone's moderate Alpine climate and its strategic location have contributed to many of its political and religious triumphs. Its rich soil is ideal for the cultivation of chestnuts and grapes, symbols of the two very different cultures that live side by side here. At the meeting point of the Isarco and Rienza rivers stands the village of Stufles, which was inhabited as early as the Mesolithic period and later by the Romans. Here, a quadrangular plan was drawn from the Roman model of the *castrum*, and upon it a citadel was built whose purpose was to be the stronghold of one of the most powerful feudal states of the Empire and to control an important route between Italy and northern Europe. The towers and ramparts of Bressanone's historic center remain more or less intact. The thirteenth-century Duomo is the town's most distinguished monument, and its beautiful fourteenth-century cloister is adorned with medieval frescoes and a Romanesque colonnade. In the area around Via Portici Maggiori and Via Portici Minori, the arcaded houses are built with embrasures and characteristic wooden shutters. The Diocesan Museum, formerly the Bishop's Palace, is home to the artifacts of the political and religious powers that were once Bressanone's lifeblood.

Just outside the town stands the Abbey of Novacella, where the remains of fortifications that protected the chapel of San Michele and its twelfth-century hospice can be seen. The abbey was founded in 1142 by Hartmann, bishop of Bressanone, and by the count of Sabonia, and was administered by Agostinian monks. The complex includes the late-Baroque church of the Madonna and its original Romanesque bell tower, a second-century cloister, and the grandiose seventh-century library, furnished in the rococo style and rich with manuscripts and more than sixty thousand books. While you are seated in the courtyard beside the Pozzo dei Miracoli (Well of Miracles) admiring these beautiful buildings, you can enjoy some dark bread and Speck (bacon) and have a glass of the local Langrein or Gewürztraminer, a spicy German wine produced in the Abbey's historic cellar.

Those with a hearty appetite might be able to stand up to the challenge of the so-called "elephant's dish" served at the restaurant in the historic inn Elephant in Bressanone. This one-course dish contains many Tirolean specialties, making it difficult not to finish it. For shopping, Lodenwirt is the place. The Italian sportswear firm Oberrauch–Zitt in Vandoies, a village in the Val Pusteria, sells authentic Lodenwirt apparel. In addition to a large, well-supplied showroom, there is the manufacturing department. In an interesting, interactive museum, you can discover the secrets of loden fabric and explore its unique characteristics. Loden was once used by shepherds and farmers, and was later worn by nobles and emperors.

MERANO
THE THERMAL BATHS OF THE HAPSBURGS

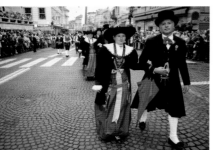

During the Grape Feast in October residents of Merano celebrate in their traditional costumes.

facing page
Via Portici, the main street for shopping.

MERANO (OR MERAN) IS A CITY THAT HAS ONLY BENEFITED FROM ITS MOUNTAIN LANDSCAPE. At an altitude of about one thousand feet, it is fortunate enough to avoid the frosty winter weather that often overcomes the plains. Because a range of high peaks shelter Merano from the northern winds, it has the good fortune of enjoying a temperate climate, little rainfall, and lots of sunshine (according to statistics, 250–300 days a year), allowing for the cultivation of lush Mediterranean gardens. During hot summer days the Passirio stream cools the sultry promenades along the shore.

The entire basin of Merano, called the Burgraviato, is studded with grand castles and flowering hamlets. Hot mineral springs on Mount San Virgilio have transformed the city into one of the most visited health resorts of the southern Alps. It seems that the combination of the air, which is ionized by radon from the springs, and the thermal baths, is near miraculous for the convalescent. Among the first to come here were the Hapsburgs, rulers of Austria at the time. Included among them were Emperor Franz Joseph and his consort Elizabeth of Austria, widely known as Sissi, who surrounded themselves with important Tirolean personages and entertained foreign dignitaries. In the first decades of the nineteenth century individuals seeking rest and relaxation flocked to the curative waters. Merano willingly adapted to its growing number of tourists and erected many elegant hotels, both large and small. Its greatest age of development occurred during the Belle Epoque era and set the city aside from all the other villages of the Alto Adige. After World War II a racecourse and new thermal baths were built, but inhabitants did not relinquish their gardens for the sake of modernity. The Maia Alta section of Merano remains a lush park area and a network of paths extending for twenty-five miles wind their way in and out of the city's borders. The Kurpromenade runs parallel to the Passirio River and, from the Teatro Bridge, it passes in front of the Kursaal and the bandstand, continuing toward Mount Benedetto and its Passeggiata d'Inverno (Winter Promenade). On the opposite bank is the Passeggiata d'Estate (Summer Promenade). The Glif Promenade crosses an exotic garden and leads to the Torre delle Polveri. The Tappeiner path, which dates back to 1882, begins here and continues for two miles on a hill with a beautiful panorama. The best seasons to visit Merano are the spring, when nature blossoms and the sidewalks teem with cultural activities, and the fall, when vineyards, orchards, and surrounding woodlands turn a palette of brilliant reds and yellows.

An obligatory stroll through Merano is along Via dei Portici, the shopping center, where one can find authentic Tirolean-style clothing handmade from loden, a thick woolen cloth. A popular children's apparel brand is Zuber, while Runggaldier fashions are for adults. Other local products include hats made by Hutter, a well-known millinery, goose-down quilts made to order by Dubis Mussner, a variety of sweetmeats and Viennese cakes by Konig, and wines from the vintners' cooperative, among which the Blauburgunder is one of the best. A trip to the Alto Adige isn't complete until you've tasted Speck, a type of pork served as an appetizer before meals or as a snack with hearty bread and a tankard of beer. If you shop in the city, it is advised to look for those articles guaranteed by the Südtirol label. While exploring the nearby villages, be brave and ask the locals for their homemade products—difficult to find in stores.

In the old city on the right bank of the Passirio River, a must-see is the fourteenth-century Gothic Duomo, restored to its original splendor at the beginning of the twentieth century. The octagonal Capella di Santa Barbara contains a fifteenth-century Pietà and used to house the cloister of the church of the Clarissas. The Castello Principesco was built for the archduke Sigismund of Austria in the second half of the fifteenth century. Frescoes, antique furnishings, paintings, and sculptures decorate the castle, and a beautiful collection of musical instruments and another of women's clothing are here on display. On the left bank of the river stand the Gothic churches Santo Spirito and Santa Maria del Conforto, which was renovated several times, but contains important frescoes from the twelfth and fourteenth centuries. Castel Tirolo dominates the basin of Merano and was the most important center for the Tirolean Aristocracy during the Middle Ages. The castle was built at the beginning of the twelfth century, later modified, and recently restored to its original form in order to accommodate the South Tirol Museum of Cultural and Provincial History. Its chapel includes a valuable Romanesque portal and frescoes from the second half of the fourteenth century.

RIVA DEL GARDA
THE MEDITERRANEAN OF CENTRAL EUROPE

THE BACK OF RIVA DEL GARDA IS SHELTERED BY AN IMPRESSIVE AMPHITHEATER OF MOUNTAINS, while the caressing waters of Lake Garda lap at its shores. Throughout prehistoric and Roman times Riva del Garda's strategic location made it a significant port and military base, ensuring routes between the southern lake, the plains of the Veneto, and the Alpine villages. It was also an important retreat for the Della Scala family of Verona, the bishops of Trento, the doges of Venice, and the Austrian emperors. Substantial remains of ancient civilizations and villages built on piles have been found in the smaller lakes above the town. Other markers of the past include the third-century Torre Apponale, the Venetian fortress, and the praetorial and municipal palaces, both from the Venetian era. At the end of the nineteenth century the town became a mythical place for central Europeans who saw it as the gateway to the most Mediterranean of the Alpine lakes, and where it was eternally spring. Hotels and villas, and sanatoriums and clinics managed by illustrious Viennese doctors, were soon established, and parks with exotic flora and walkways were planned. For those residing in the cold countries of the north the allure of Riva was irresistible. Johann Goethe, Friedrich Nietzsche, Franz Kafka, Thomas Mann, and the Austrian archdukes are just a few of the celebrated names who stayed here. Riva quickly became a meeting place for a decadent society whose revelry went unhindered until the beginning of the World War I. Such a paradise, however, could not be entirely obliterated. Riva, along with nearby Arco, remains the foremost destination place for wellness and nature. Together the towns comprise one of the most interesting territories of the region, not only because of their dramatic beauty, but because the gentle climate (a balance between Mediterranean and Alpine), rich culture, and strong roots make Riva del Garda seem like an urban center by the sea.

Historical places of note include the ruins of World War I forts on Mount Brione, the Arco Castle perched on a rocky outcrop, the unreal turquoise waters of Lake Tenno, the restored medieval hamlet of Canal, and museum of Lake Ledro. Today, Riva is again the attraction it once was, and not only for central Europeans. A diverse group of tourists come here for the balmy weather, while crowds of younger travelers come for the sports, such as windsurfing in the basin of the Sarca River.

Riva del Garda's placid harbor and tourist boats waiting to take passengers on a scenic cruise.

facing page
The Arco Castle.

The Garda Trentino area is a place for repose and a stimulant for all kinds of artistic and historical events. The natural environment is varied and is an immense training ground for every kind of open-air sport, from windsurfing to rock climbing, mountain biking, and hang gliding. There are 217 miles of bicycle trails, cliffs for climbing, and gyms for those who prefer an indoor workout. Student climbers from the Yosemite School can often be seen challenging themselves along the bluffs. Last but not least, the inviting waters and balmy winds (the famous Riva "òra" winds) are perfect for surfing and sailing championships.

Arco di Trento (from the Latin *Arx*, meaning fortress) is set atop the tall and solitary cliff at the center of the Sarca River basin. It is a fortified village dating to the Middle Ages and has been inhabited since prehistoric times. The castle at the summit of the cliff dates to the year 1000 and has recently been restored for visitors. A room with frescoes depicting people playing dice games and chess was painted between the fourteenth and fifteenth centuries. Arboreto rests at the foot of the cliff. Only one acre remains of the original ten acres created in 1872 by Archduke Albert of Austria, but the land is lush and thriving with trees from all over the world, such as sequoia, Lawson's cypress, the Himalayan cedar, the California cypress, and the Chinese palm. In the old medieval village, the collegiate church of the Assunta and the Monastero delle Servite (a monastery and convent), should be stops on any traveler's itinerary.

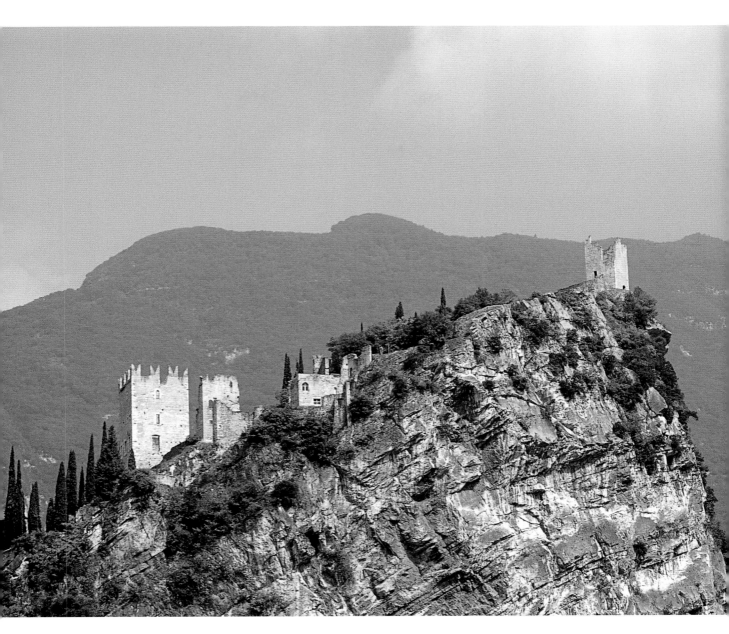

TRENTO
MEDIEVAL HAMLET IN THE MOUNTAINS

Crenellated towers along the Trento's medieval walls.

SHELTERED BY THE DOSS, THE MASSIVE ROCKY SPUR that projects from the slopes of Mount Bondone (once called the "Verruca," meaning "wart"), the Raetians lived here when, in the first century BC, Roman legions pitched their first encampments in the bend of the Adige River. Remains of that *splendidum municipium* have been uncovered by archaeological excavation, but almost everything is buried in the alluvial soil of the river.

This is due in part to the whim of the water but largely to the encouragement of Bishop Bernardo di Cles who determined to make the city grander, promoted the renewal of its buildings from 1515. The city still appears medieval, with modest houses and narrow streets. Bernardo Clesio tore down houses and widened streets, planted trees along them, and built monumental palaces. Beside the old Castello del Buonconsiglio, he built the Magno Palazzo (Great Palace), a princely residence decorated with frescoes and surrounded by gardens, and the great basilica of Santa Maria Maggiore, where the final phases of the XIX Ecumenical Council took place. He warmly supported the convocation of the Council of Trent with Popes Clement VII and Paul III, by reason of its position halfway between Rome and the German states, thereby forging a connecting bridge between the pope and the emperor, between Catholics and Lutherans. The Council took place, with alternating events, between 1545 and 1563. The prelates that gathered here attempted to repress the Protestant reform and bring the dissidents from the north of the Alps back into the Vatican fold. The temporal power of the Church and bishop princes was also involved; they were Guelphs by vocation but Ghibelline by investiture.

facing page
Detail of the cycle of frescoes in the Aquila tower of the Castello del Buonconsiglio.

Compared to five hundred years ago, the city is much richer today. The mountains of rock that surround it, and that were in the past considered to be obstacles to communication, are today the most precious asset of the Trentino, whose economy is heavily based on tourism. These massive cliffs were named the Dolomites in honor of the French mineralogist Dieudonné de Dolomieu (1750–1801), who discovered their chemical composition. The mountains are a natural architecture of cathedrals and spires that are painted red by the sunset and have no equal anywhere in the world.

In the Dolomite valleys between the provinces of Trento, Bolzano, and Belluno all the writings (including road signs) are in two languages. They are not in German, as they are in Alto Adige, but in Ladino. This is a consequence of the Romanization of the Alps in the first century BC. It left indelible traces in some populations that still speak the original Latin language. These are the Proto-Romance dialect in the Swiss canton of Grigioni, the Friuli dialect most diffuse in Carnia, and Ladino, which is spoken in Val di Fassa, Val Badia, Fodom, and Ampezzo. Until the end of the last century, this area of approximately 30,000 people used to be part of the Tyrol, and therefore of the Austrian Empire. But it has always preserved its own traditions, customs, and language. Now the *Unione Generela di Ladins dles Dolomites*, an association that unites the Ladino community, has obtained the recognition of its rights as an ethnic minority and Ladino is now taught in schools.

The hotels in Trento are comfortable and modern. To take a plunge into the past, leave the city and stay at Villa Madruzzo, an ancient bishop's residence surrounded by trees, where you can taste the typical dishes and wines of the area. The first place to visit in town is the Castello del Buonconsiglio, a bishop's residence since 1250. There are also many notable palazzos, such as the thirteenth-century Pretorio, the frescoed Geremia, and the austere and monumental Galasso. Of the religious monuments, the Basilica of Santa Maria Maggiore is an outstanding example of pure Lombard–Renaissance style, as is the Duomo, which dates back to the thirteenth century, and the thirteenth-century church of Sant'Apollinare.

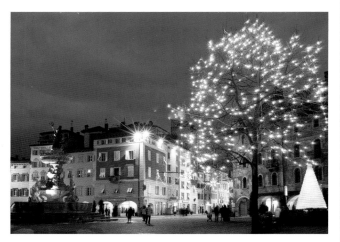

There are many feudal castles scattered along the main roads in the Trentino. The Valle dell'Adige alone provides a long list. At Mezzocorona, the ruins of the San Gottardo Castle and the Castel Firmian can be seen. It is possible to reach the San Gottardo Castle on foot, although by way of an arduous path. Castel Firmian was built in 1480 and is to this day inhabited, thus it is not open to the public. The thirteenth-century Castello di Monreale in San Michele all'Adige is today occupied by an agricultural company, and can be visited by appointment only. Castel Beseno sits defensively on a hill at Besenello and is the largest fortified complex in the Trentino. (It can be visited and is also used for open-air events.) Castel Pietra played an important role as an outpost at the bottom of the valley for Castel Beseno. It is richly decorated with frescoes and is open to the public by appointment, as is the twelfth-century Castello di Noarna, also the home offices of an agricultural company. The Avio Castle in Val Lagarina is one of the oldest and better-known fortified monuments in the Trentino district. Today it is the property of the FAI (Italian Foundation for the Environment) and can be toured. Not to be forgotten is the Castello di Rovereto, a fortress built by the Venetians atop a rocky incline to dominate and protect the walled city.

above
A Christmas market on Piazza Duomo.

right
A detail of the facade of Palazzo Geremia.

below
A detail of the tombstone of Bishop Giorgio Hack in the Duomo.

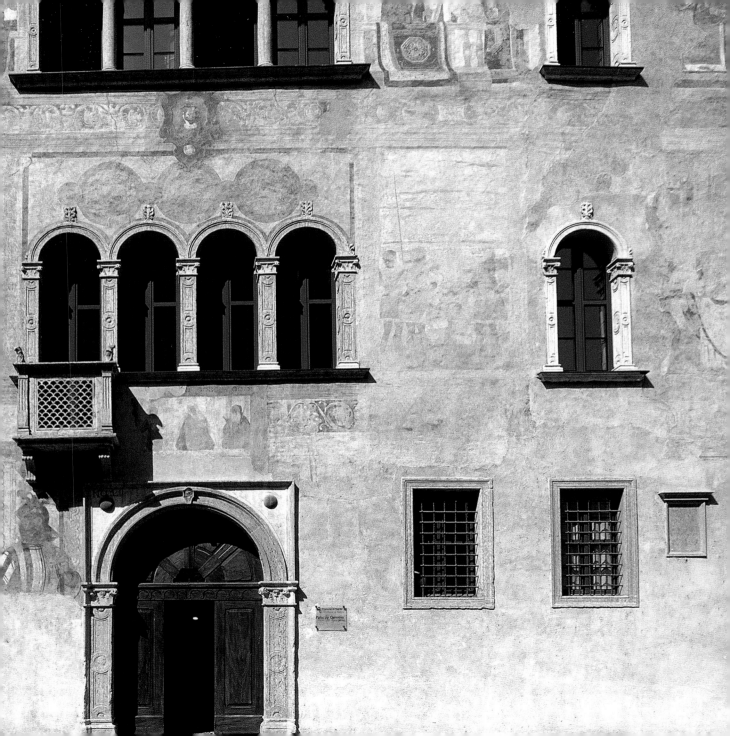

ASOLO

IN THE GARDENS OF THE QUEEN OF CYPRUS

ASOLO IS A SMALL VILLAGE FALLING BETWEEN BASSANO AND MONTEBELLUNA at the foothills of the Italian Alps. It is a pleasure to take a leisurely walk along the colonnaded streets and past the town's graceful buildings and historical landmarks, such as the Palazzo Palo, whose delicate mullions convey a lacelike structure. The Casa Tabacchi was once home to the English poet Robert Browning, Casa Malipiero was the residence of the Venetian musician of the same name, and the Casa Duse was where the Italian actress Eleonora Duse planned to retire if she hadn't died suddenly. At the Villa Contarini one can visit the frescoed mayor's loggia, which presently houses the Museo Civico, where a collection of works by the Venetian painter Canaletto, personal effects belonging to the extraordinary Eleonora Duse, and sculpture by Antonio Canova are on display. Only six miles away in Possagno, it is possible to visit the house where Canova was born, his mausoleum, and a gallery of the famous sculptor's plaster casts.

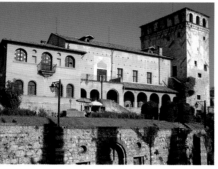

The Castle of the Queen of Cyprus with its medieval tower.

facing page
An antiques market under the loggia.

Above all, Asolo is a tranquil village where an almost perfect harmony between nature and humankind prevails. The same graceful balance is echoed in the many Palladian villas that dot the countryside, such as Villa Barbaro di Maser and Villa Emo at Fanzolo. The atmosphere of Asolo is hinted at in its name, whose root comes from the Latin *Acelum*, meaning "sanctuary." Traveling here one has the sense that the village is indeed a refuge where everyday woes dissipate into the fresh country air.

In the village, one gains an impression of a Venetian noble class that spurned the high society life of Venice and settled on the mainland to become countrified gentlemen. In 1498 the Venetian doge ordered the queen of Cyprus, Caterina Cornaro, sent to Asolo along with her court on account of her meddling in administrative affairs. Caterina lived in a castle not far from the Rocca (fortress) where she held lively gatherings with poets and scholars. Upon the queen's death, the peaceful hamlet might have returned to its old life, hidden among the fruit trees that speckle the hilltops. It could have been left out of tourist guides had it not been for the progressive thinking of a couple of famous Anglo-Saxons. Robert Browning happened upon Asolo in 1838 during one of his wanderings in the Marca Trevigiana in search of inspiration for his poem *Sordello*. Through his works, Asolo became known to many of the English intellectuals of the Romantic age, who immediately fell in love with the place. The town is infused with a desire to live life well, as is evident from its excellent restaurants and well-appointed hotels, such as the Villa Cipriani.

Along with Alfred, Lord Tennyson, Robert Browning is the English poet most representative of the Victorian era. He was born in London in 1812 and dedicated a great deal of his poems to Italy. He traveled to Asolo on his first trip abroad and the following is the prologue to his play, *Pippa Passes*, which is part of one of his first collections: "New Year's Day at Asolo in the Trevisan. A large airy chamber. A girl, *Pippa*, from the silk mills, springing out of bed, 'Day!'" It is perhaps the perfect exclamation for a newcomer. Browning remained in Asolo for an extended period of time and wrote his last book, *Asolando*, here, which was published in Venice in 1889. His son, Pen, continued to live (or rather, reign) in Asolo until his death.

Villa Cipriani is a good choice for visitors. The hotel was built out of a sixteenth-century villa and is located in a peaceful, beautiful setting, surrounded by a garden from which one can enjoy a delightful and ample view. Nearby is the Villa Rassolin Loredan, a restaurant where one can taste the region's traditional dishes. At Asolo there is a school for the embroidery of sheets, table linens, blouses, handkerchiefs, and even tapestries. Together with Montebelluna and Cornuda, Asolo forms the apex of the so-called "shoe triangle," where almost half of the ski boots in the world are made, as well as climbing and trekking shoes. Less than a mile away is the town of Maser, where you can visit the Villa Barbaro, one of Andrea Palladio's most graceful conceptions.

BASSANO
ON PALLADIO'S BRIDGE

BASSANO IS SPREAD OUT IN A BASIN AT THE FOOT OF MOUNT GRAPPA. Its latitude and position would have one think that it is a mountain town, but the climate of Bassano is so mild that olive groves thrive here, and olive oil is one of the town's most widely manufactured products. The history of Bassano revolves around the storied bridge that spans the Brenta River. First erected by the condottiere Ezzelino da Romano who, in 1228, became master of the city, the bridge was destroyed by flooding and war many times, but was always rebuilt. The initial structure was made of wood and only once, in 1524, was it fashioned from stone. The Italian Renaissance architect Andrea Palladio eventually rebuilt the bridge in wood, and since then the original material has always been respected, with only a few slight modifications. The present bridge was renovated in 1948 and is supported by a structure of great beams and covered with a roof that rests on two rows of nineteen columns. Beyond the Ponte degli Alpini lie the elements that characterize Bassano: a memorial to the Alpine troops and the Nardini distillery. The war museum stands at the head of the bridge and commemorates the heroic deeds of the Alpine forces during World War I. On the left bank of the Brenta, in the historic center of town, is the Nardini grappa distillery, where some of Italy's finest grappa is produced.

Interior of an ageing cellar for grappa.

facing page
The old bridge over the Brenta.

For centuries, nobles have come to Bassano to build villas on the pastoral hillsides at the foot of the towering Dolomites. Following the Pedemontana that traces the Altiplano dei Sette Comuni (the Plateau of the Seven Communes) one finds the small hamlet of Marostica. Marostica is primarily a town of medieval battlements and magical castles connected by walls and trenches that were built by Cangrande della Scala in 1300. But architecture isn't the reason to come to Marostica—it's chess that draws visitors to this riverside town. Every year a game of chess is carried out on the Piazza Castello with human players. The origins of the match are based on a contest between two noblemen, both in love with the daughter of the lord of the castle. In 1454 they challenged each other to a duel, but since duelling was prohibited in the Republic of Venice, the father of the young woman decided that the two contestants should face each other in a noble game of chess, to be played with living pieces in military dress. The event was remembered for the first time in 1923 and now takes place in the renovated lower castle, where the piazza is paved to resemble a chessboard. Two teams, dressed in Renaissance costume, challenge each other every year.

Grappa is a potent liqueur made from the distilled residue of grapes. Skins and seeds are boiled in stills, producing a strong and fortified drink. Nowadays the grappa is made not only from the *vinaccia* (stalks, skins, and seeds of the grapes), but from the grapes themselves and even the wine. There are many different kinds of grappa: young, aged in wooden casks, aromatic (derived from varieties of grapes such as muscat or mamsey), or spiced, which means pressed with medicinal plants such as rue or gentian. The oldest distillery in Italy is said to be in Bassano. It was founded in 1779 at the lodge Osteria del Ponte, by Bortolo Nardini, who transformed the inn into the Nardini Distillery. The family tradition continues to this day with two distilleries and a bottling center. Nardini is part of the international club Les Henokiens, which represents companies more than two hundred years old. In a fifteenth-century palazzo facing the bridge is the first Italian museum dedicated to grappa.

White asparagus is cultivated in Bassano and surrounding areas. Every May, there is a fair dedicated to this particularly delicate-tasting vegetable. Another product of regional gastronomy is *baccalà* (salted cod), served many different ways in local restaurants. Alla Riviera is an old hostelry that has been renovated and is one of the places where you can sample asparagus and *baccalà* dishes. The making of ceramics is an art form that dates back to 1500. The characteristic decorations that adorn vases, soup tureens, and plates are floral motifs and colorful still lifes, or scenes depicting work in the fields inspired by eighteenth-century landscape paintings. These artisans also create other objects with great realism, such as life-size domestic and wild animals (dogs, cats, tigers, or panthers).

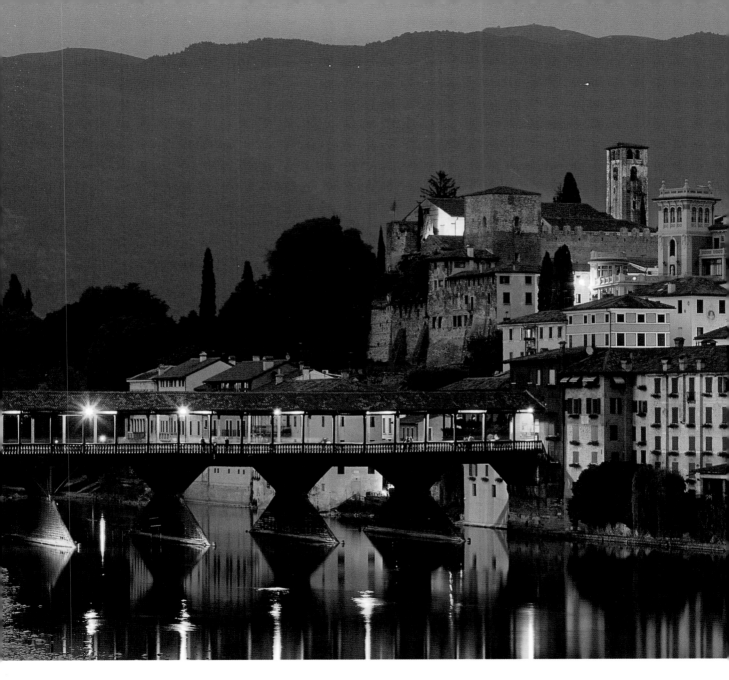

BELLUNO
FLOATING RAFTS FOR VENICE

BELLUNO RESTS ON A PROMONTORY ABOVE THE PIAVE RIVER, which flows calmly after having carved its way through the winding valleys of the Dolomites. Here, at the gravelly shore of the river, stands Borgo Piave, and, a little further away, the parking lot of Lambioi. Two diverse and emblematic realities represent the past and the future of the capital of the largest province in Italy: with few resources, as Belluno's riches depended first on the domination of Venice, and now on the accumulated remittances of emigrants. The nineteenth century was a period of major progress owing to the increase in the area's demographics. A term was even coined for the emigrants: *esambonèr*, which was a distortion of the German *Eisenbahn* (railway), used to refer to those who worked on the construction sites of the central European railway.

At first glance the parking lot of Lambioi seems far away from Belluno's historic center, but it is a modern and functional solution to the invasion of the automobile. The Venetian palazzos on Via Mezzaterra and the arcades of the Piazza dei Martiri would not have been able to withstand the traffic. It is possible to park your car for the entire day for a modest fee and be transported in a few minutes to the atrium of the Palazzo del Comune, several steps away from the colonnades and the elegant shops of Piazza dei Martiri.

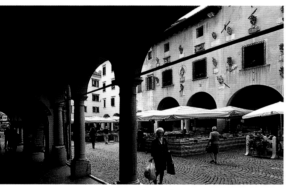

Piazza delle Erbe with the fruit and vegetable market.

facing page
Detail of the facade of Palazzo Rettori.

Though Borgo Piave was essentially an old river port, it has not been in use for over a century. The port was in a state of disrepair, but work is now being done to restore it to its former splendor. Tools and strong arms used to build the ships and wharfs of the Republic of Venice were transported from here. Most important of all, the ships carried wood of excellent quality with which the barges themselves were made. The wood became the hulls and the masts of the ships belonging to the Venetian fleet.

Today Belluno is the portal to one of the most breathtaking mountainous regions in the world: the Dolomites. A veritable marvel of nature, the Dolomites are a series of fantastic massifs that stretch toward the sky like Gothic cathedrals to the heavens. A principal economic resource, the Dolomites offer a network of ski slopes intertwining with those of the Alto Adige and Trentino, which together form a downhill skiing area that is arguably the most spectacular in the Italian Alps.

The eastern Dolomites can be reached from Belluno. On the way up the Cordevole Valley one passes under the walls of Mount Civetta, the so-called "towered city," to reach the Marmolada, the queen of the Dolomites, at an altitude of over eleven thousand feet. After reaching the top via a gondola, one can admire the glacier from above and the magnificent panorama of the Austrian Alps. If, however, you take the State 51 Alemagna road you will reach the basin of Cortina, where a crown of splendid mountains awaits you. Not surprisingly, the region was already a hub of tourism two hundred years ago. A detour brings you to the Val di Zoldo, famous for its Marmolada Glacier, where you can admire the imposing bulk of Mount Pelmo as its gigantic mass rises above an expanse of forest.

The stretch of the Piave River valley extending from Belluno to Feltre (a distance of eighteen miles), is home to roughly two hundred villas. There is no definitive itinerary to visit them, but one must go zigzagging around (by bicycle if possible) the winding roads of the Val Belluna, asking the owners if you can have a look inside. Most of the villas date to the seventeenth and eighteenth centuries, and do not have one unifying style. These are some of the villas worth seeing: Vescovile and Fulcia near the gates of Belluno, Sandi and Sospirolo, Tanuro in Cesiomaggiore, Rudio and Suppani in Sedico, Tonello in Fonzaso, Bellati in Le Case, Miari in Modolo, and Pasole in Pedavena. The tour ends at the Heineken Beer Cellar, a large building next to the factory where you can have a good draft beer accompanied by a plate of sausage or Speck and cheese.

CHIOGGIA

VENICE AWAY FROM THE CROWDS

CHIOGGIA STANDS AT THE SOUTHERN LIMIT OF THE VENETIAN LAGOON. Here, as in Venice, the streets are called *calli,* the piazzas, *campi* and *campielli,* and the wharves, *fondamenta*—and, similar to the Grand Canal, Chioggia's Canal Vena imbues the city with life. Long, parallel roads are grafted onto it so that the plan resembles, fittingly, a great fishbone. Groups of women and children can be seen on the *calli* and *campielli,* and on Sundays they take their leisurely walks along the canal's wayside, often deep in *ciacole* (gossip) or crocheting, a hobby that perhaps stems from the technique used by fishermen to make nets. The people of Chioggia hold fast to their traditions. Among them, fishing remains the activity of choice at *Clodia major* (Chioggia), while at *Clodia minor* (nearby Sottomarina) gardening is a favorite pastime. Proud and not inclined to mix with others, the people of Chioggia, however, welcome buyers on the market square where an abundance of fresh fish and vegetables are sold. The heavy volume of tourists traveling to Sottomarina has unfortunately diminished the number of vegetable gardens here, except for those along the lagoon of Lusenzo, where fires are lit at night and fish are roasted.

Religion also has a strong influence on the lives of city dwellers. One of the events in which religion and superstition are intertwined is that of the *ex votos,* when objects are offered in gratitude to saints or to the Madonna (who is said to have appeared at Sottomarina in 1508). These objects are often silver hearts; wooden, marble, or metal statuettes; but mostly *tolèle,* small pictures on wood describing the dramatic events from which the supplicant miraculously escaped.

Chioggia can be reached by boat from Venice, or by taking the Romea road. Via a small detour, one can see the beautiful marshy expanse of the Millecampi and Brenta valleys. In Chioggia, Porta Garibaldi leads to the Corso del Popolo, where the artistic heritage of the city is revealed. Among the noteworthy sites are the Piazza Vescovile and the seventeenth-century Duomo designed by Baldasarre Longhena, and the thirteenth-century bell tower. The temple of San Martino is constructed from *cotto* (terra-cotta) and is executed in the Gothic-Venetian style. The church of Saints Peter and Paul dates to the fifteenth century. Farther ahead stands the Church of San Giacomo, the nineteenth-century municipal building, the fourteenth-century Palazzo del Granaio, and the Auditorium of San Nicola that preserves a *Madonna with Child* in painted papier-mâché attributed to Jacopo Sansovino.

"Bragozzi" in the Vena canal.

facing page
Life on the canals as it was long ago.

Fish is the principal resource of Chioggia. At one time fishing was done with the *bragozzi,* the typical flat-bottomed boats designed for shallow water. On holidays these brilliantly-painted vessels can be seen from the Ponte San Domenico. However, the brightly decorated sails that once coursed the waters here have been replaced by engine-propelled boats that use modern echo-sounding gear and radar. A trip to the shipyards reassures traditional-minded individuals that boats made from wood are still in use. Borgo San Giovanni is the fishermen's arena where the *vieri* (wooden crates used to catch crabs) are found in the canals, and where wholesale buyers await the return of the *bragozzi,* when the custom of fish auctioning can begin.

Lace making is a tradition on the islands of the Venetian lagoon. It is said that artisans worked to adopt the technique used by fishermen to make their nets. It is not unusual to find women in Chioggia bringing their wooden chairs out onto the narrow streets where they work the cotton into "gossip." A typical souvenir from Chioggia is the terra-cotta pipe that is sold at the market. Fresh fish can be found at the restaurant Garibaldi do Sottomarin, which also serves a tasty eel dish from the Po Delta. The Brenta flows north of Chioggia and in the summer a boat service on the river takes you to some of the most beautiful villas of the Veneto region, such as the Malcontenta and the Villa Pisani in Stra.

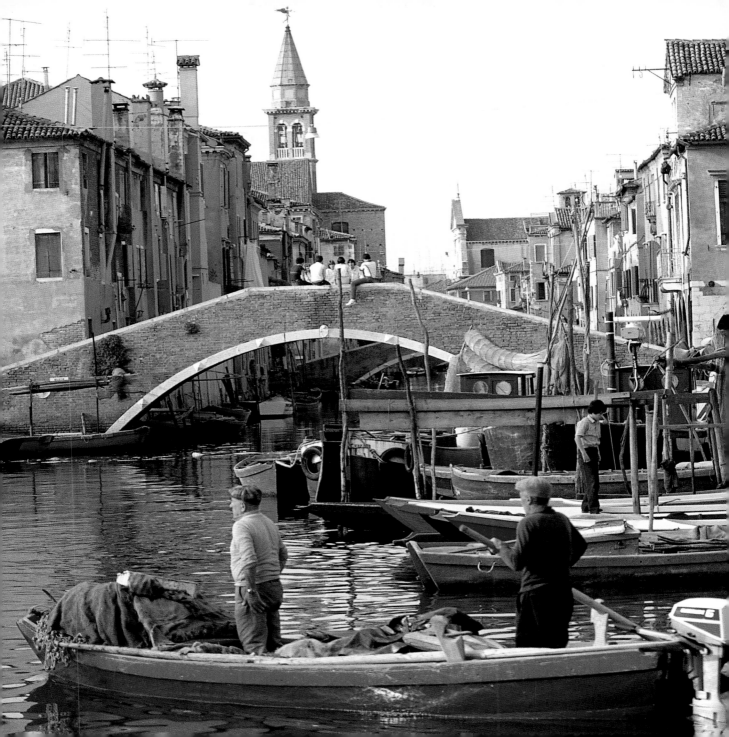

ESTE

VILLAS AMONG THE EUGANEI HILLS

THE EUGANEI HILLS RESEMBLE VOLCANIC ISLANDS EMERGING FROM THE VENETO PLAIN, particularly in the autumn when mists enshroud them and only their peaks are visible. Thousands of years ago, lava spilled down their sides and plumes of smoke came out of their tops similar to Mount Etna or the volcanic Aeolian island of Stromboli. In truth, the Euganei Hills were never active volcanoes, only boils on the earth's crust produced by magma that was pushed up from the interior during our planet's formative stages. In 1989 the area was deemed a regional park, which aided in the preservation of the unique landscape, a mixture of Alpine foothills and Mediterranean greenery. Archaeological sites abound and include the flint quarries and the Roman aqueduct. Historical sites, such as the villas of the Venetian noble families Rezzonico and Morosini, the house once belonging to the Italian poet Francesco Petrarca (1304–74) at Arquà, the Este castle, and the hermitages and abbeys, such as the one at Praglia, are all worth a visit.

Crenellations of the fourteenth-century castle.

facing page
Interior of Petrarch's house at Arquà.

Este is located at the southern passage to the Euganei Hills and is the most refined of the villages that comprise the area. Greatly loved by the English poets Lord Byron and Percy Bysshe Shelley, Este was a source of inspiration for many of their writings. The imposing mass of its castle and walls, almost a mile high, were built by Ubertino da Carrara in 1339 where a former military garrison stood. Este was the setting for many historical events and reached the height of its splendor long ago, when the ancient Venetian Ateste was one of the most flourishing centers for trade in northern Italy and much larger than it is today. Necropolises and votive columns have been discovered around the town center, the remains of which are now displayed in the nearby Atestino National Museum. Roman ruins have also been discovered near the Chiesa della Salute, where visitors can view funerary urns whose lids are typically decorated with a pinecone and flanked by either two lions or hounds.

As in the past, the draw of Este remains the hills and their volcanic origins. The Abano Terme (thermal baths), a few miles north of Este near Padua, are noted for their hot springs and curative mud baths (they were once called *Aponos,* meaning "free from pain"). The waters that flow below Abano originate in the Dolomites; they penetrate the earth at a depth of nine thousand feet and reach the surface at a temperature of over 180 degrees.

There are 120 hotels in Abano and Montegrotto Terme, all with regional permission to use the waters and extract the mud from the two small lakes called *le cave.* The waters are used for hydrokinetic and inhalation therapy. The development of the thermal mud is most important, as it is considered almost miraculous in the rehabilitation of muscles and bones and in easing arthritic and rheumatic pain. The mud is left to rest in basins filled with thermal water until green algae form, which indicates it is ready to be used. The effectiveness of this therapy is guaranteed by the Thermal Study Center, an organization dedicated to Pietro D'Abano, a fourteenth-century alchemist, physician, astrologer, mathematician, and philosopher. It is the only center of its kind in Italy.

The Euganei Hills are home to the ancient village of Arquà Petrarca, which owes its name to the poet Francesco Petrarca (Petrarch to anglophones), who wrote his *Canzoniere* (*Book of Songs*) here, where the Tuscan and the Provençal mingle, before dying. His house is open to the public and is well worth a visit. The *jujube* (Ziziphus sativa), a sweet-flavored fruit, is cultivated at Arquà. The little brown drupes are used to make jam and a liqueur called Brodo di Giuggiole, which means "seventh heaven." The restaurant La Montanella serves duck with fruit spread, a recipe originating in the seventeenth century in Padua. The seventeenth-century Villa Barbarigo in Valsanzibio has a splendid Italian garden and fountains dedicated to the rivers and the winds. Praglia is one of the most interesting hidden places in the hills, where you can visit an abbey founded in 1080 and renovated in 1469, as well as the church of the Assunta, and the vast Benedictine monastery.

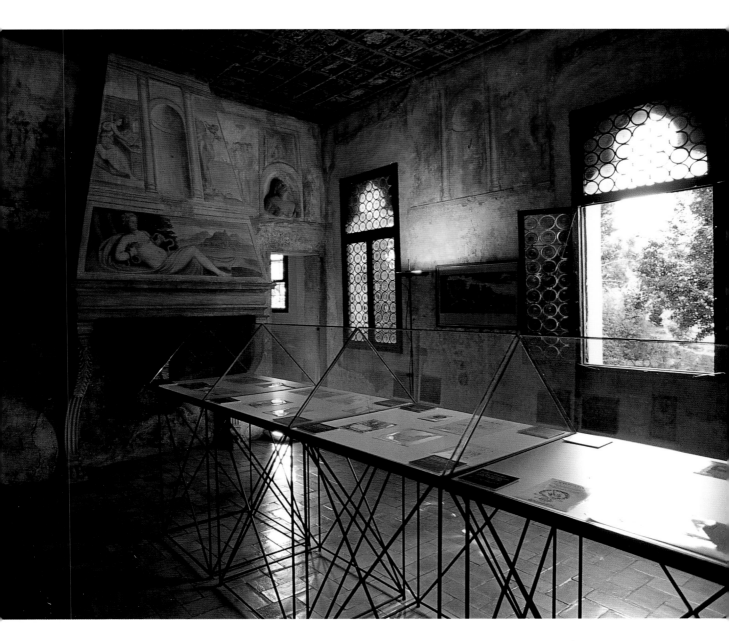

TREVISO
ELABORATE FACADES AND CANALS

OVER THE PAST FEW DECADES THE OLD MARCA TREVIGIANA (the region's ancient seal) has become synonymous with Treviso's prosperity. During the Carolingian age, the minting system grew out of flourishing, specialized small- to medium-sized industries that were often family owned. It was initially thought of as an inadequate program destined to fail; today, however, it is upheld as a model of efficiency.

Regardless of the success of the Marca, the area surrounding Treviso, inhabited since the Bronze Age, had deep and moneyed roots. Hundreds of graceful villas decorate the Vicenza–Padua–Treviso triangle, about thirty of which were designed by the Italian Renaissance architect Andrea Palladio. Built between the eleventh and eighteenth centuries, they represent a significant aspect of Italy's artistic legacy. Credit is due to the Venetian nobles and wealthy merchants who transferred their capital to the mainland and reclaimed areas of marshland, building upon them canals and roads, and fashioning the rural landscape and villages in good taste.

Ancient Roman Treviso (Tarvisium) became an important center when the Terraglio was built, a twelve-mile-long road which originated in Venice and rapidly changed the face of Treviso from a pastoral to an urban one. To this day, the old fish market by the Cagnàn Canal thrives, as does the mill in Mulinetto. The homes overlooking the Canal dei Buranelli are adorned with frescoes and embrasures with a Venetian flair.

Treviso's historic center is enclosed by walls and resembles a medieval township. It is the social heart of the city and includes the Palazzo dei Trecento, the Torre Civica, the Prefecture, and the Piazza dei Signori, where you can sip an espresso in one of the many outdoor cafés. Nearby is the thirteenth-century Loggia dei Cavalieri and the Monte di Pietà palazzo with its sixteenth-century Chamber of the Chancellors and its splendid frescoed ceiling. The colonnade of Calamaggiore houses the finest shops in the city and leads to the Piazza del Duomo, where the Romanesque Baptistry housing Titian's *Annunciation* of 1520 can be seen. Also worth a visit are the Venetian gateways of San Tommaso, Santi Quaranta, and Frà Giocondo, and the medieval churches of San Francesco and Santa Caterina, where a cycle of fourteenth-century frescoes cover the walls. In the western corner of town stands the Gothic Church of San Nicolò, built in the thirteenth century by Dominican monks.

The harvest at Valdobbiadene.

facing page
Elegant mullioned two-light windows with leaded glass panes.

Prosecco is one of the best sparkling white wines produced on the northern hills of Treviso, in particular in Valdobbiadene and Conegliano. Prosecco is widely known as a light and fruity wine, but it is also processed as a still wine. It should be drunk as an aperitif or with meals in its Brut form. Cartizze Superiore is the noble kin of Prosecco and is produced from grapes of the same name. Red radicchio is another unique product of Treviso, from where it is exported all over the world. Grown only in the countryside and mainly in the winter, radicchio is traditionally eaten raw in salads, grilled, or added to risotto; and, of course, it should be accompanied by a glass of Prosecco.

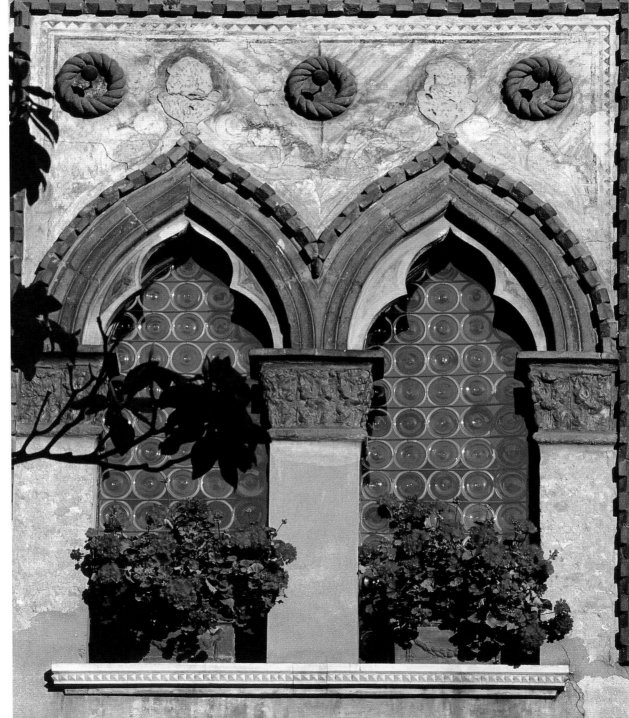

The restaurant Dei Bana Ai Buranelli, near the Piazza dei Signori and the fish market, serves many dishes made with radicchio Trevignano (a kind of chicory). The restaurant was built on the foundations of a sixteenth-century building and is fitted out with antique furniture. In the summer it is possible to dine by the canal under an arcade. The Relais Villa Fiorita di Monastier, about eight miles east of Treviso, is a good place to book a room. The hotel is a nineteenth-century villa where Hemingway was known to have stayed. Sample the Prosecco and Cartizze from the Valdobbiadene Hills, where these sparkling wines are produced.

VERONA
SHAKESPEARE'S MUSE

THE FIRST THING THAT COMES TO MIND WHEN THINKING OF VERONA IS THE ARENA DI VERONA, the Roman amphitheater on Piazza Brà where, during the summer months, operas are performed before an audience of up to sixteen thousand onlookers. The Piazza Brà has a long and dark history. It was once the city's main military base and was fittingly called the Piazza d'Armi. After the fall of the Roman Empire, Verona was ruled by the Barbarian king Theodoric, who used the square as a place of execution and where, in 1278, the city's most notorious dynasty, the della Scala, sent two hundred heretics to their deaths. Despite its grisly past, the Piazza Brà is today a cheerful square with a park and a magnificent arena that was named a UNESCO World Heritage Site. Other remains from Verona's Roman antiquity include the Teatro Romano, the Arco dei Gavi, and the portals of Borsari and Leoni. Churches to be explored include the Romanesque San Zeno Maggiore, San Lorenzo, and Santi Apostoli, and the Gothic Sant'Anastasia and Sant'Eufemia. Important landmarks such as the Loggia del Consiglio, where administrative gatherings took place, and the Palazzo degli Scaligeri, the medieval fortress from which the della Scalas ruled, are of great historical interest. The streets and the piazzas were the settings of romantic legend.

facing page
A modern-day Juliet on her balcony.

below
Battlements on the Ponte Vecchio.

It is said of the Veronese: "Veronesi tuti mati" (the Veronese are quite mad). There may be some truth to the phrase. Perhaps it's the breeze from Monte Baldo, but probably it is their irresistible excursions to the inns and wine shops for a glass of aroma-infused Valpolicella red or fine Custoza white, depending on the time of day. The area of Verona is home to the largest cellars in Europe that produce the Amarone, considered by connoisseurs to be one of the best wines in the world. In April, Vinitaly, the international show of wines and distilled liquors, is held in Verona, with approximately four thousand exhibitors from all over the world.

Verona is at the so-called "crossroads of Europe," where routes from the north, south, east, and west intersect. The highways trace the ancient roads of the Roman Empire: the Via Gallica and the Autostrada del Brennero (Brenner Pass) follow the Roman Claudia Augusta road. More than the merchants and condottieri,

it was William Shakespeare (1564–1616) who brought fame to Verona, making it the setting for the story of his fated pair of star-crossed lovers, Romeo and Juliet. Whether the story is true or not, the Veronese have brought the tale to life with the Casa di Giulietta (Juliet's House), where visitors can imagine Romeo calling out to fair Juliet as she stood on her famed perch. (Although the balcony was built in the twentieth century, the atmosphere of the place is timeless.)

The Arena has been *the* theater of Verona since Roman times. It was built in the first century AD, and was originally a stage for gladiatorial combat. Today, in the greatest open-air theater in the world, one of the most famous opera seasons takes place every year from June to August. The first performance occurred in 1913, promoted by the tenor Giuseppe Zenatello and the theater impresario Ottone Rovato, to celebrate the centenary of the birth of the Italian composer Giuseppe Verdi. On opening night, Verdi's *Aïda* was performed, and it has become the arena's standard. The opera's impressive production, including monumental sets, a huge chorus, and the use of live animals, is a crowd-pleaser. Famous singers and illustrious conductors such as Beniamino Gigli, Maria Callas, Mario Del Monaco, and Roberto Rosellini have all appeared here. Before each performance spectators light candles, creating a magical atmosphere of dancing flames.

The hills surrounding Verona are known for their vineyards. The most famous wine produced here is the Amarone of Valpolicella. A similar wine can be obtained only with great patience, and of course, technical knowledge. The wine is made primarily from the most mature and healthy of the Valpolicella grapes (the Corvina Veronese, Molinara, and Rondinella varieties), which are dried for four months on grates in well-aired rooms. During this time the *botrytis cinerea* (the noble rot) develops, giving the wine its particular taste. Before it is bottled the must resulting from fermentation is kept in oak casks for at least seven years—sometimes up to ten—re-fermenting every spring. The result is a richly-colored, fragrant, and fruity-tasting wine. Two of the region's best wine merchants are the Allegrini label in Fumane and the Dal Forno in the village of Illasi.

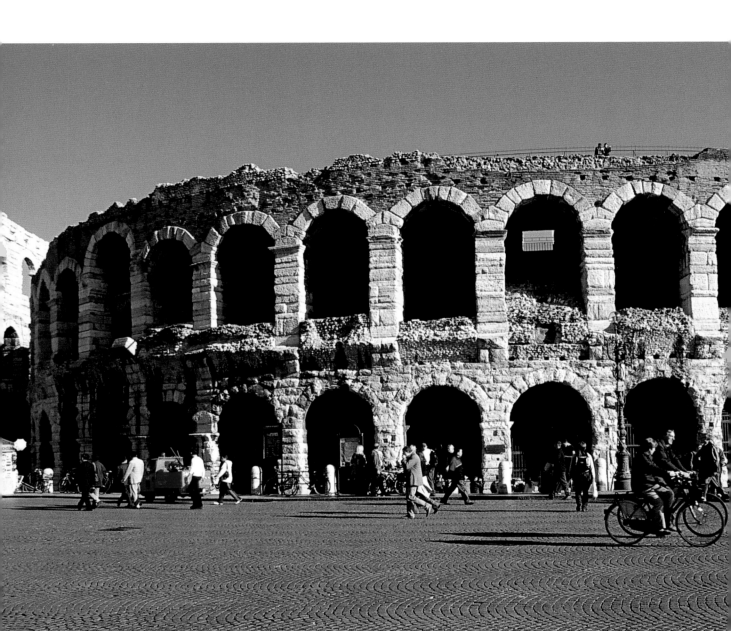

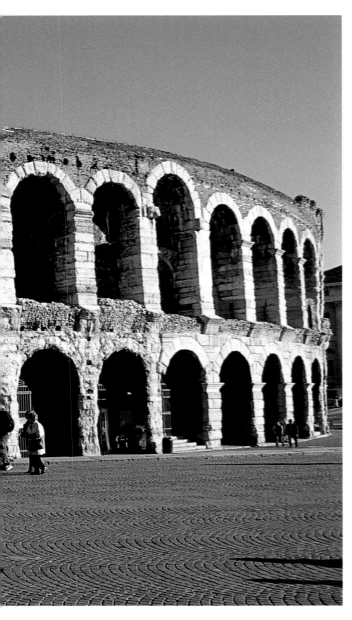

Walking up the Val d'Illasi, one comes to the Monti Lessini, a hilly area that is now a protected national park. It was the site of bitter battles during World War I, and the remains of communication trenches can be seen. Halfway up one of the hills, there is an exit for Bolca, one of the most interesting paleontological sites in Europe, where caves of fossils have been discovered. The area is studied by scholars, but visitors can take a tour to what is known as the "petrified lagoon," because of the wealth of fossils here of fish, reptiles, shellfish, mollusks, and marine and root plants. The fossils have retained their original shapes and colors, but the most precious of them are kept in Verona's Museum of Natural History.

Umbrellas providing shade from the sun on Piazza delle Erbe.

The Arena di Verona, the largest open-air theater for opera in the world.

A café on Piazza Bra.

AQUILEIA
THE ROMAN RIVER PORT

UNLESS A PERCEPTIVE EYE CATCHES A GLIMPSE OF ITS SOARING BELL TOWER, AQUILEIA is easily lost among the plains of the Isonzo River. Not far removed from the coast, the village is home to several monuments of exceptional beauty: the Gothic-Romanesque Basilica di Santa Maria Assunta is richly decorated with frescoes and an impressive fourteenth-century floor mosaic displaying geometric figures and religious sym-

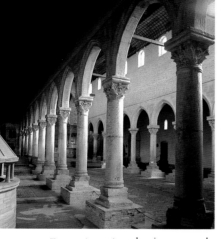

The central nave of the Basilica di Santa Maria Assunta and, *facing page*, the exterior.

bols. A crypt under the basilica contains the ruins of four buildings from four different ages, including walls, mosaics, and pottery shards. The vault of the *Massenziana* (a monument dedicated to the Roman emperor Maxentius) is decorated with twelfth-century frescoes. These, however, are only some of the sights that make Aquileia one of the most interesting places to visit in Friuli. For its wealth of archaeological treasures and art historical significance, the town was named a UNESCO World Heritage Site in 1998.

Aquileia lies on the banks of the Natisone River and was inhabited in the second century BC by the Carni until the Romans conquered it in 118 BC. The emperor Augustus turned it into one of the most important cultural centers of northern Italy. He ordered the consular roads to pass through it and named it capital of the tenth regiment of the Roman army, building important monuments and houses along the Via Julia Augusta. Noteworthy remains of Roman history from the north of the peninsula are collected in the archaeological museum. Excavations have revealed walls, roads, a forum, an amphitheater, two aqueducts, thermal baths, a mausoleum, the imperial palace, mosaics, statues, coins, and urns. The busy port is on the banks of the Natisone where the river meets the waters of the Torre. Two wharves made of Ischia stone are approximately one thousand feet long, and it is still possible to see the great square blocks with their rings for anchorage. Aquileia prospered from trade between the Adriatic cities and the Balkans, particularly in amber, but was devastated by Attila's Huns in AD 452 and later by the Lombards. All traces of the city were wiped out and the inhabitants were forced to take refuge in the lagoons of Grado and Venice. The city had slowly become a marsh, but it rose after AD 1000, when the territory was reclaimed and the patriarchs once again turned it into a bustling commercial center for another four centuries, until it was subdued by Venice in 1420 and then by Austria a century later.

Among the many historical artifacts discovered in the caves at Aquileia are objects that reveal the diet of the ancient Romans. After 2000 years, chefs from the lower plains of Friuli continue to prepare these ancient recipes. The recipes, however, are somewhat altered. A typical Roman meal consisted of the potio (an aperitif), parvae promulsides (appetizers), gustatio (antipasto), prima cena (first course), altera cena (second course), and the secundae mensae (dessert), followed by the comissatio, a debate about politics or history accompanied by much wine drinking.

Grado is primarily a fishing port, and in Roman times it was the port of Aquileia. Its historic center is a fascinating series of streets and small piazzas where the remnants of pre-Christian fortifications, sarcophagi, and temples can be visited. Grado is the so-called "Golden Island," named after the color of its sand and its therapeutic properties. The first to benefit from the sands were the Austrians at the end of the nineteenth century, when the emperor Franz Joseph decreed Grado a health resort for the Hapsburg Empire. Nowadays it is a well-known thermal spa specializing in sand baths that ease arthritic pain, rheumatism, and post-traumatic stress disorder.

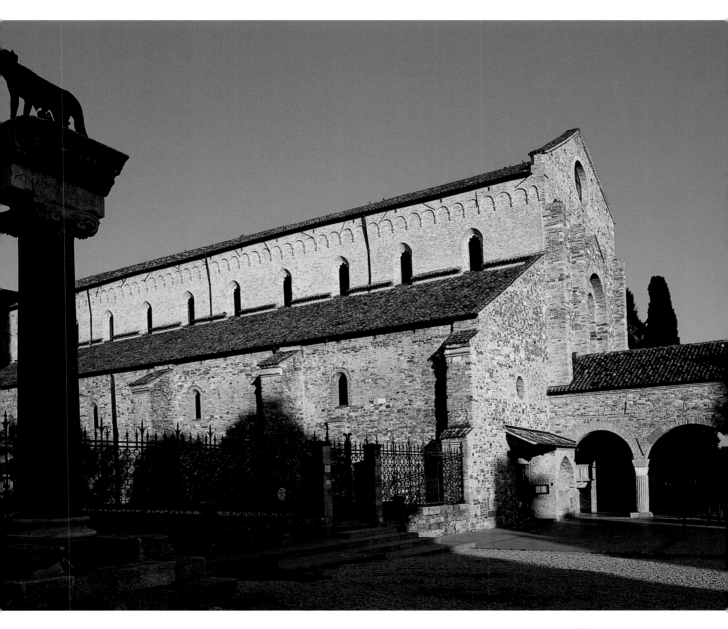

CIVIDALE
THE CAPITAL OF THE ANCIENT LOMBARD TERRITORIES

AT LEAST FOUR CENTURIES BEFORE CIVIDALE BECAME A ROMAN MUNICIPALITY, it was inhabited by the Celts, a tribal people bound together by their common customs, language, and religion. However, for the people of Cividale, the history of their town began in 50 BC, when Julius Caesar is said to have founded the city. The Roman Forum Iulii, where the Natisone River meets the plains, bears the name that later defined the region of Friuli. In AD 568 the Lombards made Cividale the Italian capital of their empire, and in the eighth century it became a stronghold of the Franks, who called it Civitas Austrae, or "city of the eastern part." The city is divided on the foothills of the Alpi Giulie, a short distance from the Slovene highlands, a location that made it an ideal defensive barrier against invasions from Eastern Europe. In the last centuries of the millennium, thanks to the Lombards and the patriarchs who came from Aquilea, Cividale grew into an important commercial and cultural center. The Tempietto Longobardo (Lombard Temple), also known as the oratory of Santa Maria delle Valle, enclosed in a Benedictine convent, is a true architectural gem. It is adorned with decorative stuccos depicting female figures and frescoes dating from the beginning of the seventh century. The Pala di Pellegrino II, a magnificent altar, is preserved in the fifth-century Duomo. Embossed and gilded in gold, the altarpiece was executed toward the end of the year 1100 and is said to be one of the most impressive works by an Italian goldsmith. A collection of High Medieval sculpture in the Duomo museum, such as the octagonal column niche of the Baptistery of Callisto and the Altar of Ratchis, is well worth visiting. The Museo Archeologico (Archaeological Museum) in the Palazzo dei Provveditori Veneti displays a wonderful collection of artifacts including weapons, jewelry, and household objects, which provide one of the most complete pictures of Cividale's Lombard past.

A glimpse of Cividale from the Natisone River—below the Devil's Bridge that links Borgo Ponte with the spur of land where the Roman Forum was—gives one an idea of how difficult the city was to conquer and why it became important in medieval times. After touring some of the best wine cellars in the region (Conte d'Attimis, Villa Russiz, Ca' Bolani, Perusini, Felluga, Conti Pormentini), visit the castle of Albana, the villas in Buttrio, the churches in Faedis, the fossil museum in Attimis, the church of Saints Gervasio and Protasio in Nimis (the oldest church in Friuli), the medieval hamlet of Tarcento, and the Venetian village of Gradisca, which the Hapsburgs once usurped.

Modern copies of antique Lombard jewelry.

facing page
Interior of the eighth-century Lombard Temple with seventh-century frescoes.

A symbol of hospitality in Friuli is the nutty, aroma-filled sweet called Gubana (meaning "good luck"), which has been the traditional pastry of the Natisone River valley since 1600. Gubana is a treat eaten at celebrations and intimate gatherings alike and has a special recipe: puff-pastry dough is spread fairly thick and covered with hazelnuts, walnuts, raisins, pine nuts, dried figs, and shards of chocolate, equal in weight to the dough. It is then rolled and baked in an oven. After cooling, it is served in slices generously doused with grappa. Many bakers still use this age-old recipe.

Il Collio is the "white vineyard" of Italy: white wines of excellent quality are produced here, such as Picolit, Ramandolo, Ribolla Gialla, Verduzzo, Tocai Friullano, and Pinot Grigio. Good choices abound for buying and tasting among the vintners and wine cellars. For example, the Cantina Produttori of Cormons is noted for its unique wine, the Vino della Pace, produced from grapes of the "Vigna del Mondo," which is said to contain 450 different grape varieties. The vine is harvested by volunteers who come from all over the world. The special labels placed on the bottles are designed by master artists and are donated to heads of state. However, nothing is known about the taste of the wines because no one has ever opened a single bottle, preferring to keep them as precious heirlooms.

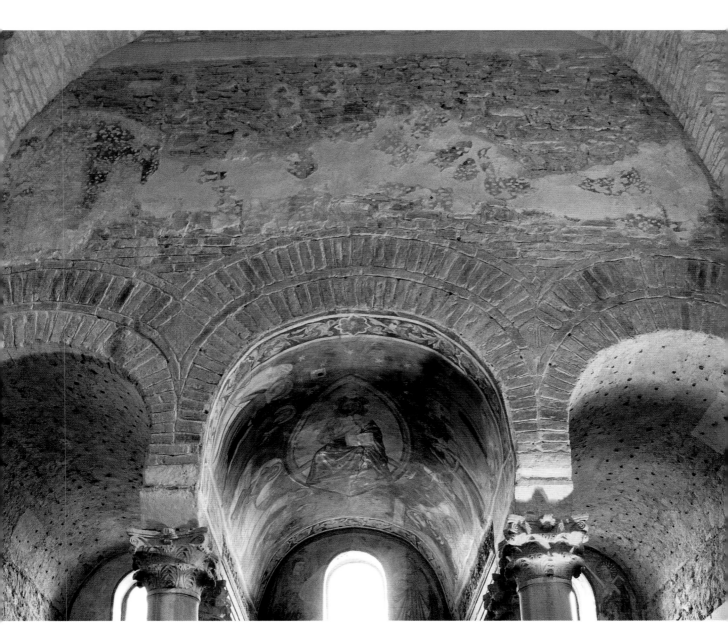

PALMANOVA

A NINE-POINTED STAR

THE BEST WAY TO TAKE IN THE EXTRAORDINARY PERIMETER OF WALLS surrounding Palmanova is in a small low-flying plane. Still intact and forming a nine-pointed star, with a network of streets in the form of spokes that lead to the central piazza, the walls are one of the best remaining examples of military architecture from the Renaissance. However, since most visitors arrive on foot, tours of the ramparts, bastions, underground walkways, gates, and checkpoints are well-organized. The perfect starting point to plan a visit is the Civico Museo Storico (Civic Historical Museum), where an exhibition traces the evolution of Palmanova from its foundation in 1593 to World War I.

Despite its bucolic location and wonderfully preserved landmarks, Palmanova hasn't always been an "ideal city" of Renaissance culture, nor did it fulfill the role of a fortress in defense of its territory. At the end of the sixteenth century, when the Republic of Venice surrendered the castle at Gradisca to the Hapsburgs, it transformed Palmanova into a powerful stronghold fortified by two concentric rings of walls acting as a double barrier. The design was carried out by Giulio Savorgnan, a military engineer commissioned from Venice.

The three gates, facing Udine, Aquileia, and Cividale, are attributed to the famous architect Vincenzo Scamozzi. Most likely, the people of Friuli did not take to the idea of a star-shaped city, primarily because they had to sustain the major part of the costs, but also because they were not inclined to live in the shadows of such massive confines. In fact, the work proceeded slowly, and, no doubt due to the construction, the population of the city dropped dramatically from 20,000 to 6,000. After the fall of Venice, Napoleon ordered more ramparts to be built in order to strengthen the walls against the power of modern artillery, and renamed the city Palmanova. In 1999 Piazza Grande, the ancient military parade ground, was restored to its original form. The city's most important buildings look out onto it: Palazzo del Provveditore, that of the Military Governor, the Monte di Pietà, the loggias, and, perhaps the most significant structure, the Duomo. Designed by the Office of Fortifications in Venice, the inhabitants of Palmanova were not satisfied with the Duomo's final blueprints. Nevertheless, the first stones of the foundation were laid in 1603 and work proceeded solemnly until it was completed in the second half of the seventeenth century.

The square in the center of town.

facing page
The shape of Palmanova's nine-pointed star is perfectly visible from above.

The tradition of wood carving and chair making in Friuli dates back to the Middle Ages (see, for example, the details of the Altar of Ratchis in Cividale). Today, in the villages of Manzano, San Giovanni al Natisone, and Corno di Posazzo, there are 1,200 companies that employ 15,000 artisans and produce 80 percent of the chairs in Italy and 50 percent in Europe. Since the 1950s the so-called "triangle of the chair" has become one of the most representative industrial areas of Italian style, due in part to its association with world-class designers such as Gio Ponte and Carlo de Carli. The International Show of Chairs, the only exhibition in the world specializing in this sector, has taken place in Udine since 1977.

The fortifications of Porta Cividale, beside the museum of military history, could be likened to an illustrated dictionary of military architecture. Here one can see the cortina (one of the nine sides of the fortress), the cavaliere (high position for the artillery), the logge (corners of the ramparts), the baluardo or bastione (glacis with space for artillery), falsabraga (glacis to observe troop movements), the fossato (separating the first circle of walls from the second), the rivellino (rampart-shaped glacis protected by the moat), and the lunetta (third line of defense accessible by an underground trench).

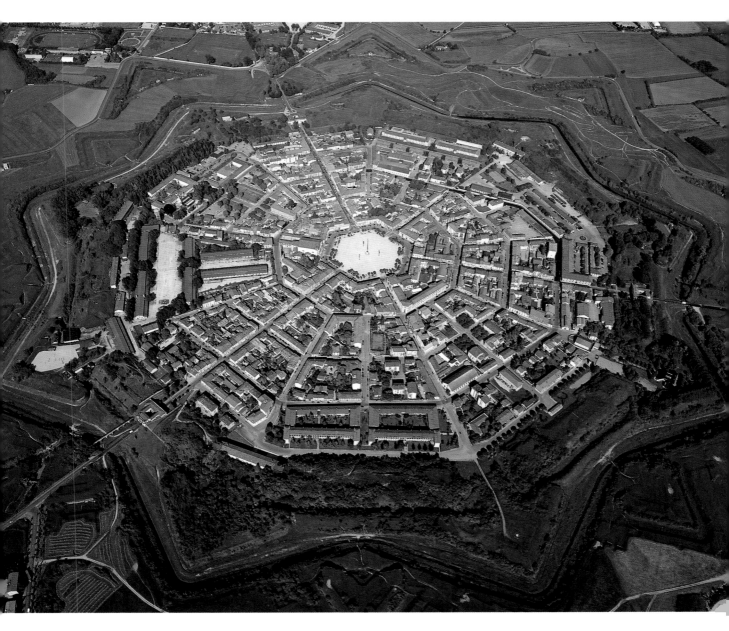

TRIESTE

THE PORT OF MARIA THERESA OF AUSTRIA

TRIESTE IS SITUATED AT THE EASTERN END OF A NARROW STRIP OF LAND along the Istrian Peninsula and is surrounded by the sweeping coastline of the Adriatic Sea and the steep slopes that rise above the karstic plateau. The people of Trieste enjoy a moderate coastal climate mixed with spells of northern winds and often spend their free time in the open air, enjoying water sports or hiking in the upper plains.

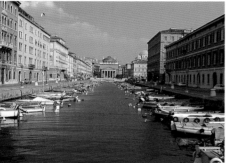

A view of the Grand Canal Borgo Teresiano, topped by the Neoclassical church of Sant'Antonio.

facing page
The romantic Castello di Miramare.

For centuries, Trieste has had more in common with Eastern Europe than nearby Friuli. Not surprisingly, then, the city possesses the noble and decadent air of the old capitals of the Austrian Empire and owes its fortune to that very kingdom, built in the first half of the nineteenth century almost entirely on the shipping industry. The port and shipyards saw their greatest periods of development under Maria Theresa of Austria, when the great navigation and insurance companies were founded. They brought prosperity to a frontier city that had been a free port under Imperial decree since 1791. By order of Empress Maria Theresa, the Borgo Teresiano was erected on the salt flats and navigable canals for the transportation of goods were built. (Only the Grand Canal remains, but it is the most significant testimony to her reign.)

The Borgo Teresiano was probably the first functional and modern urban project, comprised of a city that combined homes with the workplace. The original plan was symmetrical and included parallel streets, piazzas, and low houses (that later increased in height) with workshops and storerooms on the ground floor, living quarters on the first floor (the *piano nobile*), and offices on the second floor, topped by attics for servants and dependents. Inner courtyards with vegetable gardens were inevitably covered with gravel, owing to the excessive saltiness of the soil. The period's prosperity was marked by the building of graceful seafront palazzos, churches of all denominations, and the nineteenth-century Castello di Miramare, built for the Archduke Maximilian of Hapsburg, which sealed the love of the Empire for its city on the sea. The San Giusto Hill is a pre-Hapsburg settlement where Roman ruins were found and where visitors can tour the cathedral of San Giusto and the Venetian castle of Amarina, from which there is a panoramic vista. In the surrounding area, stops should be made in the Rocca di Monrupino, at Duino Bay, the Roman aqueduct, the spectacular Grotta Gigante, the falls of Val Rosandra, the Basilica and Duomo of Muggia, and the fascinating Karst Caves—limestone grottos characterized by sinkholes and mysterious caverns.

The Teresiani, or inhabitants of Trieste, can often be seen sitting in the elegant cafés on the Piazza dell'Unità d'Italia, taking part in the daily ritual of the *rebechin*, or snack. Served mid-morning in inns and bars, the *rebechin* traditionally consists of strong-tasting sardines, salamis, or prosciutto baked in a pastry dough and accompanied by a glass of wine. A tour of Borgo Teresiano will reveal innumerable intriguing storefronts, in particular secondhand shops and antique bookstores selling volumes worthy enough to be displayed in a museum.

The Grand Hotel Duchi d'Aosta is located on the Piazza dell'Unità d'Italia and is an ideal place to stay. The hotel is a classic palazzo in Central-European style. For a traditional *rebechin* (snack), go to Al Rebechin, whose name speaks for itself, or to Pepe, an Austro-Hungarian–style hostelry, or to the Antica Trattoria Suban. For authentic Trieste cuisine visit the highlands of the Carso, where the food has an Eastern-European flavor in the choice of produce used to prepare meals and in the mixing of sweet and sour——for example, gnocchi or ravioli with plums, *jota* (Savoy cabbage soup), venison goulash, and shin of pork. These dishes can be sampled near the fortress of Monrupino in Castelliere, the Carso in Bozo, or at Da Furlan.

The church of San Giusto.

The rite of coffee drinking in Trieste is a special one, with at least a hundred variations, and the custom employs a terminology that is quite different from the rest of Italy. For example, to order a regular coffee, ask for a *nero* (black coffee), which can be diluted or strong; *gocciato* means with a drop of milk froth floating in the center of the cup, and when sugar is added it should slide along the edge of the cup without breaking the froth. For a cappuccino, order a *caffèlatte in tazza grande* (coffee with milk in a large cup), because Trieste coffee is called *capo* and is served with a drop of milk and can vary in dozens of different ways according to the container or cup, the temperature, and the froth of the milk. Many coffeehouses carry on ancient traditions, such as the Tommaseo, which has been frequented by business people and artists since 1830. The Caffè degli Specchi spreads out onto the Piazza dell'Unità d'Italia. The Tergesteo café is named after a gallery of the same name located between the Verdi theater and Piazza Borsa. The San Marco is where the intellectuals of Trieste used to gather in the 1920s.

One of Trieste's many antique book shops.

right
Ruins of the Roman Basilica Forense

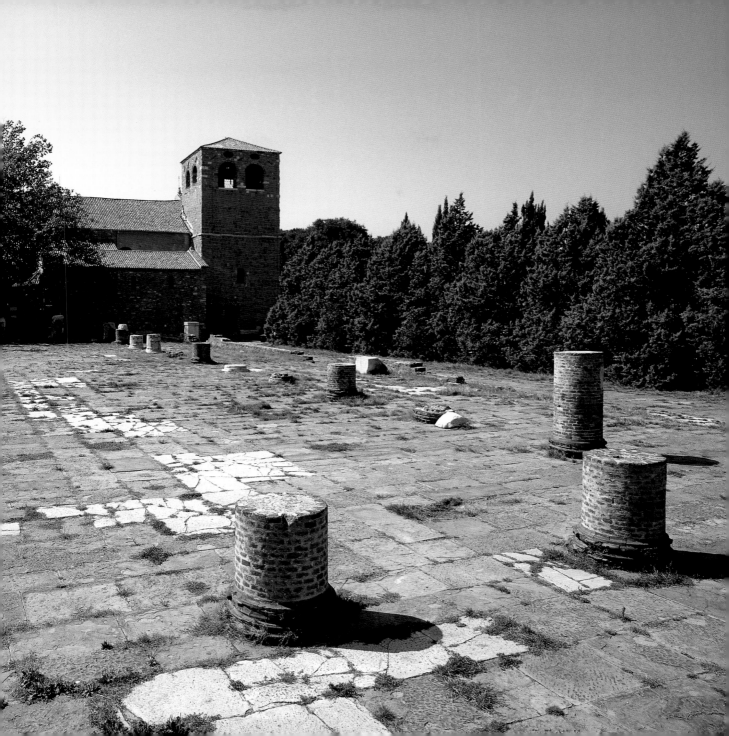

CASTELL'ARQUATO

A THOUSAND BATTLEMENTS AMONG HILLS

VISITORS TO CASTELL'ARQUATO SHOULD SEEK OUT THE VILLAGE, climbing from the plains of Emilia below the Po River, up the Val d'Arda to where the foothills of the Apennines begin. However, Castell'Arquato is worth the journey. It was a stage for Rome and for the many capitals of an Italy shattered into counties and duchies. Beyond the mountains lies Velleia, a small but complete Roman town carefully hidden in the folds of the Apennines between the valley of the Arda River and that of the roaring Chero. Velleia was destroyed by a landslide in the fourth century AD and discovered by chance during the middle of the eighteenth century when Philip Bourbon, duke of Parma, began the recovery of the city's ancient ruins. Recent excavations have brought to light, grouped around the forum, a basilica and a tribunal, baths, an amphitheater, shops, and houses.

Judging from the imposing fourth-century Rocca (fortress) that dominates the valley, Castell'Arquato must have been an important city center one thousand years later, at the time of the Free Communes. The town most likely owes its name to Caius Torquatus, a Roman soldier who, legend has it, built a fortification here in the second century BC. The other possibility is that its name came from the term *arcuatus* (meaning the form of an arch), perhaps reminiscent of the shape of the hill upon which it was built. Its strategic importance is obvious: to the north, the physical boundary of the Po was a great defensive asset, while to the south, the frontier dividing the fiefs of the great ducal families (such as the Este and the Farnese) and the Papal States provided a social barrier.

Approached from Piacenza, the fourth-century Rocca appears imperious, overlooking the valley and shadowing the village behind a cloak of high walls. Entering through Porta Borghetto, the village preserves a medieval atmosphere, particularly in the areas of Borghetto and Monteguzzo, and, above all, in the monumental center at the top of the hill. Along the road are the crenellated walls of the Stradivari Castle (where the famous violin maker Antonio Stradivari had a workshop) and the sixteenth-century Farnese Tower. It is, however, in the Piazza del Municipio (also called Solario) that Castell'Arquato reveals its artistic heritage in full. Not far from the Rocca stands the Palazzo del Podestà, an elegant Gothic building built at the end of the third century and attached to the Loggia dei Notari. The Romanesque Collegiate Church of Santa Maria, founded in the first years of the twelfth century and built from hewn volcanic rock and blocks of sandstone, is also worth a visit.

The Palazzo del Podestà.

facing page
Piazza della Rocca.

Gastronomical specialties from Piacenza include salamis, *anolini* (stuffed pasta), tortelli with herbs, *pisaréi e fasö* (gnocchi and beans), sturgeon from the Po, and almond torte. But above all, snails are the centerpiece to a meal in this town. The snails are first removed from their shells, boiled, and then washed with water and vinegar and dusted with yellow flour to rid them of impurities. In Piacenza they are traditionally steamed, then seasoned with oil, salt, pepper, and various vegetables (onions, leeks, parsley, celery, or carrots). They are then boiled for three to four days consecutively for at least two hours a day, letting them rest in a covered pan. They are traditionally eaten with polenta, accompanied by a light, perfumed white wine.

A winding road leading from Castell'Arquato over the Appenines leads to Salsomaggiore Terme. It was the Romans who enjoyed the waters here, which are rich in sodium chloride. In fact, the mineral water of the Salsomaggiore Spa is one of the saltiest to be found in nature. During the empire of Charlemagne the increased need for salt improved the economic development of the area and encouraged the extraction of salt from the water. At the beginning of the nineteenth century the salt–bromine–iodine composition of the water was considered therapeutic and the first spa was built in 1847. Today there are three thermal baths, the most luxurious being the Terme Berzieri–Zoia, with its beautiful facade and sumptuous Art Deco–style interiors. The Tempio di Igea is a health center that offers hydrotherapy and aesthetic medicine treatments.

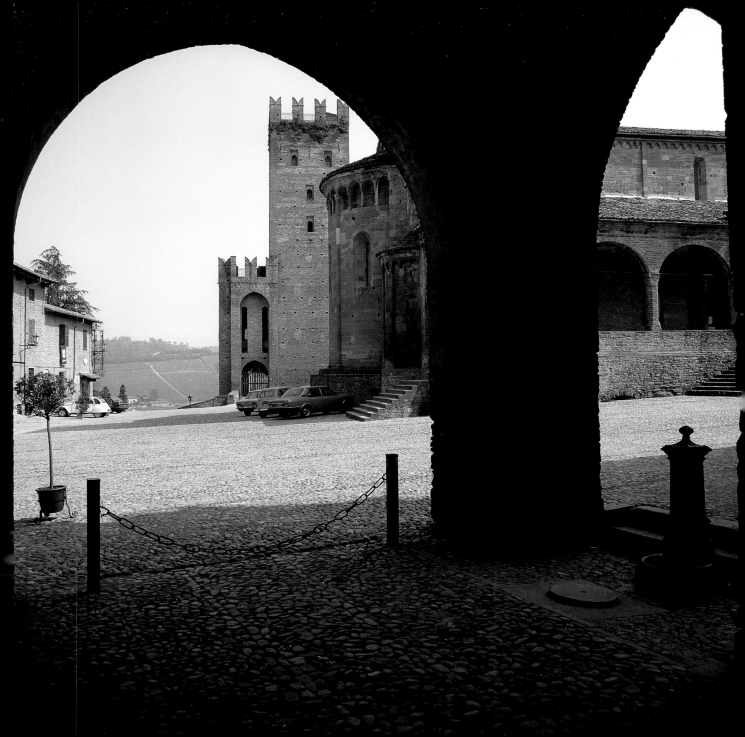

FAENZA

FAIENCE, CERAMICS, AND MAIOLICA

FAENZA'S RENOWN COMES NOT FROM ITS FIFTEENTH-CENTURY CATHEDRAL, medieval palazzos, or vast picture gallery of thirteenth- and fourteenth-century paintings and sculpture, but from the production of a certain type of white-glazed ceramic called faience. Since the twelfth century Faenza has been a major center for artisans working in clay. It is still possible to visit the workshops and schools of fine art where faience is crafted to witness the modeling of vases or the preparation of colors. The decorative elements of plates, urns, and centerpieces are often classic motifs that have been passed down from the Middle Ages and the Renaissance, while shapes, colors, and techniques are modern and inspired by internationally famous contemporary artists.

An artist perfecting her masterpiece.

facing page
A sixteenth-century ceramic plate.

The art and industry of ceramics is spread for the most part over Emilia Romagna and has developed considerably (the town of Sassuolo is famous for its tiles), but it all began over eight centuries ago in Faenza, where the soil is rich with clay suitable for forming and baking. Faenza vases certainly were not the only ones of their kind, but in the Middle Ages they became more prized than Tuscan pottery, which employed an ancient Etruscan tradition for its creations. This was due to the use of a delicate white glaze, made from lead oxide and tin, which made decorated everyday objects such as bowls, jugs, and plates more attractive and more valuable. Shortly after the middle of the sixteenth century, at the height of its technical perfection, Faenza introduced *compendario,* or "white ware," a style of ceramics characterized by the prevalence of white glaze, with simple, lightly sketched embellishments in yellow, orange, and turquoise. Not suprisingly, Faenza is home to the International Museum of Ceramics, one of the largest collections of ceramics in the world. The museum was founded in 1908 and displays works dating from the Middle Ages through the nineteenth century and includes examples of *compendario* and a private bequest of 960 maiolica plates and vases donated by Galeazzo Cora, a passionate scholar and art historian who specialized in ceramics. The museum also details the history of the potter's craft as well as the different periods and styles of faience—from the archaic, floral, and Berettino styles, to the blue-white glaze of eighteenth-century chinoiserie. For an in-depth study, over fifty thousand volumes detailing the history of faience can be consulted in the museum's specialized library.

Ceramic (from the Greek word for clay, *keramòs*) is a paste made from clay that is dried and baked in a special oven at a high temperature. It can be white or colored, porous or compact, and decorated with paints and glazes. The various types of paste, compactness, and baking give rise to terra-cotta, faience, earthenware, and porcelain. Terra-cotta is a product of clay that remains porous after it is baked and takes on a color between yellow and red. Faience is achieved by placing terra-cotta in a blast furnace (in this case it takes the name *biscotto,* or twice-baked), which is used for glazed ceramics. Maiolica, a type of painted, tin-glazed earthenware that may take its name from the Spanish island of Majorca, is, like faience, fashioned from porous clay and covered with a painted glaze or a hard glaze, such as glass. Porcelain is a semi-transparent compact ceramic of white paste used for objects of value.

The history of ceramics in Faenza can be traced by examining the different styles that developed over time. The Arcaica phase produced decorations (textiles and miniatures) illustrating medieval stories and were often embellished by plant motifs (vines and flowers), animals (fantastic birds and monsters), and heraldic patterns. The Severo style appeared at the beginning of the Renaissance with vibrant colors (intense yellows and blues), and its recurring motifs were four-petaled flowers, allegorical figures, and biblical and mythological scenes. In the sixteenth century, maiolica in the Berettino style was characterized by gray-blue shades, fanciful themes, and trophies overflowing with fruit. The Bello style followed and depicted historical or legendary subjects in deep blues, yellows, and oranges.

FERRARA

THE DIAMOND OF THE HOUSE OF ESTE

FERRARA IS AN IMPORTANT AGRICULTURAL CENTER ON THE LOWER PLAINS OF THE PO RIVER, so close to the river's delta that high embankments are built in order to protect the farmland from periodic flooding. It is a flat town, as are many of the villages on the plain, with short houses above which rise the bell towers of the churches.

The proud profile of Ferrara is visible from a distance as it etches the sky. The magnificently preserved encircling wall, erected by the architect Biagio Rossetti by order of Duke Ercole I (a member of the infamous Este dynasty) between 1493 and 1505, can be seen from the approaching road. Beyond the fortifications, the Viale Cavour leads to the Castello Estense, the moated fortress of the Este family. Walks are recommended along the Corso Ercole d'Este, the main street that extends straight from the castle to the walls and flanks the patrician houses. Window-shopping is a great pastime under the Loggia dei Mercati (Merchants' Bazaar) as is strolling among the houses along the Via delle Volte. Ferrara was born from the waters of the Po, and it died and was reborn from these same waters. In 1152 the river broke its banks and changed course, leaving two inadequate canals, the Volano and the Primaro, and transforming the area into an unattractive marsh. But Ferrara rose again and became more beautiful than ever before. The Po brought the city a significant amount of trade and transformed its once quiet shores into a bustling port. Added to this, the arrival of the Estes, who employed a heavy-handed rule, was a crucial event that turned Ferrara into one of the most powerful city-states of northern Italy. The historically rich Castello Estense is a testament to Ferrara's rebirth. Alfonso I (who ruled from 1553–1534) initiated an important revitalization program with the participation of some of the most illustrious artists of the time: Titian, Dosso and Battista Dossi, Raphael, and Giovanni Bellini. Near the Castello is the Palazzo Schifanoia (*schifanoia* literally means "avoid boredom"), where an elaborate cycle of frescoes by the Ferrarese School painters Ercole de' Roberti and Francesco del Cossa decorate the interior. The Palazzo dei Diamanti is so called for the thousands of blocks of marble cut into facets used to create its facade. The Palazzo di Ludovico il Moro Sforza is a Renaissance masterpiece built for the eponymous husband of Beatrice d'Este; it now houses the Archaeological Museum. Ferrara is also home to the distinguished University of Ferrara, founded in 1391, where the Polish astronomer Copernicus studied canon law and the Swiss alchemist and physician Paracelcus studied medicine.

Bicycles are the preferred means of transportation in Ferrara. The elegant Gothic Duomo stands in the background.

facing page
The Palazzo dei Diamanti.

Ferrara's ramparts have been transformed from medieval defenses into idyllic gardens and bike paths. A suggested route is along the Via Baluardi, past the seventeenth-century Porta Romana and along Viale Alfonso d'Este, beside the Mount of San Giorgio. Continuing farther, descend to Via Porta a Mare and then climb beside the Tower of San Giovanni, where the most interesting part of the ride begins. Here there is a view of the gardens and the Certosa of San Cristoforo. The path to the Porta degli Angeli and the Torre Barco rises and falls, with passages of flat terrain in between.

Traveling about thirty-eight miles east of the city along the old Strada Romea that skirts the Po River delta, the beautiful Benedictine abbey of Pomposa can be visited. Founded in the eighth century, the abbey is mentioned in a letter from Pope John VIII in 874. The complex was completed in the first half of the year AD 1000. The abbey church preserves fourteenth-century frescoes and a valuable mosaic pavement dating to the eighth or ninth centuries. The marshlands of the Po Delta are home to whispy reeds called *pavere*. The stems of the reeds are used to plait mats and baskets; bags and hats are made out of their leaves. Taste the popular dish of eel at the Capanna restaurant at Ponte Vicini, a hostelry nestled among the waterways and canals with a working kitchen. Once the meal is served, you'll quickly forget the trouble it took you to find the place.

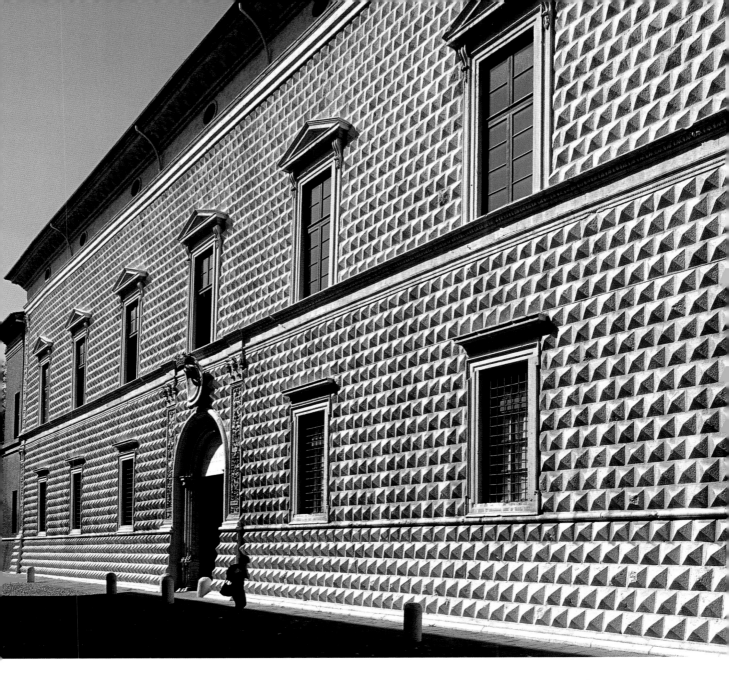

MODENA
GREAT CUISINE AND POWERFUL ENGINES

ON A FERTILE STRIP OF PLAIN BETWEEN THE PANARO AND SECCHIA RIVERS, Modena occupies one of the most abundant countrysides in Italy. Both artisan and industrial centers specializing in ceramics (in Sassuolo) and clothing (in Carpi) bring further prosperity to the area. Modena's motto has always been to accept new challenges and not to rest on its laurels. The city owes its fortune not only to its Parmesan cheese, *zamponi* (pig's feet stuffed with sausage meat), and its prized *aceto balsamico* (balsamic vinegar); it is also a center of cultural prestige. The Piazza Grande, together with the Duomo and the bell tower, called La Ghirlandina (the Little Garland), were named UNESCO World Heritage Sites in 1997. The Duomo was begun in 1099 by the Italian architect Lanfranco and decorated by the sculptors Wiligelmo and Anselmo da Campione. The Duomo set a precedent for the many Romanesque buildings of the region, as did the Ghirlandina belfry. The nearby Palazzo Ducale was built by Duke Francesco d'Este in 1631 and underwent renovations at the suggestion of Gianlorenzo Bernini, and now houses the celebrated Military Academy. The city's main museum, the Palazzo dei Musei, is home to the Galleria Estense, a picture gallery once belonging to the House of Este, and the Biblioteca Estense (the Este family library) where the Bible of Borso d'Este, illuminated by Taddeo Crivelli, is conserved. Also of note are the Clock Tower and the Palazzo Comunale.

A specialty shop on the Via Farini.

facing page:
The Duomo on Piazza Grande.

The city is literally divided in two by the historic Via Emilia. Traffic is now diverted to allow space and safety for pedestrians and cyclists, perhaps the most popular means of transportation. However, the great passion of city dwellers is and always has been speed. From childhood on, men and women alike are enamored of the two fastest cars in the world, the Maserati and the Ferrari, both of which are produced in Modena. The Maserati brothers opened their first workshop in Bologna in 1914, but the company was bought by the Orsi family and transferred to Modena in the late 1930s. In 1929 Enzo Ferrari founded the sports company Scuderia Ferrari in the city. He separated from Alfa Romeo, and, at the beginning of 1940 began building his own cars. Three years later, right in the middle of the war, the Auto Avio Costruzioni Ferrari was transferred to Maranello. Some twenty miles further away, Ferruccio Lamborghini opened his own automobile factory in 1963. Before that he had been building tractors at Pieve di Cento (Ferrara) until the end of the 1940s.

The vinegar found in supermarkets is rarely the traditional balsamic vinegar of Modena. It is most likely a seasoned version made to imitate the original, an elixir with an ancient history. Balsamic vinegar was produced in the twelfth century, but references to it have been found in writings from the first century BC by the Roman poet Virgil. Authentic Aceto Balsamico di Modena does not contain spices and is prepared by following a strict recipe: the must of Trebbiano grapes is cooked immediately after being pressed and then left to age for at least twelve years. It is then passed through a series of wooden casks of decreasing size and kept at a constant temperature. The duke of Este is said to have kept a precious stash in the tower of the Palazzo Ducale. Balsamic vinegar is used on salads, but it should be tasted with shards of *grana* cheese, on strawberries, or eaten *al cucchiaio* (by the spoonful) as an aperitif.

In the "land of motors," a pilgrimage to the sacred places of this mythic site is obligatory. First, there is the Galleria Ferrari at Maranello, where the historic Ferrari cars driven in the Formula One and Granturismo races are on display. Modena is home to the Maserati factory, the Umberto Panini collection of historic cars and motorbikes, the Righini collection of cars in the Panzano Castle, the historic Stanguellini Museum of Cars, the factory and museum of the De Tomaso family, and the birthplace of Enzo Ferrari. If you wish to lengthen your stay, visit the Enzo and Dino Ferrari racing track at Imola, the Museum of the Automobile at Rio in Reggio Emilia, the Ferruccio Lamborghini Museum at Dosso in Ferrara, the Lamborghini Museum at Sant'Agata in Bologna, and the Ducati Museum at Bologna.

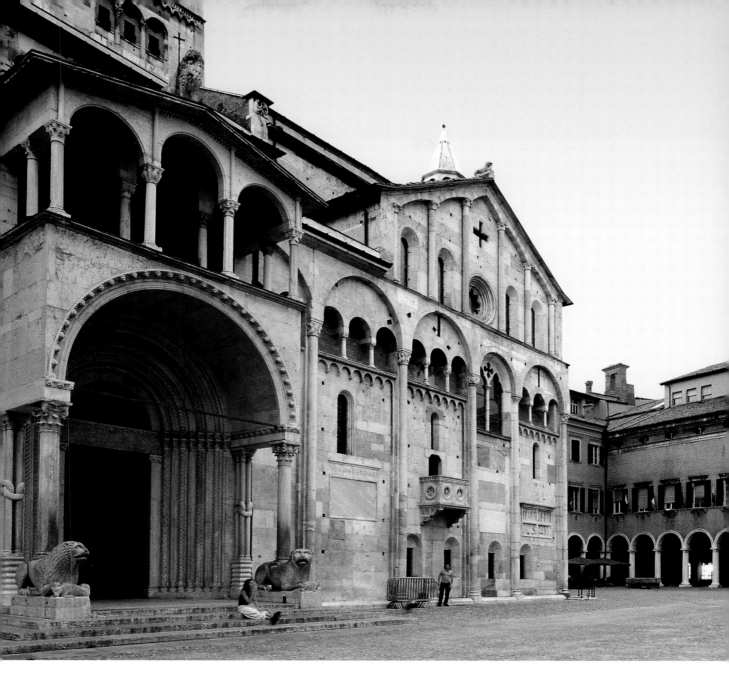

PARMA
A NIGHT AT THE OPERA

PARMA WAS THE HOME OF THE COMPOSERS GIUSEPPE VERDI AND ARTURO TOSCANNINI. For many of Parma's citizens, bel canto singing is an innate and blinding passion. Opera pervades every aspect of life, and it is not unusual to meet people who have been named after the libretti of some of the most famous dramas, such as *Simon Boccanegra* and *Parsifal.* The Teatro Regio (Parma's opera house) was built by Maria Luisa, a former wife of Napoleon who is quoted as saying about the French emperor, "I had wished him many more years of a long life as long as he stayed a thousand miles away from me."

The Regio was inaugurated in 1829 with a performance of *Zaira* by Vincenzo Bellini and is still the lion's den for all opera singers. Audiences, mostly made up of locals, consider opera their birthright; they are acute listeners and critics and their intransigent ferocity is well known. One who leaves the Regio with applause can face any other audience in the world with the certainty of success. Opening night at the opera (traditionally December 26) is a great occasion to meet people. Special dinners are sometimes served at intermission during the first nights of the Regio's season, in homage to the great passion of the citizens of Parma—to eat well.

Some of Parma's gastronomic jewels have brought Italy's name to worldwide attention: the sweet cured ham called prosciutto di Parma, the salami of Felino, and the *culatello,* the finest cut of the ham. Parma's biggest boast, however, is *grana,* the Parmigiano Reggiano cheese (widely known as Parmesan). Though excellent eaten on its own, there are many dishes, called "alla parmigiana," that base their recipes on Parmigiano Reggiano. Verdi loved the Spalla di San Secondo (cooked shoulder of pork) and would present it to his friends with precise instructions on how to prepare and eat it. The composer Gioacchino Rossini ate *cotechini* (boiled sausage) and *zamponi* (pig's foot stuffed with sausage); and who could resist the *tortelli di erbette* (pasta stuffed with herbs) or the *busecca* (tripe soup served with garlic bread)?

Besides gastronomy, Parma offers masterpieces of art and architecture: Benedetto Antelami's twelfth-century octagonal Baptistery, frescoes by Antonio da Correggio in the Cupola of San Giovanni, a fresco cycle by Parmigianino in the sixteenth-century church of Santa Maria della Steccata, and the romantic wooden Teatro Farnese in the Palazzo della Pilotta.

Interior of the Teatro Regio, temple to Giuseppe Verdi.

facing page
A lion guards the portal to the Duomo and the Baptistery.

Of all the tasty products in Emilia, first place should definitely be given to *culatello,* the greatest of all prosciutto di Parma. It is produced between Zibello and Langhirano in a small area along the Parma River. Only the back muscle of the pig's flank is used. It is deboned and stripped of its fat, washed with wine, seasoned with salt and pepper, and then stuffed into entrails. It is then seasoned for ten to twelve months, during which time it is dampened at intervals with a cloth dipped in white wine or cognac. Considering this process, it is no surprise that no two *culatello* are the same, and the slicing of the first pieces is a much anticipated rite.

The historic center of Parma is home to a collection of art-historical and architectural masterpieces. Parma's Duomo displays frescoes by Antonio da Correggio (1489–1534), while the Baptistery is built from pink Verona marble and contains a cycle of the months by Benedetto Antelami (ca. 1150–1230), and the Room of Saint Paul painted by Correggio. The Palazzo della Pilotta houses the National Gallery, the Palatine Library, the Farnese Theater, and the Bodonian Museum, which preserves rare editions of antique books and 80,000 punches and dies belonging to the great printer Giambattista Bodoni, who directed the Royal Printing Press. The Renaissance church of Santa Maria della Steccata contains frescoes by Parmigianino (1503–40) and Michelangelo Anselmi (ca. 1492–1556). The cupola of the church of San Giovanni Evangelista was painted by Correggio.

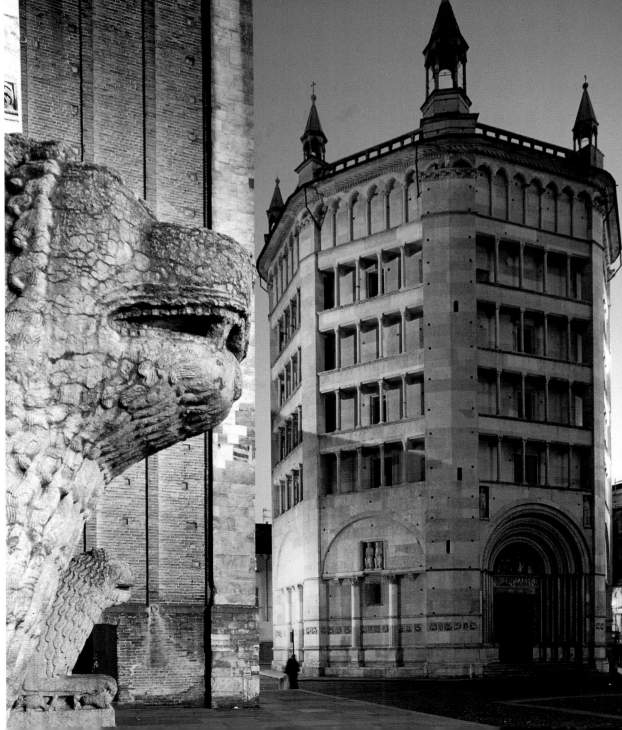

RAVENNA
BYZANTIUM ON THE ADRIATIC

RAVENNA IS NOT A SHOWY CITY AND IT KEEPS ITS MOST PRECIOUS MASTERPIECES under modest appearances. It was founded in ancient times and inhabited by the Umbrians. The high points of Ravenna's history are concentrated into only three centuries of its long history, and the city preserves the marks of three separate civilizations in its art and architecture: the Roman era of Galla Placidia from AD 386 to 452, the barbarian Ostrogoth period of Theuderic (AD 493), and the Byzantine age, which lasted from 540 to 751. The artistic legacies of these three diverse cultures share two basic stylistic factors: the essence of exterior forms and the simplicity of the materials used. Although exteriors were often constructed from clay brick and undressed stone, interiors were richly decorated, with stuccoed walls and gold and polychrome mosaics.

In 425 Galla Placidia, daughter of Emperor Theodosius, had a mausoleum built. The innovative solutions employed are most surprising for the time period, such as the choice of the quality of light, which was a fundamental element in Byzantine culture and had direct connections with cosmology. The light that enters from the windows of the mausoleum is filtered by sheets of alabaster and illuminates the figures of the saints and the doves in the star-studded mosaic sky of the vaulted ceiling. It is this light, more than the direct light of the sun, that distinguishes the unique characteristics of the mosaics of Ravenna. The tiny glass tesserae are crafted to adhere to the surface mortar, each at a different angle, so every kind of light at every hour of the day is reflected in a different direction. For this reason, the mosaics of Ravenna shimmer with colors that never seem to be the same and create an atmosphere of suffused illumination. This technique was also used in the sumptuous mosaic decorations belonging to the church of Sant'Apollinare in Classe and the Basilica di San Vitale. The church of Sant'Apollinare is most representative of Ravenna's architectural heritage, simple in form and remarkably decorated with mosaics depicting scenes from the Old and New Testaments, royal processions, landscapes of pine trees, and Ravenna's lagoon. The Basilica di San Vitale was erected in the sixth century and remains the most famous structure in the city. It is octagonal in shape and suggests a mosque more than a church. Above the altar are an elaborate and breathtaking series of mosaics portraying the emperor of the East, Justinian, his wife, Empress Theodora, and between them on the front wall of the apse, the figure of Christ.

The Church of Sant'Apollinare in Classe.

facing page
The Empress Theodora and a minister, a detail of a mosaic on the lateral wall of the apse in the Basilica di San Vitale.

The art of the mosaic is taught in specialized schools in Ravenna, the most important of which is the Institute of Art for Mosaics (established in 1959), where techniques are taught for the faithful reproduction of ancient mosaics. The design is first put onto paper, and then glass tesserae are applied. The method of making the tiles is similar to that used in Roman and Byzantine times. With new types of tesserae (glass, stone, and even synthetic resin), mosaic is also used in contemporary architecture, furnishing, and design. In many mosaic workshops, the art of mosaic-making is passed on from generation to generation.

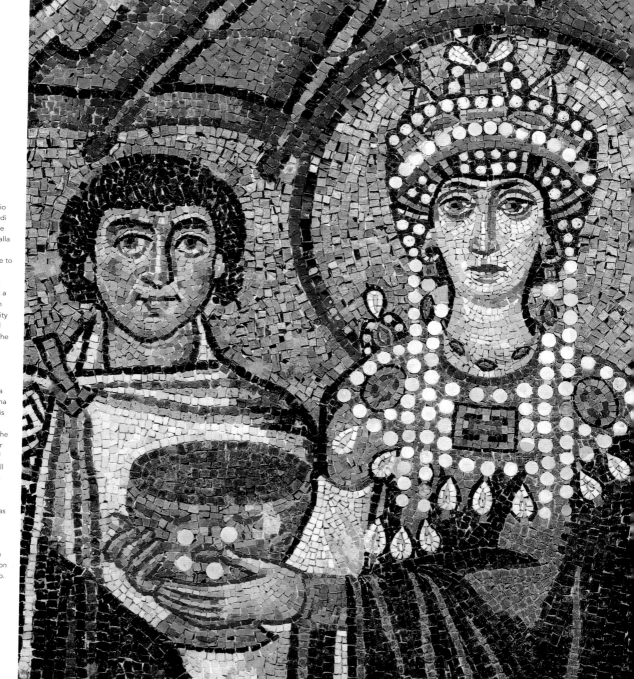

The Hotel Bisanzio near the Basilica di San Vitale and the Mausoleum of Galla Placida is a comfortable place to stay, as is the Cappella, a hotel transformed from a historical house in the heart of the city that offers several creative menus. The wine cellar and restaurant Ca' de Ven prepares traditional dishes from the Romagna region. The Taverna di San Romualdo is an excellent restaurant lost in the countryside not far from the village of the same name. All kinds of delicacies can be bought at the Bottega di Giorgioni, as well as aromatic herbs, spices, jams, and hand-rolled pasta. Mosaic panels with various motifs are on sale at Artemosaico.

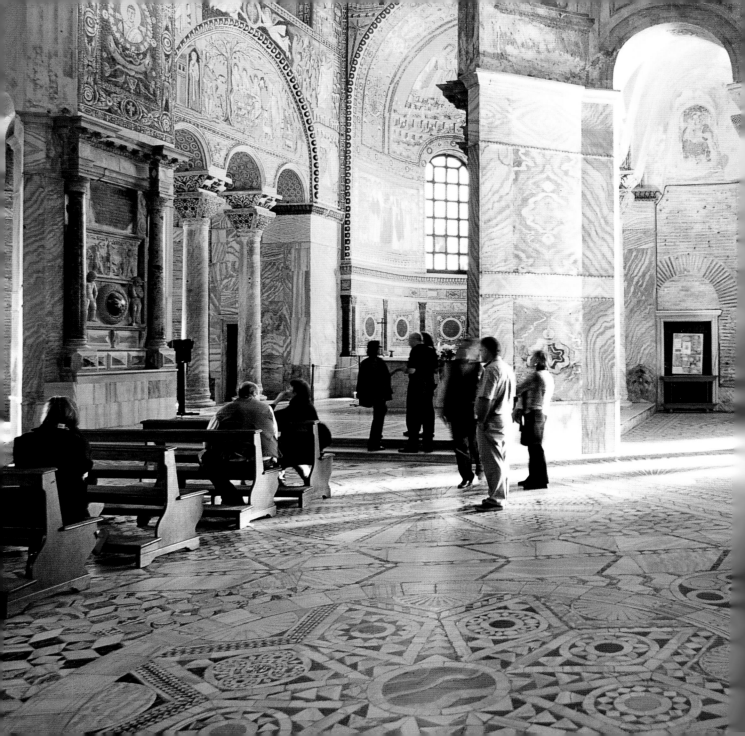

In the Ravenna Apennines, lost in the valley of the Senio River, stands the Italian capital of herbs. Since 1938 the village of Casola Valsenio has been home to an herb garden called the Giardino delle Erbe Augusto Rinaldi Ceroni. It is one of the largest herbalist centers in Europe and produces an impressive number of different types of herb species: about 400, more than 200 of which are grown annually. Since 1974 the garden has been a museum for medicinal, cosmetic, and gastronomic herbs and occupies more than eight acres of land. It produces fourteen different types of lavender, and it is here that the so-called "Lavender Road" begins, a breathtaking road that joins Casola to Fontanelice. Every Friday in July and August an herb market is held at Casola, and the local restaurants organize the Piatto Verde (Green Dish), a gastronomic review of aromatic herbs.

left
Interior of the Basilica di San Vitale.

below
The semicircular vaulted apse of Sant'Apollinare in Classe.

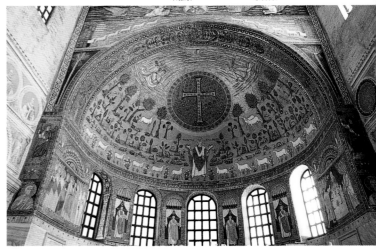

SAN MARINO

THE OLDEST REPUBLIC

A COUPLE OF MILES INLAND FROM THE ADRIATIC COAST, between the valleys of the Marecchia and Conca rivers, stands the distant shape of a fortified castle overlooking the chalk-white cliffs of Monte Titano. The edifice is in reality a combination of four different monuments: the second-century towers of the Guaita, the Rocca (fortress) restored in the sixteenth century, the Cesta, home to a museum of antique weapons, and the

The illuminated fortress at night.

facing page
A detail of the facade of Palazzo Pubblico.

Montale, once used as a prison. Behind them rises the village of San Marino, surrounded by its medieval fortifications. According to a tenth-century manuscript, the birth of the village dates to the fourth century and is credited to one, Marino, who worked on the restoration of the walls of Rimini. He was persecuted for his Christian faith and fled to the cliffs of Monte Titano, where he founded a religious community.

San Marino is the smallest and oldest republic in the world. It is also politically and commercially one of the wealthiest and most efficiently run. It is, however, a strange republic where the common law has remained, for the most part, unchanged for eight hundred years. Society is governed by a council of sixty resident members, chosen among the nobles from the upper middle-class, while the farmers elect the Captains Regents. The administration of justice is entrusted to foreign lawyers, elected for a term of three years. The first form of independent government in San Marino goes back to at least the year AD 1000, when the power of the community passed from the feudal abbot to the Arengo, the assembly of heads of families that met to decide the most important issues of public life. In the fifteenth century governmental processes were entrusted to the Grand Council, and since then San Marino has enjoyed absolute independence. As battles raged between her powerful neighbors, San Marino has watched impassively from the height of Mount Titano. The city held onto its freedom in a difficult balance between the Papal States and the armies that besieged it, perhaps due to its small size and lack of valuable resources that might have attracted powerful neighboring duchies. The inhabitants themselves had no ambitions to dominate. In 1797 they refused Napoleon's offer to extend the territory and, as a gift, they were promised one thousand hundredweights of grain and four cannons (the first arrived, the second never did). Nevertheless, this hearty and picturesque town draws the curiosity of visitors for its thousand-year history of independence and its natural and artistic attractions.

San Marino's low taxes make it a popular shopping destination. After an obligatory and gratifying tour, take time to pause at the innumerable bazaars and specialized shops. Here attention should be paid to useful articles (taking advantage of their lower cost), such as sunglasses and clothing, or the local craftsmanship in wrought iron and ceramics. Leave the car at Borgo Maggiore and use the funicular, which makes trips to the center of town. San Marino is best experienced in the fall, not during the summer when tourism is at its peak.

The fashion for sea
bathing was born at
Rimini when the
town was still part of
the Papal States.
The first bathing
establishment dates
to more than 150
years ago. Since
then the
phenomenon has
spread along the
Adriatic coast to
such an extent that
it is the longest
beach in Europe,
with bathing
establishments from
the Po Delta to
beyond Cattolica, on
the first rocks of
Gabicce. Behind is
an incredible
complex of hotels,
restaurants, and
public places, which
are open day and
night and full of
young people who
come from cities far
away. This is due to
the strip of fine,
golden sand, the
innate friendliness of
the locals, and the
professionalism of
their hotel industry,
which has set a
precedent
throughout Italy.

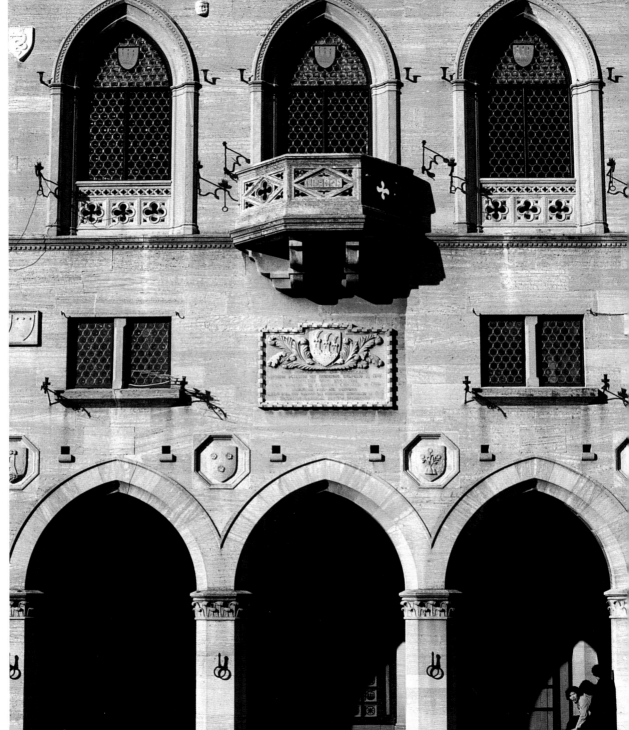

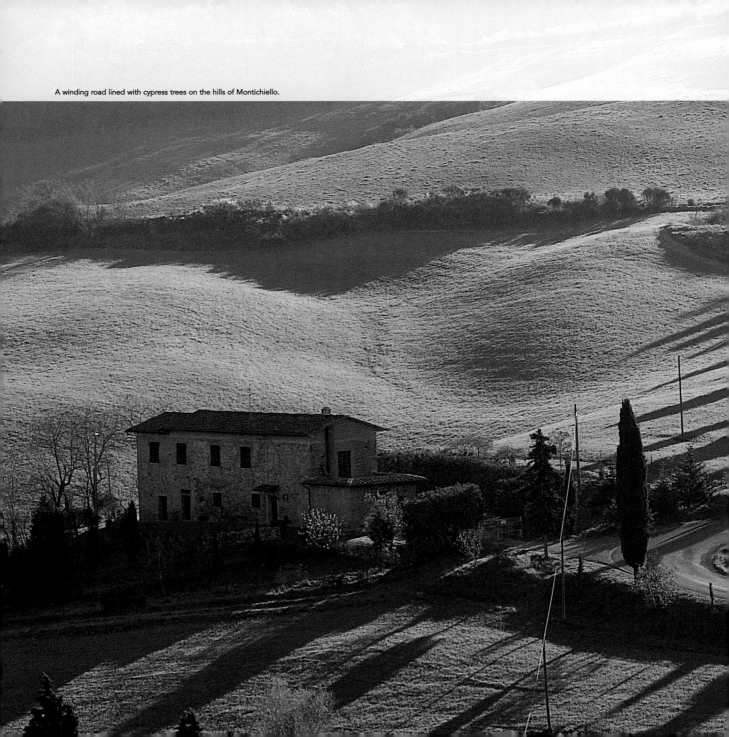

A winding road lined with cypress trees on the hills of Montichiello.

AREZZO
ANTIQUE COLLECTORS' TREASURES

ALTHOUGH THE SMALL TOWN OF AREZZO HAS GROWN INDUSTRIALLY OVER THE YEARS, it remains among the Italian cities possessing the highest quality of life. Hundreds of goldsmiths and other artisans have isolated the city in an industrial belt that has contributed to its expanding commercial center. Praised in Roman times by the architect Vitruvius and the philosopher Cicero, the so-called "Paese Beato" (blessed town) is surrounded by its most precious assets. The first of these is the medieval Piazza Grande, the center of social life. Arezzo's most widely known monument, the Basilica di San Francesco, contains scenes from Piero della Francesca's *Legend of the True Cross* (ca. 1452–66), one of the most important fresco cycles of the fifteenth century. The church of San Domenico holds Cimabue's painted crucifix, and the church of Santa Maria della Pieve is a quintessential expression of Romanesque Tuscan architecture, most evident in its beautifully decorated facade. Don't miss the Medici Fortress, the Palazzo del Comune, and the Casa di Giorgio Vasari (Giorgio Vasari House), the sixteenth-century artist and art historian's private home. The Monastery of San Bernardo is now home to an archaeological museum chronicling the history of Arezzo from its Etruscan origins to the present, and it displays jewelry and other artifacts found in the many necropolises nearby. The museum boasts the richest collection in the world of coralline vases dating from the first century BC to the first century AD. These ceramic vessels are characterized by a red varnish upon which scenes have been etched, in imitation of beaten copper.

The antiques market on Piazza Grande.

facing page
Palazzo dei Priori on Piazza della Libertà.

To wander through Arezzo is to become intoxicated by an otherworldly atmosphere. Michelangelo attributed this to the air: "If I have anything good in my mind it has come from being born in the subtlety of the air of Arezzo." The town's streets are paved with great gray slabs of uneven stone, and when they are wet with rain they resemble a turbulent dark sea. One has to keep one's eyes on the ground, even if there are more attractive things to look at, such as shops and restaurants, or the magnificent palazzos. The best example of this sense of vertigo can be found on Piazza Grande, where the buildings bordering it are a thrilling mixture of different styles. It is here in the center of the city that an antiques fair takes place on the first Sunday of every month. It began in 1968 and is now one of the most successful fairs of its kind, attracting nearly one thousand exhibitors from all over Italy. On these days, all routine activity stops in order to make way for the planks and platforms upon which stalls are set up, overflowing with objects geared toward every taste and style.

The Giostra del Saraceno (Joust of the Saracen) is Arezzo's lively reenactment of medieval jousting. The event dates back to about 1200 and has been held in Arezzo twice a year since 1931. The tournament relives the struggle between the Crusaders and the Saracens and is held on Piazza Grande, where a historical procession of 250 costumed revelers and *sbandieratori* (flag wavers) commence the festivities. Some of the most skilled local jousters compete with each other to affirm the triumph of good over evil. During the contest, horsemen from the four districts of the city (Porta Crucifera, Porta del Foro, Porta Sant'Andrea, and Porta Santo Spirito) attempt to strike a figure armed with a shield and a spiked metal ball on a chain. The figure represents the Saracen Buratto, king of the Indias.

Arezzo is an important center for the shoe and clothing industries and for craftsmen working in gold. At the beginning of the twentieth century a gold factory was established where precious metal was fashioned into fine jewelry. The working of gold continues today and has expanded to include thousands of goldsmith workshops. Book a room outside of the city, for example, in Bagnoro, where the historic residence Val di Colle is located. Various fourteenth-century buildings scattered throughout the countryside are open to the public. Stop for a bite at the nearby historic Buca di San Francesco, a restaurant with lovely frescoed rooms. Amid a rolling Tuscan landscape enjoy a meal in Campriano at La Capannaccia, a restaurant serving hearty regional food.

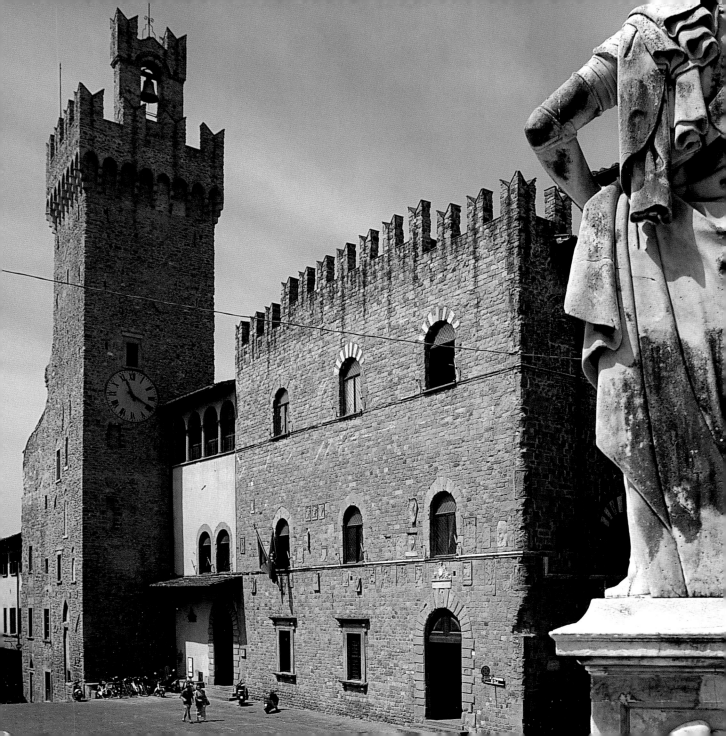

CARRARA

MICHELANGELO'S MARBLE

THE BRIEF CHAIN OF THE APUAN ALPS, A REGIONAL PARK SINCE 1992, is geologically different from the Apennine spine of which it forms a part. Running parallel to the Tyrrhenian coastline for about thirty-seven miles, with sharp limestone peaks rising 7,000 feet above a series of alluvial cone deposits, the Apuan Alps are known throughout the world for their fine high-quality marble, quarried since Roman times. The unceasing work has remodeled the landscape indelibly, even though sections of the quarries have been abandoned for a long time.

Carrara lies in the foothills of these mountains and is separated from the sea by the pine forests of the Versilia. It is the most important center in the world for the production and shipment of certain types of marble: Bardiglio (blue- and white-streaked), black, veined, Cipollino (green and white), Paonazzo (peacock blue), peach blossom, arabesque, and, above all, the brilliant snow-white marble, the most valuable marble in the world. Donatello, Brunelleschi, Michelangelo, and Canova are just a handful of the Renaissance artists who used white marble to create some of the finest sculpture and architecture in the history of art. Michelangelo Buonarroti (1475–1564) came to Carrara for the first time in 1505 looking for marble with which he could create the tomb of Pope Julius II. He lived near the quarries for a year, personally choosing the best blocks before having them cut to measure.

Although the quality of the marble had been known since Roman times, development on an industrial level can be claimed by the Duchy of the Medici, when Carrara marble was used to build many of the palazzos in Florence. At Tagliata, Fossacava, Mandria, and other sites near Carrara, important signs of excavations from the second century BC are still apparent. Imperial Rome bears the marks of marble's popularity in the facades and ornamentation of buildings, and in statues, obelisks, bas-reliefs, and fountains. Thousands of slaves were employed to quarry marble with hammers and chisels. Specialized machinery lifted and moved blocks of marble, and then, with a *lizza* (a wooden ramp), they were brought to loading areas to be transported. Today the ramp method is no longer employed; however, in the summer months, there is a historical reenactment of this fascinating process. The Civic Museum of Marble tells the story of this valuable form of limestone, tracing its history from the Romans to contemporary sculpture, and includes an exhibition displaying cutting tools and machinery and documenting quarrying techniques. It also holds a rich collection of Apuan marble and samples of Italian and foreign marbles, stones, and granites.

An artist at work in the Carlo Nicoli Sculpture Studio.

facing page
A marble quarry.

Campo Cecina is the best place to view many of the Apuan Alps' three hundred quarries, both active and abandoned. Take in the beautiful panorama along the walking and cycling trails following the railway line that was built in 1890 (it was put out of commission in 1962). The railway was once used to transport marble from the quarries to Marina di Carrara, where it embarked on ships. From Carrara, and following the signs for Ponti di Vara, the road climbs and meanders to Tarnone, continuing to Colonnata, where it is worth stopping to sample the local specialty—flavorful bacon prepared and aged in shells of marble—that has made the village famous.

For more than five centuries, a special kind of aged bacon has been produced in Colonnata, a village near Carrara. This unique delicacy undergoes a complex aging process before it is served. Marble tubs are first filled with layers of lard alternating with layers of sea salt, aromatic herbs, oil, and spices. The fat is then coated with a dense brine and aged for at least six months, after which it can be purchased at Giannarelli's grocery store or eaten as an appetizer at Venanzio's restaurant. The fare at the restaurant Ninan is possibly the best in Carrara. The Hotel Carrara in Avenza is the perfect place to stay near the coast. Other recommended hotels include the Mediterraneo in Marina di Carrara and farther south in Marina di Massa, the Hotel Cavalieri del Mare, a lovely eighteenth-century villa surrounded by gardens with access to a nearby beach.

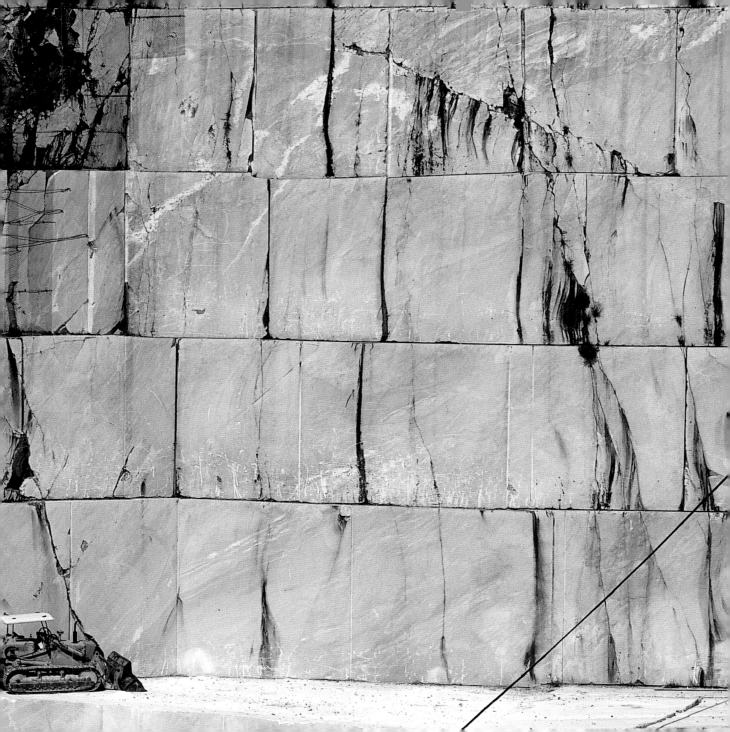

CORTONA

THE TREASURES OF AN ACADEMY

FROM A PLACID HILLTOP, CORTONA OVERLOOKS THE VALDICHIANA PLAIN and the sparkling Lake Trasimeno, near where the epic battle between the armies of Hannibal and the Romans occurred. Its name comes from the Greek *corythus*, meaning "helmut." Set in a landscape of olive trees, vineyards, and graceful cypresses, the city's picturesque locale makes Cortona a quintessential Tuscan hilltop town. Early settlers were the Etruscans, who left great burial mounds, called "melons," scattered over the plain. Today these tombs are mainly hidden by bushes and bramble at the edges of the fields, plundered of their goods and precious artifacts. Most of these items are now in regional museums or in private collections. In the eighteenth century the city founded an academy with an archival library, whose purpose would be to provide a research and conservation center for Cortona's treasures. The Etruscan Academy in the Palazzo Casali preserves a number of objects found during excavations and donated by collectors. Among them are bronzes, vases, gold, jewelry, and a bronze lamp that came from a fifth-century BC tomb and was bought for the Academy by its members.

Around the hill stands the Hermitage delle Celle, the Abbey of Farneta, and a number of medieval churches, constructed from warm-colored volcanic rock. The *Ruga piana,* or Via Nazionale, is the main road and the only one on level ground. The church of Santa Maria delle Grazie is a typical Tuscan structure, massive and square, as designed by the architect Francesco di Giorgio Martini (ca. 1439–1501). The Via Nazionale leads to the Piazza della Repubblica, the heart of Cortona, where it is joined by the roads that enter the gateways of the city's fortifications. Before Cortona was besieged in 1529 by the troops of Philibert of Orange in the service of Charles V, the piazza was much larger than it is today, with a beautiful fountain at its center. In order to prevent the sacking of the city, payment of a large sum of money was agreed upon. The town's residents were forced to remove furnishings and relics from the churches and demolish the fountain in order to sell part of the square to private buyers. The most beautiful buildings, however, were spared, including the Palazzo del Capitano del Popolo and the Palazzo Comunale, whose elegant staircase invites visitors to climb and enjoy the view of the square. Farther on is the nineteenth-century Piazza Signorelli bordered by shops and the elegant Loggia del Grano.

The Palazzo Comunale.

facing page
The red rooftops of Cortona from above.

There is a reason why the villages of the Valdichiana are all perched on the hills that surround it and not along the river: the bottom of the valley was once an unhealthy marsh. Both the Etruscans and the Romans contributed to making the plain fertile again, but it was Leonardo da Vinci, commissioned in 1502 by Cesare Borgia, who drew up an organic plan of canals and drains to contain the waters of the Chiana and Arno rivers. The complete salvation of the area was accomplished only in the first decades of the nineteenth century, and since then herds of young *chianine* (a breed of cattle) graze in the valley. Their meat is of good quality, ideal for the excellent *Bistecca alla Fiorentina*, Florentine-style steak served on the bone.

Several historical landmarks in Cortona have been converted into hotels, such as the fourteenth-century Villa Marsili, where one can take in views extending from Lake Trasimeno to the hills of the Val di Chiana and as far away as Monte Amiata. The villa was transformed into a noble palazzo in the 1700s. Its rooms and great hall are elegantly frescoed and fitted out with antiques and hand-painted ceramic plates. Breakfast is served under a pergola during the summer months. The Villa San Michele was a Renaissance palazzo and the seat of the Etruscan Academy in 1700. The l'Oasi was a thirteenth-century monastery that was turned into a hotel in 1973. Expositions take place regularly in Cortona; for instance, the National Market Exhibition of Antique Furniture is held in Palazzo Vagnotti every September and the National Copperwork Fair takes place from August to April.

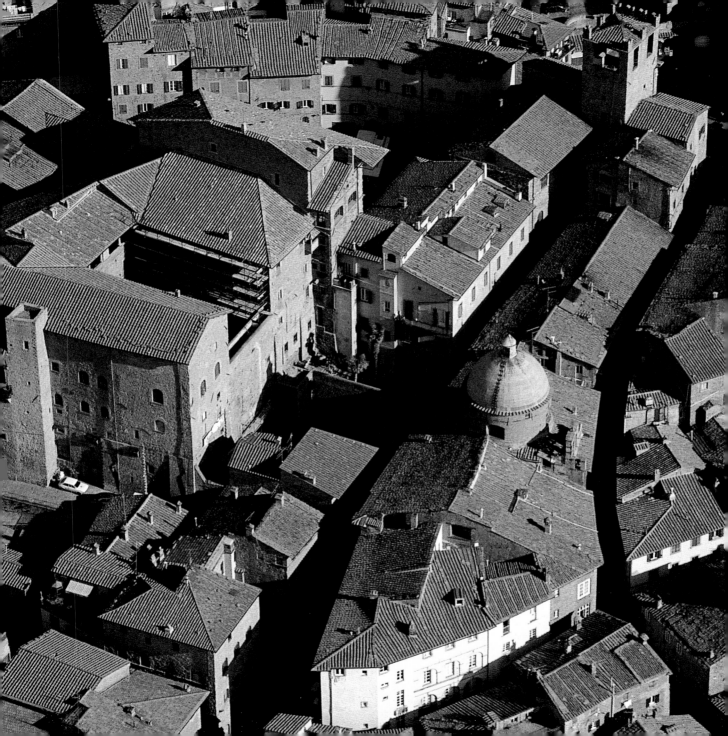

GROSSETO
FORESTS OF SHADY PINE

THE LAND SITUATED BETWEEN THE PROMONTORIES OF PIOMBINO AND THE ARGENTARIO, stretching as far as the Metallifere Hills, is called the Maremma Grossetana. Once a malaria marsh, the area has been described by poets and writers as "bitter and cursed," a place where charcoal was gathered, herds of buffalo roamed, and brigands hid from the authorities. However, where death and misery once reigned, today there are golden fields, olive groves, green pastures, stands of holm oaks, and forests of shady pine trees populated by wild boar. The Maremma is home to the regional park of the Uccellina, established in 1975, including twelve miles of coastline from the woods of Tombolo di Principina a Mare as far as Talamone. The park includes the marshes of Trappola, the last stretch of the Ombrone River, and the Uccellina Hills. Farming and horse breeding are popular here and the land has become a primary habitat for porcupines, boar, turtles, martins, and migratory birds.

The capital, Grosseto, lies on the Ombrone Plain, several miles from the coast. The city is relatively new in an ancient land of Etruscan culture and rose in stature during the High Middle Ages near Roselle, an Etruscan stronghold. It was conquered by the Romans, destroyed by the Saracens in AD 935, and gradually abandoned. But this small village on the road from Rome to Pisa quickly developed into a fortified city and a center for cattle breeding and salt production. Grosseto became even more important in 1138, when the bishopric was transferred here from Roselle. Under the governance of the Medici, the reclamation of the marshes began. Between 1574 and 1783 the Medici family had a moated fortress built and ramparts in the shape of a perfect hexagon encircling the city. By 1855 the defensive battlements were no longer necessary and Leopold II, Grand Duke of Tuscany from 1824 to 1859, transformed them into public offices, exhibition halls, study centers, and tranquil gardens.

The heart of the city is the Piazza Dante, where the Palazzo della Provincia and the second-century Duomo can be visited. The Duomo was originally in Sienese style but was restructured in the centuries that followed. The wide Corso Carducci is flanked by elegant storefronts and bazaars overflowing with souvenirs. Nearby is the Romanesque church of San Pietro, the oldest in the city, and the church of San Francesco, with its convent and cloister containing the Pozzo della Bufala, a sixteenth-century well.

Inside an antique shop on Via Giulio Cesare.

facing page
The Palazzo della Provincia and the statue of Grand Duke Leopold II.

They wear cotton twill trousers, velvet jackets, chaps, boots, felt hats, and black cloaks, and carry a *mazzarella*, a long, pointed cherry-wood stick used to prod horses. The *butteri* (cowboys) of the Maremma have worn this uniform since time immemorial. Colonel William Cody, the classic American hero of the Wild West, more commonly known as Buffalo Bill, traveled here in 1905 with his Wild West Show and measured himself against the *butteri* in the buffalo and pony corral. In the end, the *butteri* proved they were much more experienced than the American actors.

The Grand Hotel Bastiani is located in an elegant building dating to the beginning of the twentieth century and is an ideal place in order to visit the heart of the Maremma. In the Maremma, the villagers breathe the air of the ancient Etruscans, whose testimony is particularly rich in the valley of the Fiora River. At Poggio Buco, Pitigliano, Sorano, and Sovana, tour the necropolises with their monumental tombs, roads, and grottos carved out of tufaceous rock. The beautiful square in the delightful medieval village of Sovana is the perfect place to stop for a meal, in particular at the Taverna Etrusca, once the thirteenth-century servants' quarters belonging to the neighboring Loggia del Capitano. Visit the Cantina Cooperativa in Pitigliano where the delicate yet earthy-tasting Bianco di Pitigliano wine can be purchased.

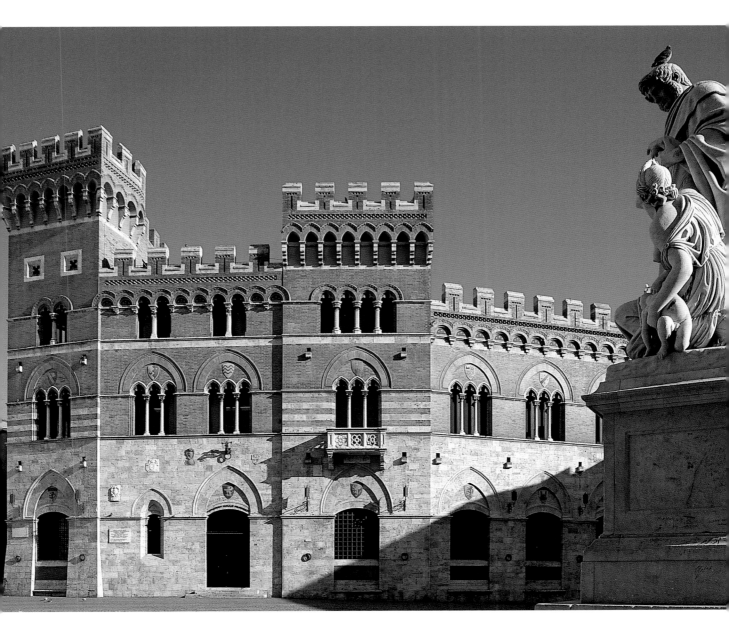

ISOLA D'ELBA
NAPOLEON'S EXILE

THE ISLAND OF ELBA IS SIX MILES FROM ITALY'S TUSCAN COAST and can be reached by ferryboat in one hour from Piombino. Even from a distance one can see the wild beauty of the rugged mountainous terrain as it steeply rises from the coast. On second glance, one sees that welcoming sandy coves also trace the sea's edge. The rough character of the island seems to be confirmed in Portoferraio, Elba's capital, by the walls of the

The commemoration of the Austerlitz Battalion.

facing page
Portoferraio at sunset.

Volterraio fortress. The two forts, Falcone and Della Stella (the latter so called because of its five-pointed shape), overlook the town. The imposing walls of the Torre della Linguella, built by Duke Cosimo de' Medici I in 1548, enclose the bay in a horseshoe. The Spanish responded in 1603 by raising the mighty fortress of San Giacomo at Porto Azzurro, which dominates one of the most beautiful coves on Elba.

Elba, however, is forbidding only in appearance. It is an island used to giving a great deal. The people are friendly, the land produces generously—notable products include the Aleatico and Moscato wines—the sea is full of grouper and amberjack, and the rocks are rich in minerals, particularly iron, which has been extracted for 3,000 years from the mines of Rio Albano, Vigneria, Rio Terranera, and Calamita. There is evidence that the first people to take advantage of this resource were the Etruscans followed by the Greeks, who would roughly smelt the metal before transporting it back home. In the fourth century BC the Romans created smelting furnaces at Populonia on the point of the Baratti Gulf, north of Piombino. On the island of Ilva (Elba's Latin name), they founded cities such as Fabricio (Portoferraio) and Caput Liberum (Capoliveri) and built magnificent villas in some of the island's most scenic places, such as Le Grotte and Cava.

Portoferraio has played host to many illustrious guests. Napoleon Bonaparte was exiled to Elba in May of 1814 following his abdication at Fontainebleau. He set up a small court in the Villa dei Mulini, which was constructed from two windmills and is now a museum that holds Napoleonic furnishings, paintings, and other artifacts. The Villa dei Mulini overlooks the village and stands beside the Falcone Fort. There is a beautiful Italian garden overhanging the rocks and the sea. Napoleon's summer residence was the Villa San Martino, four miles from the town on the road to Marciana. The modest building was bought in 1851 by the Russian Prince Demidoff, who built a house of his own here, where it is now possible to admire nineteenth-century paintings in the Canova Gallery.

The Tuscan archipelago lies between the coasts of Livorno and Corsica, and in addition to Elba, consists of the following islands: Gorgona, Capraia, Pianosa, Giglio, Montecristo, Giannutri, and other tiny ones referred to because of their size as *formiche* (ants), such as Grosseto, Capraia, Palmaiola, and Zanca. The seabed here is among the most beautiful in the Mediterranean and has been protected since 1989. The most populated island after Elba is Giglio, dominated by the village of Giglio Castello and enclosed within its Pisan walls. The most untouched of the islands is Montecristo, where the famous count imagined by Alexandre Dumas in his book *The Count of Monte Cristo* was said to have hidden a fabulous treasure. Capraia has maintained its character, aided by the fact that it was once the site of an isolated penal colony. A boat trip around the island allows one to admire its gray and pink rock cliffs hanging over the sea.

The mineral deposits found on Elba are thousands of years old. Today these mostly open cast mines are not much in use, but their importance for museums and collectors of crystals and minerals has never diminished. Some of the minerals found here include hematite, pyrite, native lead sulphite, cerussite, anglesite, siderite, fluorspar, quartz, calcite, tourmaline, beryl, topaz, zircon, azurite, and malachite, and the list goes on. Less is known, however, about the abundance of fruit on the island, such as grapes, olives, and chestnuts. Wine has been a local product here for more than 2,000 years. Several Roman shipwrecks laden with wine amphorae have been discovered along the seabed encircling the island. Wines from this region made from overripe grapes are called *passiti* and include Alelatico, Ansonica, and Moscato. Don't miss out on a *limoncino* or *arancino*, refreshing liqueurs made from citrus fruit.

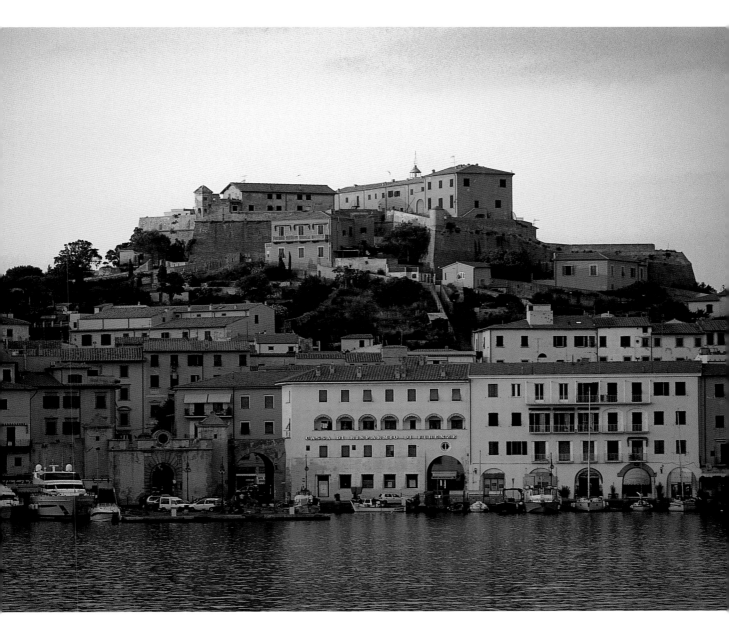

L U C C A

A HIDDEN GEM WITHIN WALLS

EVER SINCE THEY WERE CONSTRUCTED BETWEEN THE SIXTEENTH AND SEVENTEENTH CENTURIES, the massive three-mile-long ramparts encircling the city of Lucca have been witness to many bloody battles. The original defensive function of these fortifications was to protect the city from the flooding of the Serchio River as well as from hostile invasions. In the nineteenth century, Marie Louise of Bourbon transformed the walls into a public park with incomparable walkways, while below them under a series of arcades, concerts, exhibitions, and cultural gatherings took place.

The historic center of Lucca is protected by the Superintendent of Environmental, Architectural, and Artistic Patrimony and can be little altered. Yet, in this seemingly immutable context, the inhabitants of Lucca are passionately active, and have been since they transformed a village in the middle of the marshes ("lu" in Celtic means a marshy place) into the most important center for the manufacture of silk in Europe. During a visit in 1581 the French writer Michel Eyquem de Montaigne noted, "One cannot enjoy the company of the people of Lucca because they are all, including the children, always busy with their own affairs and in the making of things to market." And so it is to this day in Lucca, where the habit of the citizens is to begin doing one thing while another is still being finished. All activities, however, are carried out with great energy and common sense.

The architecture within the city walls is in tune with this balanced philosophy of life. No one structure stands out from the whole or seems jarringly out of place. The different styles blend together with incredible naturalness. The Piazza del Anfiteatro is where the Roman amphitheater once stood, its shape recognizable in the medieval houses that surround the Piazza del Mercato, forming the oval of the theater. In Lucca, objects of artistic interest are often hidden and one stumbles upon them by chance. In order to appreciate the beauty of the palazzos one should look upward. The towers were once the pride of all the Tuscan communities; they do not stand out insolently, but seem to appear suddenly while turning a corner. Visitors from all over Europe come to see their beauty. Some decide to stay forever and inhabit the hills behind the city, enchanted by Lucca's hospitable atmosphere.

Playing soccer outside the city walls.

facing page
The church of San Michele in Forio.

Long-standing pharmacies in Lucca, such as the Massagli, produce *china Massagli*, a liqueur prepared since 1885 from a secret formula. One of the oldest pharmacies in the world, Angolo di Santa Maria Novella, is said to have been founded by the Dominican fathers in the thirteenth century, even though the official date of establishment is recorded as 1612. The pharmacy is defined as an "Officina Profumo-Farmaceutica," or a shop that manufactures perfumes and medicines. To this day, perfumes are prepared using formulas studied in the 1500s for Catherine de' Medici, including the *l'acqua della regina* (queen's water), later called "eau de cologne," that was brought to Cologne in 1715, and magic potions such as the vinegar of the Seven Thieves, which dates back to 1600 and was sniffed after fainting. Other remedies include rose water, which is considered beneficial to the eyes, white hand powder, soaps, liqueurs (such as alkermes, medicinal liqueurs, elixir of Edinburgh), oils, essences, and floral mixtures.

There is a store in Lucca to satisfy every desire, and the narrow Via Fillungo is Lucca's shopping hub. Shops of all kinds display their wares in elegant palazzos. The old Caffè Caselli (now called Di Simo) is where the Italian painter Pino Pascoli and the composers Giacomo Puccini and Pietro Mascagni used to stop for coffee. The restaurant Buca di Sant'Antonio is located in a historic building and prepares traditional dishes. To experience the aristocratic atmosphere of the city visit the garden and frescoed rooms of the Antico Caffè delle Mura. A walk along the city walls and a visit to the Duomo are obligatory. The elegant Romanesque facade of the Duomo is decorated with thousands of small marble columns. On display inside is Jacopo della Quercia's 1408 tomb of Ilaria del Carretto, the second wife of Paolo Guinigi, a local merchant tyrant.

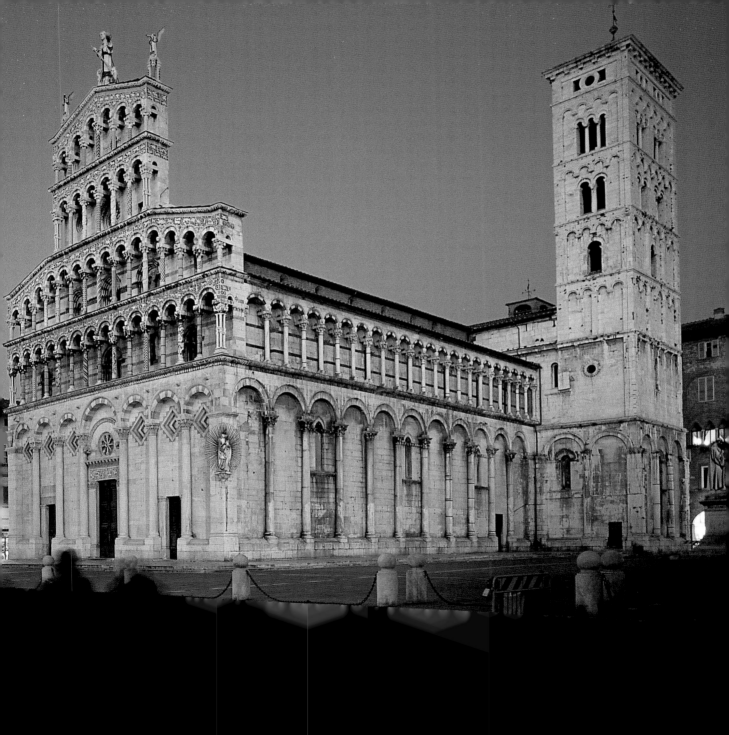

The grandiose seventeenth-century villas outside of Lucca are well worth a visit. These include Villa Torrigiani in Camigliano, Villa Bernardini in Coselli, Villa Malpigli in Loppeglia, Villa Olivia-Buonvisi in San Pancrazio, Villa Antelminelli in San Colombano, and many others. Some of the villas have been transformed into elegant hotels, such as Villa Orlando at Segromigno in Monte. This eighteenth-century building once belonged to Caroline Murat Bonaparte, Queen of Naples in 1808. Villa Mansi in Monsagrati was once a patrician farm and is where Giacomo Puccini composed his opera *Tosca* in August of 1898.

above
The famous Caffè Di Simo and, *below,* Villa Torrigiani in Camigliano.

right
The ancient oval shape of the Roman amphitheater now serves as the Piazza dei Mercanti.

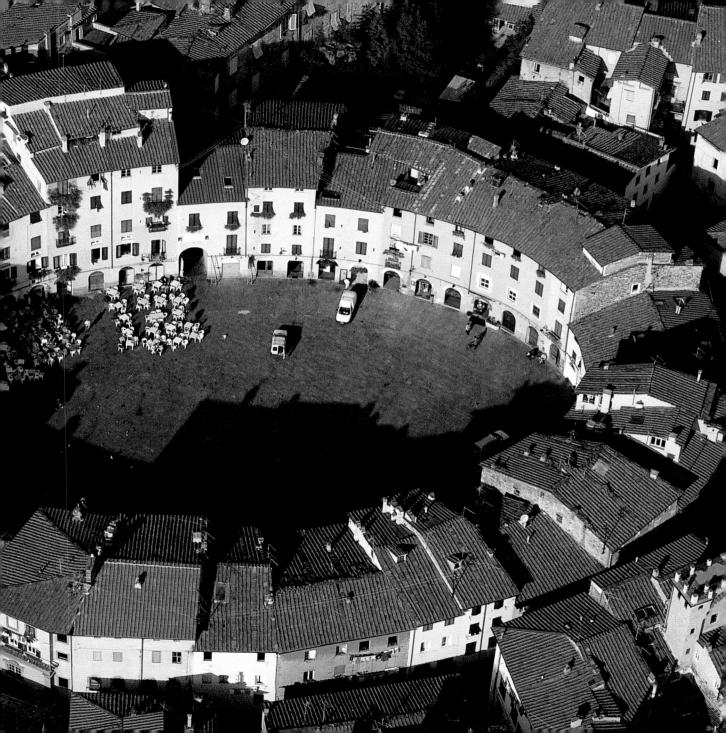

MONTEPULCIANO

STEEP LITTLE STREETS ON A RIDGE

THE TOWN OF MONTEPULCIANO SITS PERCHED ON A CLIFF OF TUFACEOUS ROCK and is dominated by a citadel that stands guard over its old medieval center. Viewed from the lush green hills of the Valdichiana, Montepulciano appears to be an impregnable stronghold, but the *Mons Politianus* was repeatedly besieged by the invading armies of Siena and Florence during the Middle Ages. Today the city is a choice exhibition of

A typical wine cellar.

facing page
Palazzo Nobili Tarugi
on Piazza Grande.

sixteenth-century Tuscan architecture, more Florentine than Florence itself. Akin to the Palazzo Vecchio in Florence, the Piazza Grande is the heart of Montepulciano and is home to several historical landmarks, including the Palazzo Comunale, built between the fourteenth and fifteenth centuries with a facade designed by the sculptor and architect Michelozzo Michelozzi (1396–1472), and the Pozzo dei Grifi e dei Leoni (Well of the Griffins and Lions). The urban plan is laid out according to the contour of the hill, with steep winding streets alongside imposing palazzos. Light columns of porous rock, graceful arches, ornate windows, and elegant facades imbue the city with a gracefulness owed to the designs of Antonio da Sangallo the Elder (ca. 1455–1534), a Florentine artist, architect, military engineer, and politician who was responsible for the resurgence of the city in the sixteenth century. Outside Montepulciano's walls, the church of San Biagio (dating to 1515) is considered the architect's masterpiece. The church is the centerpiece of a large piazza and is admired for its cupola crowned by a Greek cross, its bell tower, and the impressive pilasters executed in Travertine marble that give the church its solemnity. When the nobles of Montepulciano first saw Sangallo's masterpiece, they vied for the architect's talents in order to construct palazzos of their own. As a result, the Contucci del Monte and Nobili Tarugi palazzos were built, two palaces bordering the Piazza Grande. Pope Julius III sent the architect Giacomo da Vignola (1507–73) to beautify the village and assist Sangallo. He designed the palazzos Cagnoni, Tarugi, and Avignonesi. Michelozzo also executed the design for the exquisite facade of the Renaissance church of Sant'Agostino and the Duomo's beautiful funerary monument to Bartolomeo Aragazzi, scholar, scientist, and

Brunello is a legendary wine aged in oak and chestnut barrels in the cellars of Tuscany's Montalcino, a sun-drenched hillside town not far from Siena. Brunello is highly regarded and rather pricey, due to the unique quality of the Sangiovese grapes from which it is made. Great care is taken in producing and aging Brunello, which takes almost four years (five for the reserve). The resulting wine is an intense ruby-red color due to the late maturation of the grapes. To better appreciate Brunello's rich aroma and fruity taste, bottles should be uncorked a few hours before drinking and enjoyed at room temperature.

papal secretary to Pope Martin V. Although the monument was dismembered and scattered in 1600, pieces of it were rescued in 1835 and mounted in different areas of the church. Reliefs can be found on the pilasters while the statue of Aragazzi and the life-size allegory of Justice reside over the main altar.

Il Borghetto is the place to stay in the heart of Montepulciano's historic center. The hotel is located in a sixteenth-century palazzo and is furnished with antique beds, sofas, tables, and chairs. Just outside the town in Valiano is Borgo Tre Rose, a medieval ward that was converted into a hotel. For typical Tuscan cuisine, dine at La Grotta in San Biagio, where the famous *pappa col pomodoro* (tomato soup), spelt soup, and other delicacies are served. Local wines, such as Montepulciano and Montalcino, can be tasted at the Enoteca Oinochoe in the historic center. Frantoio Sociale on Via di Martiena sells cold-pressed extra-virgin olive oil. On the road to Pienza, stop at the store of the cheesemakers Cugusi for a sampling of sharp pecorino cheese.

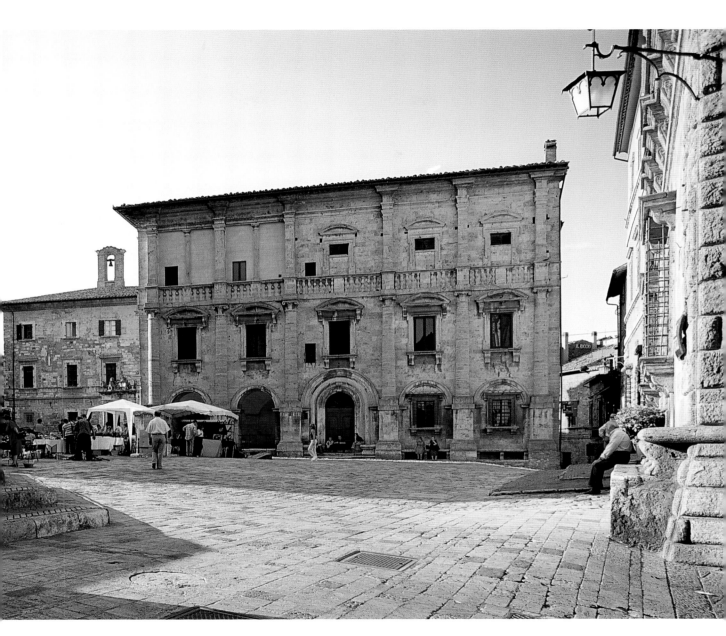

PIENZA
A POPE'S IDEAL CITY

THE ARCHITECT BERNARDO ROSSELLINO, A PROTÉGÉ OF THE RENAISSANCE ARCHITECT and theorist Leon Battista Alberti (1404–72), was commissioned by Enea Silvio Piccolomini (also known as Pope Pius II) to build the city of Pienza. Rossellino almost accomplished the task in three years and three months time (from 1459 to 1462). The Piccolominis were a wealthy Sienese family of scholars, cardinals, merchants, and soldiers of fortune. Enea Silvio was born in a castle in the rural village of Corsignano (Pienza's original name). When he came to power, and in order to accommodate his court in the style that was his due, he transformed the village of his birth. He ordered all the buildings torn down and rebuilt, with the exclusion of the church of San Francesco. The skeleton of the medieval village was maintained, centralized along the main road (the Via Rossellino) from Porta al Ciglio to Porta al Prato, and joined at right angles by a series of narrow lateral streets. Although the town was never completed—work was halted by the death of the architect in 1464 and that of the Pope who had inspired it—Pienza became a so-called "ideal city," conceived by the humanistic culture of the Renaissance. Pienza was to be a city based on the harmony of forms and spaces, ordered and rational, built to the measure of the individual. At the time, these ideas were thought to be the fulcrum of the earthly world but also connected to the divine, in which the sacred and the profane were equal. It is emblematic of the founding concepts of Pienza to see streets called Via dell'Amore and Via del Bacio (the street of love and of the kiss, respectively).

Pienza is located on a hill in the Val d'Orcia, one of the main inspirations for the classic iconography of the Tuscan landscape. However, entering the village, the outside world seems to vanish, reappearing only as the background beyond the wrought-iron gates that enclose the Italian gardens and framed by the windows of the palazzos—as though it were a painting hanging on a wall. The piazza bearing the name of Pope Pius II is home to the fifteenth-century Palazzo Piccolomini. For reasons of perspective, the square is trapezoid-shaped. It is a soothing place, paved with Tuscan *cotto* (terra-cotta) tiles and surrounded by the most significant buildings of the period. The interior of the fifteenth-century Duomo is Gothic in style while the facade of travertine marble drew inspiration from Alberti's designs. The Palazzo Comunale has a beautiful arcade and crenellated towers. The Palazzo Piccolomini was inspired by Alberti's Palazzo Rucellai in Florence, with a courtyard and a loggia overlooking a hanging garden. It is now the Diocesan Museum, where an extensive collection of paintings, tapestries, sacred objects, and wooden sculpture are on display.

facing page
The cathedral on Piazza Pio II.

below
A glimpse of Pienza's narrow streets.

The Chiostro is a former convent dating to the fifteenth century that has been transformed into a hotel. An alternative place to stay is the all'Olmo in Monticchiello, a lovely seventeenth-century farmhouse that has been renovated and furnished with antiques. Classic Tuscan cuisine can be had at Latte di Luna, a small trattoria in the historic center, or at Taverna di Morando in Monticello. The famous pecorino cheese of Pienza is sold at Agricola San Polo. A selection of some of the best Italian products is available at the Cornucopia del Club delle Fattorie, also in the historic center.

The Romans knew of the therapeutic properties of the waters at Bagno Vignoni, an old village in the Val d'Orcia, nine miles from Pienza. The baths were widely known in the fourteenth century and visited by the likes of Catherine of Siena and Duke Lorenzo the Magnificent, as well as by pilgrims traveling to Rome along the Via Francigena. Pius II had a sumptuous villa built here, where he entertained prelates and politicians (it is now the Hotel Le Terme). The thermal pool at the Posta Marcucci Hotel is open to the public. Its waters are said to ease the pain of respiratory illnesses, inflammations, arthritis, and sciatica.

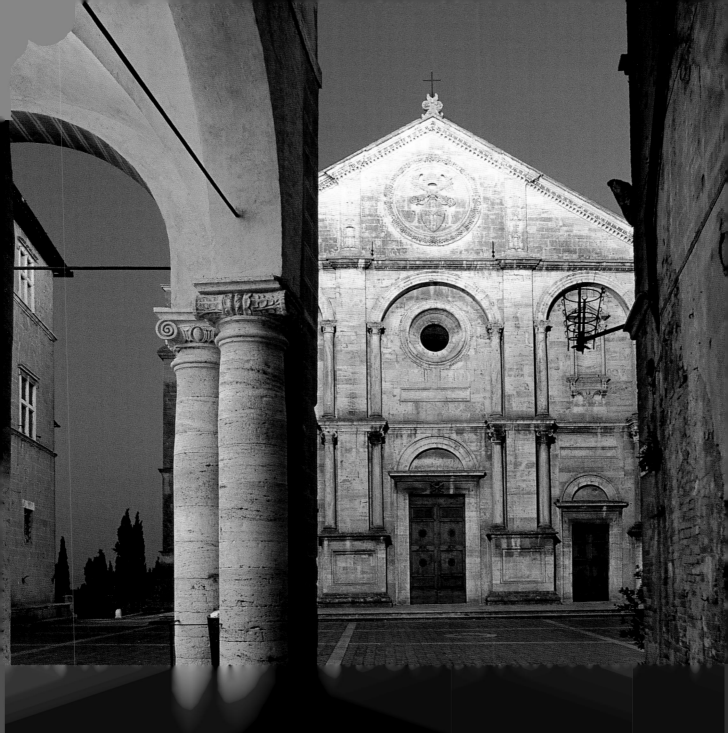

PIETRASANTA
THE RECTANGLES OF GUISCARDO

Pietrasanta was founded in 1255 by Guiscardo Pietrasanta, Lord of Lucca, who gave the town his name and family crest. Built upon the ruins of a Lombard fortress at the summit of the Sala Hill, Pietrasanta commanded too strategic a location to leave uninhabited. The town extends along the Via Francigena where it traces the foothills of the Apuan Alps and nears the maritime port of Motrone. It was Guiscardo's desire to build a city according to scrupulous geometric parameters, and the layout of the town today preserves the original grid plan. The initial blueprint consisted of a great rectangle centralized along the Via Francigena (today Via Mazzini and Via Garibaldi) from which the streets depart. Castro Castracani, governor of Pietrasanta from 1316 to 1329, extended the city walls stretching the urban rectangle as far as the Rocca di Sala (Sala Fortress). The city was bandied about between Lucca, Genoa, Pisa, and Florence, until it passed definitively under the dominion of Florence in 1513.

Inside the marble workshop of the brothers Cervietti.

facing page
Flag tossing on Piazza del Duomo.

Since Roman times, Pietrasanta and its surrounding areas have been a major center for artisans working in marble. Michelangelo, one of the geniuses of the Italian Renaissance, spent three years here working on a project to establish marble quarries in the basins of the Apuan Alps. Famous modern artists such as Henry Moore and Fernando Botero have inspired local craftsmen to reproduce their immortal works, creating copies that are so similar to the originals that even experts cannot distinguish them apart. However, if you plan to commission something, do not expect to hear that it is "ready" when it is finished, but that it is "finished" when the artist considers it ready.

During the summer months, the magnificent Piazza del Duomo comes to life and is transformed into an open-air art gallery where well-known sculptors from around the world display their prized works. Seated at the Michelangelo Bar on the piazza, sipping a refreshing aperitif, one's eye turns to an urban landscape accented by the round figures and geometries of sculptures by Botero and Arnaldo Pomodoro among others. The Museo dei Bozzetti (Museum of Models) was founded in 1984 and its permanent exhibit displays sketches, drawings, and models (in gesso, wood, terracotta, and plaster) by 250 Italian and foreign artists. Exhibitions on photography, painting, and sculpture, and cultural conventions are held in the former sixteenth-century monastery of Saint Augustine.

Crossing the lush plain of Pietrasanta in the direction of the sea, one reaches Forte dei Marmi, a port for marble transported from the Apuan Alps. Forte dei Marmi is also the most elegant resort of the Versilia River, punctuated with villas and frequented by artists and intellectuals. Located in the center of town, the port was built in 1788 by Leopold II, Grand Duke of Tuscany from 1765 to 1790, centuries before iron from the island of Elba was stored here and then brought to the forges along the Versilia River. The area is famous for its coastal beaches on the Tyrrhenian Sea from Forte to Cinquale, where the fine sand and gentle waves invite you to linger. The poet Gabriele d'Annunzio enjoyed riding his horse along the dunes as far out as the Villa Versiliana.

The Villa Versiliana was an agricultural and forestry estate along the Tyrrhenian coast and belonged to the Digerini–Nuti counts. It has been a public park since 1980 and covers more than one hundred acres including the nineteenth-century villa that the poet Gabriele d'Annunzio called, "the most beautiful place in the universe." The park is home to great maritime pines and holm oaks and other species indigenous to the Mediterranean. It is possible to hike, bicycle, or go horseback-riding through the dense network of paths winding through the thick scrub. The proximity of the marble industry has encouraged the development of artisan shops in the region. The craftsmen produce objects ranging from vases and columns to decorative fruits and vegetables of extraordinary realism. Marbles can be purchased at Fratelli Galeotti.

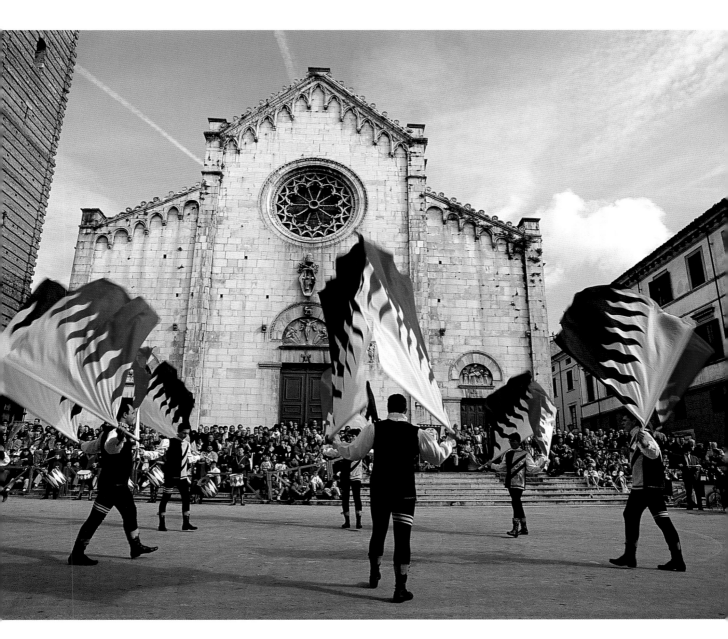

PISA
AN ANCIENT MARITIME REPUBLIC

PISA IS OFTEN CALLED THE WIDOW OF THE SEA, that same sea that once included her among the Four Maritime Republics (Genoa, Venice, Pisa, and Amalfi). The town's port is connected to the Tyrrhenian Sea by the last leg of the Arno River, and, more importantly, the Canale dei Navicelli, built in the sixteenth century by Cosimo de' Medici I (1519–74), Duke of Florence and Grand Duke of Tuscany. The pleasant dock where residents fish the somewhat brackish waters for mullet and young eel (the latter here considered a delicacy) is the perfect place to take in Pisa's coastal charm. Shipyards where yachts and pleasure boats are maintained comprise a large part of Pisa's thriving industry, but it is primarily tourism that propels the city's economy.

The Campo dei Miracoli, a piazza dating back to AD 1000, is the starting point from which to see Pisa's main attractions: the eleventh-century Duomo, the Gothic Baptistery dating to 1153, the thirteenth-century Camposanto (a large, covered cemetary), and, of course, the celebrated Torre Pendente, known throughout the world as the Leaning Tower of Pisa. From its inception—even before it began to lean—the tower was singled out for its bold circular shape and has since come to

The circular interior of the Leaning Tower.

facing page
The Leaning Tower of Pisa and the Duomo on the Campo dei Miracoli.

represent an integral part of the fabric of architectural lore. Although the tower was primarily intended to serve as the Duomo's bell tower, the originality of its structure, the mystery behind its architect, and, above all, its famous tilt, has transformed the Leaning Tower into one of Italy's most symbolic monuments Many visitors undertake the climb of 293 steps to the tower's belfry where a breathtaking view awaits them. The delicate, lacelike arcades of the Campanile reflect those of the Duomo's flat facade, while the Baptistery's cylindrical volumetric force compliments that of the Duomo's grand size. Together these three buildings form a remarkable trio of architectural grace and harmony.

The Leaning Tower of Pisa is nearly 185 feet tall and tilts at an angle of about seventeen degrees—a challenge to the laws of physics (the tower also withstood the city's last earthquake in 1999). The tower's architect is unknown, but speculation has attributed the project to either Bonanno Pisano or the architect of the Baptistery, Diotisalvi. From the beginning of its construction in 1173, the tower began to settle, sinking into the soft ground beneath it, which is rich in clay and crossed by water faults. Construction was plagued by frequent interruption and the project was first completed in 1360. Over the years the tilt has continued to worsen, and in 1990 the tower was closed to the public when a committee of experts convened to save the building from collapse. After a period of restoration, the Leaning Tower of Pisa is once again safe to enter and groups of twenty-five to thirty people can climb to the top accompanied by guides.

Although the Campo dei Miracoli is considered the heart of Pisa, it is situated on the northern border of the town where foot traffic is less intense. Here one can enjoy peaceful walks under the arcades of the Borgo Stretto, on the grounds of the palazzos lining the Corso Italia, or on Lungarno Mediceo between the fort and the Ponte di Mezzo.

Pisa is home to many wonderful landmarks. On Piazza dei Cavalieri the palazzo of the same name was once the center for the Order of the Knights of Santo Stefano (it is now a high school). Walking along the Lungarno Pacinotti road you will reach the Royal Palace, built by Duke Cosimo I in the second half of the sixteenth century. On the opposite bank of the Arno stands the church of Santa Maria della Spina, a jewel of Gothic–Romanesque architecture. Farther along is San Paolo a Ripa d'Arno, a Romanesque church dating to the twelfth century. The Royal Victoria hotel is a convenient ten minutes from the Campo dei Miracoli and has been run by the same family since 1837. Taste Pisa's traditional cuisine at Osteria dei Cavalieri or, for more innovative fare, dine at A Casa Mia on the Vicarese provincial road.

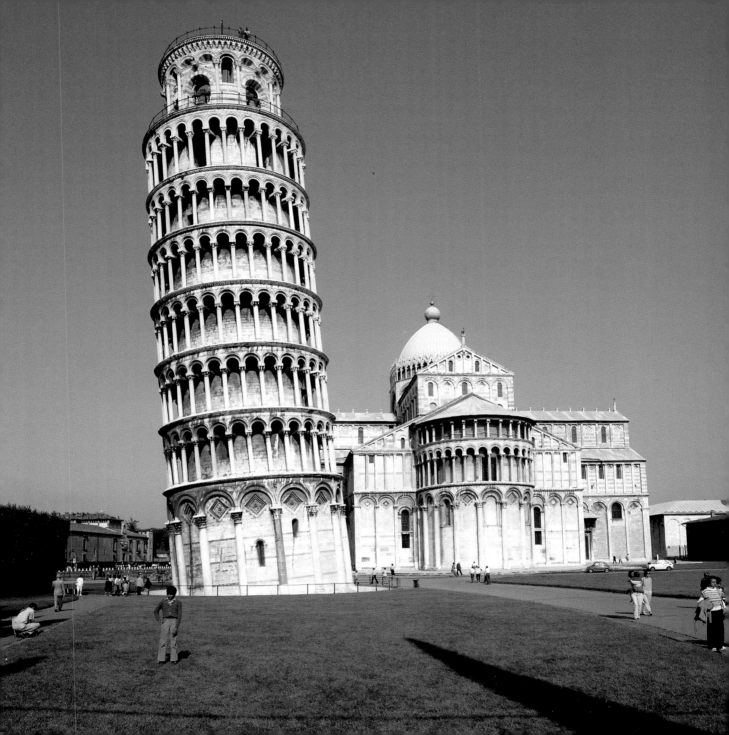

SAN GIMIGNANO
FIFTEEN TOWERS

Set high on a hill dominating the Val d'Elsa, San Gimignano lies at the center of a region whose earliest inhabitants preceded the Etruscans. In the tenth century San Gimignano developed into a mecca for trade. Both merchants and pilgrims alike made use of the Via Pisana and the Via Francigena as they traveled to Rome to see the pope. At one time San Gimignano was known as the "city of a hundred towers," and in 1200, when there were nine *hospitatores* (inns) for pilgrims and foreign tradesmen, seventy-two towers stood on the mount, symbolizing the village's prosperity. Saint Gimignano (the town's namesake) was immortalized by numerous artists, the Sienese painter Taddeo di Bartolo, in particular, whose works can be seen in the Museo Civico (Municipal Museum).

San Gimignano was designated a UNESCO World Heritage Site in 1990. A law passed in 1282 forbade the demolition of houses and towers in the region unless taller and more beautiful ones were built in their place. The main feature of the Palazzo del Podestà is La Rognosa, a 168-foot-tall tower that set the height limit for new projects. The Torre Grossa and the twin towers of Ardinghelli are centered around the Piazza del Duomo and the triangular Piazza della Cisterna, named after the well that perches on its slope. Today the classical iconography of the village is preserved by fifteen towers that have withstood time.

To better appreciate the view from the village, walk along the old Via Francigena (Via San Giovanni and Via Matteo), passing under the arch of the third-century gateway of San Giovanni and along the ancient walls. Those interested in the town's medieval history will have plenty to look at: inns and modest pagan altars erected near the gates, rows of houses where artisans had their shops, and noble palaces that encircle the extraordinary system of the two communicating central piazzas. Note how the Palazzo Pratellesi, the Torre Cugnanesi, and Torre dei Becci resemble a typical Tuscan architecture, but with ornamentation that betrays hints of an Eastern influence brought by traveling merchants. Places to visit include the collegiate church of Santa Maria on the Piazza del Duomo, built in the twelfth century and Romanesque in style. The church complex includes the cloister of San Giovanni, the chapel of Santa Fina, one of the most significant structures of the Tuscan Renaissance, and frescoes by the Florentine artist Domenico Ghirlandaio (1449–94). Behind the church along the narrow slate-covered streets and stairways is the fortress of Montestaffoli. From here the forest of towers can be seen as they emerge from the red rooftops of the village. It is an impression that few other places in the world can offer.

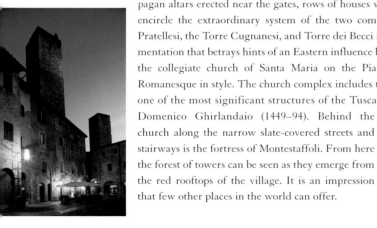

The Antico Pozzo is a hotel in the historic center that was built from a fifteenth-century palazzo. Just outside San Gimignano is the Relais Santa Chiara, a hotel with a panoramic view of the Tuscan countryside. Within Monteriggioni's thirteenth-century walls is the hotel of the same name. The Osteria delle Catene in the historic center offers hearty Sienese cuisine. Traditional fare, such as spelt soup, a medieval broth made with saffron, can be had at Osteria Antiche Terre Rosse, an old farmhouse in San Donato. The classic Vernaccia di San Gimignano wine is sold at the Enoteca Il Castello near the Piazza della Cisterna.

San Gimignano represents the pinnacle of ancient commercial wealth. Monteriggioni, just south on the road to Siena, is a symbol of military power. The villagers have preserved the magnificent walls and looming towers described by Dante Alighieri (1265–1321) in his *Divine Comedy:* "In the round circlet Monteriggione crowns herself with towers"; Dante also compared the structures to horrible giants. The walls were built between 1212 and 1219, and of the fourteen quadrilateral towers, seven of them have recently been restored. About two miles from Monteriggioni is Abbadia Isola, a marsh village whose heart is the Cistercian abbey of San Salvatore, founded in 1001.

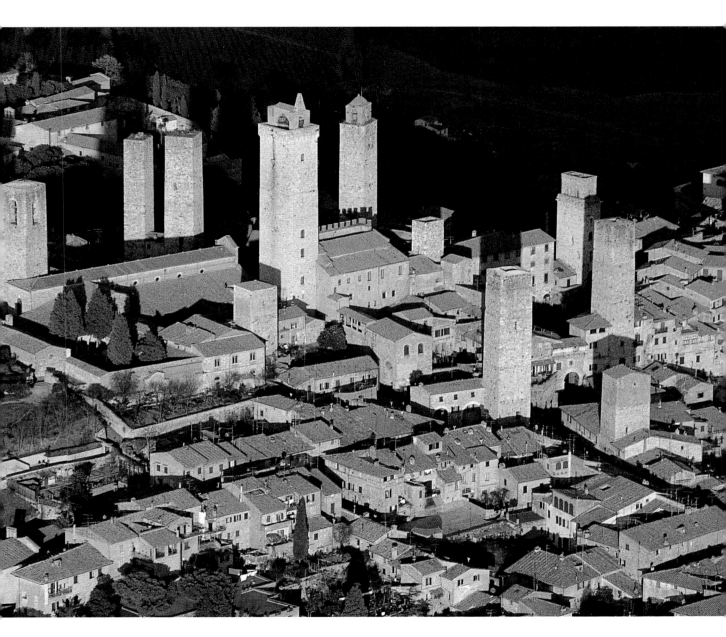

SIENA

THE PALIO OF THE CONTRADE

SIENA'S PIAZZA DEL CAMPO IS ONE OF ITALY'S FINEST SQUARES and was declared a UNESCO World Heritage Site in 1995. The thirteenth-century Gothic Palazzo Pubblico (Town Hall) gracefully resides over the Campo. Siena embodies the idea of the medieval city, characterized by a Gothic–Romanesque style that prevailed from the twelfth to the fifteenth century. The Sienese painters and architects Duccio di Buoninsegna, Simone Martini, Ambrogio Lorenzetti, and Jacopo della Quercia beautified the town with churches and palazzos, and in so doing, greatly influenced the trajectory of Italian art.

The seventeen medieval *contrade* (neighborhoods) that comprise Siena are marked by distinct boundaries and ruled as if they were miniature fiefdoms. Their primary function during the Middle Ages was to secure Siena's freedom from Florence by banding together inhabitants to form small military states. The heart-stopping Palio delle Contrade horse race is held twice a year, on July 2 and August 16, and is a celebrated event reported in newspapers and on television stations throughout the world. Many travel from around the globe to observe the festivities—taking part is the privilege of only a few. Seeing the historic procession and the breathtaking whirlwind of color as horses and jockeys dash around the square is an experience not to be missed.

The pomp of the Palio may seem excessive, but it could not be otherwise. The race is the only tradition that remains from the fourth century when the Sienese celebrated the saints and blessed protectors of the city. The many festivals included great revelry, gaming, horse and donkey racing, and bull-fighting. Siena lost the supremacy that had made her a rich and beautiful city, and was threatened by excommunication decreed in the mid-thirteenth century by the Papal States. This caused severe financial losses followed by many wars against neighboring communities, Florence in particular. Siena surrendered to Florence in 1555 and became part of the Grand Duchy of Tuscany. The Florentines proceeded to abolish the traditional Sienese holidays, sparing the Palio of July 2, a feast of the harvest, grain, and bread instituted in the seventeenth century, and that of August 16, a feast of wine. Both were pagan and propitiatory cele-brations, but they were also Christian, the bread and wine symbolizing the body and blood of Christ. A few days before the great race, the Sienese prepare for the ceremonies by decorating the Campo, wearing ceremonial dress, and attending banquets (and by doing a bit of gossiping as well). He who wins the Palio takes home a piece of colored cloth representing his *contrada*.

The making of sweets in Siena has a long and colorful history. *Panforte*, a sweetbread made from honey, candied fruits, almonds, and spices, is served at Christmastime and used to be called *panpepato* (peppered bread). Together with the Palio, it is a hallmark of Sienese culture. Some say *panforte* dates back at least to the 1200s, if not earlier. It was prepared by monks who baked honeyed sweets, forerunners of *ricciarelli*, Sienese cookies said to be shaped like the almond eyes of the madonnas in Renaissance paintings, and the hard-as-stones *cavallucci*, cakes made of honey, sugar, and flour.

The rolling hills of Chianti fall between Florence, Arezzo, and Siena and are famous for the wine of the same name. In 1716 the grand dukes of Tuscany extended the vineyards well beyond those hills, and a parliamentary decree in 1932 set aside land in the region specifically for the cultivation of grapes. Today Chianti wine is produced in the greater part of Chianti, from Florence to Siena and from Pisa to Arezzo. For this reason checkpoints have been instituted, and seals of approval such as Putto, Gallo Nero, Colli Senesi, Centauro, Colline Pisane, Colli Empolesi, and Consorzio Produttore vino Chianti ensure the quality of the product. Each of these wines is a traditional dry table wine, brilliant ruby-red in color with a sweet violet aroma. (Chianti Reserve is more appropriate for elaborate meals with several courses.) Chianti is matured in barrels for at least three years and lends itself to moderate aging in the bottle.

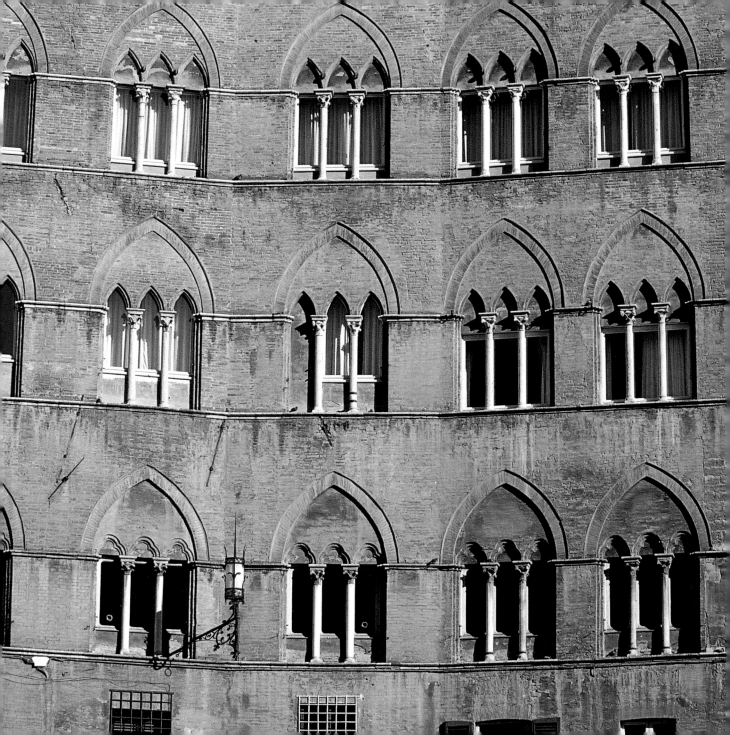

above
A detail of the equestrian portrait fresco *Guidoriccio da Fogliano* (1328) by Simone Martini in the Palazzo Pubblico.

Horses at the starting line—a heartstopping moment during the Palio.

Half an hour by car from Siena in the little village of Pievescola stands the Relais La Suvera, a medieval fortress transformed into a Renaissance villa by Pope Julius II. Until 1989 it was the country residence of the Marquis Ricci, who converted it into an elegant hotel. The family has kept some apartments for private use. The property also consists of a farm and stables, which were renovated and landscaped to incorporate rooms, a sixteenth-century church, a fish pond in the large garden, a lemon orchard, an aviary, and vineyards that produce an excellent wine. The rooms comprising the main wing are decorated with objects of great value. The Papal Suite is furnished with a Renaissance bed that sleeps up to four; the bed in the Maria Gabriella di Savoia Suite is fitted with a baldachin canopy embroidered with a gold crown. A lamp made from Bohemian crystal illuminates the room. The Napoleon Suite is decorated with the busts of famous generals.

right
The cathedral of Nostra Signora dell'Assunzione, a masterpiece of Sienese architecture.

VOLTERRA
THE HEIGHT OF THE ETRUSCAN ERA

VOLTERRA LIES IN THE VALLEY BETWEEN THE CECINA AND ERA RIVERS and is surrounded by an enchanting and ever-changing landscape rich in minerals—especially salt—that have bolstered the region's economy as well as provoked struggles for power. Deposits of copper, lead, and silver, and quarries of alabaster have been mined since Etruscan times. The Etruscan *Velathri* was the center of Villanovan civilization during the Iron Age. It was an important city of 25,000 inhabitants encircled by massive walls and became one of the most powerful members of the Etruscan federation, which also dominated the islands of Elba and Corsica. The remains of Etruscan battlements and portals still stand in the center of the city, and there is an archaeological park on the hilltop where Etruscan and Roman ruins can be explored. Volterra's magnificent medieval portals include the Porta a Selci, Porta Marcoli, Porta di Docciola, Porta Fiorentina, Porta San Francesco, Porta San Felice. The ancient Etruscan Porta dell'Arco (a splendid arch that was incorporated into the medieval walls) dates to the fourth century BC. The mount upon which Volterra was founded gives its name to the city—*vel* in Etruscan means "high place." It can be seen from a great distance, framed as it is by *biancane*, the white clay on the slopes from which meager vegetation struggles for life, and by the imposing mass of the Medici Rocca. The fortress is softened by the graceful shapes of bell towers that stand out from the silhouette of the houses.

Silent alleyways carve through Volterra's historic center.

But it is only the proud boast of a hard-working city, one of the most vivacious in Tuscany, and so welcoming that you do not need a map to visit it. Walk along the streets to magically find yourself in the medieval Piazza dei Priori, an abundance of towers and palazzos bound together by the yellow-gray sandstone from which they were built. Among the buildings is the third-century Palazzo dei Priori, the oldest in the region, while the Palazzo Pretorio's crenellated tower is known as Porcellino. The Duomo was originally built in the Romanesque style but was refurbished and enlarged in the thirteenth century, and the interior possesses a late-Renaissance style. Its apse overlooks a small square where the octagonal fourteenth-century Baptistery is situated. Among the many noteworthy sights to admire are the fourth-century BC Porta all'Arco, the third-century pergamo, and, in particular, the masterful *Deposition*, a breathtaking Romanesque carved-wood sculpture dating to 1228 and one of the oldest in the world.

Since Etruscan times Volterra has been a center for artists working in alabaster. This chalky, white stone is found in the quarries that surround the city and is softer than marble, making it an ideal medium for intricate decorative sculpture. Workshops where alabaster is shaped into objects of all kinds—statues, plates, bowls—line the Via Matteotti and Via dell'Arco. The characteristic translucence of alabaster lends itself to the creation of lamps and wall fixtures that diffuse a gentle light. It is also possible to work alabaster into thin, transparent sheets to function as windowpanes.

Those wishing to stay in the city should book a room at the San Lino, a thirteenth-century convent that has been transformed into a comfortable hotel offering modern amenities and a reception room overlooking a beautiful cloister. The Villa Nencini in Borgo Santo Stefano dates to the seventeenth-century and has views of the hills and the sea. The Enoteca del Duca is an ideal place to eat a full meal or a quick snack of local salamis and cheeses, as is the elegant and refined Etruria restaurant on Piazza dei Priori. Alabaster souvenirs are sold at Bessi, a shop that has been in business since 1879, or at the Cooperative Artieri. The traditional sweets of Volterra include *cantuccini*, anise and almond biscuits best enjoyed dunked in coffee or dessert wine, *ossa di morto* (literally, "dead man's bones"), and *panforte*. These treats can be bought at the confectioner's shop Migliorini.

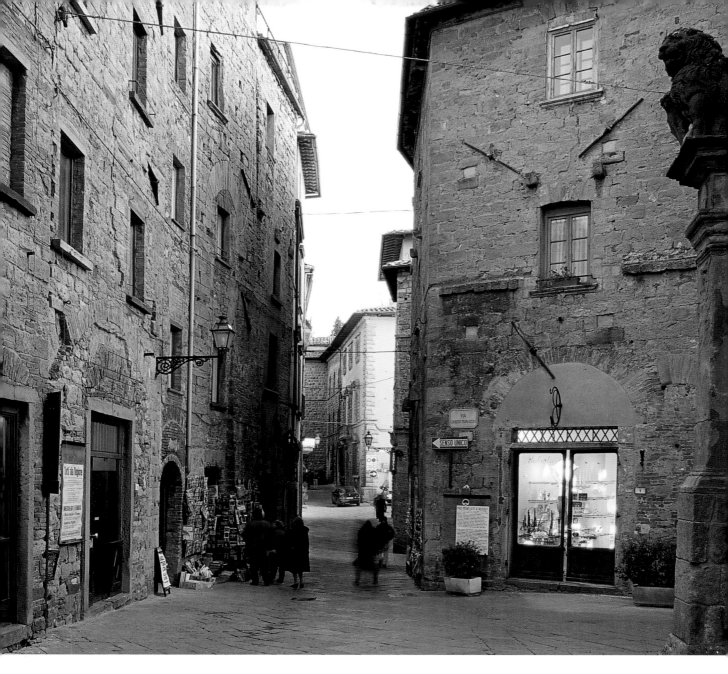

ASSISI

GIOTTO AND SAINT FRANCIS

THE ATMOSPHERE CHANGES AS ONE CLIMBS MOUNT SUBIASO, from the heights of which rises the medieval village of Assisi, the birthplace of Saint Francis. The spirit of Saint Francis pervades this hilltop village and its surroundings, a destination for pilgrims who come from around the world to pay homage to the patron saint of Italy, as well as to Saint Clare. Assisi, with its terraced slopes and long horizontal streets connected by steep stairways, is unlike other crowded hilltop Umbrian towns characterized by dark tones. Assisi was named capital of peace and spirituality and since 1961 has been the final stop of a march for peace that begins in Perugia and brings together politicians, priests, lay people, and the faithful. It was here in 1986 that Pope John Paul II summoned for the first time representatives of all the religions around the globe for a world day of prayer.

Here, in the chapel of Porziuncola, the *poverello d'Assisi* (or "poor man of Assisi," Saint Francis) began his meditation and preaching. The chapel was transformed into Santa Maria degli Angeli, where Saint Francis gathered his first followers; in the convent of San Damiano he composed the Canticles of the Creatures, the manifesto of his ideas based on humility and poverty. Two years after his death the construction of one of the most grandiose basilicas in Italy was begun in 1228 to house his remains. The greatest artistic geniuses of the time, Cimabue (ca. 1251–1302) and Giotto (ca. 1267–1337) , and other master painters from the Sienese school, Simone Martini and Pietro Lorenzetti, took part in the pictorial ndecoration of the Basilica of Saint Francis. Giotto painted a cycle of twenty-eight frescoes in the Upper Basilica depicting scenes from the life of Saint Francis; the cycle is one of the greatest masterpieces of the Italian Renaissance. In 1997 an earthquake seriously damaged the vaulted ceiling of the Upper Basilica, but restoration efforts managed to piece together colored fragments of the frescoes by Cimabue and Giotto found in the dust and debris of the aftermath, and, after a long period of intense work, they have been restored.

Adjacent to the church of Santa Maria degli Angeli is the miraculous rose garden where Saint Francis was said to have rolled naked to overcome the Devil's temptation. Since then it is said that the roses grow without thorns. Nearby is the church of Santa Chiara, dedicated to Saint Clare, who claimed the inheritance of Saint Francis and founded the Order of Poor Clares in the convent of San Damiano. The church is decorated by frescoes depicting the life of the saint and displays her preserved body in the crypt.

The massive Basilica of Saint Francis illuminated at night.

facing page
Saint Francis renounces worldly goods, a detail of a fresco by Giotto in the Upper Basilica.

Artisans in Assisi specialize in sacred objects such as rosaries made of both precious and base materials, wood and wrought-iron crucifixes, Byzantine-style icons, ceramics decorated with religious themes, and fabrics woven in "punto Assisi," a combination of cross-stitch and stem-stitch employed since the fourth century. Plates and vases depicting the lives of Saints Francis and Clare can be purchased in local shops, as well as copies of the relics of the saints and the crucified Christ of San Damiano, reproductions of Giotto's frescoes, history books, and art books (the best selection is found in the shop at the cloister of Saint Francis).

The Hotel San Francesco is a converted palazzo where visitors are encouraged to stay. Also recommended is the Santa Maria degli Ancilotti, a beautiful countryside residence in Sterpeto. Popular restaurants include La Fortezza in Assisi and the Locanda dei Cavalieri in bucolic Petrignano. Both offer high-quality regional cuisine. There are several enchanting villages to visit not far from Assisi, including Spello, Bevagna, and Montefalco. Spello resembles a nativity scene cut out of the southern rocks of monte Subasio. Bevagna's tiny Piazza Silvestri is permeated by a medieval atmosphere and is home to the Palazzo dei Consoli and the churches of San Silvestro, San Michele, and Saints Domenico and Giacomo. Montefalco sits on a rocky spur that dominates the magnificent panorama of rolling hills and olive groves, and is the ideal spot for a picnic lunch.

GUBBIO
THE FESTIVAL OF THE FLAMES

GUBBIO IS A TOWN KNOWN FOR ITS MANY FESTIVALS. The biggest annual celebration is the pagan Corsa dei Ceri (Race of the Candles), held each year on May 15. The event began in the twelfth century to honor Saint Ubaldo, the then bishop of the town who helped free Gubbio from the tyranny of a neighboring city–state.

The *ceri* (candles) are three sixteen-foot-tall wooden pillars weighing over eight hundred pounds. They are octagonal in shape and crowned by small statues of Saint Ubaldo, Saint George, and Saint Anthony Abate, the patron saints of bricklayers, traders, and farmers, respectively. The candles are hoisted on the shoulders of the *ceraioli* (candle-bearers) and raced around town before running up Mount Ingino to the Basilica of Saint Ubaldo. The event is preceded by a procession of statuettes of saints and a display of traditional costumes in which all the villagers take part. Each year the celebrations attract a huge crowd and are essentially unchanged from when they were first held in 1151. On the morning of the festival the candles are paraded through the town finishing up on Piazza della Signoria. At noon, the candles are raised and water is poured on them from three vases, which are then hurled into the crowd of onlookers. Once the vases hit the ground and shatter, the people begin to scramble to find a piece of broken pottery as the shards supposedly signify abundant crops and good luck for the coming year. The candles are raced around Piazza Grande three times after which they are sent on a course through the city streets. At two o'clock the teams gather at the Palazzo dei Consoli for an eleborate banquet. Around four o'clock, Saint Ubaldo's relics and the *ceri* are brought to Via Dante. At this point the festivities begin, reaching a climax at six o'clock, when the candles are blessed and the race proper starts. The candle-bearers, three teams of fit young men dressed in different colors—yellow for Saint Ubaldo, blue for Saint George, and black for Saint Anthony—charge up an impossibly steep mountainside (a vertical incline of more than 1,000 feet) toward the massive Basilica of Saint Ubaldo as the crowd cheers them on. The first team to reach the doors of the Basilica tries to shut the other two out, but the real winners are the ones that manage to carry their candle the entire way without letting it fall (the team representing Saint Ubaldo somehow always wins). The race was possibly named after Ceres, the Roman goddess of the harvest. There were once about fifty civil and religious festivals distributed throughout the year in Gubbio. Among them were the crossbow and flag-tossing competitions, which are still celebrated today.

One of the heavy *ceri*, which are carried during the Corsa dei Ceri race.

facing page
A detail of the facade of Palazzo Ducale on a windy day.

Gubbio stands at an impressive height atop Mount Ingino and its medieval core is characterized by dramatically steep roads. Piazza Grande is a hanging shelf constructed in the fourteenth century on a precipitous slope. From here there is a view of the village, built on the hills of Mount Ingino. Above the piazza rises the thirteenth-century Duomo, erected to replace the older one in San Giovanni. On the Piazza della Signoria the elegant tower of Palazzo Pretorio faces the Palazzo dei Consoli (where the parliament used to convene) across the square, where the Tavole Eugubine (Gubbio Tablets) are conserved. These bronze tablets are inscribed in the ancient Umbrian language using Latin characters, and hold the key to the region's curious tongue.

The Hotel Villa Montegranelli is a beautiful eighteenth-century residence with a hedge maze and a long cypress-lined entranceway. It was recently restored and commands graceful views of the countryside. The regional cuisine is served here, as is the local delicacy, the earthy black truffle. The Hotel Castello di Petroia was converted from an eleventh-century castle and is not far from town. The old-fashioned Hotel Bosone Palace in Gubbio's historic center is steps away from the Piazza della Signoria in a seventeenth-century palazzo. The Hotel Relais Ducale is located in the Palazzo Ducale, the former residence of Duke Federico da Montefeltro. Restaurants abound and include the Fornace di Mastro Giorgi, which serves local dishes in a medieval setting. The menu at the Park Hotel Ai Cappuccini is more refined. Ceramic and wrought-iron souvenirs can be purchased in craft shops.

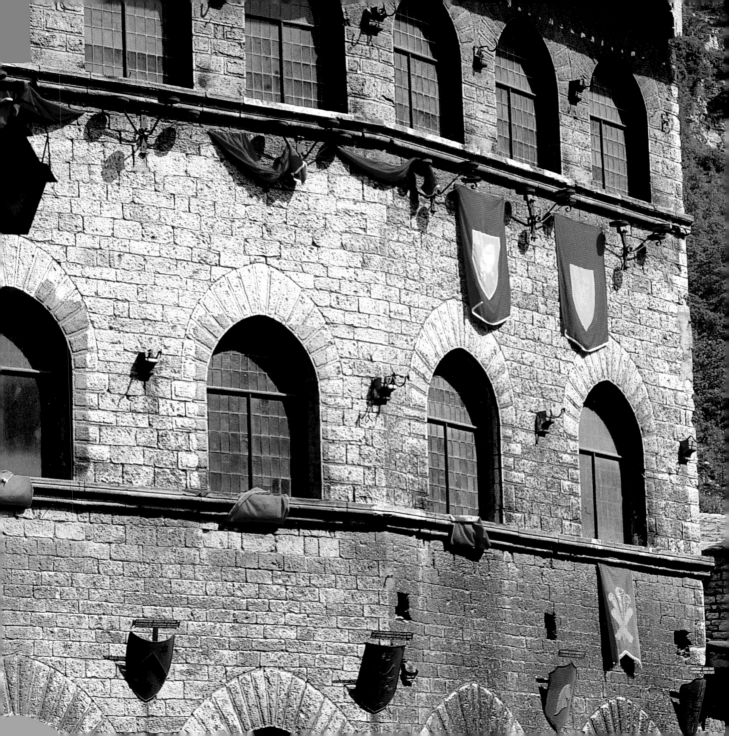

ORVIETO
CARVED FROM TUFA

FROM A DISTANCE ORVIETO APPEARS TO BE AN ISLET, FUSED AS IT IS INTO A SPUR OF TUFA, or volcanic rock, that was most probably an island in geological times. Spread along the foothills of the Apennines, Orvieto's coast is bathed by the Tyrrhenian Sea. Since the highway was built, there is only a short road from the plain that winds between the densely packed houses. Even if the journey to Orvieto is made easier by an enchanting landscape, the road to reach the city was at one time arduous and long. It would have been equally tiring to get to the train station at the foot of the mountain if it were not for the funicular that goes straight up to the upper city and to the fortress of Albornoz.

Because of its isolated location, Orvieto has been spared the ravages of the modern tourist industry. In fact, there are few hotels, and most restaurants are typical outdoor trattorias as befits a city where one can breathe the country air. Yet Orvieto has known golden times, for instance, when it swore fidelity to the popes and received in exchange recognition and wealth that enabled the city to build luxurious palazzos and grandiose monuments, such as the Duomo, one of the greatest expressions of Italian Gothic architecture; the third-century Papal Palazzo; the Romanesque Palazzo del Popolo; and the Abbey of Saints Severo and Martirio, now a hotel complex.

The Italian poet Gabriele d'Annunzio called Orvieto the "city of silence," and it still is if one walks in the old medieval quarter or along the panoramic Viale Carducci that overlooks the vineyards on the hills. It is certainly silent in the spider's web of subterranean caves, excavated under the city over the course of 2,500 years. There are miles of tunnels, passageways, and connecting antechambers carved by ancient inhabitants most likely in search of water and protection during sieges. Orvieto is certainly not silent, however, along the five-foot-wide Via dei Dolci, flanked as it is by dozens of local artisan shops. To celebrate Pentecost, the people of Orvieto dress in costume and gather on the Piazza del Duomo, where they light firecrackers and a white dove tied to a wire is descended from the bell towers to a tabernacle. It is said that auspices for the coming year are divined from the configuration of feathers on the sacrificed dove's head.

The Palazzo del Popolo.

facing page
The graceful portals of the Duomo's facade.

The extraordinary Well of Saint Patrick in the Fortress of Orvieto was commissioned by Pope Clement VII to guarantee a supply of water for the city in case of a siege. It was designed by the Renaissance architect Antonio da Sangallo the Younger between 1528 and 1537 and is 43 feet wide and 207 feet deep. The well is dug entirely from tufaceous rock with the exception of the terminal, which is brick-laid. Its originality lies in the two superimposed spiral stairways lit by seventy-two windows opening onto the interior; 284 shallow steps descend to a bridge spanning the water. The steps once enabled donkeys to carry buckets of water up to the village.

For a unique hotel experience, the Hotel La Badia, a thirteenth-century Romanesque abbey, is the place to stay. The recently renovated sixteenth-century Palazzo Piccolomini, which was built for the pontifical Piccolomini family, is now a hotel with authentic period rooms. The Osteria dell'Angelo and the trattoria Il Giglio d'Oro offer excellent dinner menus. Both serve traditional fare as well as some imaginative dishes. Orvieto is know for its white wine, which is produced on the surrounding hillsides. The region's extra-virgin olive oil has an unmistakable flavor and aroma. Both the wine and olive oil can be purchased at the Loggia wine cellar, the Carraro grocery store, or at Le Velette farm, near where the mellow Orvieto Classico wine is made.

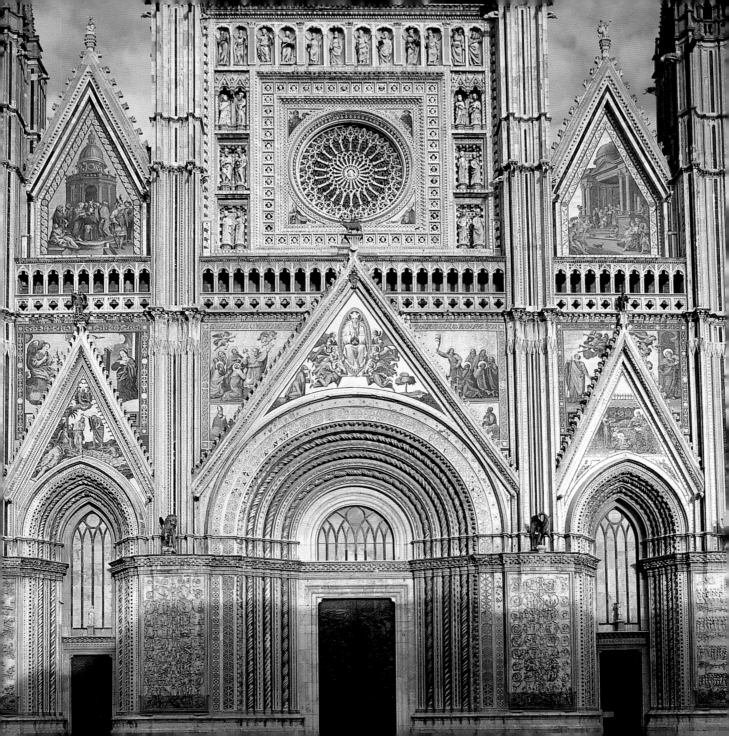

There are many important monuments aside from the fortress of Albornoz and the Pozzo di San Patrizio (Well of Saint Patrick). The Romanesque Duomo was begun in 1290 and was completed three centuries later. Beautiful frescoes by Luca Signorelli (ca. 1441–1523) and Fra Angelico (ca. 1400–55) decorate the walls of the interior. Nearby, the thirteenth-century Palazzo Soliano houses the Museo dell'Opera dell Duomo. The Piazza del Popolo dates to 1157 and is executed in typical Orvieto Gothic—Romanesque style. The tufaceous cliff upon which Orvieto sits is riddled with underground caves and grottos. A guided tour leads you through labyrinthine passageways full of archaeological remains, medieval ovens, Etruscan tombs, cisterns, and ancient wine cellars.

above
The fourth-century
BC Etruscan
Necropolis of the
Crucifix of Tufo.

below
A narrow alley in the
old city.

right
The massive ridge of
tufa and the church
of San Giovenale.

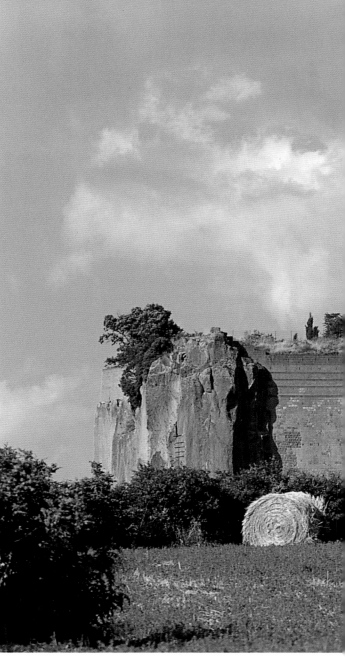

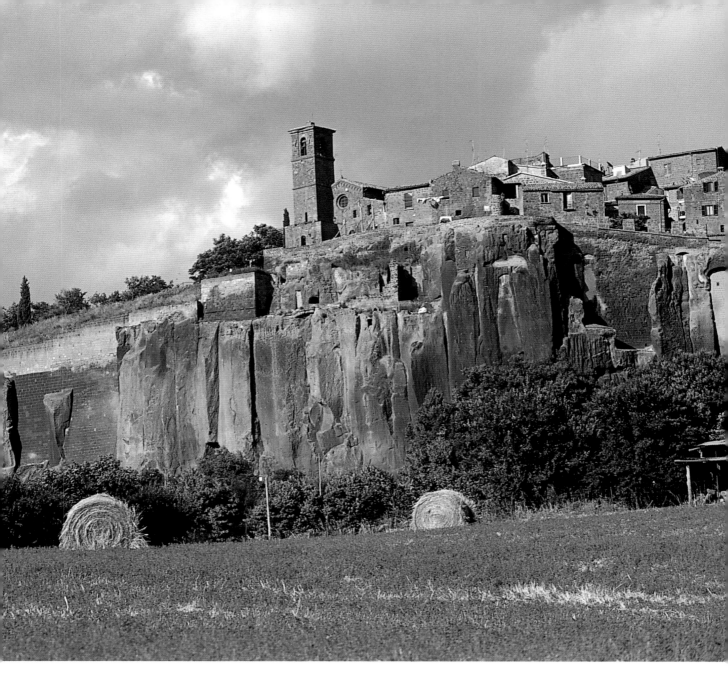

PERUGIA
A BABEL OF LANGUAGES AND CULTURES

PERUGIA, THE CAPITAL OF UMBRIA, IS A MELTING POT OF LANGUAGES AND PEOPLES. Students from a diverse group of nations flock to Perugia to study at the city's two universities, one of which is specifically designed for foreigners. It is true that Perugia lies at the heart of a land known for its hermitages and convents; however, the inhabitants of Perugia would rather talk about their adventurous ancestors, such as the ferocious Braccio Fortebraccio da Montone, Niccolò Piccinino, or the Gattamelata, than about saints. There are no lilies or doves on the town's coat of arms, but a powerful griffin. Moreover, Perugia's economic fortunes have not been built on faith, but on material goods. The world-famous Perugina company began manufacturing chocolate here in 1907, and in 1922 invented its famous *Baci* (kisses), hazelnut-filled chocolate candies each individually wrapped in a poetic love note.

Perugia was fortunate enough not to have been chosen in 1863 by the Savoy government as the capital of the Kingdom of Italy. It would have suffered too much—more than Florence, which was elected instead, and whose medieval walls were destroyed to construct the regal avenues that today encircle the city. There is much to see in Perugia, and a visit could begin at the audience chamber in the Collegio del Cambio (Bankers' Guild Hall), the ancient place for the exchange of money, where there are splendid benches of intarsia work and frescoes by the Renaissance painter Perugino. Raphael's *Trinità* can be viewed in the church of San Severo; other works by Piero della Francesca and Perugino are on view in the National Gallery of Umbria in the Palazzo dei Priori.

Ceramics for sale on the steps of the cathedral.

facing page
The Fontana Maggiore in front of the Palazzo Comunale.

Perugia is best taken in slowly, strolling through the streets, letting oneself be gradually captivated by this Umbrian hilltop town's atmosphere. This is the only way that one can appreciate, for example, the Via delle Volte della Pace (Street of the Faces of Peace), which is almost entirely covered by arches and bordered by modern palazzos. It is home to craftsmen, particularly blacksmiths, who carry on the ancient traditions of the city. The aqueduct that carried water to the town and crosses the Conca, the oldest district of Perugia, was built to bring water to the Fontana Maggiore, a medieval fountain built during the second half of the twelfth century. Corso Vannucci is the street that divides the city and contains the best shops. It passes in front of the imposing stairway of the Palazzo Comunale.

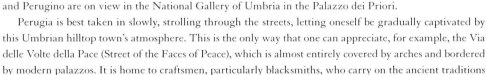

Every year in July musicians from all over the world flock to Perugia for the Umbria Jazz Festival, one of the most important gatherings in Europe of its kind and second only to the celebrated Montreal Jazz Festival. It originated in 1973 as a traveling show but wasn't the first music festival to come to the region, which also is the proud home of the Sagra Musicale Umbra (a celebration of sacred music held in September). The jazz players made Perugia their home in 1982 and were soon organizing paid concerts in the Morlacchi and Pavone theaters and performing free on various piazzas and in the gardens of the Frontone. Artists such as Bill Evans and Dizzie Gillespie, Miles Davis and Wynton Marsalis, Sarah Vaughan and Sonny Rollins, and Sting (with Gil Evans' orchestra and Branford Marsalis on saxophone) have all taken part in the Umbria Jazz Festival.

Pietro Vanucci (1448–1523), known as "Il Perugino" (the "man from Perugia"), painted a great deal in Umbria, in particular to the south of Lake Trasimeno from Perugia to Città della Pieve. Many of the artist's works are on display in villages outside of Perugia; for instance, in the church of the Annunziata in Fontignano one can view his *Madonna with Child*, Perugino's last work before falling victim to the plague. In Panicale one can admire the artist's *Martydom of Saint Sebastian*. In Città della Pieve, where Perugino was born, the Oratory of Santa Maria dei Bianchi to display's his *Adoration of the Magi* (1504) and *Deposition from the Cross* (1500s) in the church of Santa Maria dei Servi.

SPOLETO
MAGICAL SCENES SET IN STONE

IT'S EASY TO ENJOY SPOLETO AT ANY TIME OF THE YEAR, but during the three summer months when the town turns into a stage for the Festival of Two Worlds, it is not to be missed. An elaborate carnival of music, painting, sculpture, and opera, the festival brings together artists from all over the globe in a tribute to creative endeavors. But even when Spoleto isn't celebrating, its unusual beauty will make a lasting impression. Spoleto

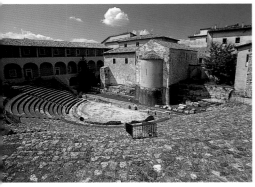

The Roman Theater and the apse of the church of Sant'Agata.

facing page
Every year the Duomo becomes the magical proscenium for musical and theatrical performances.

(*Spoletium*) was an important Roman colony. In the sixth century it became the capital of the Lombard Duchy, during which time it was enclosed by medieval walls constructed from ancient Umbrian and Roman stones. Roman vestiges such as the arches of the amphitheater and the theater, are sights to explore. One side of the first-century Arco di Druso is attached to a row of medieval houses, as if lending support to the buildings. The Ponte Sanguinario (Bloody Bridge) once crossed the Tessino River and, according to hagiographers, is so named because it was here that the persecution of the Christians took place. The Romanesque Duomo was rebuilt in the twelfth century over the ruins of the original cathedral, and with its impressive bell tower, it is the dramatic climax of the square. It contains splendid frescoes by the Florentine artist Fra Filippo Lippi (1406–69), as well as Bernardino di Betto, (ca. 1454–1513), called Il Pinturicchio (the little painter) on account of his great facility. The fortress of Cardinal Albornoz, called La Rocca, was built between 1359 and 1363 and served as the residence for popes and princes. The notorious Lucrezia Borgia, daughter of the infamous Rodrigo Borgia who became Pope Alexander VI, also lived here during her ascendancy. At one point the fortress was used as a maximum security prison, and it is now in the process of being restored to house museums and research centers. The bold Ponte delle Torri (Bridge of the Towers) is an impressive 264 feet high and 780 feet long and spans an area stretching from the hill of Spoleto to the Tessino River valley.

Nearby Monteluco is covered by a thick forest of holm oaks, sacred to the Romans. Visit the sanctuary of Saint Francis and the church of San Pietro, which dates to the early Christian period and is one of the oldest in the region. The facade of the church is sculpted stone, and the portal is embellished by bas-reliefs depicting Bible scenes. On the road to Foligno, stop at the springs of Clitunno, where an early Christian temple unites a landscape of poplars and weeping willows, a place so beautiful that it inspired the likes of Virgil, Johann von Goethe, and Lord Byron.

The Spoleto Festival was officially given the name "Festival of Two Worlds" in 1958, transforming a provincial town into an artistic capital. Gian Carlo Menotti, the festival's founder, created a grand institution in which all the artistic disciplines were represented. The first festival was inaugurated on June 5, 1958, in the nineteenth-century Teatro Nuovo, with a performance of the opera *Macbeth* by Giuseppe Verdi, conducted by Thomas Schippers and directed by Luchino Visconti. Aided over the years by his son Francis, Gian Carlo Menotti was able to attract some of the most important representatives of contemporary culture, from Ernest Hemingway to Eugene Ionesco, from Alexander Calder to Henry Moore, and from Jean Cocteau to Ezra Pound.

Several hotels in Spoleto offer interesting accommodations, such as the Hotel San Luca, which was built from a series of nineteenth-century buildings. The Villa Milano occupies a panoramic spot a few miles from the center of town on the grounds of a sixteen-acre park. It was also built at the end of the nineteenth century and has reception rooms full of works of art. In Campello sul Clitumno, six miles from Spoleto, stands the Vecchio Mulino, an old water mill that was converted into a hotel. The architects managed to retain the mill's fifteenth-century character while making the hotel as comfortable as possible. A great salon has been reworked from the mill's warehouse and overlooks the river and a beautiful garden. Sample the regional cuisine at Tartufo, where the chef makes good use of black truffles, or dine at Capanno in Terrecola, one of the finest restaurants in the area.

TODI
RELIVING THE MIDDLE AGES

A PRETTY HILLTOP TOWN IN THE TIBER RIVER VALLEY, Todi is protected by a triple belt of walls dating to the Umbro–Etruscan and Roman periods, a large part of which only the gateways remain (the outermost medieval walls are, however, almost entirely intact). As if this were not enough to distinguish Todi from many other medieval Umbrian villages, the unmistakable form of the sixteenth-century church of Santa Maria della Consolazione, attributed to Bramante, is a sure giveaway. At one time, the path to Todi was a perilous one. Arriving from Orvieto it was necessary to cross the Pontacuto Bridge, so steeply arched that it posed a threat to every carriage and cart. The bridge no longer exists, but legend has it that it was presided over by the devil himself, who stole the souls of passersby. It is said that the Archangel Michael destroyed the bridge, once again securing the journey.

In Todi one takes in the air of the Middle Ages. The main square is adorned with symbols of political and clerical power, while along the narrow streets that were once the center of everyday life, time seems to have stopped. The heart of the village is the long rectangular Piazza del Popolo, where a medieval atmosphere reigns. The twelfth-century Duomo straddles the Romanesque and Gothic periods and is part of a complex that includes the Palazzo dei Priori, the battlements of the Palazzo del Popolo, and the nearby arched Palazzo del Capitano. The Gothic church of San Fortunato houses the remains of Jacopone da Todi, a nobleman who, in 1278, having lost his beloved wife, Vanna, abandoned society and dedicated himself to a life of prayer and penitence by entering the Franciscan order. Jacopone wrote ninety-two *laudi* (spiritual hymns of praise) that were among the first examples of Italian poetry in the vernacular. They reflected his profound religiosity and open dissent of the permissiveness of the church. He was among the most intransigent of the Franciscans and opposed Pope Boniface VIII, by whom he was excommunicated and imprisoned in the fortress of Castel San Pietro in Palestrina.

Inside an antiques shop on Via Ciuffelli.

facing page
Palazzo del Podestà and Palazzo dei Priori.

The Tiber Fluvial Park, established in 1995, encompasses thirty miles of the middle course of the Tiber River, from Todi to Alviano. It is a territory prone to natural disasters causing cultural rifts and archaeological ruin. At Montemolino the waters of the Tiber are fast flowing and, for this reason, the river is here called *Il Furioso* (the furious one), while at Todi it calms down and becomes the *Tevere Morto* (the dead Tiber). After it joins the Naia it flows through the narrow gorge of Forello and gives life to the marshlands of Alviano. Following the course of the river one can visit the Accademia dei Pazzi or, in Montecastello di Vibio, the Concordia Theater, called *La Bomboniera* (the candy box) because of its small size. The Poggio Castle at Guardea, the fortress of the condottiere Bartolomeo at Alviano, and the World Wildlife Foundation refuge are all noteworthy destinations.

Modern life in Todi continues the old artisan traditions along the bustling streets near the central Piazza del Popolo. Engravers, cabinet makers, masters of wrought iron, and other craftsmen carry on the trades of the ancient guilds, the most famous of which is the carpenter's guild, which has its own headquarters in the church dedicated to Saint Joseph, the patron saint of carpenters.

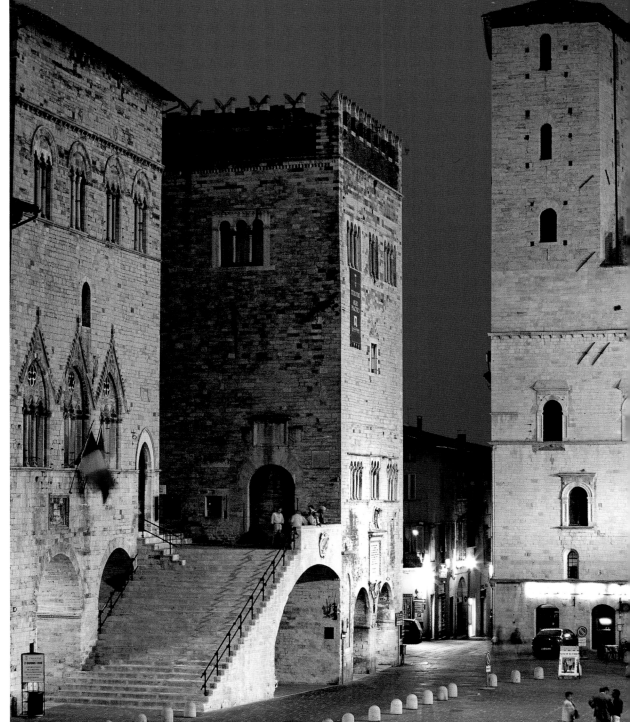

Todi is one of the foremost centers for Italian antiques and period furniture. The palazzos del Capitano and del Podestà are hosts to a museum that preserves Etruscan, Roman, and medieval artifacts, including textiles, ceramics, and coins. An antiques show is held here between September and October and displays objects ranging from carpets and furniture to fine jewelry and porcelains. Terni is about seventeen miles south and is known for its steelworks, which are now considered monuments to industrial power. Outside of Terni are the spectacular Marmore Waterfalls, formed by the Velino River and considered the most beautiful—certainly the most famous—in Italy. It takes about an hour to hike the path from the lower outlook point to the upper ridge, passing under the first drops of the magnificent cascades.

ANCONA
TRAJAN'S PIER

THE PORT OF ANCONA JUTS OUT INTO THE ADRIATIC AS IF CHALLENGING THE SEA. It extends along a promontory resembling an elbow, a feature that gave the city its name (the Greek *ankòn* means "elbow"). Its strategic position made it an important harbor in Roman times, when the Emperor Trajan sailed from the shores of Ancona to battle the Dacians. He was cheered to victory from the tall arch on the pier. Ancona was a mecca for trade between Florence and other Mediterranean ports and it was the most important port of call for steamers traveling to and from Italy and the former Yugoslavia. At one time Napoleon occupied the city, enlarging his empire still further. At the beginning of the twentieth century, iron and coal arrived here from the great steelworks of Terni. Today, although Ancona has lost most of its industrial might in the Adriatic, one of its major resources is fishing. In fact, there is an annual International Fishing Fair, which is unique in Italy and one of the few in Europe. The fair takes place in a new exhibition center behind the innermost dockyard.

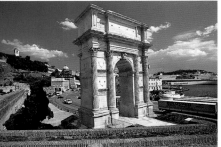

Trajan's Arch has dominated the port since the second century BC.

facing page
A view from the portal of the church of San Ciriaco.

The sea at Ancona is synonymous with holidays, tourism, and entertainment as well as productivity and hard work. Ancona's historic center is rich with monuments and the city is surrounded by a natural landscape that is the envy of many other towns. Highlights include the second-century BC Trajan's Arch, the Roman amphitheater, and the sixteenth-century fort of the Citadel built by the Renaissance architect Antonio da Sangallo the Younger (1484–1546). The imposing Mole (pier) built by Luigi Vanvitelli was once a quarantine hospital and storehouse and is now an exhibition center. The Gothic Loggia dei Mercanti (Merchants' Bazaar), the Marches National Museum of Archaeology, and the Pinacoteca Comunale (a painting gallery) are important sites, but nature is Ancona's most precious gift. Just under the "elbow," at the bottom of the Viale della Vittoria, the inhabitants take in the sun on the Passetto beach. It is separated from the city's traffic by a rocky spur, where grottos have been dug for sheltering boats. Now they contain bars and restaurants where you can sit in the open and enjoy a typical *brodetto* (fish stew).

The most beautiful stretch of Adriatic coastal hinterland extends behind the city, with the gemlike village of Sirolo, "the pearl of the Adriatic," whose medieval center is enclosed within the walls of an ancient castle. Sirolo is an ancient Picene center whose story is documented, for the most part, at the State Aquarium, which also preserves ancient vases, jewelry, a gig or two-wheeled horse carriage, and other remains from the tombs of the nearby necropolis.

From a height of 1900 feet, Monte Conero overlooks the Adriatic coast from the Gulf of Trieste to Gargano. The town's regional park, founded in 1987, ranges over about four acres of land and offers a lush seaside terrain. Here one can walk through the thick Mediterranean brush or under the holm oaks and pines. Among the historical sights to see, the most interesting are the Abbey of San Pietro and its connecting convent (now a hotel), the Romanesque church of Santa Maria di Portonavia, which sits atop a promontory above the sea, the Torre di Guardia (Watch Tower) built by Pope Clement IX in 1716, and the Napoleonic Fort built by the viceroy Eugenio di Beauharnais on the Bay of Portonovo as a defensive garrison against the English.

The Hotel Emilia is found on the road that climbs the Portonovo Hill, from which there is a wonderful view. The Hotel Fortino Napoleonico is in Portonovo and set aside at the foot of the Conero Hill. It occupies the summit of a lush promontory and offers a beautiful panorama. The eccentric shapes of the fort were built by Eugenio di Beauharnais around 1810 to prevent the English army from provisioning with water from the fount at Portonovo, and the hotel has left the structure untouched. Naturally, one eats fish at Ancona, freshly caught in the clear waters offshore. The *stoccafisso*, dried cod or stockfish, has been a staple in the local diet for centuries. *Stoccafisso* is served at Torrette da Carloni, a restaurant whose owners personally fish for the evening's main course, or at the Osteria Strabacco, which is open until late and offers live music.

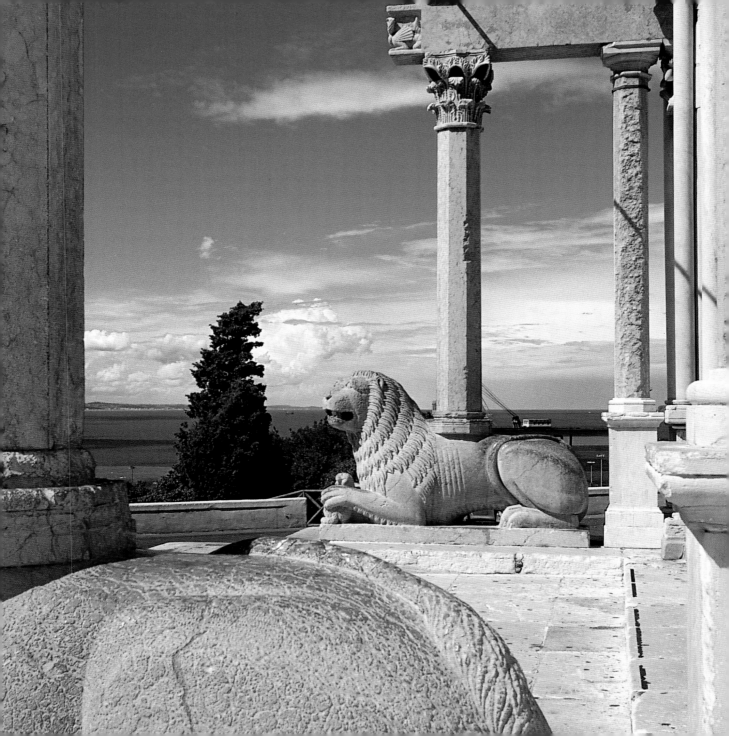

ASCOLI PICENO
A TRAVERTINE FLOWER

THE WELCOMING LAND AROUND ASCOLI WAS COLONIZED a few centuries before the era of the Umbro–Sabelli, a peaceful people who lived as shepherds and farmers. The Umbro–Sabelli came to the region during a spring migration, following the flight of a woodpecker, a bird sacred to Mars, from which the city's name, Piceno, from *picus,* was taken.

Old shops on Corso Mazzini.

facing page
The Roman bridge of Porta Solestà, the ancient access route to the city.

On a hill covered with cyclamens at the foot of Mount San Marco, between the Tronto and Castellano rivers that rush by with melted glacier water, the Picenes founded *Asculum* and began to cultivate the land, tend to their herds, weld tools, and fashion women's jewelry. Events led them to forge weapons and armor in order to defend themselves from the enemy who wanted to drive them out of their precious land, full of mysterious olive groves and grottos carved from the naked travertine rock face where the Sybil is said to hide. The Gauls and the Romans came, as did the Lombards and the Saracens, popes and emperors, all leaving traces of them behind. Ascoli is truly an ancient city, but don't expect to find ruins and signs of a glorious past. The arched Solestà Augustan bridge spanning the Tronto is still crossable, and is named after the place where the Roman troops of Sila (*Sullae Statio*) set up camp. Nowadays pedestrians and vehicles pass under the arched Roman gateway, Porta Gemina, which was the ancient entrance to the city from the Via Salaria.

Time has been kind to the city, thanks to its travertine-built walls and edifices. Travertine is a beautiful and often banded stone that is found in abundance in the area; it does not crumble or crack, has a solid calcium carbonate structure, and weighs little. Over decades the stone forms a patina that protects it and imbues it with an outward glow. The history of Ascoli is best explored through its most important monuments and less-trodden streets flanked by the more modest buildings, whose graceful, mullioned windows are elegantly decorated. The people of Ascoli respect the old by combining it with the new. Witness the area around Piazza Arringo, where renovations carried out from the eleventh to the eighteenth centuries blend in with the city's most important symbols of religious and political power: the Cathedral of Sant'Emidio and the Palazzo Comunale. Ascoli's central square, Piazza del Popolo, is paved with great slabs of travertine around which stand the sixteenth-century Loggia dei Mercanti, the thirteenth-century Palazzo dei Capitani del Popolo, and the Gothic church of San Francesco.

The elegant, Art Deco Caffè Meletti should not be missed. Found under the porticos of Piazza del Popolo, the café represents a piece of Ascoli's history. It is the ideal place to taste the famous *anisetta* (anisette), a sweet, usually colorless liqueur, made from aniseed (*Pimpinella anisum*), cultivated in the region. Anisetta was made for the first time in 1870 by Silvio Meletti, founder of the historic café in 1907. Among those who have sat here and sipped the *anisetta con la mosca* (a glass of anisette with a coffee bean at the bottom), are Ernest Hemingway, the painter Renato Guttuso, the musician Pietro Mascagni, and the tenor Beniamino Gigli.

The town of Fabriano is the paper-making capital of Italy and is home to the Paper and Watermark Museum, an institution devoted to chronicling the history of paper. Special paper, in particular personalized stationery, is handmade in Ascoli. Another craft here that reaches back over 500 years is the art of lace making, especially in Offida, Appignano, Castel di Lama, and Castorano. Many items made of straw are also produced in the region. Every year on the first Sunday in August Ascoli Piceno celebrates the *Giostra della Quintana* (Joust of the Quintana), a historical pageant with knights in armor and medieval festivities. After a procession of flag-tossers and revelers in fifteenth-century costume, the jousters prove their mettle by challenging the blows of a rotating Saracen.

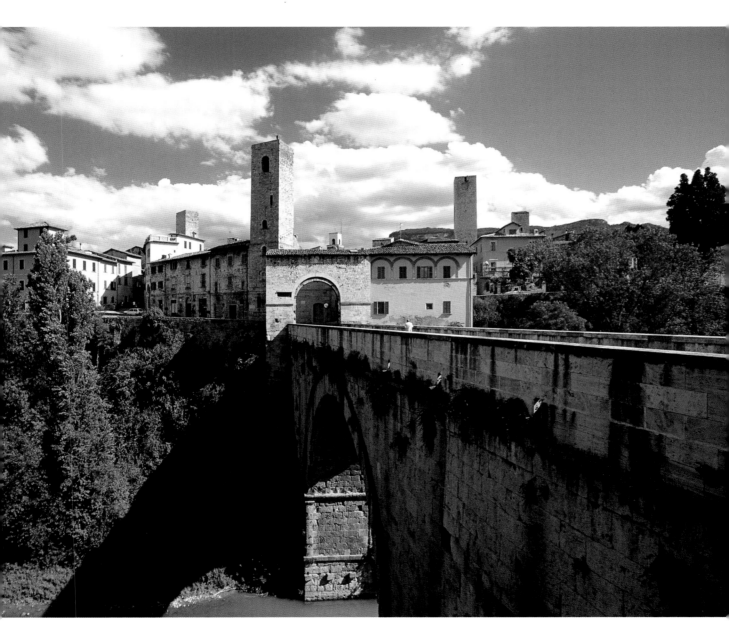

LORETO
A GIFT FROM THE CRUSADES

LORETO IS A SANCTUARY AROUND WHICH THE CULT OF THE VIRGIN has brought about the growth of a city where prelates, pilgrims, and merchants coexist. Even the dragons and sea monsters that enliven the Fountain of the Blessed Virgin created by the Italian architect Carlo Maderno (1556–1629) seem to be singing hymns to the Madonna. Local tradition tells of the night of December 9, 1294, when an intense light appeared in a forest of laurels (the name Loreto is derived from the Latin *lauretum*, meaning "laurels") on a hill not far from Recanati. It lit up the sea and the Apennine Mountains, and when people ran to see what had happened, they came upon a simple hut without foundations, supposedly the house in which the Virgin Mary had lived and where the Annunciation had taken place. Legend has it that angels carried the hut to the hills of the Marches from Nazareth, but it could be realistically supposed that the Crusaders, fearing that what they considered to be the house of Mary could be profaned, dismantled the sacred sandstone bricks, loaded them onto a ship, and rebuilt it in Loreto. One thing is certain, and that is that this modest building became one of the most celebrated objects of the Christian faith. In 1469 Pope Paul II transformed the Santuario della Santa Casa (House of the Virgin Mary) into the symbol of the cult of the Virgin and had the hut encircled by a wall to protect it from Turkish incursions. The pope ordered a great basilica to be built and conceded the first plenary indulgences to the pilgrims who came to visit. Artists involved in the building of the basilica were Antonio da Sangallo the Younger, Giuliano da Sangallo, Bramante, Sansovino, Vanvitelli, and Francesco di Giorgio Martini, among others. The hut lies under an octagonal cupola designed by Giuliano da Sangallo (ca. 1445–1516) (the second such cupola in the world after that of Brunelleschi's in Florence) and is protected by a marble facade. The humble interior, in which can be found the hearth where Jesus is said to have warmed himself when he was a child, contrasts with the grandiosity of the structure that contains it. There are numerous frescoes by the Umbrian School painter Melozzo da Forlì (1438–94) in the sacristy of San Marco and by Luca Signorelli (ca. 1441–1523), a pupil of Piero della Francesca, in that of San Giovanni. Only later were inns for pilgrims established, as well as a center for members of the clergy and administrators, a palazzo for civil authorities, taverns, and workshops for the manufacture of rosaries, statuettes of the Madonna, and *ex votos* (objects offered in gratitude to the saints or to the Madonna).

A detail of the Baroque Fountain of the Blessed Virgin on the Piazza della Madonna.

facing page
The sanctuary of the House of the Virgin Mary.

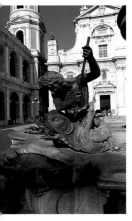

Rome, Mecca, and the Ganges River are places of pilgrimage familiar to all, but there are innumerable locales in the world that attract millions of believers of every possible faith. The first organized pilgrimage to the Holy House in Loreto occurred in 1319 under the pontificate of John XXII. Today four million pilgrims arrive each year and there is no telling how many there have been in centuries past. Traces of their passing can be seen in the two channels by knee-marks in the stone that surrounds the shrine. Many are famous names inscribed on a slab of marble in the corridor leading to the sacristy: Christopher Columbus, Bartolomeo Colleoni, Galileo Galilei, René Descartes, Queen Christina of Sweden, Wolfgang Amadeus Mozart, Joachim Murat, Stendhal, and Giacomo Casanova.

The making of rosary beads in Loreto is a unique craft with a long history that is connected to the cult of the Virgin. At one time the manufacture of rosaries employed almost all of the women in the village. Rosary beads made in Loreto are in high demand throughout Europe and are even exported to America. Tiny shops on the Via dei Coronari, the town's main street, offer a vast selection, including beads made from silver. In Recanti and the surrounding area artisans produce barrel organs, poor relations of the accordion, characterized by brightly colored casings and brought out for dances and village festivities. The organs are made of wood and paper and produce sounds by vibrating metal sheets. The Marches are world-famous for the production of accordions, which hold a double status here as precious objects as well as musical instruments. Accordions can be purchased at Serenellini in Loreto or at Castagnari in Recanati.

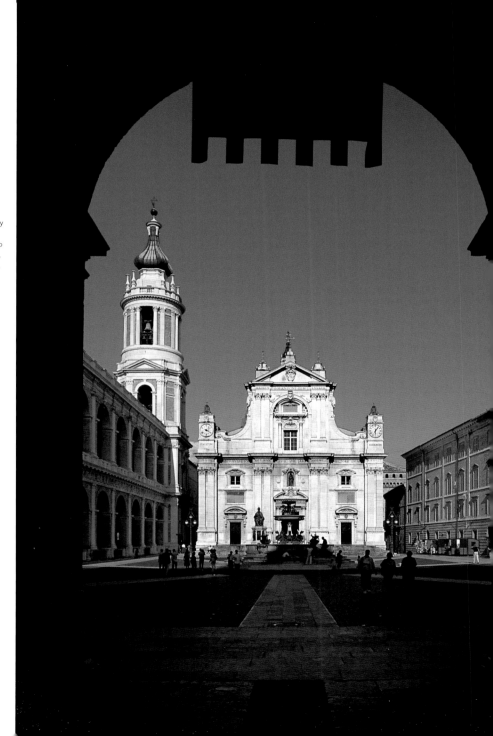

URBINO
RAPHAEL'S BIRTHPLACE

THE NATIONAL MUSEUM OF THE MARCHES IN THE DUCAL PALACE OF URBINO is one of the most prestigious art museums not only in the region but in all of Italy. It houses works by Piero della Francesca, Paolo Uccello, Francesco Laurana, and, of course, Raphael, who was born here in 1483 and went on to study painting under his father, the court artist Giovanni Santi. The building itself is an extraordinary complex, built at the beginning of the Renaissance by the architects Luciano Laurana and Francesco di Giorgio Martini for Duke Federico da Montefeltro (1422–82), the enlightened condottiere who transformed Urbino into one of the most prestigious cultural and artistic capitals of its time. The palace is a celebration of the Renaissance ideals of harmony and balance, evident in several of its attributes including the duke's study, a gem of intarsia work and trompe l'oeil scenes; the Cappellina del Perdono (a small chapel); the Salone d'Onore (also known as the throne room; the Sala degli Angeli (Salon of Angels), which takes its name from a series of friezes by Domenico Rosselli (1439–98); a set of doors designed by Sandro Botticelli (1445–1510); and an arcaded courtyard and magnificent hanging garden. In the first years of the sixteenth century the scholar Baldassar Castiglione described the Ducal Palace as "a city in the form of a palace," characterized by the unmistakable

Piazza Federico da Montefeltro seen from the stairway of the church of San Domenico.

facing page
The west wing of the Ducal Palace.

profile of the two *Torricini*, "little towers," of the main facade, but also symbolically by the monumental gateway to the city that welcomes those coming from Rome. Today, traces of the Renaissance mingle with the Gothic–Romanesque, with successive Neoclassical restructuring, and the extensive program of restoration that was begun in 1968. The recent restoration has, however, been discrete and respectful and has not damaged the beauty of the city, such that it remains a center for art and is recognized by UNESCO as a World Heritage Site for its exceptional street pattern, harmonious continuity from the Middle Ages onward, and the wealth of its architectural and artistic patrimony. Until the end of World War II the city lived within the bounds of the sixteenth-century ramparts, between the Poggio and the Monte, two hills bound by a series of undulating roads (Via Raffaello, Via Veneto, Via Saffi) that follow the ancient *Cardo Maximus* and the *Decamanus Maximus,* two of the main thoroughfares during the Roman period.

The National Museum of the Marches houses a rich collection of Renaissance masterpieces, including the *Madonna of Senigallia* and the *Flagellation of Christ* by Piero della Francesca (ca. 1420–92) and the *Ritratto di gentildonna* (known as *La Muta*) by Raphael (1483–1520). These paintings were stolen in 1995 but were returned to the museum a few years later. This has not been the case for hundreds of masterpieces "legitimately" removed three centuries ago. In 1600 there were more than a thousand paintings in the palace. When Francesco Maria della Rovere ceded the duchy to the Papal States, Cardinal Barberini stripped the museum of its best works; paintings, statues, and manuscripts were removed to enrich his own collection and to help him ingratiate himself with the powerful nobles of Europe.

Beyond the walls where modern Urbino thrives, there were once only fields and farmers' lodgings. Under the elegant towers of the Ducal Palace stood and still stands the Piazza Mercatale, the great esplanade designed by Francesco di Giorgio Martini, where farmers and shepherds once sold their produce and livestock.

Talamello is the uncontested home of the extraordinary "ditch" cheese, tender pecorino cheese aged in tufaceous rock hollows carved in the ground. Almost every household in Talamello has at least one ditch in their cellar for preparing cheese. The hollows remain cool and fresh year-round. In August they are lined with straw and filled with different types of pecorino cheese stuffed into sacks of jute. The ditches are covered with wooden lids, which are then sealed with plaster. Not until November are they opened and the savory aroma of pecorino wafts through the village. The aging cheeses take on irregular shapes and range in color from amber to light yellow. The taste is sharp and piquant and varies dramatically. Pecorino can be sampled at the Angolo Divino, a hospitable restaurant in the center of Urbino that was once an ancient palazzo.

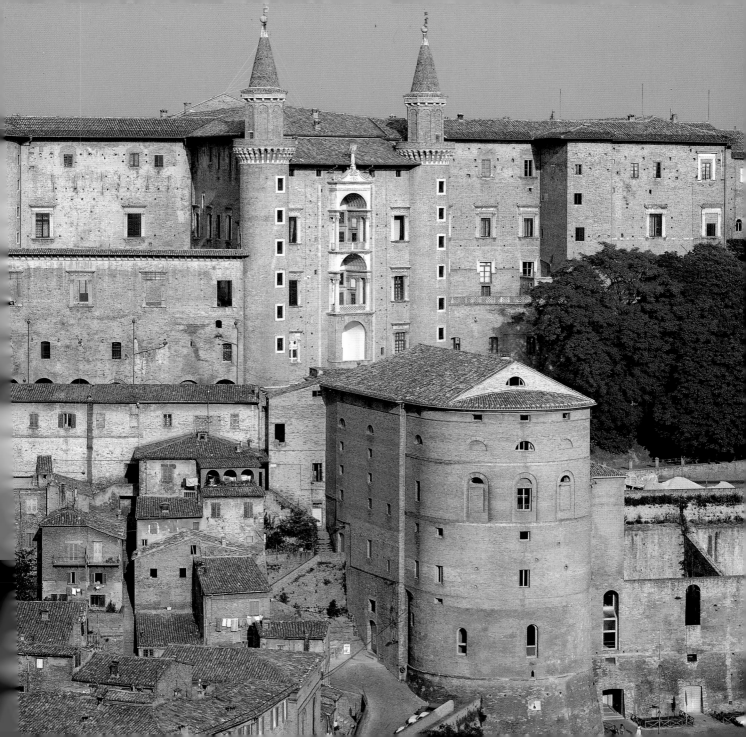

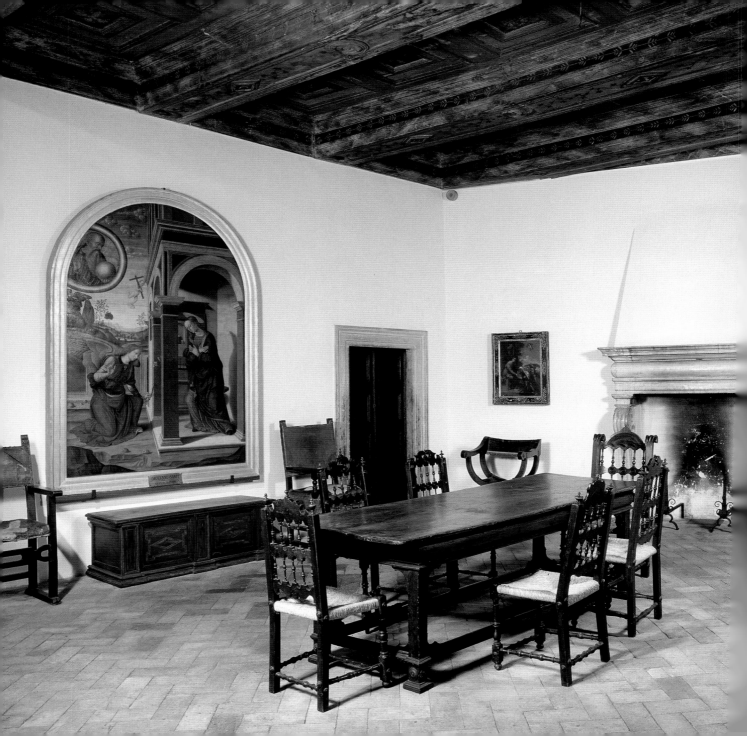

The poet Giovanni Pascoli studied in Urbino for seven years as a guest of the Raffaello College. In memory of his most famous verse, the city celebrates the Feast of the Kite on the last Sunday in August: "…now we are still: we have Urbino before us / windy: Each man jerks / his comet to the deep blue sky…" The six districts of Urbino hold kite competitions, with kites signifying each neighborhood's colors. The kites take off from the Albornoz Fortress and from Colle delle Vigne. A jury equipped with binoculars rewards the kite that flies the highest and farthest and is the most beautiful and original.

left
Inside the house where Raffaello Sanzio (Raphael) was born in 1483.

above right
A sixteenth-century ceramic plate.

right
The courtyard of the Renaissance Ducal Palace.

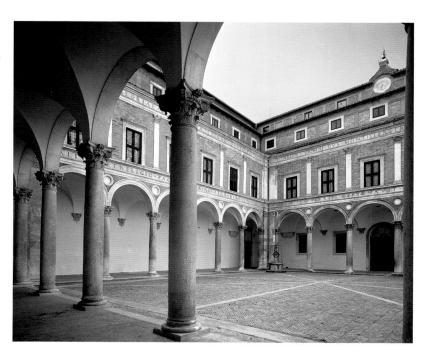

ANAGNI
FOUNDED BY SATURN

ANAGNI IS A NAME ONE LEARNS AT SCHOOL BY BEING SLAPPED. In this case it was a special slap to the face of a pope. The story goes that after various disagreements, Pope Boniface VIII was preparing a bill to excommunicate King Philip the Fair of France, who was openly anticlerical and determined to affirm his own absolute sovereignty. The French king replied by sending his emissaries to Anagni, where the pope was staying in the palace built a century before by the family of Pope Gregory IX. Their orders were to hold him prisoner and take him to France. On September 3, 1303, Guillaume de Nogaret, assisted by Sciarra Colonna, confronted Boniface VIII and gave him a resounding slap on the face. Perhaps it was only a metaphorical slap, but some days later the inhabitants of Anagni revolted and freed the pope.

The origins of the city are also the stuff of legend. It is said that Saturn, the Roman god of the harvest and the personification of time, took refuge in central Italy after the war between the Gods and the Titans. In Lazio he founded five cities, all beginning with the letter A: Alatri, Arce, Arpino, Atina, and Anagni. According to the Roman scholar Pliny the Elder (AD 23–79), even Saturnia, the first city founded by Saturn, was originally called Aurina. Anagni overlooks the Sacco River valley and from afar does not betray its medieval roots or its historical origins. Before it was conquered by the Romans, Anagni was the capital of the Hernici people, who built the massive walls of the acropolis and the imposing Arcazzi di Piscina, a series of arches resting on columns that were probably once part of ancient thermal baths. From a distance, the town appears to be a stand of great buildings nestled around a hill. It is only after entering the town that its noble palazzos are discovered and the monuments reminding us of a more flourishing time in Anagni, when it earned its nickname as the "city of the popes," is the past brought to life.

Anagni was for years a papal place of residence, and Popes Innocent III, Gregory IX, Alexander IV, and Boniface VIII were all born here. The cathedral, with its elegant loggia giving onto Piazza Innocenzo III, was built in the eleventh century and, although Gothic elements were added over time, its Romanesque and Lombardian characteristics remain intact. Inside is the crypt of San Magno, where a cycle of frescoes dating to the first half of the third century is preserved (they were restored to their original splendor between 1987 and 1999). This vast cycle was painted by at least three artists and bears witness to the passage from the Byzantine pictorial technique to the Romanesque.

The room in the Palazzo di Bonifacio VIII where the famous slap took place.

facing page
The crypt of the cathedral.

Fiuggi is a charming medieval village a few miles from Anagni and is known for its thermal springs. The healing waters found here were known to the Romans and began to be actively used between the thirteenth and fourteenth centuries. The water was even carried to Rome for the benefit of the popes. However, not until the beginning of the twentieth century did construction begin on hotels and thermal spas for public use. The springs (Fonte Bonifacio VIII and Fonte Articolana) are located outside of the old village and are surrounded by cultivated parkland. The fame of these curative waters immediately spread throughout Europe, thanks also to the fact that the king of Italy, Vittorio Emanuele III, visited them often. The mineral waters of Fiuggi are said to aid in the healing of kidney diseases.

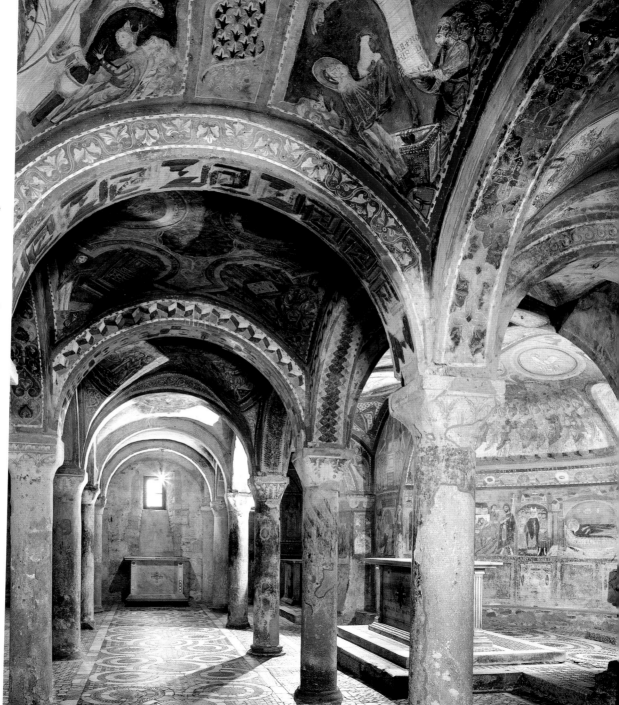

Panforte or *panpepato* is a typical sweetbread made in Anagni. Classic *panforte* has been prepared since Roman times and is based on a recipe incorporating candied fruit, cooked must, and honey—the most refined pastry chefs add layers of chocolate. The paste is baked in an oven after which it is cut into thin slices and served with a glass of local wine. The nineteenth-century Villa La Floridiana on the Via Casilina is an ideal place to book a room. The villa is surrounded by a park and is furnished in excellent taste. The food is also highly recommended. Those who prefer to stay in Fiuggi should book a room at the Grand Hotel Palazzo della Fonte, a sumptuous Art Deco building. For a taste of the local cuisine, dine at Schiaffo, a restaurant not far from the cathedral in Anagni, or the Torre al Centro Storico in Fiuggi.

TARQUINIA
ETRUSCANS OF THEN AND NOW

TARQUINIA IS SET IN A WILD LANDSCAPE RICH IN BEAUTY AND ANCIENT HISTORY. Once an important Etruscan city, it was also a center for art during the Middle Ages and the Renaissance. Founded around the tenth century BC by the Etruscan Tarconte, Tarquinia became a sacred place, where it is said the clods of earth that formed the divine child Tagete were taken from. Two centuries later Tarquinia imposed its power over the twelve Etruscan tribes and extended its territory as far out as Lake Bolsena and the Monti Cimini. It controlled the fords across the Tiber River and traded with Greece and the East. It also contributed to the greatness of Rome, when it submitted to the Tarquins (seventh to sixth century BC) two centuries later. Tarquinia's past is preserved in the marble blocks that make up some of its most important monuments, including its medieval walls (some five miles long) and the Ara della Regina, the largest temple in Etruria, where the winged terra-cotta horses that became the symbol of the city once adorned the pediment. More numerous and significant are the objects and frescoes discovered in the Etruscan Necropolis, where excavations have revealed thousands of tombs containing extraordinary riches. Vivid wall paintings depicting scenes from everyday life decorate the walls of many of the tombs and have helped archaeologists piece together one of history's most mysterious civilizations.

A winged horse from the pediment of a Tarquinian temple, now at the National Museum of Tarquinia in Palazzo Vitelleschi.

facing page
The twelfth-century Santa Maria di Castello.

There is, however, another way of exploring Tarquinia. In a great underground cave of tufaceous rock at the edge of the city, Omero Bordo, a tomb raider known as the "king of cracked pottery," has reconstructed seven of the most significant painted crypts that were found, complete with utensils and decorative objects. Called *Etruscopolis*, the exhibit enables the preservation of the more precious tombs not open to the public. Omero's fame is so far-reaching that news of his acts came to the attention of King Gustav of Sweden, who invited him to his court despite his illegal activities. Omero was, and still is, a great artist. He exhibits his false Corinthian vases, as though they were authentic, in museums and private collections in Italy and abroad. Omero presently lives in Tarquinia where he has a studio and sells his creations, each with the declaration that "they are handmade by Omero Bordo, the last Etruscan."

Southeast of Tarquinia, on the Monterozzi Hill, lies a vast necropolis that dates to the sixth century BC. It has made Tarquinia the most important archaeological site for the study of the ancient Etruscan people. There are approximately six thousand classified tombs, some of them discovered in the fifteenth and sixteenth centuries, some in the nineteenth century, and others during excavations that were begun in 1958. Each tomb is unique, but many of them have ornately decorated walls and are full of sculptures, urns, bronzes, household objects, coins, and jewelry. The artifacts are on display in the fifteenth-century Palazzo Vitelleschi, now the National Museum of Tarquinia, together with the reconstruction of four tombs from which frescoes were removed. Other famous tombs and those with the most beautiful pictorial decorations include the tombs of the Panther, Lioness, Juggler, Polyphemus, the Fowling and Fishing Tomb, the Bear, the Augurs, the Bulls, and the Tomb of the Leopards.

Tarquinian artisans specialize in handmade copies of Etruscan art objects, in particular works in ceramic or bronze. Tarquinia is even home to an art school for the creating of replicas of ancient works of art. These objects are often valuable and can be found at the shops of Marco Bocchio and Omero Bordo. Book a room at the Hotel Tarconte, a quiet inn with a wonderful view, or at the Torre del Sole in seaside Marina Velca. The Arcadia restaurant in the historic center prepares local fare. For a fish dinner, the Velcamare restaurant at the Tarquinia Lido is recommended.

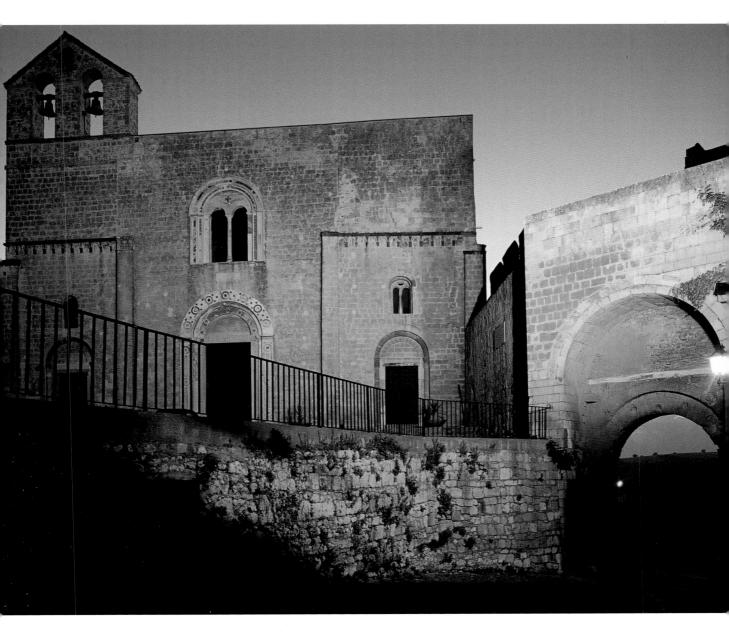

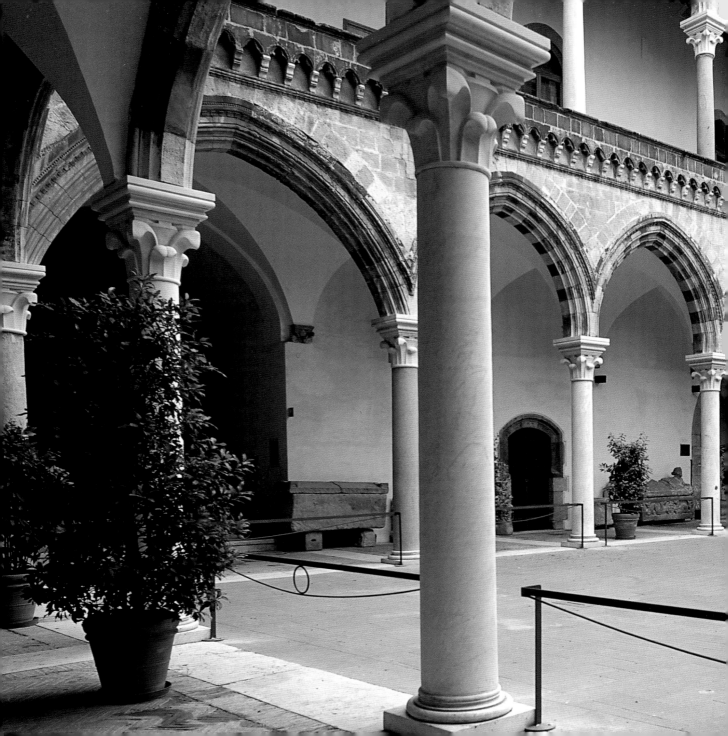

In addition to Tarquinia's treasure trove of Etruscan artifacts, many of the town's monuments speak of a later time, when it became a major center during the Middle Ages. The eighteenth-century Piazza Matteotti is home to the Gothic—Renaissance Palazzo Vitelleschi; the twelfth-century church of Santa Maria di Castello houses a splendid mosaic pavement; and the Duomo of Santa Margherita was rebuilt in the mid-seventeenth century after it was destroyed by a fire.

above
A view of Santa Maria di Castello.

below
Etruscan sarcophagi on display at the National Museum of Tarquinia in Palazzo Vitelleschi.

left
The cloister of Palazzo Vitelleschi.

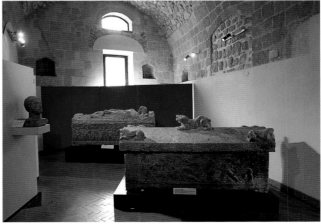

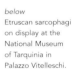

T I V O L I
TWO THOUSAND YEARS OF VILLAS

TIVOLI IS A PLACID TOWN IN THE ANIENE RIVER VALLEY, where several waterfalls cascade down the hills. The area is rich in travertine marble, a stone popular among the Romans and best known for its use in constructing the extraordinary Villa Adriana (Hadrian's Villa), built between AD 118 and 130 and one of the most spectacular examples of Roman opulence. The villa was personally designed by the Emperor Hadrian, who was inspired by the buildings he had admired during his travels in the East and through Greece. The Roman poet Horace once lived to the north of the town, but complained, "there is no more land left on the Tibertine plain to cultivate with the plough." Indeed, the nature of the territory itself, with its crisp air and mild climate, was appealing to individuals seeking pastoral retreats, and construction throughout the ages produced many famous villas, including the sixteenth-century Villa d'Este and the nineteenth-century Villa Gregoriana.

Fountains in the gardens of the Villa d'Este.

facing page
Villa dell'Isola in the complex of Villa Adriana.

Tibur was a Sabine village before it was discovered and occupied by the Romans, who transformed it into a residential area for senators and nobles and built the Tiburtina, a road that simplified travel to and from Rome. Remains of the Roman era include parts of the battlements, the amphitheater, the Temple of Vesta on the Acropolis, the Temple of the Tosse, and the sanctuary of Hercules on the Tiburtina. After the fall of Rome, Tivoli blossomed into a medieval village dotted with houses characterized by towers bordering the Piazza delle Erbe. Churches in the Romanesque style graced the town: Santa Maria Maggiore, San Pietro in Carità, San Silvestro (also noted for its twelfth-century frescoes and its bell tower), and the seventeenth-century cathedral of San Lorenzo. When Tivoli ceased to be a free commune it fell under the auspices of the Papal States and other important monuments were raised, such as the Pia Fortress built by Pope Pius II using stones from the Roman amphitheater, the Palazzo del Comune, and the grandiose Villa d'Este, begun in 1550 by Pirro Ligorio for Cardinal Ippolito d'Este. The villa's splendid terraced garden is a celebration of romantic whimsy and, above all, water, which is playfully tossed about by elaborate fountains. The Villa Gregoriana park, built by Gregory XVI, who, in 1832, diverted the Aniene to form a great waterfall, was inaugurated in 1835, with grottos, galleries, paths, ancient ruins, and statues.

Villa Adrianna spreads over at least seven miles with pavilions tastefully sculpted into the natural scenery of the landscape. It was built between AD 118 and 130 by Emperor Hadrian himself, a cultivated individual and a soldier and politician with a true passion for architecture, and is the largest building complex of Roman antiquity. The villa was meant to recall places dear to the emperor's memory or sites that had impressed him during his many voyages abroad and in the provinces. For example, the Pecile is a replica of the *Stoà Poikile* (a portico with a front colonnade) in Athens, while the Valle di Tempe evokes Thessaly. The Canopo is an area of water that is reminiscent of the canal that once connected Alexandria to Canopus on the Nile. Works of exceptional beauty have been found in the villa, such as sculptures of centaurs in gray marble by the Aphrodisian artists Aristeas and Papias, and a mosaic of doves, executed in such a refined technique and with tesserae so small and irregular that the spaces between them are undetectable.

The Acque Albule bath complex has been famous since ancient times. The thermal springs here are so called for the off-white color that appears on the surface of the water when carbon dioxide is released and hydrogen sulphur is dissolved in the water. Covering an area of almost 53,820 square feet, they are Europe's most important thermal springs and form the small but deep lakes, Regina and Colonnelle (129 and 231 feet, respectively). The Acque Albule were known by the ancient Romans, and much appreciated by Nero. The emperor had the waters diverted to his Domus Aurea on the Colle Oppio in Rome. Emperor Hadrian used them to fill the pool at his Villa Adriana. In modern times the springs were developed from 1850 on and were restructured in the 1920s. The waters are said to ease irritations caused by skin diseases, as well as respiratory allergies and post-traumatic stress disorder.

TUSCANIA

A BALCONY OF TUFA IN LAZIO

HALFWAY BETWEEN THE TYRRHENIAN SEA AND LAKE BOLSENA, Tuscania stands at the center of the *Maremma* (marshland) of the Lazio region. The town is a vast and undulating plateau of porous rock modeled over time by nature, with deep crevices excavated for thousands of years to make building blocks and caves—homes for the living and the dead. From the churches and the defensive walls of the city to the noble palazzos, modest homes, and burial monuments, the entire town has been sculpted from tufaceous rock. Tufa is a beautiful warm-colored stone and is easily worked into all kinds of shapes. Its malleable qualities have, however, made it difficult for researchers to date many of the town's buildings. The ancient Etruscans played with tufa in the queen's grotto, and sculptors and artists made beautiful sculptures from it to decorate their churches. An abundance of Etruscan tombs lie in the surrounding countryside but there is none larger and more extensive than that of the queen's, a labyrinthine maze of chambers, corridors, subterranean passages, stairways that descend for hundreds of feet connecting one floor with another, and about thirty sarcophagi (these are now in various museums). Tuscania was severely damaged by an earthquake in 1971, but the core of the city seems to have been frozen in time. The houses and palazzos overlook narrow streets that open onto piazzas leading to hidden cul-de-sacs where cults are said to have once convened. It is perhaps for this reason that one marvels at the sight of the monumental church of San Pietro at the top of the hill where the acropolis can be found. San Pietro stands in solitary splendor on a great grassy square surrounded by the remains of the walls, its back to the city and its facade facing the bridge over the Marta River and the ancient Via Clodia leading to Rome. Tuscania was donated to the church by Charlemagne at the end of the eighth century and built on seven hills like Rome; it was indeed a copy of the capital and became a holy, fortified center. The facade of the twelfth-century church of Santa Maria Maggiore resembles the nearby church of San Pietro that was founded in the eighth century and renovated in the eleventh century. From the time San Pietro was built, the village had grown to such an extent that its progress encroached on the church. In 1495 it was sacked during an invasion by French troops under Charles VIII, after which city officials decided to repair the damages. Other churches worth visiting include the Duomo, the Romanesque San Marco, and the Gothic–Romanesque Santa Maria della Rosa.

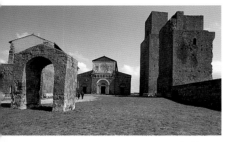

The monumental complex of San Pietro surrounded by an intensely green lawn.

facing page
A detail of the portal leading to the church of San Pietro.

Lake Bolsena is the largest volcanic lake in Europe. Many old and beautiful villages surround its shores, such as Capodimonte, Marta, and Bolsena, and the two islands of Martana and Bisentina. It is said that Theodoric, king of the Visigoths, had his wife, Amalasunta, murdered on Martana. Bisentina, where the Farnese Castle dominates the horizon, can be reached by boat from Capodimonte. The island preserves many important architectural gems, such as the convent and church of Saints Giacomo and Cristoforo, the church designed by the architect Jacopo Vignola, and seven small oratories or chapels. Bolsena, the ancient *Vulsinii*, is dominated by the twelfth- to fifteenth-century Monaldeschi Castle. The Chapel of the Miracles can be found in the Romanesque Basilica of Santa Cristina, which was rebuilt in the seventeenth century to contain the relics of the miracle of Corpus Domini in 1263: during the celebration of the Eucharist, it is said that the host dripped with blood and stained the marble of the altar.

Two small and modest hotels in the historic center offer intimate rooms and excellent cuisine: the Locanda di Mirandolina is a family-owned guest house with a restaurant, and the Hotel Al Gallo is furnished with antiques and known for its varied and imaginative kitchen. If you prefer to stay closer to Lake Bolsena, book a room at the Royal, a hotel steps away from the water. Traditional cuisine can be had at Da Dante, the oldest trattoria in Montefiascone, or at Da Picchietto, a fourteenth-century palazzo near the ancient portal to Bolsena. Tuscania is famous for its handmade products in leather, wood, and terra-cotta. Souvenirs can be purchased at Barlozzini.

VITERBO
REFUGE OF THE POPES

VITERBO WAS THE CAPITAL OF ANCIENT TUSCIA, a region of Upper Lazio that stretched from the Tyrrhenian Sea and from the *Maremma* (marshland) of Lazio as far as the Cimini Mountains. Three thousand years ago the Etruscans lived here and their presence has remained, scattered in the necropolises and collected in the museums. Two thousands years later Tuscia became the privileged fiefdom of the popes and the noble families associated with the Church, and, over a period of four hundred years, it was the place where princes and cardinals built fortresses and grand houses with sumptuous gardens. It could be said that every village in the region was founded by the Etruscans and ennobled by the Popes. The Renaissance Palazzo Farnese at Caprarola and Villa Lante at Bagnaia, with its magnificent Italian garden, are the most outstanding examples of the work of the architect Giacomo da Vignola (1507–73). Common representations of Tuscia are watercolors depicting villages built out of tufa, castles, forests and sunny beaches, fields of grain and olive groves, and *butteri* (cowboys) and their herds grazing on meadows where once brigands and saints passed each other.

The thirteenth-century Palazzo Papale.

facing page
The elegant gardens of Villa Lante in Bagnaia.

Viterbo is known as the "city of the popes," and a first visit should include the Palazzo Papale (Papal Palace). From 1268 to 1271, the eyes of Catholics around the world were set on this building, where it took cardinals over thirty-three months to elect Pope Gregory X, successor to Clement IV. The palace was begun in 1255 and, with the loggia, finished in 1267. It is the pride of the city, but the medieval district of San Pellegrino, is one of the most interesting and best preserved in the region. Tours begin on Piazza Plebiscito; to the left stands the Palazzo del Podestà and the church of Sant'Angelo; to the right is the Palazzo dei Priori. Continuing along Via San Lorenzo one arrives at the Renaissance Palazzo Chigi and the Romanesque church of Santa Maria Nuova, perhaps the most beautiful church in the city. Reaching the Piazza della Morte, walk under the colonnade of Palazzo Farnese to Piazza San Lorenzo, where the Romanesque Duomo, Chiesa di San Lorenzo, stands. From Piazza della Morte, walk along Via San Pellegrino, flanked by houses with unique exterior staircases and coats of arms decorating their facades. Intimate piazzas, crenellated towers, and graceful arches adorn the streetscapes. The museum of the Macchina di Santa Rosa displays a tower that is ninety feet tall and weighs five tons. On the evening of September 3, it is carried on the shoulders of a hundred men along the darkened streets and lit with thousands of flickering candles, which is why it is called the *torre rovente* (burning tower).

The garden at Bomarzo was called the "sacred forest," but there is nothing sacred about it as it is said to be inhabited by monstrous figures sculpted from stone representing exotic animals and mythological and demonic creatures. Prince Vicino Orsini had it built in 1552 beside the Villa delle Meraviglie (Villa of Marvels) in memory of his wife, Giulia Farnese. The architect was Pirro Ligorio, who, after the death of Michelangelo, was called to work on Saint Peter's Basilica in Rome. The garden was abandoned for hundreds of years and was called the "park of monsters" because it was covered in weeds and brambles forming terrible and unrecognizable shapes.

The Grand Hotel Salus delle Terme and the Hotel Nibbio in the historic center are both excellent hotels that offer the full run-down of health and beauty treatments. Several restaurants in the city prepare local cuisine, such as La Zaffera in the San Pellegrino district, located in the former convent of San Bernardino. The Tre Re restaurant behind the Piazza delle Erbe dates to 1622 and is the oldest in Viterbo. Il Ricastro is set in a romantic sixteenth-century palazzo, as is the elegant Enoteca La Torre, a beautiful vaulted wine cellar. Sample the gelato at Chiodi while shopping for souvenirs at Cencioni. Local crafts made from Art Deco cast iron and hemp can be found at Matteucci.

179

L'AQUILA
NINETY-NINE FOUNTAINS

ONE SHOULD REACH L'AQUILA BLINDFOLDED SO AS NOT TO SEE THE ELEVATED MOTORWAYS that surround and almost suffocate the city. The inhabitants prefer to keep their cars outside the city walls, far from the daunting narrow streets and the crowded but lively squares. The story of L'Aquila's beginnings is not a glamorous one, but one worthy of recounting. In the middle of the thirteenth century, under orders from Emperor Frederick II of Swabia, ninety-nine local squires put aside their futile territorial quarrels and built a city in a hollow surrounded by the mountains of the Gran Sasso and the Sirente. They called it Aquila because of the many rivers flowing through the land (*Acculum*). It immediately became an important center for trade and was visited by merchants from all over the world. The names of some of the streets in the old city are an indication of L'Aquila's wealth and beauty: Via dei Lombardi, dei Veneziani, dei Francesi, and degli Alemanni. The ninety-nine founders are remembered with ninety-nine city wards, squares, churches, and ninety-nine peals of the Reatinella bell, sounded after sunset to signal the closing of L'Aquila's four gates. The Reatinella was eventually melted down to make cannons, but its bell tower still tolls from the piazza. There are ninety-nine *cannelle* (spouts) coming out of the third-century Fontana delle 99 Cannelle, the city's best-known monument and its symbol. Also worth a visit is the Basilica di Santa Maria di Collemaggio, built in 1287. The facade is characterized by striated white and pink hewn stone and three fifth-century portals. The structure stands on a great space of hallowed ground and is a masterpiece of Gothic–Romanesque architecture built under orders of Pietro del Morrone, who was crowned Pope in the austere interior. He took the name of Celestine V and was consecrated on August 29, 1294, after a conclave in Rome that lasted twenty-seven months. The event is remembered today during the feast day of Perdonanza Celestiniana (Celestine Pardon), which commemorates a plenary indulgence granted by the new pope during the two months of his stay in the city. On the evening of August 28, the archbishop reads the Bull of Pardon and the Holy Door is opened. The following day the faithful enter the basilica to pray before the relics of the saint in order to obtain absolution for their sins.

The impressive Gran Sasso Mountains.

facing page
A detail of the Fountana Delle 99 Canelle (Fountain of the 99 Spouts).

The Gran Sasso range traces the crest of the Apennines. The Corno Grande (Big Horn) rises to a height of over nine thousand feet and is the highest point of the Apennines. The mountain group includes the Calderone Glacier, the southernmost in Europe. The National Park that includes the Monti della Laga and the Monti Gemelli is one of the largest in Italy. It covers over 370,000 acres and encompasses a great variety of flora and fauna. Some of the town centers are worth noting: Amatrice preserves artistic works from the thirteenth and sixteenth centuries; Arquata del Tronto is a medieval village dominated by its Rocca (fortress); Colle's ancient charcoal-burning areas are still in use; Campli is home to the necropolis of Campovelano; and Civitella del Tronto is also well known for its fortress. Nearby is a pathway that crosses the fascinating Salinello gorges.

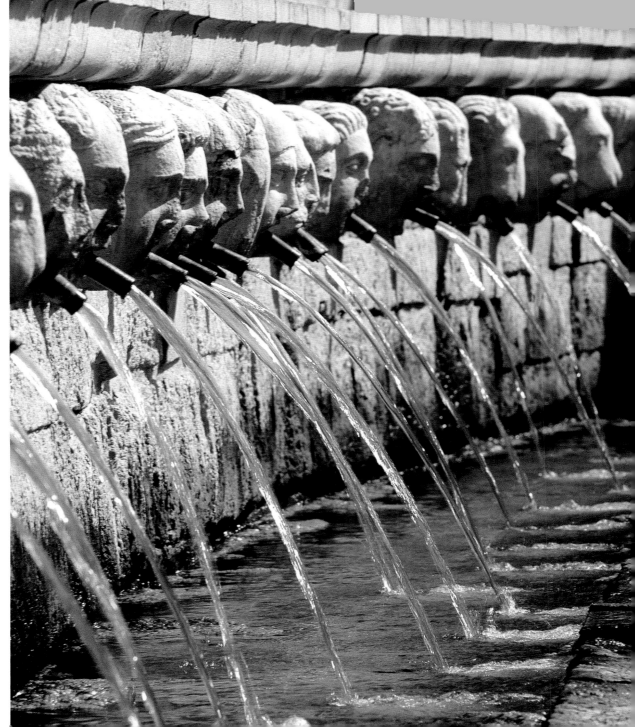

It is said that the Benedictine nuns of Cluny introduced lace making to L'Aquila in 1700 and taught it to the locals. Since then a particular kind of lacework has developed in the area called *fuselli*, a technique that employs wooden spokes around which yarn is plaited. *Tombolo aquilano*, as lace making is known in Italian, is even more popular in Scanno and Pescocostanzo, where lace is made to order. The Abruzzo has an ancient tradition of craftsmanship; for example, ceramics have been produced in Castelli on the slopes of the Gran Sasso since 1500. It is possible to visit the many workshops in the area and admire this artistic process. Sulmona is noted for artisans working in gold, as is Scanno and Pescocostanzo. Objects made from beaten copper can be found in Guardiagrele, while Pretoro is known as a center for wood carving.

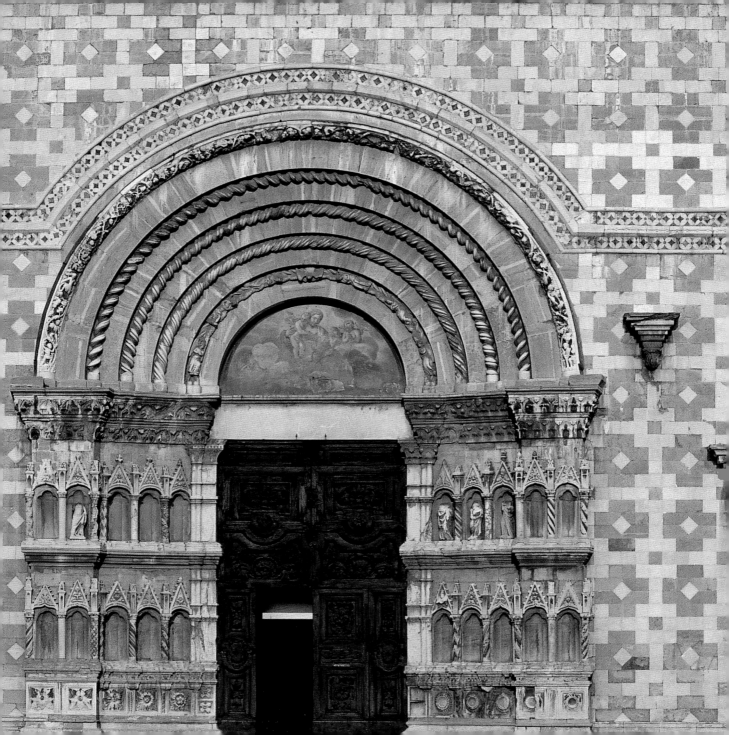

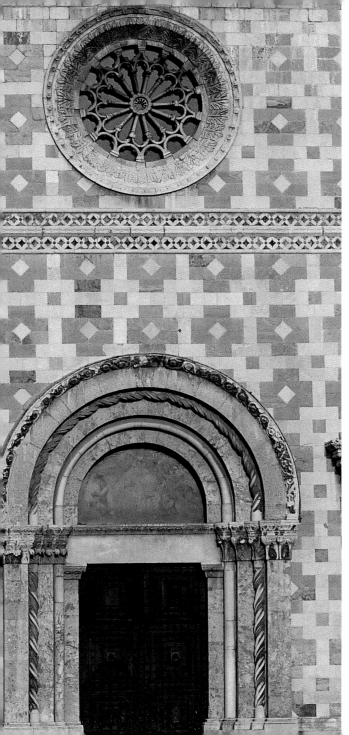

The Grand Hotel del Parco is surrounded by a lush green park. Local specialties from Abruzzo can be found at the restaurant Elodia in Camarca or at the Della Conca farm. In Santa Stefano di Sessanio, about twenty-eight miles east of the city, a fortified medieval village has been recreated, with hotels, restaurants, and craft shops.

The colonnade of
Via San Bernardino.

left
A detail of the patterned facade of the Basilica di Santa Maria di Collemaggio.

below
The sixteenth-century fortress built by Don Pedro of Toledo.

ORTONA
THE FARNESE PROMENADE

THE SEA IS SLOWLY ERODING THE PORTSIDE TOWN OF ORTONA as if it were a pile of sand near the tide's ebb. The 693-foot-high spur of fragile sandstone rock on which the town rises is literally falling into the ocean. During World War II the Castello Aragonese (Aragonese Castle), the pride of the city, was the site of a battle that lasted twenty-four days and caused considerable damage. Although it had been weakened by bombardments, it managed to remain intact until 1946, when a devastating landslide destroyed a large part of the castle's north wing. Erosion has probably been occurring here since before the ancient Frentani peoples settled on the hill in the sixth century BC. The promontory itself must have stretched further out to sea and consisted of a village and a port for trader ships from Illiria. The Romans, who used the city as a launching pad for incursions against pirates, were constantly plagued by landslides. As a result, we are left with nothing but conjecture about Ortona's distant history. A part of the possible architectural testimony has drowned in the sea, and what is left has been recycled to provide for more urban space. The present Corso Matteotti, extending from largo Plebiscito to largo Castello, was most probably the main thoroughfare during Roman times. A temple to Janus once stood where the Duomo now resides, while the acropolis occupied the castle grounds.

Two fishermen preparing their nets.

facing page
The Aragonese Castle.

The Aragonese Castle, built by King Alfonso of Aragon in 1452, is one of the most representative examples of fortress architecture from the period between the Middle Ages and the Renaissance. The remaining fortifications seem to embrace the sea that erodes them. The original trapezoidal plan was characterized by four cylindrical towers, marking the corners and high walls that joined them and enabling the sentries to do their rounds. The castle can be reached by crossing Terravecchia, a neighborhood characterized by narrow streets and arches. It was erected in the Middle Ages between the cathedral of San Tommaso, which underwent renovations in 1127, and the Palazzo Farnese, which was begun in 1584. The Passeggiata Orientale, a walkway with a breathtaking view of the sea, overlooks the port. It is particularly romantic at sunset, when many fishing boats idle home after a day's work.

Lanciano was an ancient community of the Frentani peoples and later a colony of the Romans, and is found in the Feltrino River valley, just south of Ortona and several miles from the coast. During the Middle Ages, it was a center for the production of wools, silks, ceramics, leather, bronze, and iron utensils, and gold jewelry; many local artisans carry on these traditions today. The two main districts of the area are Civitanuova, where imposing medieval ramparts and towers have been well preserved, and Lancianovecchia (the Roman *Anxanum*), which is surrounded by battlements punctuated by dramatic gateways. Among the more important monuments is the cathedral of the Madonna del Ponte, built in the fourteenth century, the sanctuary of San Francesco del Miracolo Eucaristico, and the churches of Sant'Agostino and Santa Maria Maggiore.

Ortona's cathedral has ancient roots but was reconstructed numerous times—the first time in the twelfth century. The Baroque churches of Santa Caterina and San Rocco are worth a visit to see the beautiful cross of Santa Brigida, dating to 1360. The elegant Palazzo Farnese is attributed to Giacomo della Porta (1533–1602), one of the leading architects of the late sixteenth century. From the Hotel Ideale there is a broad vista of the tranquil countryside. *Agriturismo* (local hospitality) is ample at Agriverde in Caldari, where only biological products produced at the farm are used to fertilize and tend to the soil. The farm sells its renowned extra-virgin olive oil here. From Miramare there is a beautiful view of the sea and the rich local fare is based mainly on fish.

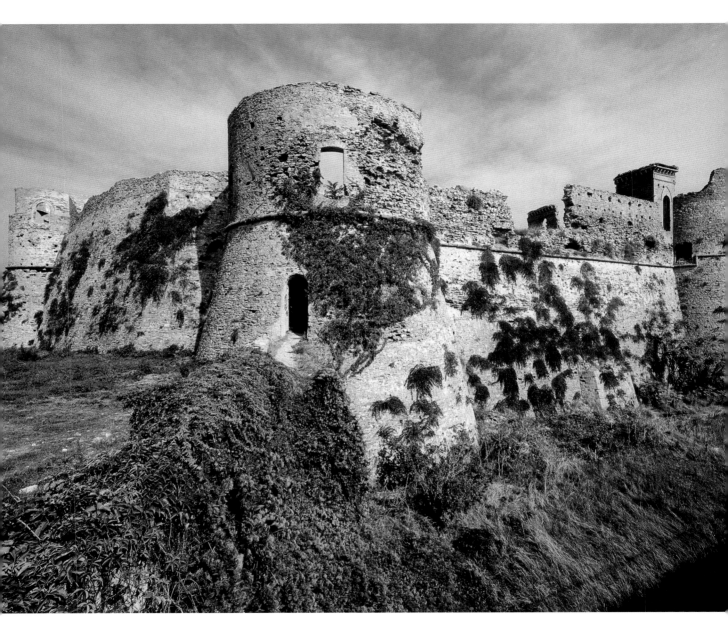

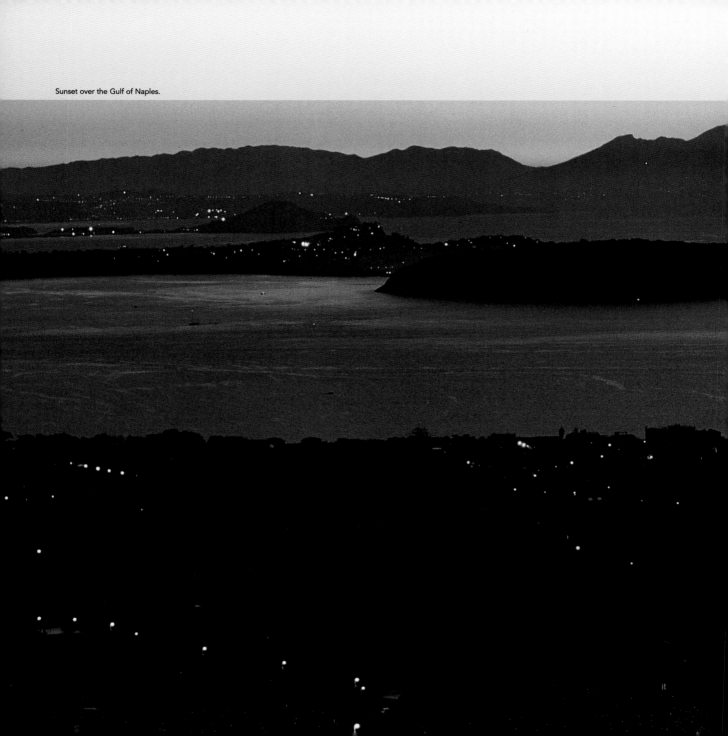

Sunset over the Gulf of Naples.

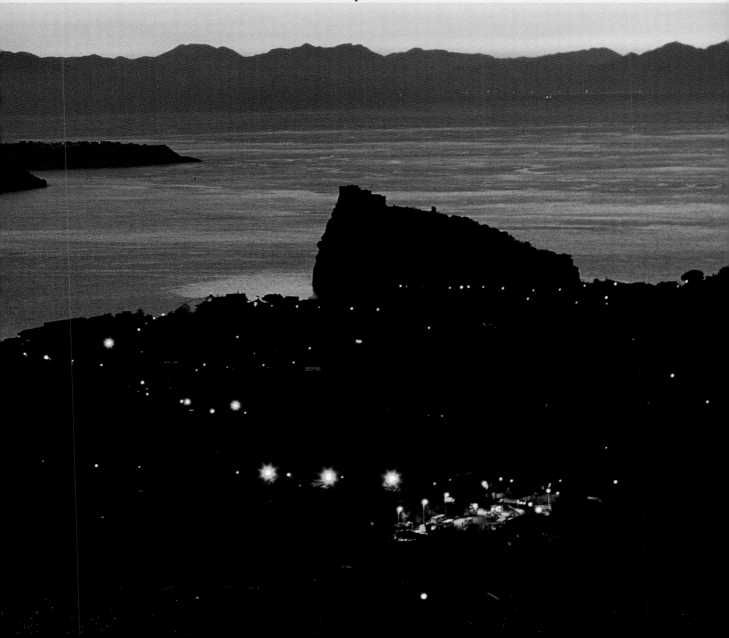

SOUTHERN *Italy and the* ISLANDS

AMALFI
ARABESQUES ON THE SEA

THE TWENTY-TWO-MILE STRETCH THAT COMPRISES THE AMALFI COAST is one of Italy's most dramatic, with plunging cliffs, shimmering seaside towns, and perhaps the bluest waters of the Tyrrhenian Sea. Many of the villages that dot the coastline were once sleepy fishing ports, but their unmatched beauty has turned them into bustling tourist meccas. The hillsides teem with lemon and orange groves and brilliant flower gardens that tumble down toward the dazzling beachfronts. A village at the mouth of the Valle dei Mulini (Valley of the Mills), the sea has always commanded Amalfi's destiny. During the tenth and eleventh centuries Amalfi became one of the four Maritime Republics and grew into a prosperous and influential dominion extending as far back as the Duchy of Naples. It established commercial colonies in the Mediterranean, participated in the Crusades, and instituted the Order of Saint John in Jerusalem (from which the Knights of Malta originated). Of particular note, the *tablula amalphitana*, preserved in the Civic Museum, is the maritime codex containing the laws and customs of the ancient republic. In 1302 Amalfi witnessed the invention of the compass, attributed to Flavio da Amalfi, which opened up new horizons in navigation. The town was sacked by the Pisans in the twelfth century, leaving it powerless and subject to the rule of the kingdom of Naples.

For nineteenth-century romantics, Amalfi's basking-in-the-sun glory provided the perfect summer retreat. Its gently sloped profile resting on the side of the Lattari Mountains is punctuated by curving passageways that lead from the sandy beaches below to the town's impressive monuments. One must-see is the Duomo, or Cattedrale di Sant'Andrea, built during the eleventh century but characterized by a strong Byzantine-inflected architectural style. Centuries back, the greatest galleys of Europe ploughed the waves that brought Amalfi back to greatness. Amalfi's status as the Queen of Hospitality stems from the many luxury hotels built upon the ruins of its old convents. These plush retreats turned the town into a hot spot for an elite class of tourists. A few miles down the coast and up a steep, snakelike road, the elegant village of Ravello sits perched on a promontory from where one of the most beautiful vistas of the Gulf of Salerno can be seen. Removed as it is from the clamor of high society, Ravello enjoys a tranquility that was not a part of its historical past, when it took part in lucrative trading with the East. The emblem of Ravello's Levantine spirit is its Vescovado Square, where visitors can explore the eleventh-century Duomo and the Villa Rufolo, an Arab-influenced pleasure-palace with splendid gardens that provided the inspiration for Richard Wagner's opera *Parsifal*.

facing page
Night descends over the Bay of Naples.

below
The Cattedrale di Sant'Andrea.

Set high on a ridge above Amalfi, Ravello is home to the breathtaking Villa Cimbrone, created in 1905 by England's Lord Grimthorpe. Grimthorpe turned this once-decaying thirteenth-century palazzo into a lofty abode 1,500 feet above the sea. On the extreme end of a rocky spur is a garden with marble statues and busts. A romantic pathway leads from the garden to the Belvedere dell'Infinita (Belvedere of Infinity), a terrace overlooking the sparkling Gulf of Salerno. The villa is now a sumptuous hotel with tasteful interiors, a great Renaissance fireplace, and a collection of antique books. Villa Cimbrone can only be reached by foot.

Amalfi is known for its paper mills, which have existed long before the twelfth century. Originally learned from the Arabs, the art of papermaking in Amalfi was a manual process until the 1700s, when other methods began to be introduced. At the end of the eighteenth century, the Valle dei Mulini was home to sixteen paper mills. Today about ten remain, two of which produce paper the way it was done long ago, when rags of cotton, linen, and hemp were mashed in great stone basins using huge water-powered hammers. The resulting pulp was collected in a vat into which a mesh frame of metal was immersed. The paste was then distributed onto the mesh to create sheets and the water was drained off. Sheets of paper were dried by stacking them in alternate layers of wool. Visitors can follow the process step by step at the Museo della Carta (Museum of Paper), once a fifteenth-century working mill.

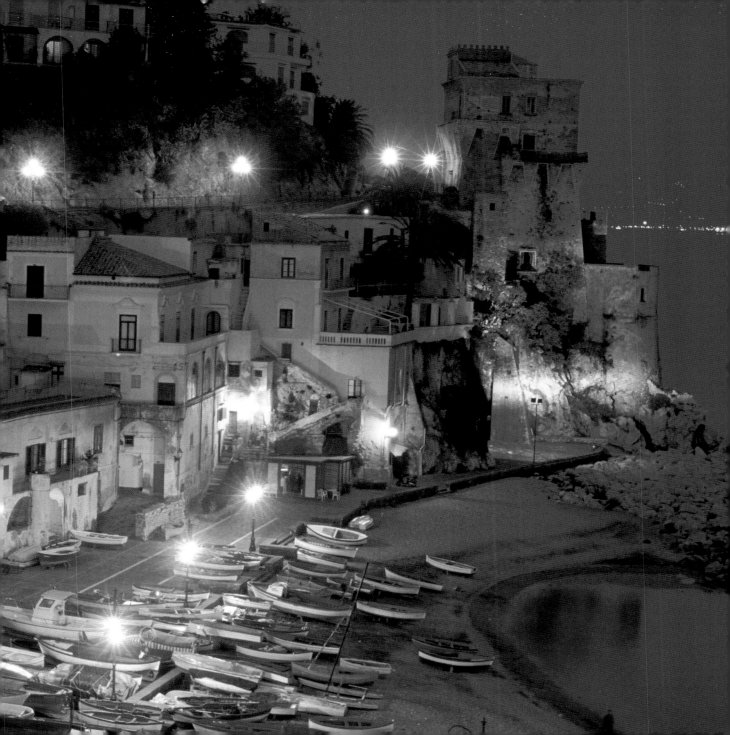

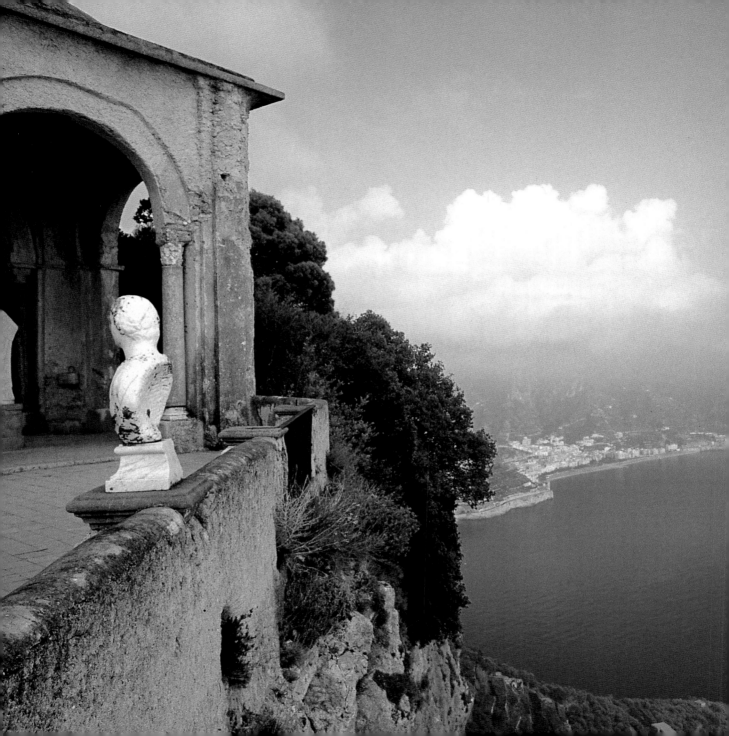

Every four years Amalfi organizes a historical regatta, which the four ancient Maritime Republics have hosted in turn since 1955. In 2005 Amalfi will once again host the event. Before the actual regatta, a costumed procession takes place on gold-painted boats. Each boat carries the symbol of its city: the lion of Saint Mark for Venice, the griffin for Genoa, the eagle for Pisa, and the pegasus for Amalfi. The event is of such great importance that in 1961, on the occasion of the centenary of the Unification of Italy, it was also held in Turin on the Po River. The regatta took place in New York in 1959 and in London in 1983.

left
The Belvedere of Infinity overlooking the Gulf of Salerno in Ravello.

right
Hints of Moorish-style architecture at the Cloister of Paradise.

CAPRI
EMPERORS' PARADISE

THE ISLE OF CAPRI IS A GREAT JAGGED ROCK SURROUNDED BY some of the deepest-blue waters of the Tyrrhenian Sea (it is also known as the "Blue Island") and was once described by Henry James as "beautiful and obsessive." Capri lies at the center of many legends and ancient tales, such as Homer's *Odyssey*, in which it was the home of the Sirens, who, with their sweet songs, attempted to lure the hero Odysseus to

The three limestone Faraglioni cliffs under a golden sunset.

facing page
The first lights appear in the village as evening approaches.

his death. The Roman emperors Augustus and Tiberius both built sumptuous palaces atop lofty cliffs here, fit with reflecting pools and hanging gardens overlooking the sea. Dozens of nineteenth-century Romantic poets and writers culled inspiration from the island's charm and it became an obligatory stop on the Grand Tour, particularly after the discovery of the Grotta Azzurra (Blue Grotto) in 1826. Not even the legendary stars of Hollywood could resist the calls of the Sirens.

Although Capri is only seventeen miles from the buzzing city center of Naples, time seems to slow down on the island. There is much to discover that is hidden by Capri's thick vegetation, such as ancient ruins and celebrity villas. The Piazza Umberto I, also known as the Piazzetta, is the island's hub, where elegant cafés aglow with some of the most glamorous vacationers to visit the coast spill out onto the tiny square. Highly recommended are hikes along the winding cliffside paths that rim the island's plunging coastline. Capri's best-known feature is undoubtedly I Faraglioni, the mysterious geological rock formations at the southeastern part of the island. Capri is surrounded by a network of fifty-five caves, the Blue Grotto being the most famous of them all. The grotto and its spectacular azure-colored water can be reached by boat from the Marina Grande or by bus and boat from Anacapri. Postcard-perfect views of I Faraglioni can be enjoyed from Via Tragara or from Tiberius' Leap. A sweeping vista of the entire gulf from the top of Mount Solaro (reached by chairlift) is an ideal spot for amateur and professional photographers alike. The island is easily explored with a map and a good pair of walking shoes. Romantics should not pass up an outing to Villa Jovis, Tiberius' main residence, located at the summit of Capri's eastern precipice. Although island flora has grown over most of what remains of the villa, the aura of the place is otherworldly. The ruins of Tiberius' summer palace, the Villa di Damecuta, are in Anacapri and offer up beautiful views of the Bay of Naples.

The Piazzetta has long been a meeting point for celebrities, and the English writer Norman Douglas rightly described it as "the smallest theater in the world." Famous names in entertainment, literature, business, and the arts, including the Irish-born writer Oscar Wilde, the Futurist painter Tommaso Marinetti, the French composer Claude Debussy, Jacqueline Kennedy Onassis, Princess Margaret of England, and the Aga Khan have all been spotted here. Since the 1950s Capri has been a favorite backdrop for film productions, such as *Strangers*, directed by Roberto Rossellini and starring Ingrid Bergman, *The Bay of Naples* starring Sofia Loren and Clark Gable, and Billy Wilder's *Avanti!* with Jack Lemmon. Rita Hayworth, Kirk Douglas, Audrey Hepburn, and Elizabeth Taylor are among the many Hollywood actors who have spent holidays on Capri.

There are several romantic hotels on Capri, including La Scalinatella, which is fitted out with antique furniture, and the Palace Hotel in Anacapri, which was built where the great palace of Augustus once stood. The Palace Hotel boasts a suite that is 1,506 square feet and a hanging garden and a private, heated pool. The restaurant La Terrazza is one of the best on the island. The Quisi restaurant at the Quisiana hotel is also highly recommended. A choice on almost every menu is the refreshing *insalata caprese* (mozzarella, tomato, and basil on a bed of lettuce), a dish that might have been invented here in the 1920s. For more traditional fare reserve a table at La Capannina, an institution on the island and a few steps from the glittering Piazzetta.

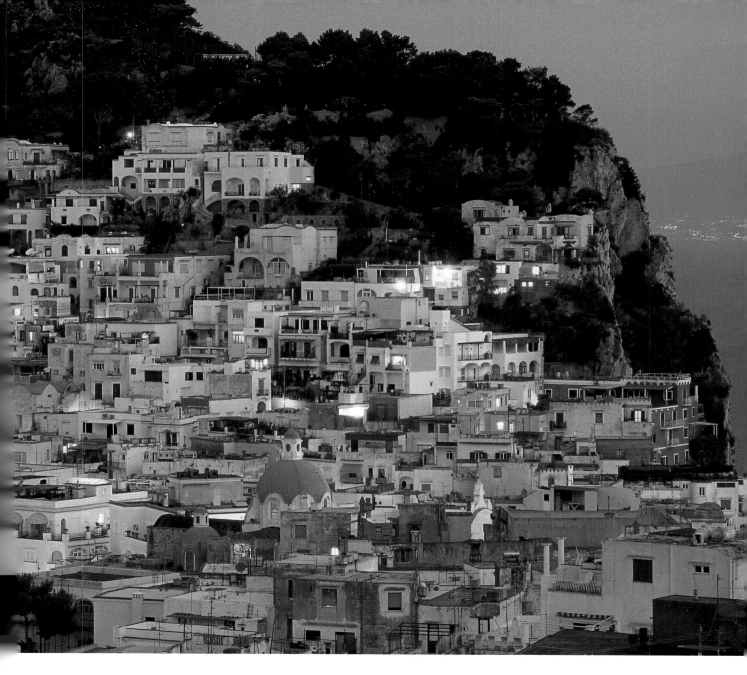

CASERTA
THE VERSAILLES OF THE BOURBONS

THE ROYAL PALACE OF CASERTA, A FIVE-FLOOR, 118-foot-tall, 825-foot-long castle with four courtyards, 1,200 rooms, 34 staircases, and 1,742 windows, built for the Bourbon king Charles III, is one of the most breathtaking structures in Italy. It took the architect Luigi Vanvitelli, his son Carlo, and hundreds of skilled workmen, women, slaves, and prisoners twenty-two years (from 1752 to 1774) to build. The rear facade overlooks a park covering nearly three hundred acres, composed of a grassy parterre, natural woodlands, and an English garden. Six fountains line an avenue stretching nearly two miles; a great fountain with a statue of the goddess Diana adorns the center of the park. The fountains are fed by springs from the Taburno River, carried here by an aqueduct that crosses five mountains and three bridges. Over six million ducats were spent to create the sumptuous palace, six times what it cost to build the whole fiefdom of Caserta. It was the king's desire to build a royal residence that would make Versailles pale in comparison. The vista from the central atrium alone is extraordinary. Luigi Vanvitelli was the son of the Dutch topographical painter Caspar van Wittel, and the palace gardens bear the fruit of his studies and his extensive knowledge of French parks. It is clear that the palace was modeled upon the great royal residences of Europe, with salons and apartments faced in marble and alabaster, mirrored walls, niches occupied by statues, and tapestries and paintings decorating every inch of uncovered space. Vanvitelli came up with several innovative architectural ideas, a couple of which were the entrance to the elegant Court Theater, with the park behind used as a backdrop, and the magnificent Stairway of Honor, a double staircase of white marble watched over by two regal lions, symbolizing strength and reason, and topped by a vaulted dome.

During the second half of the eighteenth century the Bourbons concentrated their attention on the fiefdom of Caserta, not only to celebrate the greatness of their lineage but also to affirm the new social ideas of the century of Enlightenment. They built a safe and strategic center, and at the same time, one that was healthy and had great economic value. Apart from the construction of the Royal Palace, they transformed the village on the San Leucio Hill into a "royal colony," dedicated to the production of silk. At first it consisted of no more than two hundred inhabitants, but the colony had its own statutes mandating compulsory education, wages based on merit, and the foundation of a Bank of Charity for the old and invalid. The fame of silks, velvets, and brocades enriched the Bourbon territories and spread across the confines of the kingdom. To this day artists carry on Caserta's centuries-old tradition of silk weaving.

below
The central avenue of the Royal Palace seen from the fountain of Diana.

facing page
The central ramp of the Stairway of Honor in the Royal Palace.

Caserta is famous for its *mozzarella di bufala*, mozzarella cheese made from the milk of buffalos. In 1600 the cheese was so precious that it was quoted in value in terms of wheat and gold. At Cascano there are furnaces that bake terra-cotta and ceramics, but more famous is the manufacture of porcelain from Capodimonte, which began under the reign of Charles III of Bourbon. When he became king of Spain in 1759 he moved to Madrid and closed down the factories. They were reopened with the founding of the Real Fabbrica Ferdinandea to produce objects made exclusively for the royal household.

Caserta Vecchia is the old village of Caserta that climbs up the steep slopes of Mount Virgo. It is almost entirely medieval in style, with houses made from tufa rock, portals and courtyards, loggias and mullioned windows. It stands in stark contrast to the magnificence of the Royal Palace, but is equally inviting. The village is grouped around the twelfth-century cathedral of San Michele. Over the centuries the cathedral has become an extraordinary amalgam of different eras, with its tufaceous-rock facade and octagonal lantern turret, which is a masterpiece of intarsia work. The arch of the bell tower straddles the main thoroughfare. The thirteenth-century Gothic church of the Annunziata is nearby as are the remains of the eleventh-century castle. The castle was originally built with four watch towers, but the great tower (ninety-nine feet tall) is the only one left standing.

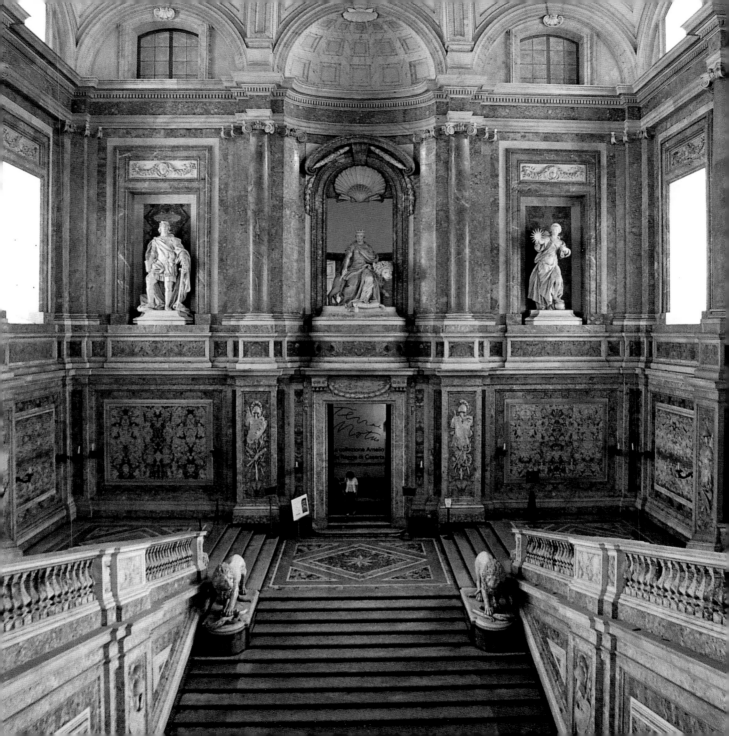

ISCHIA
ISLAND OF THERMAL SPRINGS

THE SPELLBINDING ISLANDS OF ISCHIA AND CAPRI rest at opposite ends of the Bay of Naples and share the backdrop of Vesuvius, the quiescent volcano, along with the wonderfully disheveled mass of buildings that is Naples. Ischia is the largest island of the Neapolitan archipelago and is referred to as the "green island" for its wealth of olive groves, vineyards, and vegetable and flower gardens. Mount Vesuvius appears to be

A typical restaurant in Ischia Porto.

facing page
The Castello Aragonese dominates the coast of Ischia Ponte.

far away, but not far enough for the people of Ischia to take it for granted. In fact, one can sometimes feel tremors and see signs of activity from the volcano's stirrings. Deep down in the earth's crust near the Phlegrean Fields, plumes of smoke rise from the ground, and thermal springs boil on the slopes of Mount Epomeo, the nearly 2,500-foot-high crater that formed the island. The springs warm the ocean's waters to such a degree that one can bathe here long before and after the swimming season in other places begins and ends. These volcanic phenomena have contributed to Ischia's fortune, together with the natural beauty of the island, which has inspired painters and poets of every age. Over the last two centuries a number of hotels have been built around the thermal springs, offering spas that are open year-round for those seeking wellness treatments. There are many villages scattered around the perimeter of the island, including Ischia Porto, the most popular health center. Ischia Porto arose around an ancient volcanic lake that, in the middle of the nineteenth century, Ferdinand II joined to the ocean by a channel. Ischia Ponte is an older town extending along the seafront, whose location has made it easy for it to remain a small fishing village. The village is joined via a bridge to an islet where the pretty Aragonese Castle, built in 1200 by Charles of Anjou, can be admired. In the middle of the fifteenth century, Alphonse of Aragon, king of Naples, carved a stairway into the rock face leading from the beach to the top of the island. A path enables visitors to reach the summit and enjoy the panoramic view over the Borgo Ponte, including beautiful palazzos and the cathedral of the Assunta. A winding road leading to Ischia's smaller hamlets is well worth the drive for its picturesque scenery. The elegant quarter of Lacco Ameno is full of artisans' shops and exclusive hotels. Forio is where Epomeo wine is produced.

Although Procida is also an island of volcanic origin, in contrast to Ischia it is relatively flat and covered by Mediterranean maquis, vineyards, and market gardens. It takes about three hours to sail around the island's jagged coastline. The Marina Grande is the Procida's colorful main harbor and is dominated by an impressive castle. The church of San Michele Arcangelo is worth a visit, as are the remains of the church of Santa Margherita Vecchia on the point of the Palombara. A bridge connects Procida with the smaller island of Vivara, which is uninhabited and covered with the region's characteristic thick brush.

The less-popular village of Sant'Angelo is, however, a delightful place to do some leisurely strolling. Fontana is the starting point for the climb up to Mount Epomeo. Barano occupies a scenic position above the beach of the Maronti, the longest on the island.

Almost as though to challenge the physical benefits of the thermal baths, Ischia tempts the taste buds with its varied and imaginative wines and cuisine. The local dishes are based on fish, as one would expect from an island, but also rely on the fruits of the soil. There are noble vineyards with roots going back thousands of years, and lush vegetable gardens that provide fresh produce every day. Local products include cheese and salami; in addition, goats, sheep, and pigs are bred here, as are rabbits. The typical island dish is *coniglio all'ischitana* (Ischia rabbit), made with garlic, wine, cherry tomatoes, and aromatic herbs. Il Focolare, a trattoria in Barano, is one of the best places to taste this hearty dish.

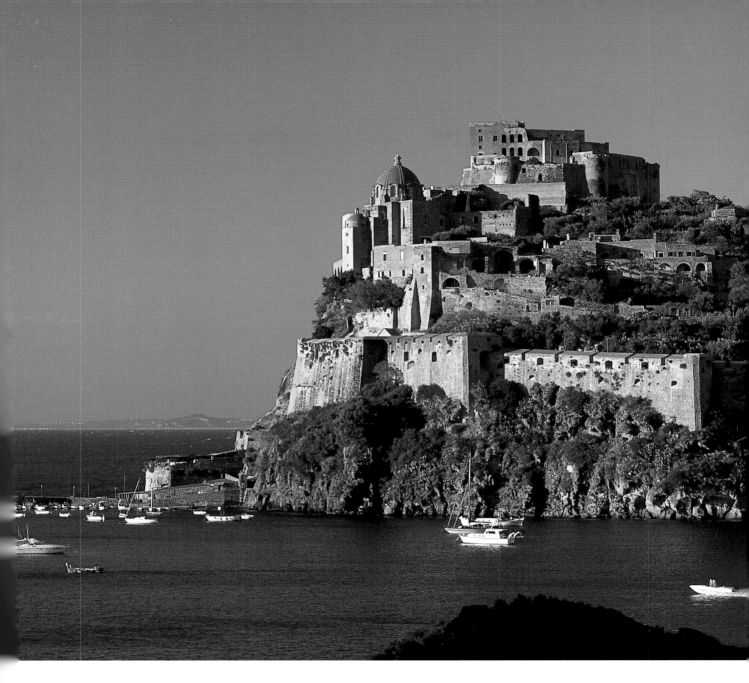

P O M P E I I
A N N O D O M I N I

It was August 24, AD 79, when an event that would end the prosperity of the towns at the foothills of Mount Vesuvius occurred. Oplonti, Stabiae, Taurana, Tora, Sora, Cossa, Leucopetra, Herculaneum, and Pompeii were centers of a decidedly advanced civilization, some of them extremely important to the Roman Empire. The massive crater of Vesuvius suddenly erupted, spewing out fire and lava in a dense, suffocating smoke cloud. It covered temples, theaters, patrician villas, and humble houses with a layer of ash and rock that was in some places over eighty feet thick, paralyzing both people and animals in gestures of panic. Herculaneum and Pompeii make up the most impressive open-air museum in the world and take us back two thousand years. The discovery of the two centers occurred by chance: Pompeii was found at the end of the sixteenth century during reclamation work in the Sarno River valley, while Herculaneum was uncovered in 1709 during the digging of a well. It was Charles of Bourbon who, in 1738, gave orders that systematic excavations were to take place, thereby presenting to the world of the Enlightenment the perfect picture of the structure and life of a Roman city. The digs continued under Napoleon and after the reunification of the kingdom of Italy. Pompeii had been a booming commercial center, with successful shops, hotels, restaurants, inns, and brothels, but it was also a thriving spiritual and cultural hub, with temples, thermal baths, a theater, amphitheater, villas, and noble residences. The objects and wall decorations preserved intact under the ash provide a detailed description of Roman life at the time. A rich trove of silver, now in the Archaeological Museum in Naples, was found in the House of Menander (a villa named after a Greek playwright of the same name). The House of Octavius Quartius has a courtyard garden adorned by painted statues and archways. Splendid frescoes of joyful cherubs and of the goddess Psyche are displayed in the House of the Vettii. The House of the Silver Wedding Anniversary was one of the most opulent in the city, while the House of the Gilded Cupids is so named for the cherubs found here etched in gold leaf. The famous Villa of the Mysteries preserves an extraordinary cycle of frescoes displaying scenes of Dionysian rites.

Descending the Corso Ercolano to the archaeological site, one has the impression of being welcomed into an aristocratic town. Here too, many frescoes, domestic objects, and mosaics have been perfectly preserved by ash. Nearby, an important collection of papyri and bronze statues were found in the grandiose Villa of the Papyri. They are now held in the National Library and in the Archaeological Museum of Naples.

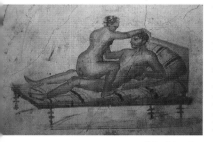

A fresco of an erotic scene in the House of the Vettii.

facing page
The fountain in the *peristylium* (court) of the House of the Vettii.

The Romans enjoyed uninhibited sexuality, as did a large number of the ancient cultures. The phallus was celebrated as a symbol of fertility and abundance and was exhibited near fountains and represented by bells (*tintinnabulum*) displayed outside the front door of many homes. A large part of the economy of Pompeii was based on prostitution, as is evident from the graffiti and paintings in private houses or brothels, where prostitutes were available for amorous meetings. Prostitutes were divided into classes: *delicatae*, educated women hired to entertain refined clients; *lupae*, those who tempted clients into brothels with a wolf-like howl; *bustiariae* lingered in cemeteries; *scorta erratica* were street prowlers; *forariae* worked in the forum; and *diabolae* fulfilled the most outrageous of desires.

Vesuvius is the only active volcano on the European continent. In 1993 it was made a national park covering 24,000 acres and including Monte Somma and Vesuvius itself, separated by the Valle dell'Inferno (Valley of the Inferno), a hollow created by the devastating eruption of AD 79. To reach the volcano from Torre del Greco or Herculaneum one must first drive up a steep road and then, accompanied by a guide, proceed on foot to the mouth of the crater (4,227 feet above the sea). Coral has been worked by artisans in the Torre del Greco area for centuries. At one time coral was found in the Gulf of Salerno, but today it is imported from Tunisia and Sardinia. A school established in 1879 for fashioning coral still exists here. The decoration of cameos was inspired by jewelry found during the excavations of Pompeii and Herculaneum.

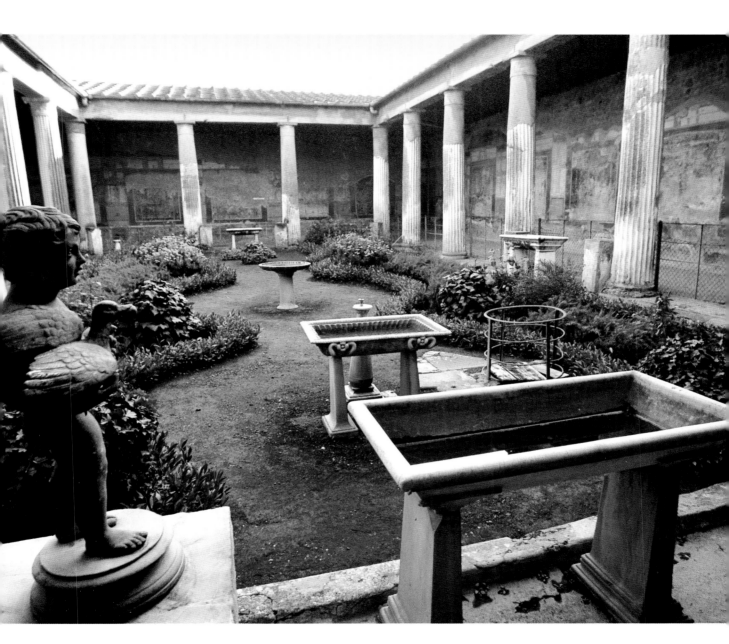

SORRENTO
THE SIRENS' SONG

SORRENTO IS THE SUBJECT OF THOUSANDS OF ROMANTIC SONGS, the most famous of which is "Turna a Surriento," sung by some of the most famous names in popular music and opera, and immortalized by the great tenor Enrico Caruso, who made it famous throughout the world. The room in which he lived in 1921 at the Grand Hotel Excelsior Vittoria has been kept as it was, furnished with objects belonging to him and with photographs of the artist. One can sleep in the Caruso suite and enjoy a fabulous holiday. A stay in this suite is awarded to the winner of an auction held to benefit the New York City Opera.

Sorrento's ancient name—Surrentum—is connected to the Sirens; for Sorrento the Sirens' song is a vocation that comes from the distant past. These mythological marine creatures, possessing the face of a beautiful woman and the body of a fish covered with gaudy feathers, could bewitch even the roughest of sailors with their enchanting song. This is only legend, but the climate and beauty of the place are indeed spellbinding. Since the time of the Roman Empire, rich patricians came here and built their sprawling villas, with gardens and pools behind a village overlooking

the dramatic coastline. Today, notwithstanding the massive urban changes, the origins of the Roman castrum are still palpable in the air. To best understand the character of this corner of the Mediterranean, which inspires "so much feeling," as Caruso's song tells us, and before visiting by land and smelling the perfumes, one should arrive via the ocean, from afar. The peninsula upon which Sorrento sits is a land of agricultural workers, rather than sailors and fishermen. It is a long spur that juts into the Tyrrhenian Sea and separates the Gulf of Naples from the Gulf of Salerno, forming part of the short chain of the Lattari Mountains that stick out at right angles from the Apennines. On the southern side, these mountains drop steeply to the coast, forming deep ravines, such as that of the fjord of Furore, which, despite its name, is docile and picturesque. On the northern side, the slopes descend gently and form plateaus in some areas,

Sweets and crushed-ice drinks to while away a pleasant evening.

facing page
A view of Sorrento's port from the town above.

Traditional meals in Campania usually consist of fish and always end with a cup of coffee (prepared with the well-known Napoletana coffeepot) and a drop of Limoncello, a natural, scented liqueur with a refreshingly unique taste. It's easy to prepare Limoncello: peels of lemon are mixed with alcohol and sugar, without the addition of any colorants or preservatives. Before tasting, the lemons must be soaked for forty days and matured for another forty. Lemons destined exclusively for this purpose are cultivated on the peninsula of Sorrento and are distinguished by a thick, rough skin and a strong scent. Limoncello has recently been rediscovered and can be enjoyed as a digestif. It is also excellent as a long cocktail, on ice cream, or with fruit salad.

trapping moisture and providing fertile plains ideal for vegetable gardens and citrus trees. The tufaceous rockface descends steeply into the sea and acts as a natural defense structure. Sorrento rose on one of these plateaus of porous rock and would have forgotten its agricultural past if it were not for the citrus groves that remind residents of their heritage with their intoxicating fragrance filling the air and mixing with the scent of the sea.

Sorrento is one of the few places in Italy where the art of intarsia (wood inlay) is still alive. A collection of works by master nineteenth-century craftsmen is on view at the Museo Bottega della Tarsialignea, owned by Alessandro Fiorentino. More excellent intarsia and decorative marquetry work can be seen at the Museo Correale di Terranova, where a selection of antique watches and Capodimonte porcelains is also exhibited. Pleasant accommodations can be found at the Hotel Parco dei Principi, which was established in 1962 and is one of the most important buildings designed by the architect Gio Ponti, who also built the Pirelli skyscraper in Milan. The hotel is a blue and white building accented by ceramic ornaments. Each of its one hundred rooms has a different patterned floor.

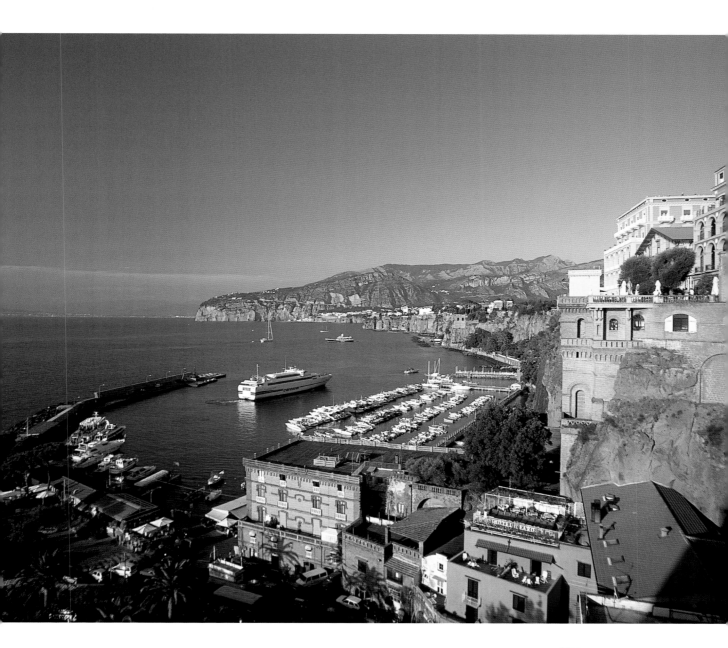

ALBEROBELLO

DOMES, CONES, AND PINNACLES

THE AGRICULTURAL VILLAGE OF ALBEROBELLO was built on land where there used to be a grove of *alberi belli,* or "beautiful trees"—hence its name. When in Alberobello, one has the sensation of being on a film set, such is the larger-than-life quality of the town's fascinating architecture. The characteristic *trulli* houses of Alberobello are white, conical-shaped homes, and with the exception of the Trullo Sovrano (a two-level

An typical alley lined with shops.

facing page
The fascinating conical shapes of the trulli.

structure), they are typically one level. The more than one thousand trulli in the Monti district (others can also be found isolated around the Murgia Plateau) and some are over five centuries old. In 1996 UNESCO declared Alberobello a World Heritage Site, but if the magnificent village is to be preserved, it must first be protected from mass tourism. A large number of trulli are still lived in today; some date back to the seventeenth century, others to the fourteenth. The stone foundation of the trulli is built into dry walls (without the use of mortar or wood) and finished with whitewash. The method of construction has roots in prehistoric times. The conical-shaped roofs are made of stones placed on top of each other in concentric circles overlaid with thin sheets of limestone called *chianche.* Each roof is topped by three stones (one cylindrical, one flat, and one round), said to avert evil. Many of the trulli have an external staircase leading to the roof. From here one has an indescribable vista of a sea of gray pinnacles rising above a sea of white ones, scored by the streets that carve them geometrically.

Similar constructions have been found in Harram, a small village in Turkey where Abraham was supposed to have stopped on his way to Canaan two thousand years before the birth of Christ. Perhaps, during the Byzantine conquest of Puglia around the year AD 1000, it was the architects of a Jewish community who actually brought those curious houses of the Murgia to the area between Taranto and Bari. Murgia is a limestone highland of rolling landscape covered with red earth that was brought there to moisten arid stones and nourish the vines, olive groves, and almond and fruit trees. The agricultural heritage of the region is reflected in the subdivisions of the land, the sparse population and the isolated settlements of the trulli.

Today the trulli have become highly sought after as vacation homes. They are rented or bought and then transformed according to personal taste.

The grottos at Castellana are eleven miles from Alberobello and form the most important labyrinth of caves in southern Italy. Formed by the erosion of an ancient subterranean river, the great quantity of stalagmites and stalactites create an extraordinary setting. The spectacular appearance of the caves is due in part to their size, each over two miles long. They were officially discovered in 1938 and quickly drew tourists from all over the world. There is a web of passageways connecting the five main karstic caves——the Grotto Nera, Grotto Civetta, Grotto Presepe, Salon of Monuments, and Grotto Bianca——to one another. The caves are open year-round.

It is possible for visitors to stay in one of these extraordinary buildings, shielded from the suffocating heat of the summers in Puglia. The Dei Trulli is a hotel that offers comfortable trulli-style cottages for those seeking an authentic Alberobello experience. Each of the trulli have a garden and are divided into rooms with a central space for a fireplace. The hotel is on the outskirts of Alberobello in Monti, and dominates the town. Even more intriguing, however, is sleeping in a large seventeenth-century farmhouse, an ancient fortified holding that once protected from incursions by the Saracens. Il Melograno in Monopoli is just such a place, with an encircling wall and towers that shield the centuries-old olive, almond, and citrus trees. The hotel is reminiscent of houses on the Greek Islands characterized by ceramic floors and antique furniture.

ANTICO
TRULLO
CON
GIARDINO

B A R I
THE OLD AND THE NEW

TWO CITIES WITH DIFFERENT URBAN AND SOCIAL STRUCTURES COEXIST IN BARI. The town's old medieval village sits on a promontory dividing the Old Port from the Great Port, under the shadow of the massive Castello Svevo, built by the Normans, expanded by Holy Roman Emperor Frederick II (1194–1250), and transformed into a Renaissance dwelling by Isabella of Aragon. The village is uniform and well preserved, with winding streets and tightly packed houses that shelter against high winds and storms. The streets around the Piazza Mercantile (insolvent debtors were tied to the Column of Justice here) have, for centuries, abounded in a mixture of peoples representing Bari's melting-pot heritage of Greek, Saracen, Norman, and Spanish culture. In order to defend themselves against frequent incursions and natural disasters, they clung to the devotion of a number of saints, just as the thirteenth-century merchants of Venice turned to Saint Mark. Whether it was Saint Irene, protector against lightning, or Saint Nicholas, who watched over sailors, the people of Bari dedicated monuments of great value to all of them. In 1087 they built the impressive Basilica di San Nicola characterized by three naves, and in 1166 they erected a cathedral with two bell towers dedicated to Saint Sabino. Only one tower and

A tower of the Swabian Castle.

facing page
The portal of the Basilica di San Nicola.

the *trulla*, a beautiful, twelve-sided baptistery, remain. Shrines were created in honor of Saints James, Anne, Gregory, Michael, Agostino, and Clare. From the beginning of the nineteenth century the new city began to develop outside the walls, where streets separate the residential neighborhoods. Fishermen, artisans, farmers, and hard-working people of the land and sea remain in the Old Quarter, whereas a middle-class consisting of mostly merchants live in the modern city. In 1929 they established the Fiera del Levante (Fair of the Levant), one of the most popular in Europe.

The two cities vary drastically in lifestyles. A visitor goes to the Old Quarter to breathe the atmosphere of the past, eat a plate of *orecchiette con le cime di rapa* (shell-shaped pasta with turnip tops), and have a glass of red wine at a local inn. In the new city one strolls along the wide streets crowded with people intent on shopping in elegant boutiques or among the street vendors of the Corso Cavour. The Corso Vittorio Emanuele II is the old town's main artery and was built to replace the defensive ramparts, which were obstacles to communication. The Corso defines and unites the borders between the two cities of Bari. Here, one can shop at an outdoor market where regional products, such as tomatoes (the red-gold kind from Puglia), olive oil, grapes, and wine are sold.

Olives have been cultivated in Puglia since ancient times, and today they constitute one of the principal economic resources of the region. Suffice it to say that olive oil from Puglia constitutes almost 40 percent of that produced in the nation, 20 percent of oil produced in the countries of the European Union, and 12 percent of global production; the olives destined for consumption amount to about 450,000 pounds. The European Union has classified olive oil in order to ensure its quality for consumers. At the top of the pyramid is extra-virgin olive oil, obtained exclusively by mechanical processes that are guaranteed to be free of preservatives and with an acidity of less than 1 percent. In Puglia, four types of oil have obtained the D.O.P recognition (Denomination of Origin Protected): Dauno, Terra di Bari, Colline di Brindisi, and Terra d'Otranto.

The port town of Bari is rich with castles that were built by the Holy Roman Emperor Frederick II. Castel del Monte is an imposing structure built in 1240 and characterized by the number eight: it has eight towers and an octagonal plan, a result of the intersecting of a circle with a square——medieval symbols of the perfection of humankind and the divine. The castle in Barletta was where the emperor conducted the business of state, and the majesty of its salons and courtyard must have been worthy of it. The emperor's royal residence, the Gioia delle Colle Castle, is connected with important episodes of his life, such as the birth of his son, Manfred. The castle at Trani was reserved for important social events, and was where Manfred chose to celebrate his wedding.

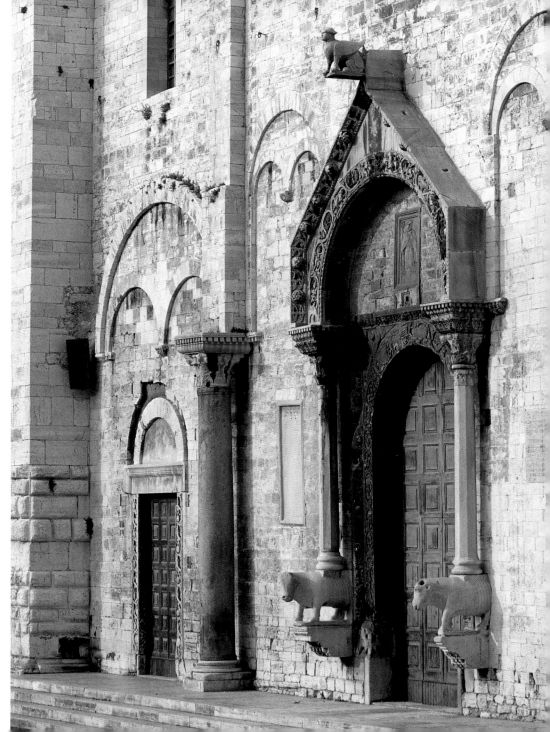

GALLIPOLI
THE PEARL OF IONIA

GALLIPOLI IS NOT A CITY ON THE SEA BUT IN THE SEA. It is on an island in the Ionian Sea on the western coast of the Salentina peninsula, the spur of the Italian boot. Legend has it that the town was founded by Occo, son of Omero Gallo, who named the island Galloccoli, meaning "city born of the sea." Another story tells that it was King Idomeneus of Crete who landed on these shores when the city was a Greek colony controlled by nearby Taranto, after being sent into exile by his subjects. The limestone platform that rises from the waters a few yards from the coast was considered an efficient natural defense. It was connected to the mainland by a narrow strip of land. The people of Taranto called it *Kalè polis,* meaning "beautiful city," and even though it has undergone change throughout the centuries, it is still a splendid fishing port. The city appears to be late medieval, with a strong Levantine influence, imposed by the Normans and the Aragonese, who employed the architect Francesco di Giorgio Martini to build the Angevin Castle. At the end of the sixteenth century, the Spanish transformed Gallipoli into one of the most important commercial centers of the Mediterranean, particularly noted for the export of olive and lamp oil.

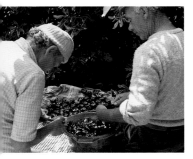

Fishermen preparing sea urchins.

facing page
The Angevin Castle on the harbor.

The Città Vecchia (Old City) is connected to the Borgo Nuovo (New Village) along its low coast by a bridge that was built in the first years of the seventeenth century, and on the mainland near a Greco-Roman fountain that dates back to the third century BC. The bridge is believed to be the oldest in Italy. The historic center is a maze of low fishermen's houses whose roofs also serve as terraces. A small courtyard with a garden overlooking the labyrinthine paths turns into a meeting place during the day where people gather to mend their fishing nets, knit, and, above all, gossip. Grand Renaissance and Baroque palazzos and a few churches rise among the houses, each one of rare beauty. The cathedral of Sant'Agata is a splendid example of Lecce Baroque architecture. The church of Santa Maria del Canneto is a temple devoted to the fishermen who spread their nets in the piazza. The church of Santa Maria della Purità is the seat of the congregation of longshoremen and is visible from the sea. The road running through the village offers up panoramic views from the perimeter of the old walls. Today Gallipoli is one of the most international places on the Ionian coast and is patronized by a set of world-class politicians. In the summer it is a hub for cultural activities, including concerts and festivals that inevitably finish with an extravagant display of fireworks.

The daily fish market under the castle is a lively place. One goes there in the early hours of the morning, as soon as the fishermen have unloaded their catch. The freshest fish and shellfish can be tasted here—clams, mussels, cockles, oysters, *tartufo di mare* (rough-shell clams), and sea urchins, accompanied by a piece of homemade bread. The market covers almost 1,000 square meters. A traditional dish of Gallipoli, available in many of the town's restaurants, is the *scapece,* a meal based on small sardines or anchovies fried in olive oil and marinated in oak vats, alternating with layers of bread crumbs, white vinegar, and saffron, which gives it its typical yellow color.

Visitors wishing to stay near the historic center can do so at the Palazzo del Corso, an elegant hotel furnished with antiques and decorated with frescoes. A few miles from the village, surrounded by gardens overlooking the sea, is the Hotel Ecoresort Le Sirene. The colorful fishing boats in the harbor of the Ionian Sea bring in fresh fish every day. Sample the daily catch at La Puritate, a restaurant in the heart of Gallipoli near the church of La Purissima, or at Olga, where the menu is simple and the locals gather regularly. The Pasticcerie Provenzano, with locations in the city and in Tuglie, sells perfect cakes and marzipan sweets.

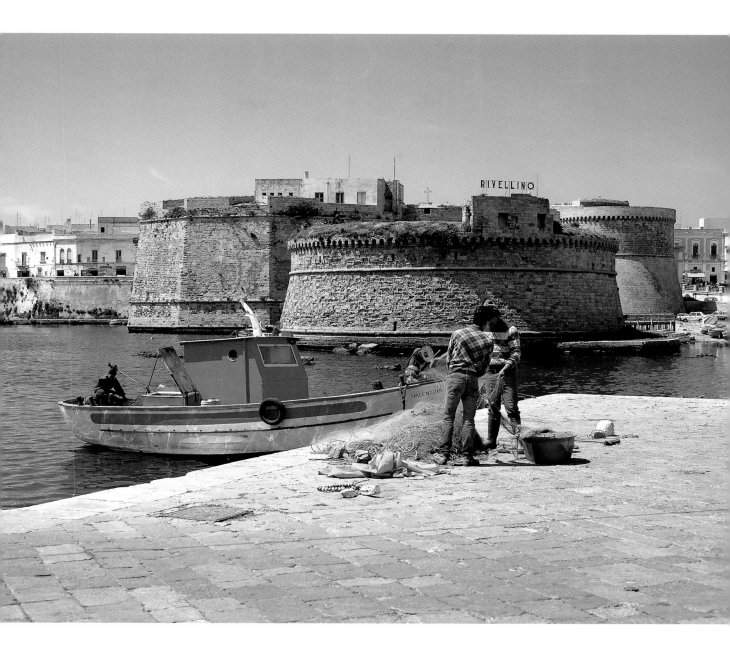

LECCE

GOLDEN BAROQUE

LECCE IS THE CULTURAL AND ARTISTIC CAPITAL OF PUGLIA, with an ancient university and important monuments that have earned the city the title of Baroque Florence. Worthwhile stops include the second-century Roman theater, the Imperial Roman amphitheater that could hold 25,000 spectators, and the imposing castle built in the sixteenth century by Charles V. But it is the Lecce's unique baroque style that makes it stand out. The historic center should be visited at the first light of dawn, when the sun bathes the walls of the churches and palazzos in gold—when the townspeople are still sleeping and shops and bars are not yet open, streets and squares deserted, and no distractions are yet to be found along the narrow streets. This is the best way to take in the architectural embellishments that decorate balconies and doorways, the jewel-like details that comprise Lecce Baroque and mirror the character of her people.

Lecce is a beautiful and fragile city, rich yet shabby, aristocratic yet provincial. Her sumptuous palazzos and elegant, pastel-colored churches are facades accented by scrollwork and crenellated cornices, fantastic human and animal figures, and altars adorned with flowers and fruit. They were built with "Lecce stone," a fine-grained tufaceous rock. It is the cheapest of stones, easily quarried, and as easily sculpted as gold, but destined to turn to dust over the years. Narrow streets branch out from the Piazza dei Mercanti and the Piazza Sacra, which have been renamed Sant'Oronzo and Piazza del Duomo. They provide fascinating glimpses of massive, bulging balconies that block out the dome of the sky, while hundreds of mocking mythological figures look down from the heights of the cornices. They seem to have been captured by a divine hand: cherubs caught in naughty poses holding royal crowns while they stick out their tongues, monstrous beasts rearing up on hind legs, and humans lying prostrate on the ground. But Lecce Baroque is primarily characterized by a sense of whimsy and joyfulness. Maybe it is because of the stone—its delicate yellow color softens everything. Unfortunately, porous tufa rock disintegrates over time, crumbling slowly, and the elegant decorations sculpted with such care have been rounded down and flattened over time, exposed as they are to pollution and bad weather.

The Roman amphitheater and the Sedile, which was the office of the Municipality until 1851.

Papier-mâché statues are the pride of Lecce. At the end of the seventeenth century the Church of the Counter-Reformation regrouped the faithful by building new churches and new statues of the saints. The project was to be done with great speed, but precious marble was expensive and needed time to be worked, and there was only just enough tufa for the buildings. Priests and patrons then asked artisans to use other materials. Thus it came about that a frame of wire was stuffed with straw and covered with layer upon layer of papier-mâché; it was then pasted with gesso and painted, giving birth to life-size figures created with incredible realism and attention to detail. This art has been kept alive through the centuries and is applied in restoration. Today this method is used for both sacred and profane figures, objects for the home, and candy dishes that are sold in artisans' shops.

The *fiocco leccese* (Lecce knot) is an ancient Turkish-influenced technique of making carpets out of raw wool and cotton. *Cotognata* (quince jam) is the pride of the confectioners of Lecce, as are the marzipan sweets that were once prepared here in convents. An assortment of local products can be purchased at La Cotognata Leccese. The Hotel Zenit offers pleasant reception rooms, as does the Hotel Patria Palace, an elegantly furnished palazzo attached to the Atenze restaurant. One can enjoy hearty meals at Le Zie, a family owned restaurant where dishes are presented professionally and with imagination.

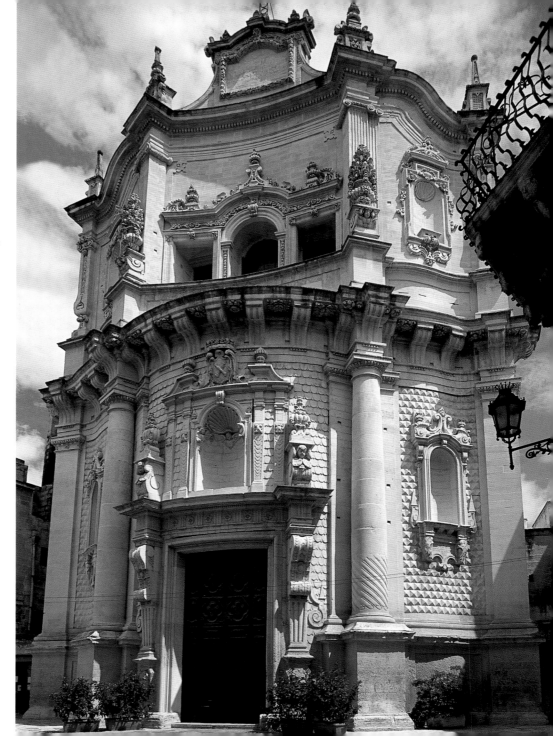

The facade of the church of San Matteo.

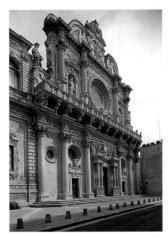

The fanciful
elements of the
church of Santa
Croce offer some of
the best examples of
Lecce Baroque
architecture.

A visit to nearby towns will complete one's
impression of the light and whimsical Lecce
Baroque style. The palazzo of the Marchesi
Saluzzo and the church of the Redentore
(sometimes referred to as the church of San
Nicola) in Lequile both date to the seventeenth
century. About a mile away is San Pietro in
Lama, with the parish church and the churches
of Santa Maria della Croce and Santa Maria
delle Grazie. The center of Galatina is full of
examples of Baroque architecture. An
exception is the church of Santa Caterina di
Alessandria, the only example of Gothic
architecture in the Salento region. Galatone is
also full of Lecce Baroque inspired buildings,
among which are the sanctuary of the
Crocifisso della Pietà, whose three-storied
facade holds numerous statues. The Baroque
also dominates in Nardò in the churches of the
Immacolata, Santa Teresa, and San Domenico.
The Palazzo Imperiale and the Matrice church
are important landmarks in Francavilla, and the
same can also be found in Manduria, where Lecce
Baroque style enlivens every street. The
imposing Palazzo Ducale in Martina Franca
dominates the panorama over the Valle d'Itria.

A craftsman paints
traditional
papier-mâché
statuettes.

facing page
The Palazzo del
Seminario on Piazza
del Duomo.

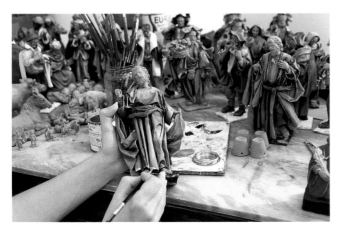

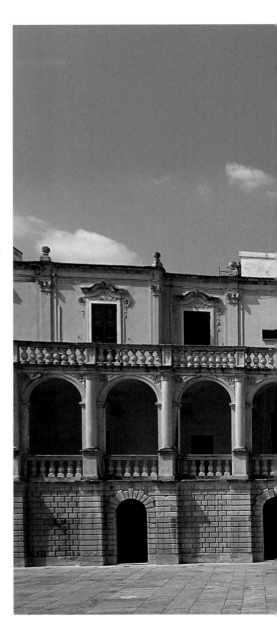

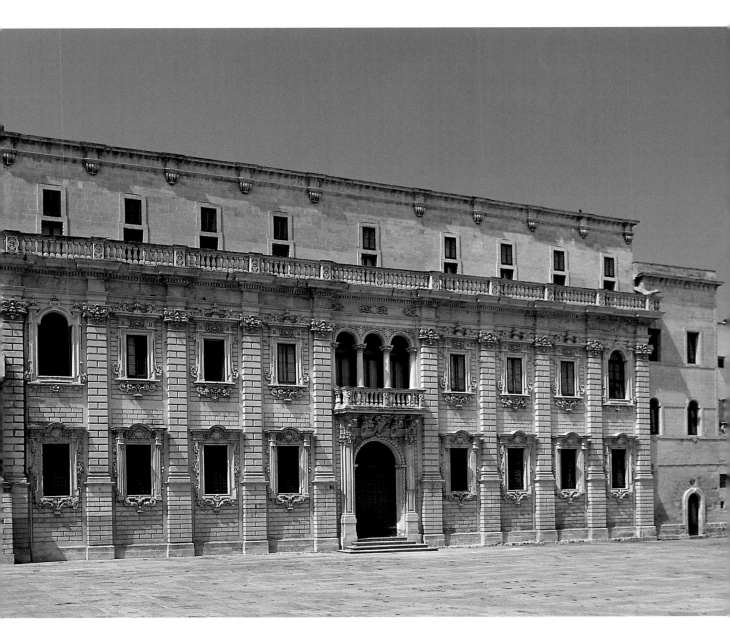

OTRANTO
RAMPARTS AGAINST THE TURKS

OTRANTO, THE ANCIENT ROMAN *HYDRUNTUM*, stood at the end of the Via Traiana and was the port closest to Epirus as well as to Greece and the East. To reach this town one must travel to the end of the heel of the Italian boot, almost to the point of the Salentina peninsula. The area is one of the most lush and intriguing in Italy, for its natural environment and for the legends that cloud it in mystery. This harsh, rocky plateau that juts out into the Ionian Sea contains caves that indicate the presence of prehistoric life. Some of the caves have become tourist attractions, such as the Zinzulusa cave near Castro Marina. Others are continually the objects of study, including the Romanelli cave and the grotto of the Cervi near Porto Badisco, where in 1970 one of the greatest series of rock paintings in Europe was discovered. The paintings have been dated to the Paleolithic period, and the place was certainly a sanctuary for the celebration of cults related to hunting, with more than two thousand red and black paintings from four to six thousand years ago. Capo d'Otranto is the easternmost point of Italy and the nearest to the Balkan peninsula, which is only forty-three nautical miles away. It has always been a port for ships from the East. The active port occupies an ideal position and connects Greece to Italy. Sailors, however, did not always have peaceful intentions. Mahomed II landed at Otranto in 1480 with ninety galleys and, after fifteen days of siege, massacred or enslaved the twelve thousand inhabitants of the city. The signs left by the colonizers and invaders are still visible. In the ninth century, a Byzantine presence transformed the city into a bishopric and the capital of the Salento. The people called it Terra d'Otranto (Land of Otranto) and left their indelible mark with the church of San Pietro and the magnificent Cattedrale, a jewel-like structure in the form of a Greek cross. Three apses lead to a monolithic cupola in the center, covered with frescoes that predate the year AD 1000. The Cattedrale has a beautiful exterior and a crypt divided into five naves and modeled on the Blue Mosque in Constantinople. An enormous mosaic pavement covers the entire floor, as important not only to the history of art but to that of religion as well.

Alphonso of Aragon built the pentagon-shaped castle between 1485 and 1494. He incorporated the Swabian fortifications and the Turkish renovations and added three imposing cylindrical towers. The spearheaded ramparts were built in 1578, and the city was encircled with the existing walls, and with the beautiful Alfonsina tower gateway.

A well-stocked ceramics shop.

facing page
The pentagonal Castello.

The mosaic pavement of the cathedral is an extraordinary representation of the Tree of Life, a depiction of the natural order that has Eastern origins and was adopted by the Bible as the source of every living thing. It is 178 feet long and supported by two elephants. Its roots are emanate from the portal, and the trunk grows along the central nave as far as the main altar. It depicts episodes from the Old Testament, the knightly tales of the Round Table, legends incorporating the signs of the zodiac, representations of the months, and monsters from the Apocalypse. The priest Pantaleone created the design in 1163 and supervised work on the mosaic. The style of the figures is slightly rough, and the details are not particularly refined, but the mosaic is of great interest for its inventiveness and variety of characters.

South of Otranto stand the remains of the abbey of San Nicola di Casole. Founded in the eleventh century by Prince Boemondo, the abbey was one of the most important monastic centers of the Middle Ages. Take a walk along the Valle delle Memorie (Memory Valley), where settlements once inhabited by hermit monks have been excavated. Here one can visit the Torre Pinta, below which lies an underground chamber or vault that was hollowed out in 2,000 BC. It stretches for dozens of yards and contains hundreds of niches carved into the walls. Traveling farther south along the coast toward Santa Maria di Leuca, one comes to Porto Badisco, a fishing village known for its caves, where 6,000-year-old graffiti can be seen. Farther south lies the picturesque Santa Cesarea Terme, a holiday destination and health resort characterized by Moorish-style architecture.

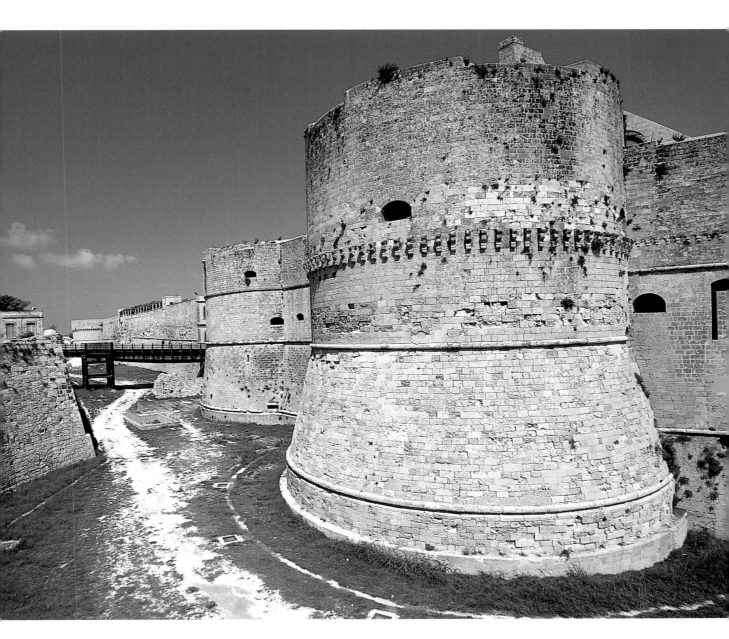

MARATEA
A GARLAND OF VILLAGES

MARATEA STRETCHES ALONG A JAGGED SECTION OF COASTLINE overlooking the Gulf of Policastro. This is a small area of the sea that belongs to the province of Basilicata, locked between the Punta dei Crivi and the D'a Gnola beach, between Campania to the north and Calabria to the south. This eighteen-mile stretch of coastline makes Basilicata the only region in Italy overlooking two bodies of water: the Tyrrhenian and the Ionian seas. Arriving by car from the Noce River valley (from Lauria or from Lagonero) feels like diving straight into the deep blue sea, together with the green landscape of the mountains that first hid it from view. Once called *Dea maris*, goddess of the sea that protects it, some believe the town's name came from a Byzantine term meaning "wild fennel," which is indeed abundant in the area. The philosophy of sustainable development is pervasive in Maratea; thus there have been few concessions for tourism (which has drifted farther south). "Goddess of the sea" brings to mind an image of crystal-clear waters (Maratea has one of the most advanced water-purifying plants in Europe), a shoreline dotted by hidden bays, rocky promontories that punctuate coves, sandy beaches shaded by great pine trees, and islands that break up the dark blue of the horizon. Earthen-

The dramatic statue of Christ the Redeemer at the summit of a hill.

facing page
An approaching view of Maratea.

ware basins where Roman slaves once steeped fish for *garum*, a fish sauce that was a favorite of the emperors, are still visible near the coast. Maratea is the perfect spot for nature lovers. It is permeated by peace and tranquility—there isn't even a cinema. The only concession to vacationers is the little port, but this is also very small. Fishing boats depart from here to drop their nets out at sea. If, during the night, there are lights shining on the water, which is as flat as glass, legend has it that the following day there will be fresh fish on the table.

Maratea is also known as the "city of the forty-four churches," among which are the small twelfth-century San Vito; Santa Maria Maggiore, with its beautiful sandstone portal, its medieval bell tower, and fifteenth-century wooden choir; the sixteenth-century church of the Annunziata; and the Baroque Addolorata. In a charming medieval village farther uphill and clinging to Mount San Biago, the great statue of the Redeemer stands on the summit.

A gigantic statue of Christ (over sixty feet tall) with his hands raised to the heavens, is second only to the statue of the Redeemer in Rio de Janeiro. A popular place of pilgrimage, the statue is reached via a strenuous pathway that seems suspended in space. The statue looks out at the mountains inland, embracing the landscape that pushes toward the spine of the Apennines as far as Mount Pollino. Below, creating a picturesque backdrop, stands the old abandoned village of Castello. On the opposite side is the basilica dedicated to Saint Biagio, patron saint of Maratea, whose relics are kept in the Regia Cappella (the Royal Chapel) built between the sixth and seventh centuries (but reworked many times thereafter). The frescoe of the *Madonna del Melograno* and the marble bas-reliefs of the Annunciation are not to be missed.

When in Maratea it is well worth staying at the Hotel Santavenere in Fiumicello. The hotel rests on a promontory overlooking the sea and is surrounded by nature. Amenities include a private beach and reception rooms furnished in eighteenth-century style. Those seeking cozy and romantic lodgings closer to Maratea's historic center should stay at the Locanda delle Donne Monache, a hotel built from an eighteenth-century convent beside the church that dominates the red-tiled rooftops of the village. Both establishments offer excellent cuisine supervised by the Scuola del Gusto, which makes use of local produce and prepares traditional recipes with a sense of creativity, resulting in dishes that are sure to pique one's curiosity even before they are tasted.

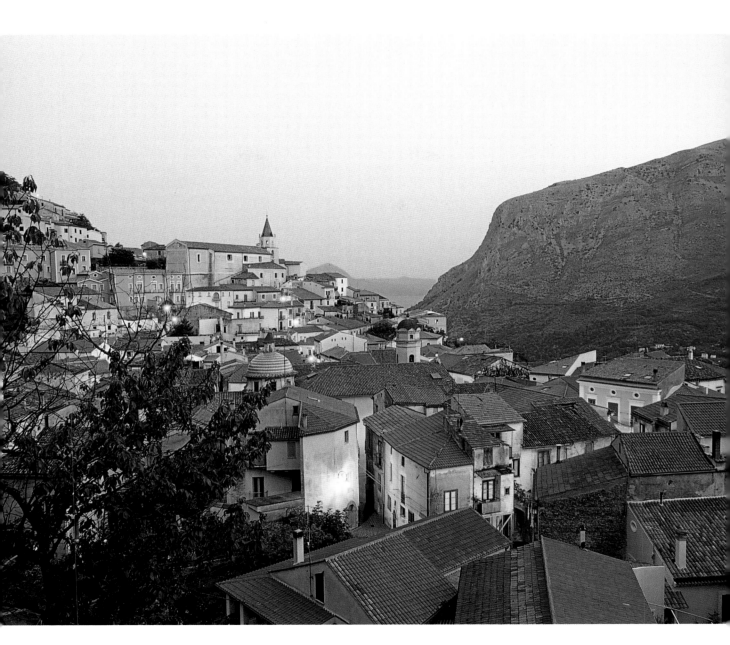

MATERA
THE MYSTERY OF THE SASSI

UNTIL ABOUT FORTY YEARS AGO, RESIDENTS OF MATERA and surrounding area lived in dwellings carved out of tufa rock. These homes are known as *sassi* and were built on the steep slope of the Gravina ravine. They were compared to rough-hewn caves with corridors (they were often built on top of each other, forming pseudo-apartment houses). The areas where the most sassi can be found are Sasso Barisano and Sasso Caveoso, which are separated by the town's Duomo. The curves of the pathways are cut into the rock and are so treacherous that they could be in one of Dante's circles of hell. The village, I Sassi, was gradually abandoned due to its damp and unhealthy living conditions. Hundreds of families lived in them, and infant mortality rates were high. In 1954 the government reluctantly forced thousands of farm workers to abandon their dwellings. Although they looked fascinating from the outside, the sassi certainly did not provide for modern living conditions (many people were cramped together and also lived with their animals). The people of Matera have since moved to the new town and into modern homes. As they achieved greater economic well-being and faith in progress, they began to look back on the past and set up a far-reaching recovery plan to give new life to the sassi. A large part of the conical houses have been restructured with the help of the Municipality. It is a pleasure to walk along the sassi on the Strada Panoramica (Via della Virtù), which overlooks the ravine and connects Sasso Caveoso to Sasso Barisano. The same sassi that were once known as hovels have been saved from destruction and are now home to studios and pleasant shops. The village of the sassi has been transformed into one of the most fascinating places in the world; and it was named a UNESCO World Heritage Site in 1993. The village has been declared the most representative troglodyte settlement in the Mediterranean. Facing the deep Gravina ravine, another spur of tufa appears with hundreds of natural and man-made caves built 10,000 years ago as places of refuge. A group of monks, followers of Saint Basil and the Benedictines of the seventh to twelfth centuries, painted frescoes on the cave walls and transformed them into places of worship. Other fugitives from Asia and Africa, from Constantinople and Sicily, took refuge here from the Arab invasions. They, too, were falling into ruin, were frequently looted, and often collapsed. However, they have also had their moment of redemption and, since 1978, have been protected within a regional park. Stone spear points, jewelry, and objects found in the crevasse of the Gravina all bear witness to the lives of these ancient ancestors.

A view of Piazza Vittorio Veneto.

facing page
Sassi piled on top of each other on a sloping hillside.

In the Park of the Murgia of Matera there are about 150 *chiese rupestri*, or rock-hewn churches, many of them underground and difficult to access. The following are the most interesting: Santa Maria della Valle, or la Vaglia, has a Romanesque facade and frescoes dating to various periods; Santa Barbara is well preserved and houses fourteenth-century frescoes; Cappuccino Vecchio is underground and has two naves; Santa Maria della Palomba is characterized by a Romanesque facade and displays the remains of several frescoes; San Nicola dei Greci stands on top of the church of the Madonna della Virtù and has two naves with a frescoed apse; Madonna delle Tre Porte is entirely covered in frescoes; and San Falcione is accented by Byzantine-style embellishments.

The ancient rock-hewn dwellings of Matera are one of southern Italy's most fascinating sights. Adventurous tourists are encouraged to explore the narrow streets that wind their way through the sassi in order to discover the curious workshops and churches carved from stone. Other sights worth visiting are the sixteenth-century Tramontano Castle, the thirteenth-century Duomo, and the churches of San Domenico, San Giovanni, and Santa Chiara. The Hotel Sassi offers guests an authentic sassi experience. Accommodations preserve the original layouts of the sassi and are simple but clean. For those wishing to bring a piece of Matera back home, a typical souvenir is the terra-cotta whistle in the shape of a cockerel, called a *cuccù*.

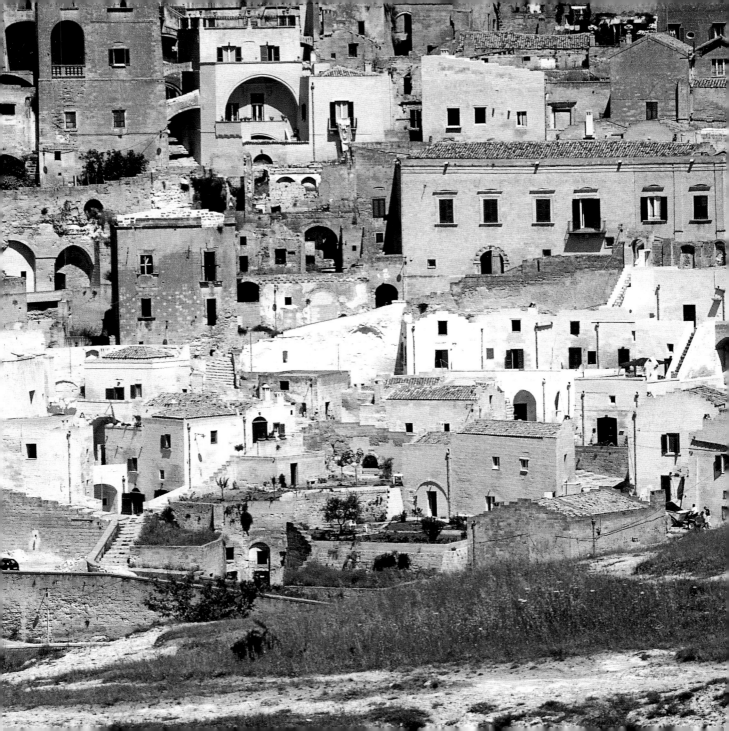

An artist adding his
final touches to a
float for the Feast of
the Madonna.

East of Matera and as far as the Murge of
Taranto lie impressive gorges and more rock-
hewn churches. Massafra, often referred to as
Italy's Thebaid (a province of the Nile River
valley but also a twelve-volume epic by the
Latin author Publius Papinius Statius) because
of the vast size of its settlements, is home to
one of the most important monastic
complexes of Byzantine art. West of Massafra
is the stunning Santa Maria della Scala, a
gleaming white church carved into the
caverned hillside. It is two miles long and 132
feet deep and full of shrines and dazzling
Byzantine decorations. The village is divided in
two by the medieval church of San Marco,
whose walls are riddled with hundreds of
caves connected by rudimentary stairways.
The most spectacular and wildest of the
region's gorges is in Laterza. Five miles long
with walls as high as 600 feet, this deep and
striking canyon is a natural oasis that is today
maintained by LIPU (the Italian League for Bird
Protection) and is an important bird sanctuary
for BirdLife International, a global alliance of
conservation organizations.

below
The frescoed walls
of the rock-hewn
church of Santa
Maria delle Malve.

right
A view of the Sasso
Barisano and the
Duomo.

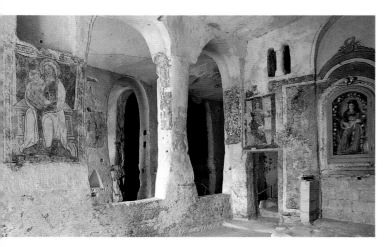

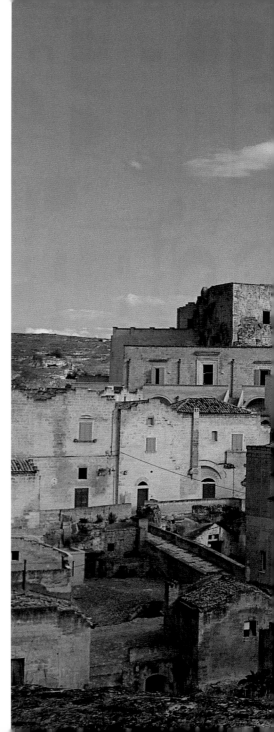

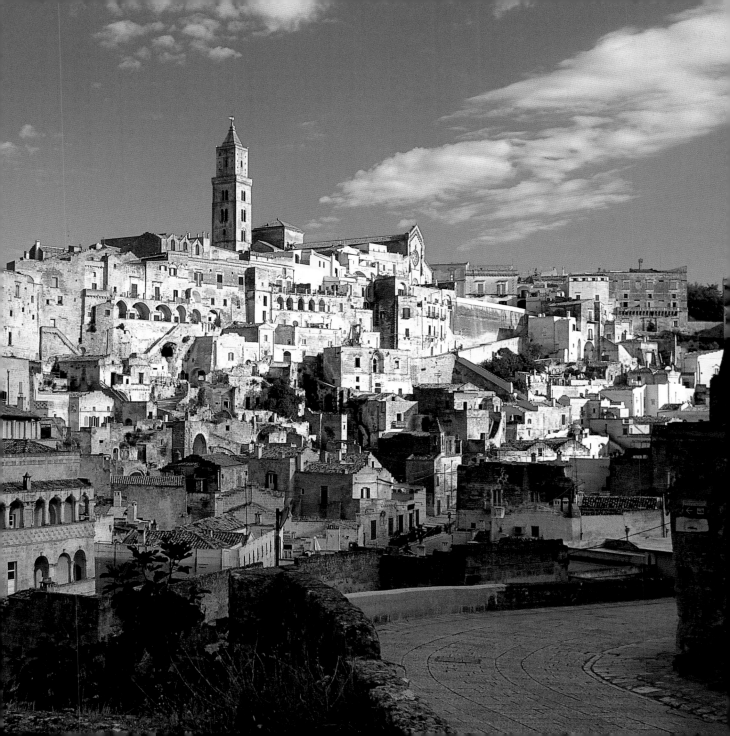

COSENZA

AN INTELLECTUAL CAPITAL

SINCE ITS BEGINNINGS COSENZA WAS A CENTER FOR PHILOSOPHICAL PURSUIT and a place fervently dedicated to learning. Even though it was conservative and decentralized, Cosenza has remained an intellectual capital and has even become known as the Athens of Calabria. The prestigious Accademia Cosentina, founded here at the beginning of the sixteenth century, is an institution dedicated to science, literature, and philosophy. Churches and palazzos were austere and plain, with facades minimally decorated so as not to overpower their sacred and dignified characters—as an expression of the powerful clergy and wealthy noble class. Excesses and esthetic irregularities were always submitted to censorship and not even the Spanish, who left an indelible mark on the city, were able to infuse a taste for the sensual curvature of shapes and the enjoyment of ostentation. In the Padolisi, the most representative area of Spanish dominion, the bulging balconies are the only touch of affectation on the plain facades, whose beautiful portals stand in great contrast to the poverty in the streets. This austerity provoked counter-measures that were sometimes excessive, such as that of the archbishop Capece–Galeota in 1748, who had the twelfth-century Romanesque Duomo adorned with statues, rose windows, pinnacles, columns, and coats of arms, almost to the point of bad taste. As soon as they could, which was not until the end of the nineteenth century, the people of Cosenza restored the Duomo back to its original esthetic severity. The interiors of churches and convents are still an accumulation of precious ornaments; the palazzos are characterized by frescoed ceilings and purely ornamental stuccowork. Even the noble Giacomo Casanova found "enough of the superfluous to render life tolerable." Craftsmanship also flourished from many favors and privileges. Tailors were allowed to build a conservatory for the education of their children, while leather workers were invited to Prague by the Emperor Maximillian to instruct his subjects. The complete cycle of silk production was formed here, from the cultivation of the mulberry to commerce in textiles.

Today the old city is a harmonious one, with streets and inclines that climb up the Pancrazio Hill as far as the Swabian Castle. The castle was rebuilt by Frederick II and renovated by the Angevins and the Aragonese, and served every purpose (from prison to seminary) except the one for which it was originally built. More than five thousand years ago the Bruttii were taken by the view from Cosenza, with its rivers flowing slowly across the plain below, the mountains in the background, and the relentless blue skies. Now the old city has become the periphery, and the living city is beyond the Busento River, where the middle-classes of Cosenza thrive. It is their spirit that has enabled them to maintain this independence in spite of their conquerors—Romans and barbarians, Arabs and Normans, French and Austrians.

Cosenza stands on the confluence of the Crati and Busento rivers in the heart of Calabria. The Busento divides the new city from the old, and tradition has it that Alaric, the Visigoth king, was buried here in AD 410 with his treasure. Alaric died during an expedition to conquer the south of Italy after having sacked Rome. According to legend, the river was temporarily diverted, and once the burial had taken place, it was returned to its natural course; the slaves and soldiers who had dug the grave were killed in order to safeguard the buried treasure's resting place. Lombards, Angevins, Normans, and Spaniards all sought the elusive riches, and today there are still people who are searching for the tomb and its precious contents.

The Swabian Castle, or Castello Svevo, is the best-preserved castle in Calabria. Other monuments worth visiting are the twelfth-century Romanesque Duomo, the thirteenth-century church of San Francesco d'Assisi and its oratory decorated with stuccowork and frescoes, and the town's many noble palazzos. Nature lovers are encouraged to visit the Sila Mountains, where numerous lakes and enchanted, centuries-old forests await exploration. The Parco Nazionale del Pollino is one of the largest in Europe and should not be missed. The park borders both the Ionian and the Tyrrhenian seas. Farther east from Castrovillari, the Gole del Raganello (a ravine) is where many pairs of predatory birds, such as eagles, falcons, and owls, have made their nesting places.

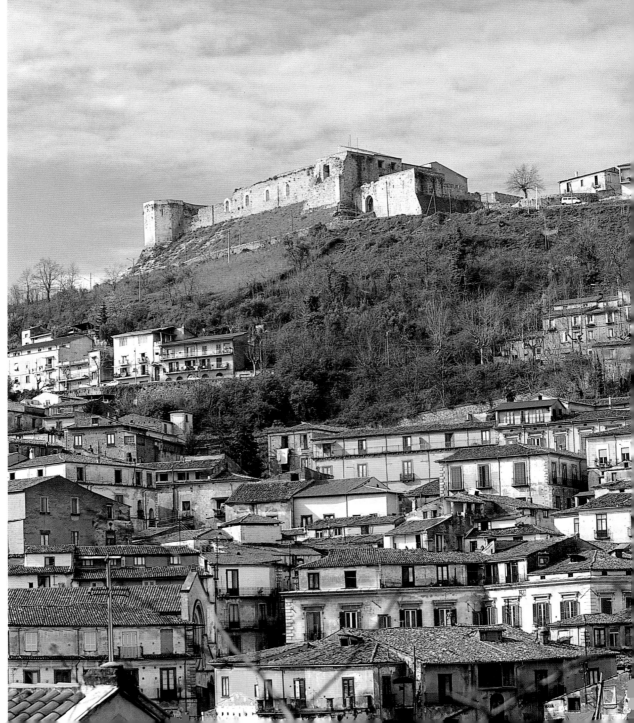

CROTONE

ON THE ANCIENT GREEK ACROPOLIS

THE FORTUNES OF CROTONE WERE PREDICTED long before its foundations had been laid, when the young Kroton was accidentally killed by his companion Hercules, who erected a monument in Kroton's memory and predicted a prosperous future for the city that would rise on that place. Crotone was founded in the eighth century BC by the Acheans, who were, it is said, guided by divine premonitions. The town lies on a fertile plain between the mouth of the Esaro River and the promontory of Lacinio, and possesses a mild climate. The city grew to be a powerful and rich one and was known throughout Magna Graecia until its conquest by the Carthaginians five centuries later. Historians of the time documented the beauty of its women and the invincibility of its athletes, such as Milo, master of all the Olympiads. A saying stated, "The last athlete of Crotone is the first among Greeks." Crotone was also home to great geniuses such as Alcmaeon, who founded a school of medicine, and the philosopher and mathematician Pythagoras, who left his mark on Crotone's social and political life. It is said that the city grew immense in size. The Latin historian Titus Livius claimed that the walls were eleven miles long, with roads over fifteen feet wide stretching as far as Capo Lacinio (the port and center of commerce) to the fifth-century BC temple of Hera Lacinia, a sacred place where women went to mourn the death of Achilles. The temple was destroyed by earthquakes, and only one solitary column remains—hence the name of the area, Capo Colonna. Nearby is the church of the Madonna, where the faithful go in procession once a year. Far from the city, the promontory is now an archaeological park; as a testament to its ancient greatness, remains are left of what was once an impressive hostel for pilgrims visiting the sanctuary: a banquet hall, Greek and Roman villas, and a thermal bath decorated by mosaics. Due to the limited space of the National Museum of Crotone, much of what has been excavated is preserved in Reggio Calabria. The historic center was enclosed within the Spanish walls, which have since been destroyed. From Piazza Pitagora at the limit of the modern quarter, and along Via Vittoria, one reaches the Piazza del Duomo, where a thirteenth-century baptismal font adorned by animal motifs can be seen, as well as the Byzantine tablet of the Madonna di Capo Colonna. Continuing along the Via Risorgimento, you will come across the Archaeological Museum, rich in ceramics, objects from the temple of Hera Lacinia, and a collection of coins, all of which have enabled scholars to piece together the history of the city. Further on stands the sixteenth-century castle of Charles V, built by Don Pedro di Toledo, on the remains of an ancient fortress on the Greek acropolis. Work on the fortifications began in 1541, and the palace eventually became a powerful military bastion against Turkish invasions.

The National Archaeological Museum of Crotone preserves the Treasure of Hera Lacinia, finds excavated from the temple dedicated to the goddess. Crotone is an important center for the production of jewelry and precious objects. Local silver mines (now abandoned) were exploited throughout antiquity, and nearby San Giovanni in Fiore was once known as the goldsmith capital of Calabria. Visitors can take home Byzantine-inspired souvenirs fashioned from precious metals sold in the village shops. Crotone specializes in filigree work, pieces in onyx, and reproducing the coins of Magna Graecia that are on display in museums.

Le Castella branches off of the island of Capo Rizzuto, about eighteen miles heading south on the coast of the Ionian Sea, and is a place colored by myth and legend. Homer's semi-goddess, Calypso, imprisoned Ulysses, King of Ithaca, on one of the nearby islands (either Ogigia or Calypso). The Aragonese Castle was built on this slender peninsula, attached to the mainland by a thread, where either Hannibal or the Brutti had built a lookout tower. For a long time it was an important stronghold of defense, enabling the village it protected to prosper, as a result of merchants and traders that followed the armies to sell them their goods. Now the majestic ruins of the castle, built in the thirteenth century by the Angevins and expanded in the sixteenth century, are strikingly silhouetted against the azure blue waters of the sea.

facing page
The castle of Charles V.

below
The only remaining column from the temple of Hera Lacinia.

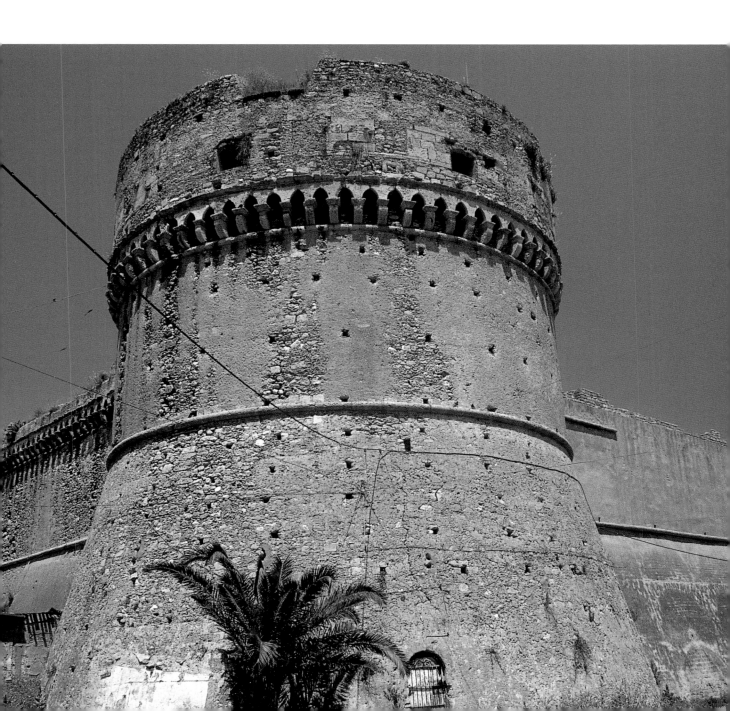

TROPEA
A MELTING POT

THE PROFILE OF CALABRIA IS DRAWN BY THE COASTLINE OF THE TYRRHENIAN SEA and the upland plain of Monte Poro, which separates the Gulf of Sant'Eufemia from the Gulf of Gioia Tauro. In the center of a stretch of seashore interrupted by sparsely inhabited beaches of fine sand stands Tropea, a village with a rich artistic heritage and today the vacation getaway for a select group of tourists. Tropea's long history has profited from the glories of the Greeks and Romans, among others. Some say the city was founded by the African Scipio upon his return from Carthage. The Spanish, Arabs, and Normans have all contributed to Tropea's past and built the palazzos and monuments that are its pride. For two hundred years the tiny island of Santa Maria della Isola has been united with the coast by an isthmus of land. It is nothing more than a big sandstone rock at the top of which stands a medieval Benedictine sanctuary, which was rebuilt after an earthquake in 1905. Before heading into town, take in the view from the island, a picturesque vista of Tropea resting on the slope of Mount Poro. From here, the houses appear to be molded from the tufaceous rock that cradles them as they dangle above a slender stretch of sand at the foot of the mount. According to some, the town's name comes from the Latin, *Tarpeius* (the name of a Roman family), but others maintain it stems from the Greek verb *trépo*, meaning "to walk around," with a clear allusion to the rounded shape of the spur on which it rises.

Calabrian wares for sale in a local shop.

facing page
A view of the town at night.

One enters the city through the Porta Nuova, a large portal that was formed as a result of an earthquake in 1783. The gateway stands beside the ancient Porta di Mare and Porta Vaticana, which enabled an escape in the event of natural disaster. Among the churches is the Cathedral of the Madonna di Romania, of Norman origin but renovated in the twelfth century. The Galluppi Chapel holds a great sixteenth-century crucifix sculpted from dark wood, called the Black Crucifix. In the central apse of the cathedral stands a Byzantine-style table depicting the Madonna of Romania, patroness of the city. The heart of the village is the nineteenth-century Piazza Ercole, flanked by the noble palazzos Gragò, Granelli, and Caputo, each with beautiful portals.

South of the promontory of Monte Poro, the plain of Gioia Taura extends toward the sea to form one of the most beautiful coasts of the Mediterranean. The Gioia Taura is one of the few extremely fertile plains in Calabria and boasts a mild climate. The area derives its name from *zoi* (life) and, because of its rich and well-preserved environment, has been inhabited since the Neolithic period. Today the economy of the area is generally centered around the industrial port, one of the most important in Europe. The real wealth—and beauty—of this upland region comes from its flourishing agriculture. The boundless groves of ageless olive and citrus trees perfume the air, and it is a privilege to taste the freshly picked oranges (varieties include the moro, tarocco, and navel), clementines, and mandarins.

The name of the piazza preserves the memory of the nearby Portus Heraculis, recorded by the Roman historians Strabo and Pliny, and possibly constituting the nucleus from which Tropea grew during the Anjou and Aragon periods. At the end of Corso Vittorio Emanuele appears the sanctuary of Santa Maria della Isola, surrounded by pristine waters of green and cobalt blue.

Traveling farther south along the coast one reaches the toe of Italy's boot, which is the closest point between Calabria and Sicily. Here stands a tranquil fishing village that thrives on the catch of swordfish that cross the narrow Strait of Messina every year between April and October. The centuries-old fishermen's tradition, of marking four signs of the cross beside the right eye of the fish is today still practiced. On the opposite side of the Strait of Messina is the cave where the sea monster Charybdis is said to have dwelled. According to Greek mythology Charybdis was the daughter of Poseidon and Gaia who was turned into a monster by Zeus. She swallowed and regurgitated the waters of the strait three times a day, thus creating whirlpools that posed dangerous threats to passing ships.

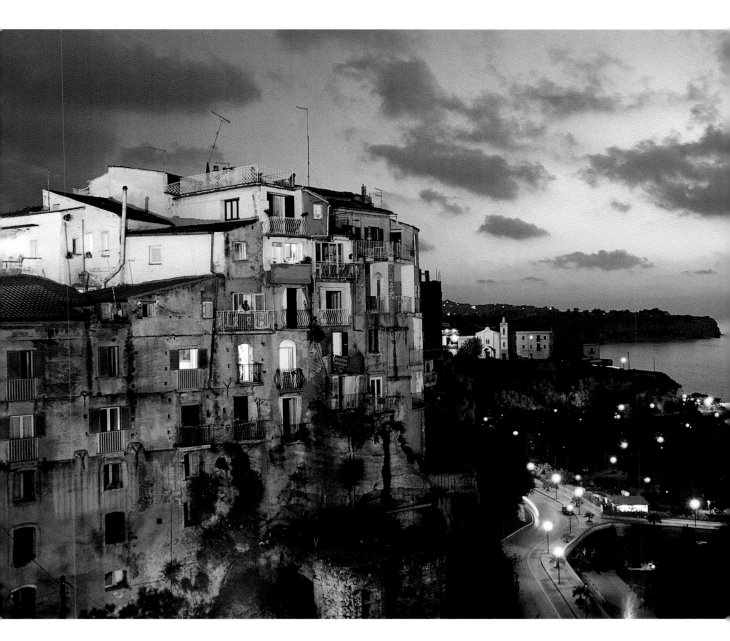

AGRIGENTO
TEMPLES AMONG THE ALMOND TREES

AGRIGENTO IS A LIVELY TOWN AND POSSIBLY THE MOST GREEK IN SICILY. Crowded and full of life, Agrigento's hub is not centered around the main arteries of the Via Matteotti or the Via del Duomo but the Valle dei Templi (Valley of the Temples), one of the most important archaeological sites left. The valley was described by the Greek poet Pindar (ca. 522–438 BC) as "the most beautiful city built by mortals." Walking along the Via Sacra, one still feels the solemnity that must have existed long ago in the sixth century BC, when the ancient Greek city *Akragas* had just been founded by a colony of people from Rhodes and Crete.

After the "hill of marvels" one first encounters the temple of the Dioscuri. Only four of the temple's original thirty-four columns remain, but they form such a fascinating sight that they represent one of the symbolic images of the valley. On its left is the sanctuary of Demeter and Persephone, where a circular altar used for sacrificial ceremonies stands. Further on is the Olympieion, a temple dedicated to Zeus, father of the gods. Nearby are the enormous statues of the *telamonis* that once held up the architrave of the temple. The only complete one of these statues is on display at the National Museum of Archaeology. The temple was built by the tyrant Tero to mark his victory over the Carthaginians, and it was to be the largest one known to the Greek world, but earthquakes interrupted its construction. Continuing along the Via Sacra are the temples of Hercules, Concord, and Juno, the first of which is the oldest, built in the sixth century BC. An important figure in the discovery and restoration of many of the temples was Alexander Hardcastle, a passionate patron of archaeology who lived in the splendid Villa Aurea and who financed the first systematic excavations in the valley in 1924. Farther on is the Temple of Concord, which owes its name to a Latin inscription describing a peace pact made between the opposing factions of Akragas. The temple was transformed into a Christian basilica in the sixth century AD and remains intact to this day. At the end of the hill, the temple dedicated to Hera Lacinia (Juno) stands out in silhouette. Its colonnade is almost completely preserved, with only nine of its thirty-four columns broken. Here you have a sweeping view of the sea to one side and the ruins of thousands of centuries scattered about to the other, not just along the Via Sacra, but also toward the coast, including the Temple of Asclepius (the Greek god of medicine), and the tomb of Tero. Down below in the valley is a Greco-Roman settlement.

The ruins of the Temple of Juno.

facing page
The Temple of Concord in the Valley of the Temples.

The almond, that sweet yet healthy nut, is the typical dry fruit of Sicily. Containing essential vitamins, minerals, and phosphorous, their bitter kind can, however, hold prussic acid and are therefore poisonous. Sicilians use almonds in thousands of different ways: for oil said to hold medicinal properties, for cosmetics, for almond milk used in preparing drinks or crushed-ice treats, and for sweets of every kind, from sugared almonds to pralines, from biscuits to marzipan. Candies made from crushed almonds and sugarcane were probably introduced by the Arabs, who dominated the region between the ninth and the eleventh centuries. The Frutta Martona, symbol of Sicily, is made from sweet almonds crushed to a paste, sugar, and egg whites, and is flavored with orange water or vanilla. The sweets are first molded into the forms of fruit (oranges, lemons, mandarins) or shellfish (mussels and clams for instance). They are then brightly painted with natural colors and made to shine with a thin layer of gum arabic.

The Hotel della Valle is a lovely hotel surrounded by a peaceful park on the hill dominating the Valley of the Temples. The Villa Athenia Hotel was converted from an eighteenth-century building near the Temple of Concord. The Leon d'Oro is a trattoria in the San Leone district that prepares fish-based meals. The Trattoria dei Templi near the archaeological area offers classic Sicilian dishes, such as grilled fish and spaghetti *ai ricci* (with sea urchin). The archaeological site containing Roman and Phoenician ruins at Eraclea Minoa is located on the edge of a hill overlooking the sea. At its foot is the beautiful beach of Capo Bianco, surrounded by dunes and cliffs of white rock containing large deposits of the mineral gypsum.

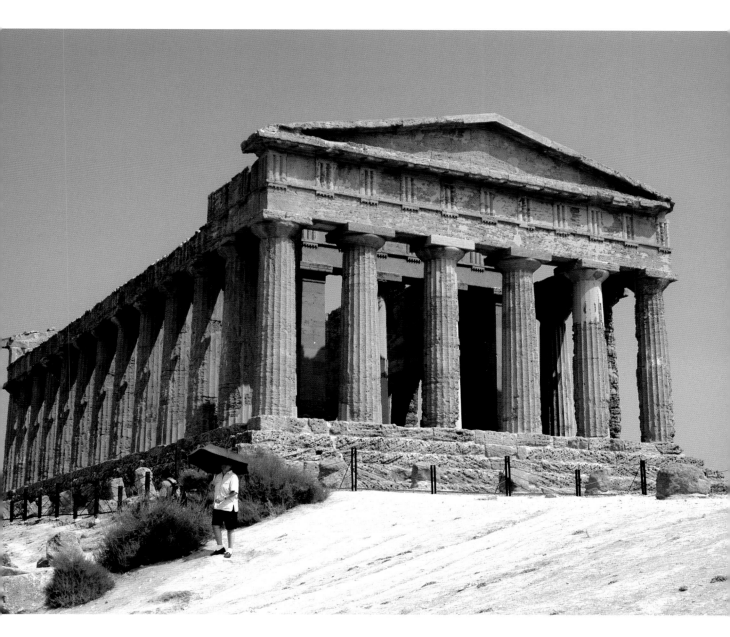

CATANIA
UNDER THE VOLCANO

IN CONTRAST TO MANY OTHER SICILIAN CITIES, Catania is characterized by a forward-thinking mindset rather than being tied to memories of its past. The people of Catania are more attracted to commercial and industrial undertakings than philosophical speculations, and are determined to follow through with every initiative. It is not by chance that the beloved symbol of the city is the *lu liotru*, an elephant, slow but stubborn and unstoppable. The symbol stands on top of the beautiful fountain in Piazza del Duomo. The people of Catania have every reason to be proud of their past, especially their cultural heritage—it is the home of the composer Vincenzo Bellini and the writer Giovanni Verga—as well as their architecture and archaeology. There is much evidence of this in the city: the Teatro Greco, the thirteenth-century Ursino Castle, the Duomo, the church of San Nicolò, the Benedictine monastery (one of the largest in Europe), and the many palazzos that beautify the city's historical streets. Catania's dynamic and entrepreneurial qualities were also on display in 1970, when the city commissioned the Japanese architect Kenzo Tange, a pupil of Le Corbusier, to create a plan for the new district of Librino (although it was never completed).

A detail of the elephant carved out of lava stone at Piazza del Duomo.

facing page
A ballroom in the Palazzo Biscari.

The postcard image of Catania shows buildings overlooking the sea, with the distinctive shape of Mount Etna in the background. The volcano is the city's symbol just as Vesuvius the symbol of Naples, and it is the largest and most active volcano in Europe. Etna erupts every now and then, and the burning lava attracts both vulcanologists and tourists. After an eruption in 2001, the city was covered by a veil of gray for days, disrupting traffic and forcing the airport to close down. At the end of the seventeenth century the volcano caused an earthquake that almost destroyed the city and killed a large number of its inhabitants. The survivors rebuilt the city and erected the Uzeda gateway near the Duomo, which leads to the port and is the beginning of the great Via Etnea, with views directly up the top of the mountain, as if to heal the relationship between the townspeople and the volcano. The area nearer the rim has been designated a National Park. Those who live at the foot of Mount Etna do not make too much of it, except when the lava encroaches on their homes. Then they promptly take flight, leaving behind glasses of wine and the key in the front door. They live on the volcano's territory and have learned to abide by its terms.

Etna has been a national park since 1987 and covers an area of more than 145,000 acres from the top of the volcano (roughly 9,900 feet high) to the belt of villages at its feet, comprising a landscape of extraordinary environmental diversity. It encompasses land consisting of lava-blackened slopes, vineyards, citrus orchards, and the picturesque gorges of Alcantara. One way to explore this terrain is to drive from Nicolosi to the Sapienza shelter at an altitude of 6,300 feet. Cross an expanse of lava colonized by birch, oak, and chestnut trees. All-terrain vehicles climb a safety shelter to the Montagnola, a crater formed in 1763, from which Mount Silvestri Superiore can be reached. From here the 2001 crater is visible, or there is the belvedere in the Bove Valley, a stone's throw away from the main crater. These sites can be visited on foot with much greater satisfaction, but it is advisable to be accompanied by one of the guides, who are on-call at the shelter.

Palazzo Biscari is one of the largest and most prestigious Baroque palaces in Catania and is home to perhaps the smallest hotel in Italy. The palazzo is the residence of the princes Moncada Paternò Castello and contains many grand rooms richly decorated with mirrors, frescoes, procelains, and chinoiserie. The Queen Mother of England heard of its fame and came to Catania specifically to visit the palace. She was particularly intrigued by the Salon for Celebrations. The palazzo is available for festive occasions such as receptions and concerts, and can also be rented for seminars.

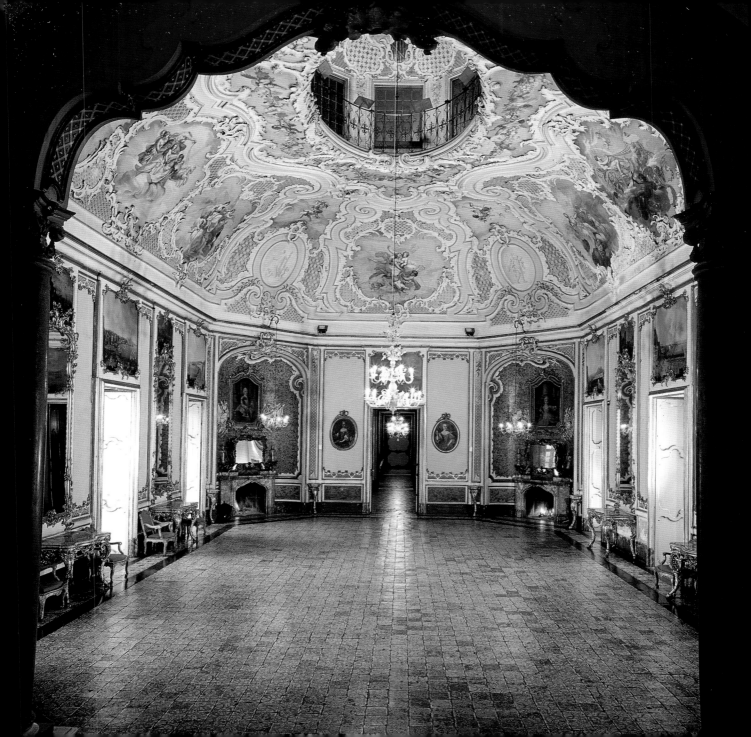

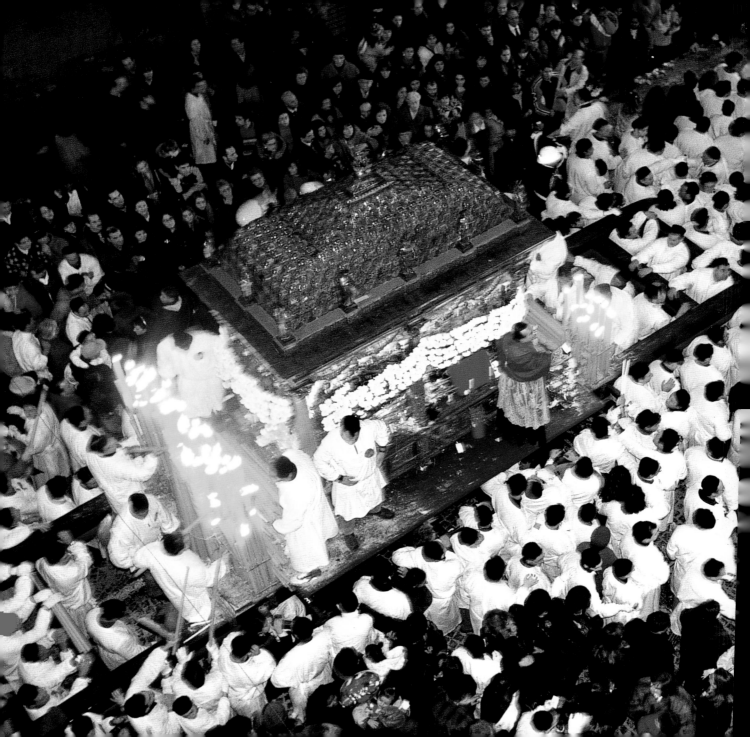

An excursion to the Gole dell'Alcantara, a series of gorges north of Mount Etna, should not be missed. Here the river has cut its bed into walls of basalt lava that are dozens of feet high. From May to September it is possible to descend as far as the riverbed and explore the most spectacular areas of this scenic abyss. Visitors may also tour the unusual and surprising world of Etna by traveling around the volcano with the Circumetnea Railroad. Trains leave from Catania and stop in several pastoral towns, including Paternò, Bronte, Maletto, Randazzo, Linguaglossa, and Giarre. There is also a tourist train in the summer that leaves from the Catania-Borgo station and travels to Giarre (the trip takes three-and-a-half hours). The return to Catania can be made by scheduled train. Until a few years ago this little train was pulled by the same steam locomotive that took the writer Edmondo de Amicis on his travels at the beginning of the twentieth century.

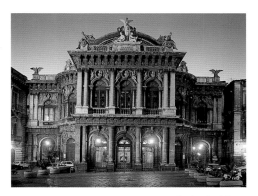

The facade of the Teatro Bellini opera house.

left
A procession during the Feast of Sant'Agata.

The well-stocked fish market.

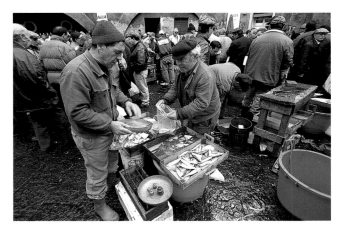

ERICE
A TEMPLE TO VENUS

ERICE HAS BEEN KNOWN AS A SACRED PLACE SINCE TIME IMMEMORIAL. One of the town's first-known temples was dedicated in the fourth century BC by the Carthaginians to Astarte, the goddess of fertility, known to the Greeks as Aphrodite, and to the Romans as Venus Ericina. She was venerated throughout the Mediterranean, and the temple was a place of pilgrimage not only for religious reasons—the beautiful priestesses of the goddess, called *hierodulae*, offered themselves up in prostitution. The temple sat beside a stretch of water between Erice and Carthage, signaling to the sailors with a series of red lights from the the *témenos* (sacred area) on top of the mountain. Among the few ruins that are left in the courtyard of the Castle of Venus, built on the acropolis during the Norman period, is the marble bust of Aphrodite. Erice sits perched on top of Mount San Giuliano, 2,300 feet above the sea of Trapani, and is contained in an almost perfect equilateral triangle. Those who have any knowledge of arcane symbols cannot help but notice this fusion of elements and see in Erice a pyramid of contact between the earthly world and the divine. Even those who shun mystic visions will be enchanted by the magic of the place, and fascinated by the silence of the populated area. The town has been able to reap the benefits of modernity without having to abandon its historical traditions. A sweeping panoramic view looks out toward the horizon, as well as down on the city of Trapani at its feet and the Egadi Islands afloat in the Mediterranean. Porta Trapani used to be part of the Carthaginian fortifications. Cars should be left outside here and the village explored on foot, so as to experience the town's medieval atmosphere properly. Stone houses cling to each other like pieces of a jigsaw puzzle, and some of the craftsmen's shops, especially those around Piazza Vittorio Emanuele, have preserved their *balatari*, massive stone shelves from where the shopkeepers leaned out into the street to sell their wares. *Frazzata,* carpets hand-woven from colorful strips of cotton, comprise an art form in Erice. The narrow streets, or *venule*, protect against the wind and connect the main thoroughfares. Only on foot can one smell the warm scent of Erice's local sweetmeats, and only on foot can one interact with the locals and possibly gain access to their homes, where they are known to cultivate intimate gardens and pergolas. The gardens are hidden behind the main door of the house, but by knocking politely, one may have the chance to enter and admire them.

A ceramic shop.

facing page
The Matrice church.

The tradition of tuna fishing (*muciara*) is one of the oldest and most popular in Bonagia. Fishermen used to operate along the more than 620 miles of Sicilian coast. The fish market was a great source of wealth for the region, providing work for thousands of people. Fishing, however, was more than an economic factor. A fusion of science and mystery, tradition and culture, and even biology and anthropology propelled this centuries-old activity. The nets were dropped along the coast to intercept the tuna during their "travels of love" in search of waters that were warm and rich in salt where they could mate and reproduce. It was called *di corsa* (outgoing) if the tuna were caught during the mating season in May and June, and *di ritorno* (return) when they were netted at the end of their journey, in July and August. The captured fish were then channeled to the "death chamber," where the *mattanza* (the killing) took place. They daily catch was hung on hooks by the fishermen and physically pulled up on board.

By the beginning of the fifth century BC Carthage had begun to influence parts of the Mediterranean, including Sicily. The town of Erice was a Carthaginian stronghold and the fortifications that remain from Porta Spada to Porta Trapani are not to be missed. Other noteworthy sights include the museum in the Palazzo Municipale, which displays the bust of Venus, and the Matrice church built by Frederick of Aragon in the fourteenth century. The Matrice is the main church of Erice and was constructed using stones from the ancient Temple of Venus, upon whose ruins the Governor's Castle was built in Norman times. The former monastery that is now the Palazzo Chiaromonte was erected between the twelfth and fourteenth centuries. Be sure to visit the oratory of the Congregazione del Purgatorio, the church of San Carlo and its convent, the church of San Giovanni resting atop a precipice, and the church of San Pietro and its convent of the Clarissas.

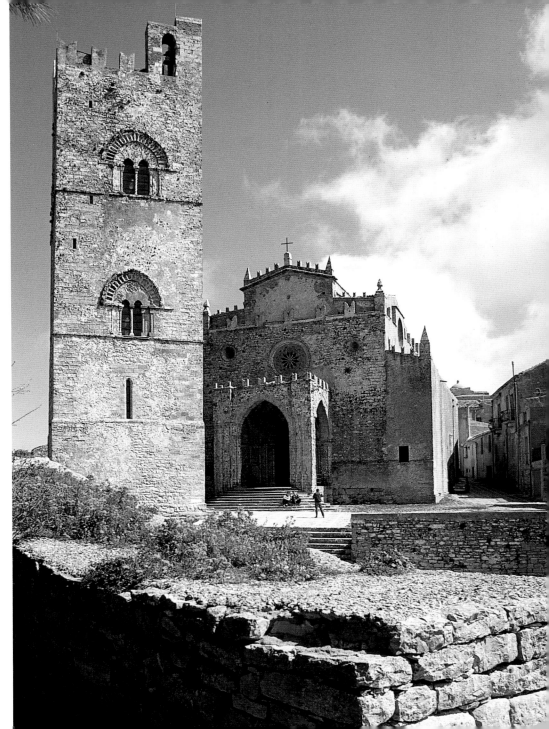

ISOLE EOLIE
THE ISLANDS OF FIRE

THE LIPARI (OR AEOLIAN) ISLANDS, A FEW MILES NORTH OF SICILY, are comprised of an archipelago of seven volcanic isles grouped in the Tyrrhenian Sea. They are wild and worldly, visited by society people, but far away from civilization. Often referred to as the "seven sisters," they are similar at first glance but vary a great deal the more one explores them. The volcanic archipelago takes its name from Lipari, the largest and most populous island. The island of Salina is now a nature reserve, while Vulcano, said to be the furnace of Hephaestus (or Vulcan) where the Cyclops forged lightning for Zeus, is a mysterious place of smoke holes and boiling water (used as a cure for various ailments). The tiny island of Panarea is surrounded by a sea of frolicking dolphins, while Alicudi, the farthest away, is the most spartan of the islands—there are almost no streets and the best means of transportation is still the donkey. The archipelago resembles a handful of stones thrown into the ocean by an angry god that is still subject to his variable moods. Sometimes he makes himself heard with his rumblings from the center of the earth in the form of violent storms and natural disasters, such as those on Stromboli, especially when the island's volcano erupts. A modest squall can block the steamers from the mainland and drive the islands away from the world. Despite their natural isolation, the islands have witnessed the passing of many a great civilization, as is evident from the vast number of preserved objects on Lipari in the Museo Eoliano, an archaeological museum with several branches throughout the island. The museum and its sites possess one of the most important collections in the Mediterranean of works from ancientWestern civilizations, including manuscripts, ceramics, paintings, sarcophagi, Greek masks of tragedy and comedy, and painted vases decorated with mythological and divine figures. The islands can, in a sense, be read: archaeologists have identified nine strata (on land and in the sea) during excavations begun after World War II. Each layer represents a page of six thousand years worth of history, beginning in the Neolithic period when obsidian was used for arrow points and cutting tools, and continuing with the successive Greek, Roman, Spanish, and Norman colonizations.

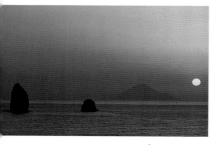

Majestic cliffs reminiscent of Capri's I Faraglioni.

facing page
A view of a volcano.

From above the islands seem deserted and inhospitable, but they are quite fertile. Four hundred types of rare plants have been catalogued in the Salina nature reserve alone, and olives and grapes are also cultivated here. By far the greatest treasures of the islands are their pristine environment and colorful marine life, the latter of which is among the most spectacular in the Mediterranean and is frequented by snorkeling enthusiasts and scuba-divers looking for a unique experience.

The roaming sheep tracks that characterize the Lipari Islands are almost all flanked by dry walls covered with caper plants. During the summer months, they burst into beautiful white flowers. The buds of the capers are collected from May through August and then left to rest in the shade for a day, after which they are sprinkled with sea salt and preserved in wooden vats to mature. Capers are used to add flavor and the perfume of the sea to a number of dishes, or they are eaten in brine with an aperitif. Beyond the stone walls, in small holes dug in the barren earth, one can see low rows of vines from which comes the extraordinary malmsey of Lipari, a sweet, aromatic wine with a low alcoholic content. The same grapes, when they are dried, produce a sweet, natural dessert wine and a fruity malmsey liqueur.

The Lipari Islands are home to a wide range of hotels, from the exclusive to the low-key. The Hotel Villa Meligunis in the center of Lipari was built from an eighteenth-century residence. The Hotel Signum at Salina is characterized by the use of lava rock brought from Etna (there are no quarries on Lipari). The exclusive Hotel La Raya on Panarea is the most Mediterranean of the hotels on the islands. On Lipari the restaurant 'E Pulera offers some of the best examples of Aeolian cuisine. The trattoria A' Tana on the port of Filicudi prepares fresh fish based on the day's catch. Cala Junco on Panarea serves non-traditional, creative dishes. The restaurant Ai Gechi on Stromboli offers dishes with subtle Eastern influences such as sushi and octopus salami.

NOTO
A GARDEN OF STONE

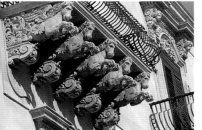

A detail of the Baroque balcony of Palazzo Nicolaci.

facing page
The church of San Francesco on Piazza dell'Immacolata.

NOTO HAS BEEN THE CAPITAL OF VALLO since the beginning of the nineteenth century. It lies on the southeastern point of Sicily and enjoys sweeping views of the sea and the eastern slopes of the Iblei Mountains. The town is at a remove from popular tourist itineraries and is best known for complex yet subtle architecture and sculpture and for its homogenous urban planning. Noto occupies a pretty setting and was built from soft tufa stone turned honey-colored by the sun, earning it the nickname "Garden of Stone," coined by the art historian Cesare Brandi. Neas, as Noto was called in Greek, was founded in prehistoric times. It was Greek, Roman, and Arab, and then Norman, Swabian, Aragonese, and Spanish. Its present layout is fairly recent; Giuseppe Lanza, Duke of Camastra, had it entirely rebuilt at the end of the seventeenth century. Ancient Noto consisted of a series of buildings that were completely destroyed by an earthquake in 1693, as were another sixty or so fortresses in the valley of the Iblei Mountains. There were lengthy discussions about where to rebuild and although many ideas were abandoned, others were either carried out on the old sites or at new locations. The entire area became a construction site during the whole of the eighteenth century. It had been thought opportune to build further inland, in order to protect the city from the hazards of the encroaching sea, but since this was no longer considered a danger, the new Noto was built nearer to the coast. The city now boasts an urban setup that is orderly, geometric, and based on the golden ratio—upon which buildings of stone designed with great inventiveness were erected.

The nucleus of monuments and noble residences are concentrated around large squares, such as that of the Duomo and the Mercato. They are distributed along great arteries, primarily the Corso Vittorio Emanuele and the Via Cavour. Sirens, winged horses, monstrous masks, and grotesque figures spring from the facades of palazzos and churches. The writer Vincent Cronin defined Noto as a "honeycomb of golden stone." Noto is indeed a unique place, and was named a UNESCO World Heritage Site. The main square is one of the most beautiful in Italy, characterized by the elegant cathedral of San Nicolò, with its impressive stairway, and by the Palazzo Ducezio, which is now the seat of the Municipality. Other places to visit include the church of San Salvatore, the Palazzo Landolina, and the Bishop's palace.

There are several other churches to see, scattered throughout the town, some on the larger piazzas and others hidden away. Not to be missed is the church of San Domenico, considered the masterpiece of the architect Rosario Gagliardi. The church is distinguished by a convex facade that imposes its colonnade on the square.

Nine miles inland, on Mount Alveria, is the archaeological park of the ancient settlement of Noto, said to be founded some centuries before Christ by the Siculi, later occupied by the inhabitants of Syracuse, and then by the Romans. It prospered during the Middle Ages, but was completely destroyed on January 11, 1693, by a devastating earthquake. The present city was built much later. A section of the ancient city walls with one of its gateways, the Porta della Montagna, remains on the archaeological site, and the ruins of a castle, the Greek gymnasium, and a necropolis with sepulchers dating back to the ninth century BC can be seen. Some finds have been preserved in the Civic Museum of Noto, located in the convent of the Santissimo Salvatore.

Lava stone has always been treated with respect in Italy. It has been used to decorate churches and palazzos destined to last over time. Despite bringing death and destruction to this part of Sicily, the earthquake of 1693 sparked a huge effort to rebuild. The result is a gemlike towm of Baroque exuberance. Many of Noto's buildings have been designated World Heritage Sites by UNESCO. Other nearby villages benefited in the wake of the earthquake, such as Modica, where tourists are encouraged to visit the churches of San Giorgio, San Pietro, del Carmine, and della Madonna del Rosario. The church of San Giorgio has one of the most beautiful late-Baroque facades in Europe. In Ragusa the churches of San Giorgio and San Giuseppe are worth a visit as are its numerous palazzos, in particular Palazzo Cosentini, which contains allegorical frescoes of the Months, the Seasons, and of the seven Vices and Virtues. In Scilci stop in the churches of San Giovanni Evangelista, Madre di San Michele Arcangelo, Santa Teresa, and the notable palazzos Spadaro and Beneventano.

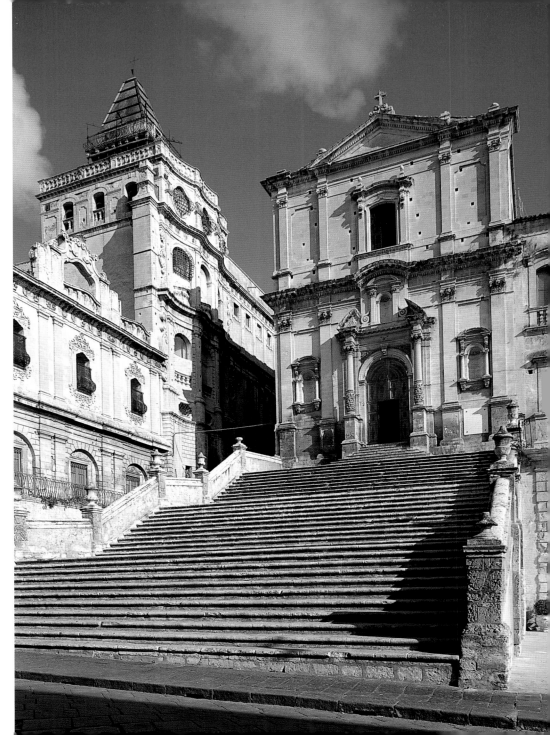

PIAZZA
ARMERINA
THE VILLA OF THE MOSAICS

PIAZZA ARMERINA IS A SMALL TOWN AT THE HEART OF SICILY, where a strange Gallic–Italic (or Lombard–Sicilian) dialect is spoken, a consequence of the Lombard migrations during the period of Norman domination. Dwarfed by the Erei Mountains, the village resembles an anthill, with thousands of tiny houses piled on top of each other on three hills distinguished by the seventeenth-century Duomo and the earlier Aragonese Castle. The most intriguing part of Piazza Armerina is hidden; one needs to dig deep to see it, to explore the narrow streets of the historic center around the Piazza Garibaldi. This is the only way to discover the churches, the Baroque and Renaissance palazzos, and what is left of the medieval Norman construction, when the city reached the height of its splendor under Count Ruggero d'Altavilla, son of King Tancred.

After a typical plate of pasta with lamb liver, it is worth taking a walk to visit some of the city's monuments. In truth, one comes here to see the splendid mosaics. Piazza Armerina and mosaics are so closely connected that those not familiar with the town think that it is one of the many squares in Italy with a famous work of art. The curious name derives from Platea, which in turn derives from *palatium*, and the name Armerina was added in 1862 (from *castrum armorum*), a reference to the Norman "castle of arms." The renowned mosaics belong to the fourth-century AD Imperial Roman Villa in Casale, a couple of miles outside the village at the foot of Mount Mangone. The mosaics are so beautiful that they have been designated a World Heritage Site by UNESCO, as the richest, largest, most complex, and best-preserved collection of Roman mosaics in the world. The villa itself is stunning and was probably the luxurious country house of Maximilian (Massimiliano Erculeo), who co-ruled the Roman Empire with the emperor Diocletian; it is certainly one of the greatest representations of Roman culture and civilization in Sicily. Forty rooms of various uses, from reception rooms to latrines, to thermal baths with *frigidarium*, *tepidarium*, and *calidarium*—comprise the 3,500-square-meter villa. All are decorated with mosaics of incredible realism, animated by characters from the works of Homer, hunting scenes, circuses, and a group of young women in two-piece costumes, possibly the first bikinis in the history of art.

A famous mosaic of "girls in bikinis."

facing page
An overhead view of the sumptuous mosaics at the Imperial Roman Villa.

The capital city of Enna in the heart of Sicily clings to the sides of a mountain that is 3,135 feet high and for this reason is called the "navel of Sicily." It is not much more than eighteen miles from Piazza Armerina and worth a visit. The city was dedicated to the cult of Ceres, and one can see the remains of her temple here. The Castle of Lombardia was built by Frederick II of Swabia and expanded by Frederick II of Aragon, who was crowned king of Trinacria in 1314. It once was one of the most ponderous fortresses in Sicily, with three great courtyards and twenty towers (six of which are preserved today). The fourteenth-century Duomo was rebuilt in 1451 and features a sixteenth-century portal and thirteenth-century octagonal tower, once the residence of Frederick II.

On August 13 and 14 Piazza Armerina celebrates the rout of the Saracens from Sicily by Count Roger d'Altavilla at the beginning of the first millennium. The story tells that in addition to an ensign bearing the Madonna and Child, he was granted dominion over Sicily by Pope Nicholas II. The count gave the ensign to the city and kept the island for himself. Since 1952 the residents of Piazza Armerina honor this historic event with the Giostra della Quintana (another name for the Joust of the Saracens). Knights from Noto's four *contradas* (neighborhoods) compete in a contest of skill and dexterity. There goal is to topple a puppet representing the enemy by sticking their lances through a tiny ring hanging from its hand. The joust is preceeded by a colorful costume procession to the cathedral to pay homage to the Madonna della Vittoria.

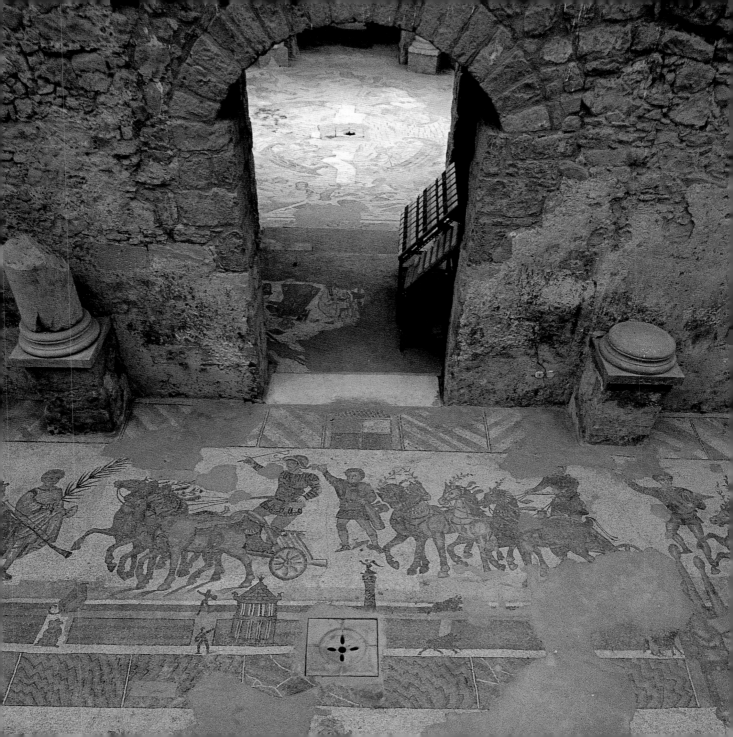

SYRACUSE

ARCHAEOLOGY AND CARAVAGGIO

THE ORIGINS OF SYRACUSE ARE LOST IN THE MISTS OF TIME. Myths tell how the Gods of Olympus (Zeus, Apollo, and Hephaestus, to name a few) amused themselves here. Syracuse could not but become a great city. Founded in 734 BC by the Greek noble Archias, descendant of Hercules, Syracuse became an important center of Greek, Phoenician, and even Jewish civilization. It was the home of philosophers such as Philo and Plato, of the poet Theocritus, of mathematical geniuses such as Archimedes (murdered here by a Roman soldier), and where the Republic of the Philosophers was founded. By the time the city was destroyed by the Arabs in AD 878, it had already accumulated 1,500 years of such a glorious history that it made Athens and Alexandria pale in comparison. Its port, facing the eastern coast of the Mediterranean, welcomed thousands of Carthaginian, Arab, Egyptian, and Turkish ships.

Ancient written texts and scattered remains attest to Syracuse's greatness. The small island of Ortygia juts out into the Ionian Sea; it is here that Syracuse's real roots lie. Here, in the shadow of the Latomie, the great mass of limestone rock caves that were used as a prison, is where the most significant artifacts have been found. In the largest cave, the Latomia del Paradiso, lies the most famous, the Ear of Dionysius, so called because of its narrow and elongated shape (the name was given by the Italian Baroque painter Caravaggio, who fled to Syracuse in 1608). Worthwhile itineraries should include the Greek Theater, the Roman Amphitheater, the Grotticelli necropolis, where many Roman tombs were buried and where it is said Archimedes was laid to rest, the catacombs of Santa Lucia, and those of Vigna Cassia and Saint John. The National Archaeological Museum contains remains from prehistoric times. Nearby stands the Castello Eurialo, the most complete military structure left from the Greek era. It was built, together with its walls, in the fifth century by Dionysius the Elder. Continued construction on the island of Ortygia, however, has overshadowed older monuments, such as the temple of Apollo, which was successively transformed into a Byzantine church, an Arab mosque, a Norman basilica, and finally incorporated into a Spanish-inflected edifice. Other landmarks that have undergone alterations include the Fonte Aretusa, (according to legend a spring that originally a transformed nymph), and the Duomo, built during the Byzantine era on top of a temple dedicated to Athena (it was expanded by the Normans, and in the eighth century was given a Baroque character by Andrea Palma). The ancient Greek urban plan is evident in the narrow, crowded houses and the lovely street promenades.

The Burial of Saint Lucy, painted by Caravaggio in 1608 when he was in hiding in Sicily.

facing page
Syracuse's ancient Duomo on Ortygia.

Roman, Arab, English, and Italian poets have been seduced by Aretusa and Ciane, two nymphs transformed into water springs in enchanted places. The *Cyperus papyrus linneo,* commonly known as papyrus, grows in the lake formed by the Ciane River and at the center of the basin of the Aretusa spring. It was imported by the Arabs, perhaps even by the Egyptians, and used in Syracuse to make paper since at least the second half of the eighteenth century. The International Institute of Papyrus (which houses the Museum of Paper) is dedicated to the study, research, and cultivation of this precious plant. To make paper as they did thousands of years ago, the stalk of the papyrus plant is cut into narrow strips that are lined up and superimposed on another stratum at right angles to the first. From this are obtained natural sheets to make refined paper for letters, or to reproduce ancient drawings and hieroglyphics.

The Grand Hotel is an elegant Art Deco construction with a private beach and excellent views. The hotel is equipped with all the modern comforts and even has a small underground museum housing the remains of Syracuse's ancient Spanish walls. The Hotel Gutkowski on Ortygia is owned by the Polish-Sicilian Paola Pretsch, who renovated this waterfront town house and opened it to the public in 1999. The hotel has fifteen rooms overlooking the sea and bears the surname of her mother. At the port of Ortygia, the restaurant La Darsena serves meals based entirely on fish. The Minosse restaurant also prepares excellent fish-based dishes and has become a favorite in Syracuse.

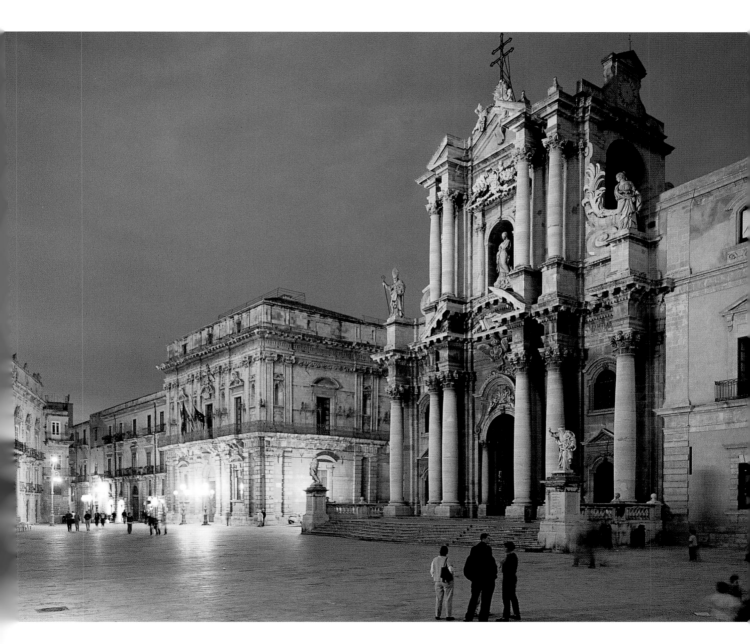

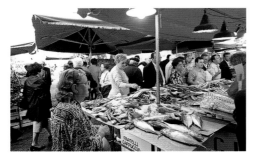

above
The bustling fish
market.

below
The marble quarry
famously named the
Ear of Dionysius by
Caravaggio.

right
The ruins of the
Temple of Apollo.

Sicilian puppets belong to a tradition that
developed in the middle of the nineteenth
century and are now one of the symbols of
Sicily. The puppets made here embody the
work of many different craftsmen: from
carpenters to inlay workers, metal artisans,
sculptors, and seamstresses. The classic
marionettes that puppeteers once performed
with delighted not only children but adults as
well, who took pleasure in their often satirical
political comments. Today the puppets are
decorative objects sought after by tourists
and are often faithful reproductions of
famous nineteenth-century characters
destined for museum collections.

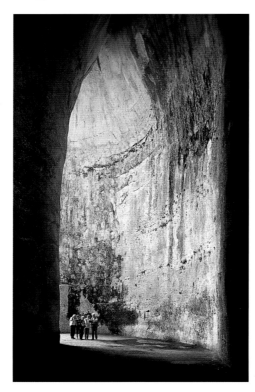

TAORMINA
A TERRACE ON THE IONIAN SEA

TAORMINA FACES THE IONIAN SEA and stands six hundred feet above it on the eastern coast of Sicily. It is the quintessential Mediterranean town in terms of climate, the color of the ocean, the sweet scent of the brush, its history and monuments, the atmosphere of its squares and narrow streets, and the friendliness of the people. Poets and writers have celebrated Taormina in enchanted descriptions and some have even confessed to lacking adequate words to describe it. In 1863 the Prussian baron Otto Geleng, a young painter, introduced Europe to Taormina. During his travels through Sicily he visited Taormina and was charmed, especially by the winter landscapes and the snow-covered Mount Etna. He exhibited his canvases in Paris, but critics accused him of not having painted from reality since he depicted almond trees in bloom with a snow-capped Etna in the background. Geleng challenged them to go to Taormina and see for themselves, and if his paintings were true to life they would have to sing the praises of that corner of Sicily. The challenge was accepted, and the fortunes of Taormina in artistic and cultural circles of Europe and America were settled. It soon became the choice vacation spot for the elite. Luxury hotels were built, including the San Domenico Palace, which was con-

An evening stroll
and shopping.

facing page
The Greek Theater
with Etna looming in
the background.

verted from a fifteenth-century convent and has about one hundred rooms and is surrounded by gorgeous Italian gardens. Today the hotel hosts film stars and the international jet set, who can be seen at the Mocambo or the Wunderbar enjoying a breakfast consisting of iced coffee with cream and croissants. Yet, more than the landscape can be admired in Taormina. There are also some worthy monuments, such as the Saracen Castle on Mount Tauro, the cathedral of San Nicolò, the Palazzo Corvaja, and that of the Duke of Santo Stefano. The Baroque churches of San Giuseppe and Sant'Agostino, with its clock tower, embrace a square that is perched above the sea. The most celebrated monument is the Teatro Greco (Greek Theater), built in the second century BC in a natural valley, which offers the most beautiful stage setting one could wish for. This is how Johann Wolfgang von Goethe saw it 1787: "If you take your place where once the spectators sat on the highest seats, you would have to confess that never did the public ever have such a similar perspective. On the right on the great rocks rise the forests. Further away and lower down is the city....Then the view extends over the whole chain of the crests of the mountains of Etna. To the left is the coast as far as Catania, as far as Syracuse...."

The richly carved and painted—and sometimes even painted-and-enameled-copper—Sicilian horse carts were created in the nineteenth century out of emulation and envy. In fact, before then, only the carriages of rich land owners were decorated and refined, while carts were employed to transport agricultural products were made with rough planks of wood. Only when the roads improved did the carts begin to be used for traveling, trade, or even to take families to mass on Sundays. At first, all that was necessary was a good cleaning and a plank to act as a bench, but then people started adorning them with epic and religious scenes, particularly the adventures of Orlando and the Paladins of France. The most beautiful examples are to be found in the Sicilian Cart Museum of Terrasini in Palermo.

The San Domenico Palace was converted into a luxurious hotel from a fifteenth-century convent. It has become one of the most prestigious hotels in Italy and has accommodated many illustrious guests, including King Edward of England, Kaiser Wilhelm II, King Umberto of Savoy, Thomas Mann, John Steinbeck, Ava Gardner, Cary Grant, Audrey Hepbrn, Richard Strauss, and many others. The Palace has preserved the feel of the convent by maintaining the cloister and its garden, the Roman ruins, and valuable paintings. The Romantik Villa Ducale was transformed into a hotel from an aristocrat's residence. Two favorite places to dine are the restaurant Al Duomo in the historic center and Il Ficodindia on the seaside promenade of Letojanni.

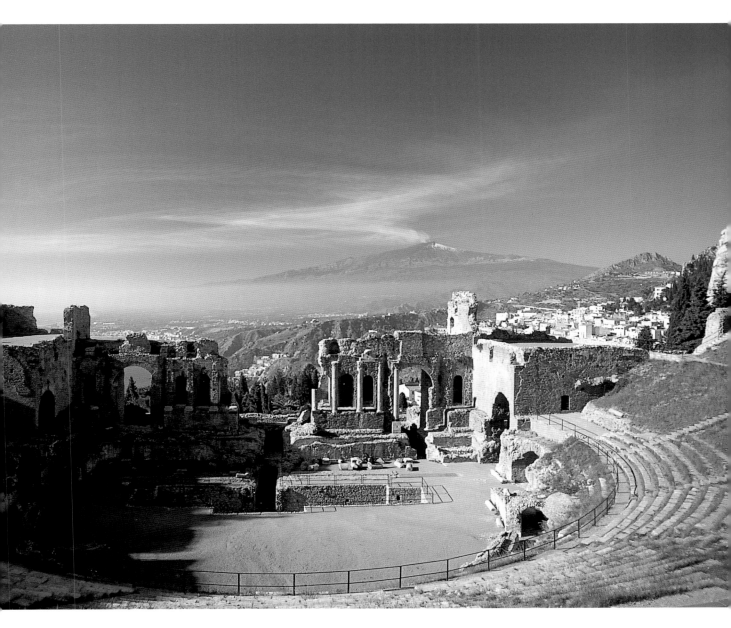

TRAPANI
SALT BEDS AND CORAL REEFS

TRAPANI LIES ON THE TIP OF A NARROW AND ARCHED PENINSULA and reaches out toward Spain and Africa. It is an ancient city that preserves its Arabic origins in the Casalicchio district, especially in the elegant streets, Baroque architecture, and the light-colored stone of the Palazzo Borgo. Almost all of the city walls were torn down in 1860. The fourteenth-century sanctuary of the Annunciation, beside the Pepoli Museum, originally lay beyond the city walls. The interior is spectacularly baroque and contains the Renaissance chapels devoted to fishermen and sailors. At the time of the Arab domination, Trapani was the center for tuna fishing and coral. The production of salt is still important today and is a valuable source of income comparable to that of the high-quality wines of Florio, Donnafgata, and Pellegrino, and the cellars of Tasca d'Almerita, Duca di Salaparuta, and Planeta, a few of the names that are among the best Sicilian vintners. The road from Trapani to Marsala is bordered by salt beds and offers an incomparable landscape. The Stagnone lagoon, the largest in Sicily and a natural reserve since 1984, is well worth a stop. The lagoon comprises four small islands, among them San Pantaleo, named after the Basilian monks who lived there in the Middle Ages. San Pantaleo is nearest to the coast and was founded in the eighth century BC by the Phoenicians, who called it *Motya*, or "spinning," because wool was spun there. The Phoenicians turned San Pantaleo into an important colony that was often at the center of ferocious disputes and contested by the Greeks and the Carthaginians. The island was bought in the nineteenth century by the magnate Joseph Whitakaer, whose family traded in Marsala wine. Whitaker began systematic excavations that brought to light important objects, part of which are now held in the museum in Whitaker's house. San Pantaleo was once connected to the mainland by a paved Phoenician road, four miles long. It is now part of the Reserve of the Salt Flats of Trapani and Pacenco, a natural reserve that

The colorful seabed of the Tyrrhenian Sea.

facing page
Salt is one of the region's main resources.

The strong sunshine and temperate climate of the Trapani coast makes it an ideal place for salt flats. Almost no rain falls in the summer, and intense and frequent Sirocco winds propel the picturesque windmills that reside over flats. The windmills have four to six sails, similar to Dutch models, or twenty-four metal sails, as do American examples, and pump water to the inner basins, while Archimedes screws turn the millstones that grind the blocks of salt. In 1154 the Arab geographer Idris documented the existence of the salt blocks and Frederick II of Swabia transformed them into a state monopoly. The blocks returned to private hands after the insurrection of the Sicilian Vespers in 1282. In 1500, when salt was a primary element for the conservation of food, more than 200,000 tons were produced annually, Trapani became the most important port in the Mediterranean. Along the eighteen-mile stretch of the salt road, one can see the flats of Nubia and visit the Salt Museum, where the various phases of salt manufacture are illustrated.

was built by centuries of work building new basins for salt beds and thereby moving the coast ever further out into the sea. The salt flats represent an ideal partnership between industry and nature: they do not cause pollution, they use the force of the wind and the heat of the sun, they do not produce waste (even the mud is reused to water-proof the basins), and they reproduce the pre-existing natural environment of the lagoon with low and warm water, an ideal habitat for many animals, especially migrating birds who pause here on their journeys.

The name Marsala holds more sway in the vineyard business than it does as a place. Marsala is the world-famous dessert wine that is sweet in taste and rich in color. It owes its fame to John Woodhouse, an English merchant from Liverpool who, in 1770, happened upon the town of Marsala and discovered its luscious wine. He found the taste comparable to the port and Madeira wines the British imported from Portugal and Spain, respectively, and began to export the wine throughout the Empire. In the first years of the nineteenth century, another Englishman, Benjamin Ingram, built a second establishment for the production of Marsala and introduced the wine to the world market. However, in 1882, the Calabrian Vincenzo Florio monopolized the production of the wine and since then the story and the fortunes of Marsala have been linked to his name.

ALGHERO
THE CATALAN FORTRESS

THE *ALGUER* IS AN ISLAND ON AN ISLAND, a Catalan enclave on the northwestern coast of Sardinia. The streets are called *carrer,* the ramparts, *muralla,* and New Year's Eve is known as *Cap d'Any*. The architecture of the churches and palazzos is Catalan–Aragonese inspired. To know why this is, one must explore the history of the island in the second millennium. In the eleventh century, the Dorias, a Genoese family, transformed a fishing village into a fortified port. Two centuries later, Pedro IV of Aragon, known as *il Cerimonioso* (the Formal One), defeated the Genoese fleet and took *Aleguerium* or *Algarium*, a place rich in algae, and renamed it *l'Alguer*. He expelled the Sardinians and the Ligurians and populated the place with Catalans, Aragonese, and Valencians, who for centuries defended the territory from invasions and managed to preserve its language and local traditions.

The old city is fascinating for its churches, palazzos, and fortifications built from beautiful, warm-colored sandstone. It shows the signs of time and has been eroded by bad weather and crumbles, as if fallen into decay. However, it is possible to enjoy pleasant walks along the narrow streets dotted with storefronts and jewelers' shops where coral is fashioned into baubles of all kinds. Look up to see the bell tower of the cathedral that rises high from a slender alleyway and dominates every viewpoint. It is more visible than any lighthouse that the fishermen see when they are out at sea. Enjoy the sea breeze from the *muralla* that encircles the old city in a horseshoe, from Porta Terra to the Magellano ramparts and to Porta Mare, beside the Maddalena fortress and the forest of masts, which are sailboats anchored in the port.

At the other end of the bay the white rocks of Capo Caccia can be seen, a promontory overlooking the sea, the most beautiful in Sardegna, where the waves of the blue-violet waters beat against the rocks. This is where the Mediterranean monk seal once lived (its last sightings were years ago), and where the griffon vulture makes its nest and takes flight from the cliffs aided by an impressive ten-foot wingspan. Overlooking the waters are the Grottos of Neptune, described as a "prodigy of the gods" by George Villiers, Duke of Buckingham and minister to King James I. A steep slope leads to the caves; if you're not up to climbing the 656 steps back up to the top, there is a boat service from Alghero that picks you up directly at the entrance to the grottos.

Alghero's pretty harbor front.

facing page
A view of the port from the Catalan fortress.

The *Corallium rubrum* is a tiny animal that forms red or pink treelike formations in the sea of Alghero. Coral has been considered a kind of jewel throughout the ages. At one time the fishermen of the Campania collected the coral. It is said that there were as many as five hundred boats involved in coral hunts, but reduced to about forty in the nineteenth century. They took the coral to the master craftsmen of Torre del Greco and Torre Annunziata. Coral is also found on the coast of Campania, but the coral of Alghero comes in larger pieces and is not affected by high heat, for example, in the unlucky incidence of a volcanic eruption. There is a considerably larger number of jewelers in the Alghero working in coral. Because it takes many years for a coral colony to form, coral fishing is restricted during certain periods and is done only by experts, who have been known to swim down 300 feet to find the best pieces. It is possible, however, to gather coral at fifty feet below the water's surface. Some underwater clubs organize such excursions.

The El Faro hotel at Porto Conte is a modern structure set in a scenic locale and has its own private beach. The Villa Las Tronas stands on a rocky promontory overlooking the sea and is located near the center of town. The regional cuisine has a definite Catalan flavor and can be sampled at Santa Tecla in the historic center or at Al Tuguri, an intimate restaurant where seaford is the focus of many of the dishes served. At La Lepanto, an excellent seafood restaurant, lobster is served *alla catalana* (with tomato and onions). A snack of stuffed flat bread and a glass of fresh Vernaccia or iced myrtle can be had at the Milese bar. Shop for objects made from coral, including jewelry, at Marogna, and for *bottarga* (smoked mullet roe) at Botarfish.

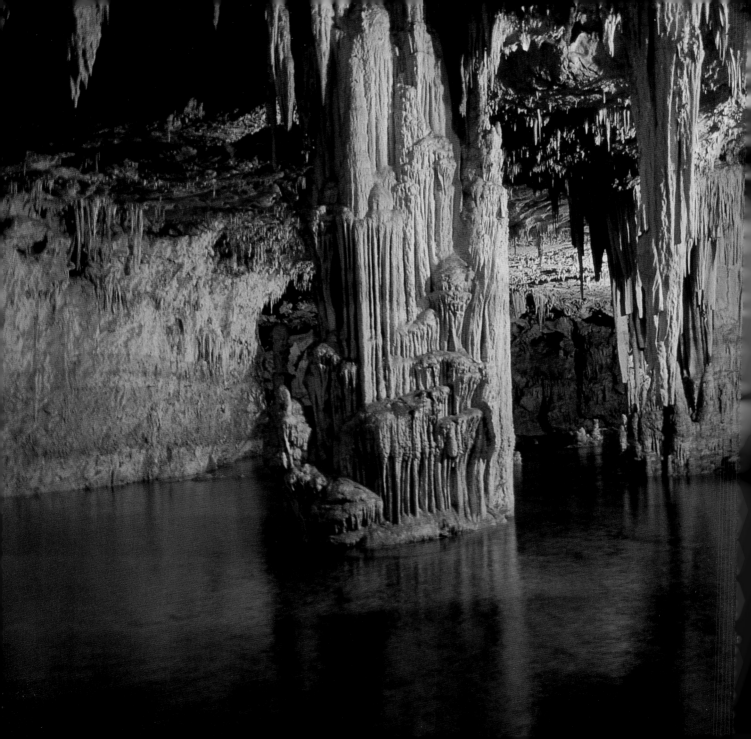

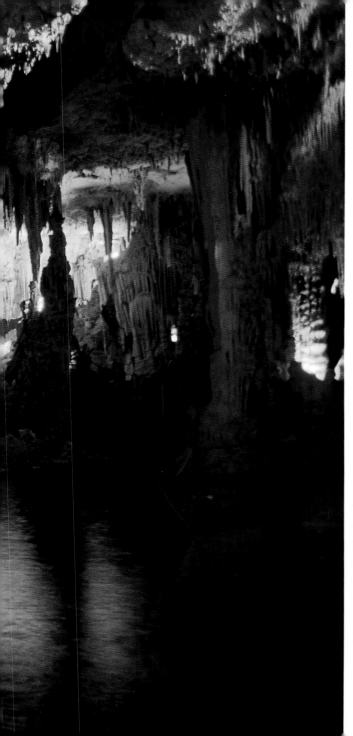

Alghero was one of the first Italian cities to bring New Year's Eve out into the streets, changing it from a private party to a public event. The *Cap d'Any a L'Alguer* (Catalan New Year's Eve) is a series of events that do not end with the single night of New Year's Eve, but begin halfway through December and end with the Epiphany (January 6). Every day, from early afternoon to late at night, the streets and squares of the historic center are transformed into a great stage where art shows are organized and theatrical productions and concerts take place. On the beaches stands are set up for dancing and revelers celebrate with glasses of champagne. The theme of Cap d'Any changes every year. It was once dedicated to Charles V, with reenactments of the emperor's visit; other times the theme has been inspired by the Flemish painter Hieronymus Bosch's *Garden of Earthly Delights*, Salvador Dali, and masks from the Museum of Masks in Venice.

Coral jewelry in a window display.

left
The luminous interior of one of Neptune's grottos.

below
A goldsmith at work.

251

ORISTANO
PHOENICIAN OASIS

THE STORY OF ORISTANO BEGINS FARTHER WEST AT THARROS, an important city built in the eighth century BC by the Phoenicians on the Sinis peninsula. Scholars suggest that Tharros may even have been built some thousand years earlier, as the burial grounds on the site of Cuccuru Is Arrius (sixth century BC) might indicate. Formally known as the Domus de Janas, the necropolises are located in grottos dating to the Neolithic period, and are known as nuraghi, prehistoric dome-shaped towers of stone with an interior cavity or room and dating to the fifteenth century BC. The nearest is the nuraghe of Losa at Abbasanta. Seven thousand of them from various periods have been counted in Sardinia, from the Punic to the Pheonician, and not to be forgotten is the imposing Su Nuraxi at Barumini, which dates back to the period spanning the thirteenth to the sixth century BC, and is listed by UNESCO as a World Heritage Site.

A selection of fish is always available on the table in Sardinia.

facing page
The little gulf of Porto Palma.

Oristano was born at Tharros because, a few years after the year AD 1000, and tired of the Saracen incursions, the inhabitants took away the stones so that they could build a new city farther inland. "*Portant de Tharros sa perda a carros,*" the shepherds would say ("They are taking cartloads of stones away from Tharros"). The new city was called Aristius or Aristanis, meaning "among the ponds," and prospered thanks to the multitude of fish and the fertile plain of Campisano. Sardinia was divided into *Giudicati* (independent duchies), and Oristano became the capital of the Guidicato of Arborea. It exercised its power over the others, and at the end of the year 1300, Eleonora di Arborea governed the duchy with strength and wisdom. Eleonora could not unify Sardinia politically, but her laws were enforced all over the island and collected in the *Carta de logu,* an extremely modern codex dealing with problems that are still being examined today, such as freedom and environmental issues. The attention given to women was also groundbreaking. Eleonora could, in fact, be defined as a feminist *ante litteram*. Community property was introduced, as well as the right to accept or refuse a marriage of reparation for violence suffered.

Just above Oristano are the great lakes that separate the city from the sandy and rocky desert of the Sinis peninsula. Lakes Mistras and Cabras, the largest, and the ponds of Paùli Murtas, Sale Porcus, and Is Benas are sources of wealth for fishermen, so much so that they could be called breeders of valuable fish. The lakes are also oases for migratory birds. Some, such as the pink flamingo and the black-winged stilt, nest in the reeds.

The ruins of the powerful city of Tharros are on the hill of San Giovanni di Sinis, a sliver of land leading to Capo San Marco. The city had Semitic and Phoenician roots, and later became Roman. There were two ports, one on the open sea and the other facing the Gulf of Oristano. It was discovered in 1851 by an English archaeologist who uncovered fourteen tombs rich with gold coins. On the slopes of the hill is a shrine where the remains of the first-born child were cremated and buried. There is a Punic necropolis, an acropolis from the imperial Roman period, and a third, Christian necropolis, near the Romanesque church of San Giovanni in Sinis. Inhabited areas of the Punic period can be visited, where there are thermal baths, sanctuaries, and even an African-inspired baptismal font. The remains of the Punic walls can also be seen here.

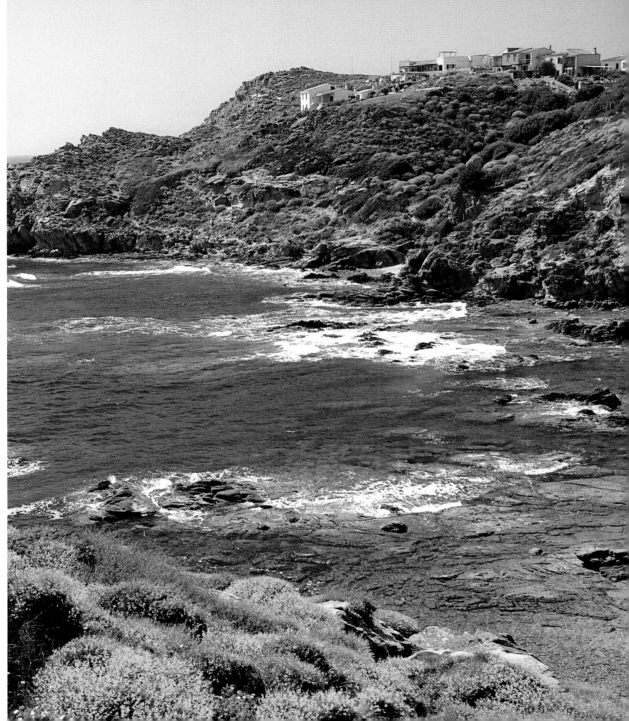

Bottarga is the extraordinary product of the roe of mullet, tuna, or other fish. It has been known for centuries and was much loved by Pope Pius V. The best *bottarga* comes from the lakes at Cabras, where mullet and sea bass abound. Sacs containing this delicacy are collected right after the fish is caught. Fresh *bottarga* is light in color and has a soft, delicate taste, while once seasoned, it appears brown and is characterized by a strong flavor. Together with other typical fish dishes, *bottarga* can be sampled at Cocco e Dessi or at the Al Faro restaurant, or purchased at Spanu in Cabras. The area is also known for its baskets and hampers made form rushes or reeds, and for the *fassonis*, boats driven on the ponds or lakes, similar to those that plied the waters of the Nile.

PORTO CERVO
THE FIVE-STAR COAST

THE COAST OF SARDINIA IS ALMOST ONE-FOURTH OF THE ENTIRE COAST of Italy, which explains why it was, in the past, an island easily approached by ship, and why today it is such an enviable mecca for tourists. The coastline has great variety: sandy coves and dunes alternate between precipitous cliffs and rocky beaches, deserted shores, and meadows and woodlands that practically fall into the sea. From an environmental point of view, one of the most beautiful sections is that of Gallura in the north, facing the Strait of Bonifacio, where we find the Costa Smeralda (Emerald Coast). The most popular of the tourist areas on Port Cervo, the Emerald Coast is a rocky one, yet with plenty of beaches and inlets that vary in shape and color. The landscape is covered by a thick coat of Mediterranean underbrush, and olive trees and myrtle and rosemary bushes scent the air. Out of this picturesque setting rises a dramatic backdrop of eroded rocks.

The Emerald Coast is dominated by the glamorous Porto Cervo, an upscale retreat founded in the 1960s when a group of financiers, together with the Aga Khan, decided to buy the land and build an exclusive tourist center. It soon became a meeting place for the toniest of tourists, who apart from taking a swim, also wanted to participate in the rabid social scene that was the center of the main piazza, called the Chiacchere (meaning "gossip"). Shopping is a sport, and boutiques carrying many famous name brands, as well as stylists and jewelers, can be found around the piazza. Some of the most beautiful yachts and boats in the Mediterranean can be seen anchored in the bay. The bay is in the shape of an antler, thus the name Porto Cervo (*cervo* means "deer" in Italian). The days are a continuous alternation between shopping and aperitifs, appointments for golf or regattas. The Yacht Club Costa Smeralda is one of the most famous in the world. During a walk on summer evenings along the narrow streets or stopping at a local nightclub, you're sure to bump into celebrities, tycoons, and Formula One champions. Other places nearby are following in the footsteps of Porto Cervo, such as Baia Sardinia, Poltu Cuato, and Cala di Volpe, each of which have an up-and-coming nightlife scene and bays of the finest sand; Cala di Volpe is characterized by some of the most romantic hotels on the coast.

Wind-beaten rock formations on a promontory.

facing page
Not only in the tropics is the sea clear and transparent.

The Archipelago of the Maddalena is a national park that consists of more than sixty islands and cays and is known as the Polynesia of the Mediterranean. The tiny islands rise out of the sea between Gallura and Corsica and are soon to become part of the future International Park of the Strait of Bonifacio. The only inhabited island is Maddalena, where there is a fishing village. Other small settlements include Caprera, the home of Giuseppe Garibaldi, where there is also a museum dedicated to him. It is possible to swim in the crystalline waters of Porto della Madonna, a lagoon lying between Budelli, Razzoli, and Santa Maria, from where you can't miss the Maldives or the Seychelles.

The exclusive Cala di Volpe hotel is found on the northernmost point of Sardinia and has a dazzling views of the Emerald Coast. Its glamorous clientele fly in to the tiny nearby airport from all over the world (the runway often has to be cleared of sheep). The hotel was built by the Aga Khan in the 1960s on a stretch of land where formerly there had only been white beaches and rocks shaped by the wind and the pounding of the sea. Once a small fishing village, Porto Cervo is today one of the most fascinating resorts in the world and the Cala di Volpe is one of Europe's most expensive hotels. Less patrician but just as comfortable is the Hotel Romazzino, surrounded by a beautiful terraced garden. The local cuisine can be tasted at the Belvedere, which is a trattoria during the day and an elegant restaurant in the evening.

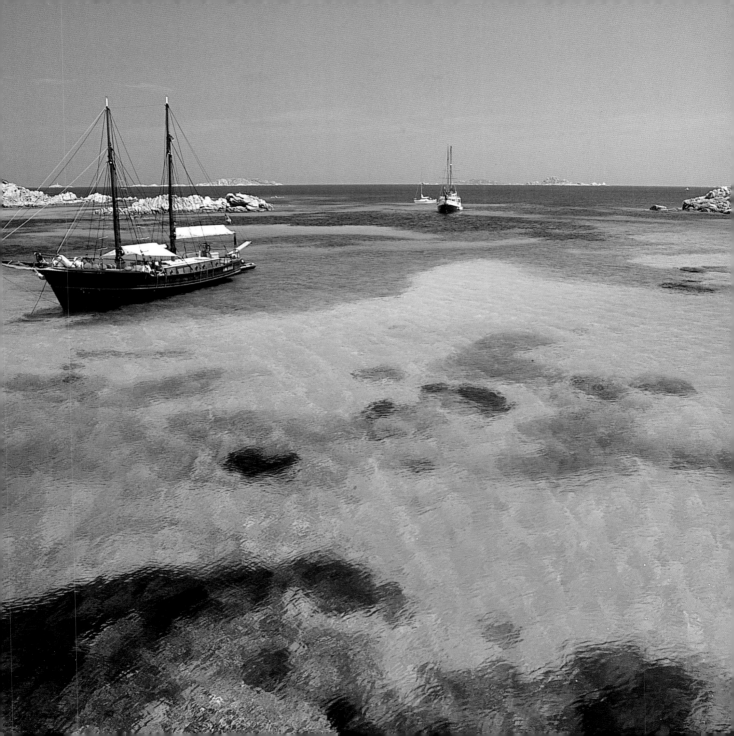

ADDRESSES

VALLE D'AOSTA

aosta

Ufficio Informazioni Turistiche (AIAT)
piazza Chanoux, 2
11100 Aosta
phone +39 0165 236627
fax +39 0165 34657
uit-aosta@regione.vda.it
www.regione.vda.it

Hotel Europe
piazza Narbonne, 8
11100 Aosta
phone +39 0165 236363
hoteleurope@ethotels.com
www.ethotels.com/hoteleurope.html

Hotel Holiday Inn Aosta
corso Battaglione Aosta, 30
11100 Aosta
phone +39 0165 236356
fax +39 0165 236837
hotelholidayinn@ethotels.com
www.ethotels.com

Ristorante Le Foyer
corso Ivrea, 146
11100 Aosta
phone +39 0165 32136
web.tiscali.it/Etnalodge/italiano.htm

Ristorante Vecchio Ristoro
via Tourneuve, 4
11100 Aosta
phone +39 0165 33238
vecchioristoro@acena.it

Hotel Ristorante La Barme
frazione Valnontey
11012 Cogne (Aosta)
phone +39 0165 749177
fax +39 0165 749213
labarme@tiscalinet.it

Azienda Agricola Agrival
frazione Resselin, 6
località Gressan
11100 Aosta
phone +39 0165 251010
lapomme@lapommevda.com

**Lavorazione Legno da K100
dei F.lli Fresc**
via de Tillier, 21
11100 Aosta
phone +39 0165 31884

Salumificio Bertolin
località Champognolaz, 10
11020 Arnad (Aosta)
phone +39 0125 966127
info@bertolin.com
www.bertolin.it

Pasticceria Boch
via de Tillier, 2
11100 Aosta
phone +39 0165 44406

PIEDMONT

alba

**Consorzio Turistico
Langhe Monferrato Roero**
via Medford, 3
12051 Alba (Cuneo)
phone +39 0173 35833
fax +39 0173 363878
info@langheroero.it / www.langheroero.it

Hotel I Castelli
corso Torino, 14
12051 Alba (Cuneo)
phone +39 0173 361978
fax +39 0173 361974
info@hotel-icastelli.com
www.hotel-icastelli.com

Hotel Savona
via Roma, 1 (piazza Savona, 2)
12051 Alba (Cuneo)
phone +39 0173 440440
fax +39 0173 364312
info@hotelsavona.com
www.hotelsavona.com

Hotel Santa Maria
località Santa Maria
12060 La Morra (Cuneo)
phone +39 0173 509826
fax +39 0173 509827
hotel@wellnessantamaria.com
www.wellnessantamaria.com

Ristorante Daniel's al Pesco Fiorito
corso Canale, 28
12051 Alba (Cuneo)
phone +39 0173 441977
www.ristoratori.it/daniels

Ristorante La Bottega del Vicoletto
via Bertero, 6
12051 Alba (Cuneo)
phone +39 0173 363196

Osteria dell'Arco
piazza Savona, 5
12051 Alba (Cuneo)
phone +39 0173 363974

Osteria Vento di Langa
via Pertinace, 20
12051 Alba (Cuneo)
phone +39 0173 293282
liliana.dellatorre@libero.it

Enoteca Regionale Piemontese Cavour
via Castello 5
12060 Grinzane Cavour (Cuneo)
phone +39 0173 231120

Torrone Sebaste
via Piana Gallo, 48
12060 Grinzane Cavour (Cuneo)
phone +39 0173 262009
info@sebaste.it
www.sebaste.it

**Drogheria Enoteca
Giovanna Burdese**
via Vittorio Emanuele, 13
12051 Alba (Cuneo)
phone +39 0173 362239

Tartufi Ponzio
via Vittorio Emanuele, 26
12051 Alba (Cuneo)
phone +39 0173 440456
info@tartufiponzio.com
ww.tartufiponzio.com

asti

Agenzia Turistica Locale (ATL)
via Grandi, 5
14100 Asti
phone +39 0141 353034
fax +39 0141 410372

Hotel Reale
piazza Alfieri, 6
14100 Asti
phone +39 0141 530240
fax +39 0141 34357
info@hotel-reale.com
www.hotel-reale.com

Hotel Salera
via Monsignor Marello, 19
14100 Asti
phone +39 0141 410169
fax +39 0141 410372
salera@tin.it
www.salera-lis.com

Ristorante Gener Neuv
lungo Tanaro, 4
14100 Asti
phone +39 0141 557270

Ristorante La Grotta
corso Torino, 366
14100 Asti
phone +39 0141 214168

Arazzeria Scassa
via Arazzeria, 60
14100 Asti
phone +39 0141 271352

Cantine Bava
strada Monferrato, 2
14023 Cocconato (Asti)
phone +39 0141 907083
fax +39 0141 907085
bava@bava.com
www.bava.com

Pasticceria Barbero
via Brofferio, 84
14100 Asti
phone +39 0141 594004

stresa

Agenzia Turistica Locale (ATL)
via Principe Tomaso, 70/72
28049 Stresa (Verbania)
phone +39 0323 30416
fax +39 0323 934335
infoturismo@lagomaggiore.it
www.lagomaggiore.it

Grand Hotel des Iles Borromées
lungolago Umberto I, 67
28049 Stresa (Verbania)
phone +39 0323 938938
borromees@stresa.net

Hotel Regina Palace
lungolago Umberto I, 33
28049 Stresa (Verbania)
phone +39 0323 936936
fax +39 0323 936666
h.regina@stresa.net
www.regina-palace.it

Hotel Villa Dal Pozzo d'Annone
via Nazionale del Sempione, 5
28832 Belgirate (Verbania)
phone +39 0322 7255
fax +39 0322 772021
info@villadalpozzodannone.com
www.villadalpozzodannone.com

Ristorante Al Rustico
via degli Alpini, 7
località Someraro
28049 Stresa (Verbania)
phone +39 0323 32172

Ristorante Piemontese
via Mazzini, 25
28049 Stresa (Verbania)
phone +39 0323 30235
info@ristorantepiemontese.com
www.ristorantepiemontese.com

Pasticceria Gigi
corso Italia, 30
28049 Stresa (Verbania)
phone +39 0323 30225

valenza

Informazioni Turistiche
piazza Castello
15033 Casale Monferrato (Alessandria)
phone +39 0142 444411 (interno 330)

Hotel Candiani
via Candiani d'Olivola, 36
15033 Casale Monferrato (Alessandria)
phone +39 0142 418728
fax +39 0142 418722
hotelcandiani@libero.it

Hotel Londra
corso F. Cavallotti, 51
15100 Alessandria
phone +39 0131 251721
fax +39 0131 253457
hotel-londra@libero.it

Agriturismo Villa Gropella
strada per Solero, 8
15048 Valenza (Alessandria)
phone +39 0131 951166

Alessandro Gioielli
via Cavour, 61
15048 Valenza (Alessandria)
phone +39 0131 941961

Orostaff Preziosi
viale Repubblica, 67
15048 Valenza (Alessandria)
phone +39 0131 947909

vercelli

Informazioni Turistiche
viale G. Garibaldi, 90
13100 Vercelli
phone +39 0161 257888
fax +39 0161 257899

Hotel Cinzia
corso Magenta, 71
13100 Vercelli
phone +39 0161 253585
fax +39 0161 253752
hotelcin@tin.it

Hotel Ristorante Il Giardinetto
via L. Sereno, 3
13100 Vercelli
phone +39 0161 257230
fax +39 0161 259311

Azienda Agricola Tenuta Cascine Strà
frazione Cascine Strà, 8
13100 Vercelli
phone +39 0161 313183
lisagre@tin.it

Azienda Agricola Tenuta Margherita
strada per Costantana, 2
13034 Desana (Vercelli)
phone +39 0161 318271
fax +39 0161 318508

Salumeria Pier Siro Malinverni
via Quinto, 9
13040 Olcenengo (Vercelli)
phone +39 0161 271162

LOMBARDY

bellagio

Informazioni Turistiche
piazza della Chiesa, 14
22021 Bellagio (Como)
phone +39 031 950204
lakecomo@tin.it www.lakecomo.com

Grand Hotel Tremezzo Palace
via Regina, 8
22019 Tremezzo (Como)
phone +39 0344 42491
fax +39 0344 40201
info@grandhoteltremezzo.com
www.grandhoteltremezzo.com

Grand Hotel Villa Serbelloni
via Roma, 1
22021 Bellagio (Como)
phone +39 031 950216
fax +39 031 951529
inforequest@villaserbelloni.it
www.villaserbelloni.com

Hotel Excelsior Splendide
lungolago Manzoni, 28
22021 Bellagio (Como)
phone +39 031 950225
fax +39 031 951224

Hotel Firenze
piazza Mazzini, 46
22021 Bellagio (Como)
phone +39 031 950342
fax +39 031 951722
hotflore@tin.it

Ristorante Barchetta
salita Mella, 13
22021 Bellagio (Como)
phone +39 031 951389

Ristorante Silvio
via Carcano, 12
località Loppia
22021 Bellagio (Como)
phone +39 031 950322
info@bellagiosilvio.com
www.bellagiosilvio.com

Ad Hoc (silk)
lungolario Manzoni, 42/44
22021 Bellagio (Como)
phone/fax +39 031 950073

bergamo

Informazioni Turistiche
viale Aquila Nera, 2 (Upper Bergamo)
24100 Bergamo
phone +39 035 242226
fax +39 035 242994
aptbg@apt.bergamo.it
www.apt.bergamo.it

Hotel Excelsior San Marco
piazza Repubblica, 6
24100 Bergamo
phone +39 035 366111
fax +39 035 223201
info@hotelsanmarco.com
www.hotelsanmarco.com

Starhotel Cristallo Palace
via B. Ambiveri, 35
24100 Bergamo
phone +39 035 311211
fax +39 035 312031
reservations@starhotels.it

Ristorante Da Vittorio
viale Giovanni XXIII, 21
24100 Bergamo
phone +39 035 218060

Ristorante Lio Pellegrini
via S. Tomaso, 47
24100 Bergamo
phone +39 035 247813

Taverna del Colleoni e dell'Angelo
piazza Vecchia, 7
24100 Bergamo
phone +39 035 232596
colleonidellangelo@uninetcom.it
www.colleonidellangelo.com

Enoteca La Lunetta
via Sant'Orsola, 14
24100 Bergamo
phone +39 035 215333

Ol Formagér
piazza Oberdan, 2
24100 Bergamo
phone +39 035 239237

Pasticceria Cavour
via Gombito, 7
24100 Bergamo
phone +39 035 943419

Tresoldi, la Boutique del Pane
via papa Giovanni XXIII, 76
24100 Bergamo
phone +39 035 237578
tresoldipane@worldonline.it

como

Azienda di Promozione Turistica (APT)
piazza Cavour, 16
22100 Como
phone +39 031 3300111
fax +39 031 261152
lakecomo@tin.it / www.lakecomo.com

Grand Hotel di Como
via per Cernobbio
22100 Como
phone +39 031 5161
fax +39 031 516600
info@grandhoteldicomo.it

Hotel Terminus
lungolario Trieste, 14
22100 Como
phone +39 031 329111
fax +39 031 302550
larioterminus@galactica.it

Hotel Villa d'Este
via Regina, 40
22012 Cernobbio (Como)
phone +39 031 3481
fax +39 031 348844
info@villadeste.it
www.villadeste.it

Locanda dell'Oca Bianca
via Canturina, 251
22100 Como
phone +39 031 525605

Trattoria del Navedano
via Pannilani
località Camnago Volta
22100 Como
phone +39 031 308080

Enoteca 84
via Milano, 84
22100 Como
phone +39 031 270482

Pasticceria Belli
via Vittorio Emanuele, 7
22100 Como
phone +39 031 264287

Seta e Tessuti da Voghi
via Paoli, 3
22100 Como
phone +39 031 525775
fax +39 031 525776
voghi@voghi.it
www.voghi.it

cremona

Azienda di Promozione Turistica (APT)
piazza del Comune, 5
26100 Cremona
phone +39 0372 21722
fax +39 0372 534059
info@aptcremona.it
www.cremonaturismo.com

Delle Arti Design Hotel
via Bonomelli, 8
26100 Cremona
phone +39 0372 23131
info@dellearti.com
www.dellearti.com

Hotel Impero
piazza della Pace, 21
26100 Cremona
phone +39 0372 413013

Agriturismo Lo Stagno
via Cascina Gerre del Pesce
26049 Stagno Lombardo (Cremona)
phone +39 0372 57055
fax +39 02 66015577
info@lostagno.it
www.lostagno.it

Ristorante Al Caminetto
via Umberto I, 26
26047 Scandolara Ripa d'Oglio (Cremona)
phone +39 0372 89589

Ristorante Italia
via Garibaldi, 1
26038 Torre de' Picenardi (Cremona)
phone +39 0375 394060
info@ristoranteitalia.cr.it
www.ristoranteitalia.cr.it

Luccini (mustard)
via Carducci, 1a
26030 Cicognolo (Cremona)
phone +39 0372 830624

Pasticceria Lanfranchi
via Solferino, 30
26100 Cremona
phone +39 0372 28743

Strumenti ad Arco di Francesco Bissolotti
piazza San Paolo, 5
26100 Cremona
phone +39 0372 34947

mantua

Informazioni Turistiche
piazza A. Mantegna, 6
46100 Mantua
phone +39 0376 328253
fax +39 0376 363292
aptmantova@iol.it
www.aptmantova.it

Hotel Rechigi
via P.F. Calvi, 30
46100 Mantua
phone +39 0376 320781
fax +39 0376 220291

Hotel San Lorenzo
piazza Concordia, 14
46100 Mantua
phone +39 0376 220500
fax +39 0376 327194
hotel@hotelsanlorenzo.it
www.hotelsanlorenzo.it

Hotel Villa dei Tigli
via Cantarana, 20
46040 Rodigo (Mantua)
phone +39 0376 650691
www.hotelvilladeitigli.it

Ristorante Il Cigno dei Martini
piazza Carlo d'Arco, 1
46100 Mantua
phone +39 0376 327101

Ristorante Aquila Nigra La Ducale
vicolo Bonacolsi, 4
46100 Mantua
phone +39 0376 327180

Ristorante Dal Pescatore
località Runate, 17
46013 Canneto sull'Oglio (Mantua)
phone +39 0376 723001

Gastronomia Lotti
piazza 80° Fanteria, 8
46100 Mantua
phone +39 0376 329350

Pasticceria Tur dal Sucar
via San Longino, 3
46100 Mantua
phone +39 0376 322320

monza

Informazioni Turistiche
piazza Trento e Trieste, 3
20052 Monza (Milan)
phone +39 039 323222
apt.info@libero.it

Hotel Ristorante de la Ville
viale Regina Margherita, 15
20052 Monza (Milan)
phone +39 039 382581
fax +39 039 367647
reservation@hoteldelaville.com
www.hoteldelaville.com

Hotel Royal Falcone
corso Milano, 5
20052 Monza (Milan)
phone +39 039 2300187
fax +39 039 2300129
hophonefalcone@galactica.it

Ristorante L'Eremo della Priora
località Pianeta IV, 2
22067 Missaglia (Lecco)
phone +39 039 9241187
eremo@eremo.com
www.eremo.com

**Ristorante Saint Georges Premier
(Alla Fagiana Reale)**
via Vedano, 7
20052 Monza (Milan)
phone +39 039 320600
fax +39 039 360298
georges@abitarelastoria.it
www.abitarelastoria.it

Sapori e Sapere
via Metauro, 3
20052 Monza (Milan)
phone +39 039 736381

pavia

Informazioni Turistiche
via Fabio Filzi, 2
27100 Pavia
phone +39 0382 22156
fax +39 0382 32221
info@apt.pv.it
www.apt.pv.it

Hotel Moderno
via Vittorio Emanuele II, 41
27100 Pavia
phone +39 0382 303401
fax +39 0382 25225
moderno@hotelmoderno.it
www.hotelmoderno.it

Hotel Ariston
via Scopoli, 10/d
27100 Pavia
phone +39 0382 34334
fax +39 0382 25667
moderno@hotelmoderno.it
www.hotelmoderno.it

Locanda Vecchia Pavia al Mulino
via al Monumento, 5
27100 Certosa di Pavia (Pavia)
phone +39 0382 925894
fax +39 0382 933300
locandavecchiapaviaalmulino@acena.it

Osteria del Naviglio
via Alzaia, 39/b (piazzale San Giuseppe)
27100 Pavia
phone +39 0382 460392

Pasticceria Vigoni
corso Strada Nuova, 110
27100 Pavia
phone +39 0382 22103

Pellicceria Annabella
corso Cavour, 1
27100 Pavia
phone +39 0382 21122
fax +39 0382 539424
info@annabella.it
www.annabella.it

sirmione

Informazioni Turistiche
viale Marconi, 2
25010 Sirmione (Brescia)
phone +39 030 916114
fax +39 030 916222
promobs@tin.it

Palace Villa Cortine
via Grotte, 12–6
25010 Sirmione (Brescia)
phone +39 030 9905890
fax +39 030 916390
info@hotelvillacortine.com
www.palacehotelvillacortine.it

Grand Hotel delle Terme
viale Marconi, 7
25010 Sirmione (Brescia)
phone +39 030 916261
ght@termedisirmione.com

Hotel Sirmione
piazza Castello, 19
25010 Sirmione (Brescia)
phone +39 030 9904922
fax +39 030 916192
hs@termedisirmione.com

Cacina Albarone Polone
via Polone, 22
località Lugana
25019 Sirmione (Brescia)
phone +39 0348 4429042
polone@antiquario.it
www.antiquario.it

Ristorante La Rucola
via Strentelle, 3
25010 Sirmione (Brescia)
phone +39 030 916326

Ristorante Vecchia Lugana
piazzale Vecchia Lugana, 1
25010 Sirmione (Brescia)
phone +39 030 919012

Gastronomia Al Caciosalume
via Colombare, 123
25010 Sirmione (Brescia)
phone +39 030 919331

Azienda Agricola Conti Guerrieri Rizzardi
piazza Guerrieri, 1
37011 Bardolino (Verona)
phone +39 045 7210028
fax +39 045 7210704

sondrio

Informazioni Turistiche
via C. Battisti, 12
23100 Sondrio
phone +39 0342 512500
fax +39 0342 212590
aptvaltellina@provincia.so.it
www.provincia.so.it/aptvaltellina
www.valtellinaonline.it

Hotel della Posta e Ristorante Sozzani
piazza G. Garibaldi, 19
23100 Sondrio
phone +39 0342 510404
fax +39 0342 510210
info@hotelposta.so.it
www.hotelposta.so.it

Sala Cereali (valtellina specialties)
viale dello Stadio, 24
23100 Sondrio
phone +39 0342 214068

Pasticceria Tavelli
via Sauro, 35
23100 Sondrio
phone +39 0342 216345

Alimentari e Coloniali Fratelli Ciapponi
piazza 3 Novembre
23017 Morbegno (Sondrio)
phone +39 0342 610223

Pietra Ollare Floriana Palmieri
via Visconti Venosta, 5
23100 Sondrio
phone +39 0342 212005

vigevano

Informazioni Turistiche
c/o Municipio - corso Vittorio Emanuele, 29
27029 Vigevano (Pavia)
phone +39 0381 299282

Hotel Nuovo
corso Togliatti, 21
27029 Vigevano (Pavia)
phone +39 0381 325026
fax +39 0381 311897

Ristorante I Castagni
via Ottobiano, 8/20
27029 Vigevano (Pavia)
phone +39 0381 42860

Salumi l'Oca Ducale
via Bercleda, 139
27029 Vigevano (Pavia)

Calzaturificio Pizzi
viale Petrarca, 35
27029 Vigevano (Pavia)
phone +39 0381 34444
fax +39 0381 691100
pizzimarco@pizzimarco.com / www.pizzimarco.it

Calzaturificio Asti Domenico
via Alfieri, 30
27029 Vigevano (Pavia)
phone +39 0381 348933
fax +39 0381 348933
elisabettaasti@libero.it

LIGURIA

camogli

Informazioni Turistiche
via XX Settembre, 33
16032 Camogli (Genoa)
phone/fax +39 0185 771066

Hotel Cenobio dei Dogi
via Cuneo, 34
16032 Camogli (Genoa)
phone +39 0185 7241
fax +39 0185 772796
cenobio@promix.it

Hotel Casmona
salita Pineto, 13
16032 Camogli (Genoa)
phone +39 0185 770015/6
fax +39 0185 775030
www.casmona.com

Ristorante La Cucina di Nonna Nina
via F. Molfino, 126
località San Rocco
16032 Camogli (Genoa)
phone +39 0185 773835

Pizzeria O' Becco Fin
via Garibaldi, 169
16032 Camogli (Genoa)
phone +39 0185 775018

Ristorante Rosa
via I. Ruffini, 11
16032 Camogli (Genoa)
phone +39 0185 773411

Pasticceria Revello
via G. Garibaldi, 183
16032 Camogli (Genoa)
phone +39 0185 770777

Il Vecchio Bastimento (wooden ship models)
via Garibaldi, 167
16032 Camogli (Genoa)

portofino

Informazioni Turistiche
via Roma, 35
16034 Portofino (Genoa)
phone/fax +39 0185 269024

Hotel Portofino Kulm
viale B. Gaggini, 23
località Ruta di Camogli
16034 Portofino Vetta (Genoa)
phone +39 0185 7361
fax +39 0185 776622
reception@cenobio.it
www.portofinokulm.it

Hotel Splendido
viale Baratta, 16
16034 Portofino (Genoa)
phone +39 0185 267801
fax +39 0185 267806
reservation@splendido.net
www.splendido.net

Albergo da Giovanni
Casale Pontale, 23
15032 San Fruttuoso (Genoa)
phone/fax +39 0185 770047

Ristorante Puny
piazza Martiri dell'Olivetta, 5
16034 Portofino (Genoa)
phone +39 0185 269037

Ristorante Ü Battj
vico Nuovo, 17
16034 Portofino (Genoa)
phone +39 0185 269379

Boutique L'Ancora
piazza Martiri Olivetta, 32
16034 Portofino (Genoa)
phone +39 0185 269438

Panificio Canale
via Roma, 30
16034 Portofino (Genoa)
phone +39 0185 269248

Portofino's Laces
salita San Giorgio, 10
16034 Portofino Mare (Genoa)
phone +39 0185 269655

portovenere and cinque terre

Informazioni Turistiche
piazza Bastreri, 1
19025 Portovenere (La Spezia)
phone +39 0187 790691
fax +39 0187 790215
m.mariotti@aptcinqueterre.sp.it
www.aptcinqueterre.sp.it

Grand Hotel Portovenere
via Garibaldi, 5
19025 Portovenere (La Spezia)
phone +39 0187 792610
fax +39 0187 790661
ghp@village.it

Antica Osteria del Carugio
via Cappellini, 66
19025 Portovenere (La Spezia)
phone +39 0187 790617

Grotta dell'Artigianato
Calata Doria, 84
19025 Portovenere (La Spezia)
phone +39 0187 790594

Hotel Porto Roca
via Corone, 1
19016 Monterosso a Mare (La Spezia)
phone +39 0187 817502
fax +39 0187 817692
portoroca@portoroca.it / www.portoroca.it

La Cantina dü Sciacchetrà
via Roma, 7
19016 Monterosso a Mare (La Spezia)
phone/fax +39 0187 817828

Hotel Marina Piccola
via Birolli, 120
19010 Manarola (La Spezia)
phone +39 0187 920103

Ristorante Cappun Magru a Casa di Marin
via Volastra, 19
località Groppa
19017 Riomaggiore (La Spezia)
phone +39 0187 920563

Ristorante Marina Piccola
via Lo Scalo, 16
19017 Riomaggiore (La Spezia)
phone +39 0187 920103
fax +39 0187 920966
marijes@tin.it

Enoteca D'Uu Scintu
via Colombo, 84
19017 Riomaggiore (La Spezia)
phone +39 0187 920965

Locanda Gianni Franzi
piazza Marconi, 1
via San Giovanni Battista, 41–47
19018 Vernazza (La Spezia)
phone/fax +39 0187 812228

Ristorante Gambero Rosso
piazza Marconi, 7
19018 Vernazza (La Spezia)
phone +39 0187 812265

Vineria Santa Maria
via Roma, 44
19018 Vernazza (La Spezia)
phone/fax +39 0187 821195

san remo

**Azienda di Promozione Turistica
Riviera dei Fiori (APT)**
largo Nuvoloni, 1
18038 San Remo (Imperia)
phone +39 0184 59059
fax +39 0184 507649
aptfiori@apt.rivieradeifiori.it
aptfiori@sisphone.it
www.aptrivieradeifiori.it

Grand Hotel Londra
corso Matuzia, 2
18038 San Remo (Imperia)
phone +39 0184 668000
fax +39 0184 668073

Grand Hotel & Des Anglais
salita Grande Albergo, 8
18038 San Remo (Imperia)
phone +39 0184 667840
fax +39 0184 668074
desanglais@sistel.it

Royal Hotel
Corso Imperatrice, 80
18038 San Remo (Imperia)
phone +39 0184 5391
fax +39 0184 661445
royal@royalhotelsanremo.com
www.royalhotelsanremo.com

Trattoria del Porto da Nicò
piazza Brescia, 9
18038 San Remo (Imperia)
phone +39 0184 501988

Ristorante da Vittorio
piazza Brescia, 16
18038 San Remo (Imperia)
phone +39 0184 501924

Ristorante Da Giannino
corso Trento e Trieste, 23
18038 San Remo (Imperia)
phone +39 0184 504014

Pasticceria San Romolo
via Carli, 6
18038 San Remo (Imperia)
phone +39 0184 531565

triora

**Ufficio di Informazione e di Accoglienza
Turistica (IAT)**
viale Matteotti, 37
18100 Imperia
phone +39 0183 660140
fax +39 0183 666510
www.aptrivieradeifiori.it

Antico Albergo Ristorante Santo Spirito
piazza Roma, 23
18010 Molini di Triora (Imperia)
phone +39 0184 94019

Villa Elisa
via Romana, 70
18012 Bordighera (Imperia)
phone +39 0184 261313
fax +39 0184 261942
info@villaelisa.com
www.villaelisa.com

Ristorante Capanna da Baci
piazza Vittorio Veneto, 9
18030 Apricale (Imperia)
phone +39 0184 208137

Ristorante Gastone
piazza Garibaldi, 2
18035 Dolceacqua (Imperia)
phone +39 0184 206577

Osteria del Coniglio
via Verdi, 4
18012 Seborga (Imperia)
phone +39 0184 223820
fax +39 0184 223428

Agriturismo Terre Bianche
località Arcagna, 503
18035 Dolceacqua (Imperia)
phone +39 0184 31230

Bottega di Angelamaria (herbiary)
piazza Roma, 26
18010 Molini di Triora (Imperia)
phone +39 0184 94021

La Strega di Triora (herbiary)
corso Italia, 50
18010 Triora (Imperia)
phone +39 0184 94301

TRENTINO—ALTO ADIGE

bressanone

Informazioni Turistiche
via Stazione, 9
39042 Bressanone (Bolzano)
phone +39 0472 836401
fax +39 0472 836067
info@brixen.org / www.brixen.org

Hotel Ristorante Elephant
via Rio Bianco, 4
39042 Bressanone (Bolzano)
phone +39 0472 832750
fax +39 0472 836579
elephant.brixen@acs.it
www.acs.it/elephant

Hotel Grüner Baum
via Stufles, 11
39042 Bressanone (Bolzano)
phone/fax +39 0472 274100
info@gruenerbaum.it
www.gruenerbaum.it

Ristorante Fink
via Portici Minori, 4
39042 Bressanone (Bolzano)
phone +39 0472 834883

Lodenwirt
via Pusteria, 1
39030 Vandoies (Bolzano)
phone +39 0472 867000
fax +39 0472 867070
info@lodenwirt.it
www.lodenwirt.it

Salumificio Paul Vontavon
via Vittorio Veneto, 30
39042 Bressanone (Bolzano)
phone +39 0472 831890

Maso Katzenlocher
Unterum, 143
39040 Velturno (Bolzano)
phone +39 0472 847008

Panetteria Sellemond
via Centrale, 33
39040 Velturno (Bolzano)
phone +39 0472 855210

merano

Informazioni Turistiche
corso Libertà, 45
39012 Merano (Bolzano)
phone +39 0473 239008
fax +39 0473 235524
info@meranerland.com
www.meranerland.com

Grand Hotel Palace
via Cavour, 2–4
39012 Merano (Bolzano)
phone +39 0473 390473
fax +39 0473 271100
info@palace.it
www.palace.it

Hotel Castel Rundegg
via Scena, 2
39012 Merano (Bolzano)
phone +39 0473 234100
fax +39 0473 237200
rundegg@tophotels.net
www.rundegg.it

Ristorante Sissi
via Galilei, 44
39012 Merano (Bolzano)
phone +39 0473 231062
sissi@andreafenoglio.com
www.sissi.andreafenoglio.com

Ristorante Hanswirt
piazza Gerold, 3
39020 Parcines (Bolzano)
phone +39 0473 967148
info@hanswirt.com / www.hanswirt.com

Cantina Produttori
via San Marco, 11
39012 Merano (Bolzano)
phone +39 0473 237734
www.meranerkellerei.com

Panificio Callovini & Co.
via Portici, 49/51
39012 Merano (Bolzano)
phone +39 0473 237753

Salumeria Meranese
via Laurin, 59
39012 Merano (Bolzano)
phone +39 0473 443095

Dubis Mussner
via Portici, 197
39012 Merano (Bolzano)
phone +39 0473 236939

Hutter
via Portici, 16
39012 Merano (Bolzano)
phone +39 0473 236809

Konig
corso Libertà, 168
39012 Merano (Bolzano)
phone +39 0473 237162
info@cafe-koenig.com / www.cafe-koenig.it

Profumeria Miele Schenk
via Cassa di Risparmio, 25
39012 Merano (Bolzano)
phone +39 0473 237927

Runggaldier
via Portici, 276
39012 Merano (Bolzano)
phone +39 0473 237454
gerti.runggaldier@dnet.it

Zuber Karl & Co.
via Portici, 298
39012 Merano (Bolzano)
phone +39 0473 234534

riva del garda

Azienda di Promozione Turistica (APT)
Giardini di Porta Orientale, 8
38066 Riva del Garda (Trento)
phone +39 0464 554444
fax +39 0464 520308
info@gardatrentino.com
aptgarda@anthesi.com
www.garda.com / www.gardatrentino.com

Hotel du Lac et du Parc
viale Rovereto, 44
38066 Riva del Garda (Trento)
phone +39 0464 551500
fax +39 0464 555200
info@hoteldulac-riva.it
www.hoteldulac-riva.it

Astoria Park Hotel
viale Trento 9
38066 Riva del Garda (Trento)
phone +39 0464 576657
fax +39 0464 52122
astoria@rivadelgarda.com

Ristorante Al Volt
via Fiume, 73
38066 Riva del Garda (Trento)
phone +39 0464 552570

Ristorante Restel de Fer
via Restel de Fer, 10
38066 Riva del Garda (Trento)
phone +39 0464 553481

Azienda Agricola Fratelli Pisoni
via San Siro 7b
località Sarche
38066 Riva del Garda (Trento)
phone +39 0461 563216
info@pisoni.net / www.pisoni.net

trento

Azienda di Promozione Turistica (APT)
via Manci, 2
38100 Trento
phone +39 0461 983880
fax +39 0461 984508
informazioni@apt.trento.it
www.apt.trento.it

Hotel Adige
via Pomeranos, 2
frazione Mattarello
38100 Trento
phone +39 0461 944545
fax +39 0461 944520
adigehotel@cr-surfing.net
www.adigehotel.it

Hotel Buonconsiglio
via Romagnosi, 16
38100 Trento
phone +39 0461 272888
fax +39 0461 272889
hotelhb@tin.it

Hotel Ristorante Villa Madruzzo
località Ponte Alto, 26
frazione Cognola
38100 Trento
phone +39 0461 986220
fax +39 0461 986361
info@villamadruzzo.it
www.villamadruzzo.it

Osteria a le Due Spade
via don A. Rizzi, 11
38100 Trento
phone +39 0461 234343

Artigianato Artistico
vicolo Vò, 21
38100 Trento
phone +39 0461 983571

Distilleria Pilzer
via Portegnago, 5
38030 Faver (Trento)
phone +39 0461 683326

VENETO

asolo

Informazioni Turistiche
piazza G. Garibaldi, 73
31011 Asolo (Treviso)
phone +39 0423 529046
fax +39 0422 524137
apt.asolo@libero.it

Hotel Al Sole
via Collegio, 33
31011 Asolo (Treviso)
phone +39 0423 528111
fax +39 0423 528399
sole@prometeo.com

Hotel Ristorante Villa Cipriani
via Canova, 298
31011 Asolo (Treviso)
phone +39 0423 523411
fax +39 0423 952095
villacipriani@sheraton.com
www.sheraton.com/villacipriani

Ristorante Villa Razzolin Loredan
via Schiavonesca Marosticana, 15
31011 Asolo (Treviso)
phone +39 0423 951088

Ristorante Ca' Derton
piazza G. D'Annunzio, 1
31011 Asolo (Treviso)
phone +39 0423 529648
caderton@caderton.com
www.caderton.com

Scuola Asolana Antico Ricamo
via Canova, 333
31011 Asolo (Treviso)
phone +39 0423 952906

Ceramiche Thea
via Marosticana, 37
31011 Asolo (Treviso)
phone +39 0423 529393

Calzaturificio Essegi
via dell'Artigianato, 21
31011 Asolo (Treviso)
phone +39 0423 950094

bassano del grappa

Informazioni Turistiche
largo Corona d'Italia, 35
36061 Bassano del Grappa (Vicenza)
phone +39 0424 524351
fax +39 0424 525301

Hotel Belvedere
piazzale Giardino, 14
36061 Bassano del Grappa (Vicenza)
phone +39 0424 529845
fax +39 0424 529849

Hotel La Rosina
via Marchetti, 4
frazione Valle San Floriano
36063 Marostica (Vicenza)
phone +39 0424 470360
larosina@telemar.it

Ristorante Ca' Sette
via Cunizza da Romano, 4
36061 Bassano del Grappa (Vicenza)
phone +39 0424 383350
info@ca-sette.it
www.ca-sette.it

Ristorante Al Camin
via Valsugana, 64
località Cassola
36061 Bassano del Grappa (Vicenza)
phone +39 0424 566409
halcamin@tin.it

Osteria Alla Riviera
via San Giorgio, 17
36061 Bassano del Grappa (Vicenza)
phone +39 0424 503700

Bottega del Baccalà
via Matteotti, 10
36061 Bassano del Grappa (Vicenza)
phone +39 0424 523847

Pasticceria Marcon
piazzale Firenze, 22
36061 Bassano del Grappa (Vicenza)
phone +39 1424 522060

Ceramiche La Gardenia
via Rivarotta, 19 (91)
36061 Bassano Del Grappa (Vicenza)
phone +39 0424 828033
fax +39 0424 827212
info@ceramichelagardenia.it
www.ceramichelagardenia.it

Ceramiche Boxer
via San Patrizio, 32
36061 Bassano del Grappa (Vicenza)
phone +39 0424 566108
fax +39 0424 567535
info@ceramicheboxer.com
www.ceramicheboxer.com

belluno

Ufficio Informazioni Turistiche
via R. Psaro, 21
32100 Belluno
phone +39 0437 940083
fax +39 0437 940073
apt-02@nonel.regione.veneto.it
www.sunrise.it/dolomiti

Hotel Villa Carpenada
via Mier, 158
32100 Belluno
phone +39 0437 948343
fax +39 0437 948345

Hotel Alla Posta
via Dogliani, 19
32023 Caprile (Belluno)
phone +39 0437 721132
fax +39 0437 721677
hotelposta@sunrise.it
www.hotelposta.com

Ristorante Al Borgo
via Anconetta, 8
32100 Belluno
phone +39 0437 926755
fax +39 0437 926411
alborgosnc@libero.it
www.alborgo.to

Ristorante Terracotta
via G. Garibaldi, 63
32100 Belluno
phone/fax +39 0437 942644
fabrizio245@interfree.it

Birreria Heineken
via Vittorio Veneto, 78
32034 Pedavena (Belluno)
phone +39 0439 3301
fax +39 0439 302168

Ferro Battuto Bruno Corriani
via A. Costa, 2
32020 Lentiai (Belluno)
phone +39 0437 751081

chioggia

Ufficio di Informazione e di Accoglienza Turistica (IAT)
lungomare Adriatico, 101
30019 Sottomarina di Chioggia (Venice)
phone +39 041 5540466
fax +39 041 5540855
apt-07@nonel.regione.veneto.it
www.chioggia-apt.net

Hotel Airone
lungomare Adriatico, 50
Sottomarina - 30015 Chioggia (Venice)
phone +39 041 492266
fax +39 041 5541325
reservation@airone.boscolo.com

Hotel Ambasciatori
lungomare Adriatico, 30
Sottomarina - 30015 Chioggia (Venice)
phone/fax +39 041 5540660
reservation@ambasciatori.boscolo.com

Ristorante Al Centro da Toni
via Centro, 62
località Cavanella d'Adige
30015 Chioggia (Venice)
phone +39 041 497661

Ristorante Garibaldi
via San Marco, 1924
Sottomarina - 30015 Chioggia (Venice)
phone +39 041 5540042

este

Ufficio di Informazione e di Accoglienza Turistica (IAT)
piazza del Santo
35123 Padua
phone +39 0498 753087

Hotel Castello
via San Girolamo, 7/a
35042 Este (Padua)
phone +39 0429 602223
fax +39 0429 602428

Grand Hotel Terme Trieste & Vittoria
via Pietro d'Abano, 1
35031 Abano Terme (Padua)
phone +39 049 8665100

Hotel Leonardo da Vinci
via Monteortone, 46
35031 Abano Terme (Padua)
phone +39 049 9935070
fax +39 049 9935232
info@hldv.com
www.hldv.com

Hotel Terme Bristol Buja
via Monteortone, 2
35031 Abano Terme (Padua)
phone +39 049 8669390
fax +39 049 667910
hotelbristolbuja@windnet.it

Ristorante Casa Vecia
via Appia, 130
località Monterosso
35031 Abano Terme (Padua)
phone +39 049 8600138

Ristorante La Montanella
via dei Carraresi, 9
35032 Arquà Petrarca (Padua)
phone +39 0429 718200
fax +39 0429 777177
info@montanella.it
www.montanella.it

Enoteca Il Giuggiolo
via Jacopo da Arquà, 14
35032 Arquà Petrarca (Padua)
phone +39 0429 718110

Ca' Lustra - Azienda Agricola Villa Alessi
via San Pietro, 50
località Faedo
35030 Cinto Euganeo (Padua)
phone +39 0429 94128
fax +39 0429 644111

treviso

Ufficio di Informazione e di Accoglienza Turistica (IAT)
piazzetta Monte di Pietà, 8
31100 Treviso
phone +39 0422 547632
fax +39 0422 419092
apt-03@nonel.regione.veneto.it
www.sevenonline.it/vapt

Hotel Continental
via Roma, 16
31100 Treviso
phone +39 0422 411216
fax +39 0422 55054
continental@sevenonline.it
www.hcontinental.it

Relais Villa Fiorita
via Giovanni XXIII, 1
31050 Monastier di Treviso (Treviso)
phone +39 0422 898008
fax +39 0422 898006
fiorita@villafiorita.it / www.sogedinhotels.it

Hotel Al Foghér
viale della Repubblica, 10
31100 Treviso
phone +39 0422 432950
fax +39 0422 430391

Ristorante Antica Torre
via Inferiore, 55
31100 Treviso
phone +39 0422 583694
info@anticatorre.tv / www.anticatorre.tv

Ristorante Al Canevon
piazza San Vito, 13
31100 Treviso
phone +39 0422 540208

Trattoria dei Bana ai Buranelli
sottoportico Buranelli, 5–7
31100 Treviso
phone +39 0422 590242

Trattoria Toni del Spin
via Inferiore, 7
31100 Treviso
phone +39 0422 543829
www.ristorantetonidelspin.com

Osteria alla Pasina
via Marie, 3
31030 Dosson di Casier (Treviso)
phone +39 0422 382112

Azienda Agricola Drusian Francesco
strada Anche, 1
31030 Bigolino di Valdobbiadene (Treviso)
phone +39 0423 982151
fax +39 0423 980000

Azienda Vinicola Nino Franco
via Garibaldi, 147
31049 Valdobbiadene (Treviso)
phone +39 0423 972051
info@ninofranco.it
www.ninofranco.it

La Casearia
via Carlo Alberto, 53
31100 Treviso
phone +39 0422 59042

verona

Ufficio di Informazione e di Accoglienza Turistica (IAT)
via Leoncino, 61
37121 Verona
phone +39 045 8068680
fax +39 045 8003638

Hotel Villa Giona
via Cengia, 8
37029 San Pietro in Cariano (Verona)
phone +39 045 6855011
fax +39 045 6855010
villagiona@villagiona.it
villagiona@abitarelastoria.it

Hotel Due Torri Baglioni
piazza Sant'Anastasia, 4
37100 Verona
phone +39 045 595044
fax +39 045 8004130
duetorri.verona@baglionihotels.com
www.baglionihotels.com

Hotel Gabbia d'Oro
corso Porta Borsari, 4/a
37100 Verona
phone +39 045 8003060
fax +39 045 590293
gabbiadoro@easynet.it

Ristorante Il Desco
via Dietro San Sebastiano, 7
37100 Verona
phone +39 045 595358

Ristorante Arche
via Arche Scaligere, 6
37100 Verona
phone +39 045 8007415

Ristorante Bottega del Vino
vicolo Scudo di Francia, 3
37100 Verona
phone +39 045 8004535
www.bottegavini.it

Azienda Vinicola Allegrini
via Giare, 9–11
37022 Fumane (Verona)
phone +39 0465 832011

Azienda Vinicola Romano Dal Forno
località Lodoletta, 4
37030 Cellore d'Illasi (Verona)
phone +39 0457 834923
az.dalforno@tiscalinet.it

Enoteca Cangrande
via dietro Listone, 19/d
37100 Verona
phone +39 045 595022

Brigliadoro (grocery store)
via San Michele alla Porta, 4
37100 Verona
phone +39 045 8004514

FRIULI—VENEZIA GIULIA

aquileia

Informazioni Turistiche
piazza Capitolo
33051 Aquileia (Udine)
phone +39 0431 919491

Hotel Patriarchi
via Giulia Augusta, 12
33051 Aquileia (Udine)
phone +39 0431 919595
fax +39 0431 919596
info@hotelpatriarchi.it / www.hotelpatriarchi.it

Agriturismo La Durida
via IV Patriarca, 3
33051 Aquileia (Udine)
phone +39 0431 918669

Ristorante La Colombara
via San Zili, 42
località Colombara
33051 Aquileia (Udine)
phone +39 0431 91513
info@lacolombara.it / www.lacolombara.it

Pasticceria Mosaico
piazza Capitolo, 16
33051 Aquileia (Udine)
phone +39 0431 919592

cividale del friuli

Informazioni Turistiche
corso Paolino d'Aquileia, 10
33043 Cividale del Friuli (Udine)
phone +39 0432 731461
fax +39 0432 731398

Locanda Ristorante Al Castello
via del Castello, 12, località Fortino
33043 Cividale del Friuli (Udine)
phone +39 0432 733242
fax +39 0432 700901
castello@ud.nettuno.it

Hotel Roma (furniture)
piazza Picco Alberto, 14/a
33043 Cividale del Friuli (Udine)
phone +39 0432 731871
fax +39 0432 701033

Trattoria Alla Frasca
via Stretta B. de Rubeis, 4/a
33043 Cividale del Friuli (Udine)
phone +39 0432 731270

Enoteca di Cormòns
piazza XXIV Maggio, 21
34071 Cormòns (Gorizia)
phone/fax +39 0481 630371
enotecadic@virgilio.it

Cantina Produttori di Cormòns
via Vino della Pace
34071 Cormòns (Gorizia)
phone +39 0481 61798
fax +39 0481 630031
info@cormons.com
www.cormons.com

Pasticceria Gubane Vogrig
traversa Libertà, 136
33043 Cividale del Friuli (Udine)
phone +39 0432 730236

La Gubana della Nonna
via Azzida, 8
33043 San Pietro al Natisone (Udine)
phone +39 0432 727234

palmanova

Azienda Regionale di Promozione Turistica (ARPT)
piazza I Maggio, 7
33100 Udine
phone +39 0432 295972
fax +39 0432 504743
arpt.ud1@regione.fvg.it

Hotel Commercio
borgo Cividale, 15
33057 Palmanova (Udine)
phone +39 0432 928200

Hotel Ristorante Roma
borgo Cividale, 27
33057 Palmanova (Udine)
phone +39 0432 928472
fax +39 0432 923302
info@hotelromapalmanova.it
www.hotelromapalmanova.it

Ristorante Al Convento
borgo Aquileia, 10
33057 Palmanova (Udine)
phone +39 0432 923042

Salumi d'Oca da Jolanda de Colò
via I Maggio, 21
33057 Palmanova (Udine)
jolandaa@tin.it

Consorzio del Prosciutto di San Daniele
via Umberto I, 34
33038 San Daniele del Friuli (Udine)
phone +39 0432 957515
fax +39 0432 940187
info@prosciuttosandaniele.it
www.prosciuttosandaniele.it

trieste

Azienda di Promozione Turistica (APT)
via San Nicolò, 20
34121 Trieste
phone +39 040 67961
fax +39 040 6796299
info@triestetourism.it
www.triestetourism.it

Grand Hotel Duchi d'Aosta
piazza Unità d'Italia, 2
34100 Trieste
phone +39 040 7600011
fax +39 040 366092
info@grandhotelduchidaosta.com
www.magesta.com

Hotel Riviera & Maximilian's
strada Costiera, 22
34014 Trieste
phone +39 040 224551
fax +39 040 224300
info@charmerelax.com
reservation@charmerelax.com

Albergo Ristorante Carso Da Bozo
località Zolla, 1
34016 Monrupino - Respen (Trieste)
phone +39 040 327113

Al Rebechin
via G. D'Annunzio, 69/b
34118 Trieste
phone +39 040 391639

Ristorante Harry's Grill
piazza Unità d'Italia, 2
34100 Trieste
phone +39 040 365646

Antica Trattoria Suban
via E. Comici, 2
34100 Trieste
phone +39 040 54368

Trattoria Al Castelliere
località Zolla, 8
34016 Monrupino - Respen (Trieste)
phone +39 040 327120

Trattoria Furlan
località Zolla, 19
34016 Monrupino - Respen (Trieste)
phone +39 040 327125

Osteria da Bepi
via Cassa di Risparmio, 3
34100 Trieste
phone +39 040 366858

Caffè San Marco
via Battisti, 18
34100 Trieste
phone +39 040 371373

Caffè Tergesteo
piazza della Borsa, 15
34121 Trieste
phone +39 040 365812

Caffè Tommaseo
riva III Novembre, 5
34100 Trieste
phone +39 040 366765

Caffè degli Specchi
piazza Unità, 7
34100 Trieste
phone +39 040 365777
info@caffedeglispecchi.net

Pasticceria Caffè Pirona
largo Barriera Vecchia, 12
34129 Trieste
phone +39 040 636046

Pasticceria La Bomboniera
via XXX Ottobre, 3
34122 Trieste
phone +39 040 632752

EMILIA—ROMAGNA

castell'arquato

Informazioni Turistiche
viale Remondini, 1
29014 Castell'Arquato (Piacenza)
phone +39 0523 803091 (seasonal)
www.comune.piacenza.it

Albergo Leon d'Oro
piazza Europa, 6
29014 Castell'Arquato (Piacenza)
phone +39 0523 803651

Albergo San Giorgio
piazza Europa, 2
29014 Castell'Arquato (Piacenza)
phone +39 0523 805149

Ristorante Maps
piazza Europa, 3
29014 Castell'Arquato (Piacenza)
phone +39 0523 804411

Trattoria Da Faccini
piazza Europa, 12
frazione Sant'Antonio
29014 Castell'Arquato (Piacenza)
phone +39 0523 896340

Terme Berzieri–Zoia
via Roma, 9
43039 Salsomaggiore Terme (Parma)
phone +39 0524 578201
fax +39 0524 576987
thernet@polaris.it /
www.termedisalsomaggiore.it

faenza

Informazioni Turistiche
piazza del Popolo, 1
48018 Faenza (Ravenna)
phone +39 0546 25231

Hotel Vittoria
corso Garibaldi, 23
48018 Faenza (Ravenna)
phone +39 0546 21508
fax +39 0546 29136
info@hotel-vittoria.com
www.hotel-vittoria.com

Hotel Cavallino
via Forlivese, 185
48018 Faenza (Ravenna)
phone +39 0546 634411
fax +39 0546 634440
www.hotel-cavallino.it

Ristorante Le Volte
corso Mazzini, 54 (Galleria Gessi)
48018 Faenza (Ravenna)
phone +39 0546 661600

Trattoria La Cantena d'Sarna
via Sarna, 221
48018 Faenza (Ravenna)
phone +39 0546 43045

Ceramiche Gemi - D'At
corso D. Baccarini, 5
48018 Faenza (Ravenna)
phone +39 0546 26566

Immagine Faentina (ceramics)
corso Mazzini, 72/A
48018 Faenza (Ravenna)
phone +39 0546 29356

ferrara

Ufficio di Informazione e di Accoglienza Turistica (IAT)
Castello Estense
44100 Ferrara
phone +39 0532 209370
fax +39 0532 212266
infotour@provincia.fe.it / www.comune.fe.it

Hotel Duchessa Isabella
via Palestro, 68/70
44100 Ferrara
phone +39 0532 202121
fax +39 0532 202638
isabella@tin.it

Hotel Annunziata
viale Cavour, 55
44100 Ferrara
phone +39 0532 206088
fax +39 0532 247002
annunziata@tin.it

Ristorante Il Don Giovanni
via del Primaro, 86
località Marrara
44100 Ferrara
phone +39 0532 421064

Ristorante Quel Fantastico Giovedì
via Castelnuovo, 9
44100 Ferrara
phone +39 0532 760570

Ristorante Capanna di Eraclio
via per le Venezie, 21
località Ponte Vicini
44021 Codigoro (Ferrara)
phone/fax +39 0533 712154

F.I.S. (Fabbrica Italiana Specialità Dolciarie)
via J. Guidetti, 30-32
44100 Ferrara
phone +39 0532 902180

modena

Ufficio di Informazione e di Accoglienza Turistica (IAT)
piazza Grande, 17
41100 Modena
phone +39 059 206660
fax +39 059 206659
iatmo@comune.modena.it
www.comune.modena.it

Hotel Canalgrande
corso Canalgrande, 6
41100 Modena
phone +39 059 217160
fax +39 059 221674
info@canalgrandehophone.it
www.canalgrandehotel.it

Hotel Rechigi Park
via Emilia Est, 1581
41100 Modena
phone +39 059 283600
fax +39 059 283910
info@rechigiparkhotel.com
www.rechigiparkhotel.com

Hotel Real Fini
via Emilia Est, 441
41100 Modena
phone +39 059 2051511
fax +39 059 364804
hophonereal.fini@hrf.it

Ristorante Fini
piazzetta San Francesco - rua Frati Minori, 54
41100 Modena
phone +39 059 223314

Osteria Francescana
via Stella, 22
41100 Modena
phone +39 059 210118

Consorzio Aceto Balsamico di Modena
via Ganaceto, 134
41100 Modena
phone +39 059 23698
info@consorziobalsamico.it
www.consorziobalsamico.it

Azienda Agricola Galli (balsamic vinegar)
via Albareto, 452
41100 Modena
phone +39 059 251094
fax +39 059 251010

Caffè dell'Orologio
piazzetta delle Ova, 4
41100 Modena
fax +39 059 367018

parma

Ufficio di Informazione e di Accoglienza Turistica (IAT)
via Melloni, 1/b
43100 Parma
phone +39 0521 218889
fax +39 0521 234735
turismo@comune.parma.it
www.turismo.comune.parma.it/turismo

Grand Hotel Baglioni
via Piacenza, 12c
43100 Parma
phone +39 0521 292929
fax +39 0521 292828
ghb.parma@baglionihotels.com

Hotel Palace Maria Luigia
viale Mentana, 140
43100 Parma
phone +39 0521 281032
fax +39 0521 231126
www.palacemarialuigia.it

Ristorante La Greppia
via Garibaldi, 39/a
43100 Parma
phone +39 0521 233686

Trattoria Sorelle Picchi
via Farini, 12
43100 Parma
phone +39 0521 233528

Consorzio del Prosciutto di Parma
via dell'Arpa, 8/b
43100 Parma
info@prosciuttodiparma.com
www.prosciuttodiparma.com

Consorzio del Culatello di Zibello
piazza G. Garibaldi, 34
43010 Zibello (Parma)
phone +39 0524 939100

Salumeria Garibaldi
via Garibaldi, 42
43100 Parma
phone +39 0521 235606

ravenna

Ufficio di Informazione e di Accoglienza Turistica (IAT)
via Salara, 8/12
48100 Ravenna
phone +39 0544 451539
www.turismo.ravenna.it

Hotel Ristorante Cappello
via IV Novembre, 41
48100 Ravenna
phone +39 0544 2198.13
fax +39 0544 219814

Best Western Hotel Bisanzio
via Salara, 30
48100 Ravenna
phone +39 0544 217111
fax +39 0544 32539
info@bisanziohotel.com
www.bisanziohotel.com

Trattoria Enoteca Ca' de Ven
via C. Ricci, 24
48100 Ravenna
phone +39 0544 30163

Taverna di San Romualdo
via Badarena, 1
48020 San Romualdo (Ravenna)
phone +39 0544 483447

Giardino delle Erbe
via del Corso, 2/1
48010 Casola Valsenio (Ravenna)
phone +39 0546 73158
giardinodelleerbe@libero.it
www.ilgiardinodelleerbe.it

La Butega ad Giorgioni
via IV Novembre, 43
48100 Ravenna
phone +39 0544 212638

Artemosaico
via Faentina, 218
48100 Ravenna
phone +39 0544 465469

republic of san marino

Ufficio del Turismo
contrada del Collegio
47890 Republic of San Marino
phone +39 0549 882914
Call Center phone +39 0549 882914
statoturismo@omniway.sm
www.omniway.sm

Grand Hotel San Marino
via A. Onofri, 31
47890 Republic of San Marino
phone +39 0549 992400
fax +39 0549 992951
grandhotel@omniway.sm

Hotel Titano
contrada del Collegio, 31
47890 Republic of San Marino
phone +39 0549 991007
fax +39 0549 991375
hoteltitano@omniway.sm

Ristorante Righi La Taverna
piazza della Libertà, 10
47890 Republic of San Marino
phone +39 0549 991196
fax +39 0549 990597

Ristorante Due Archi
via del Passetto, 43
località Fiorentino
47890 Republic of San Marino
phone +39 0549 997889

arezzo

Azienda di Promozione Turistica (APT)
piazza Risorgimento, 116
52100 Arezzo
phone +39 0575 23952
fax +39 0575 28042
info@arezzo.turismo.toscana.it
www.turismo.toscana.it

Hotel Cavaliere Palace
via Madonna del Prato, 83
52100 Arezzo
phone +39 199 720693
fax +39 0575 21925

Hotel Val di Colle
località Bagnoro
52100 Arezzo
phone/fax +39 0575 365167

Ristorante Buca di San Francesco
via San Francesco, 1
52100 Arezzo
phone +39 0575 23271

Agriturismo Fattoria Montelucci
località Montelucci, 8
52020 Pergine Valdarno (Arezzo)
phone +39 0575 896525
fax +39 0575 896315
info.montelucci@.it
www.montelucci.it

Osteria La Capannaccia
località Campriano, 51c
52100 Arezzo
phone +39 0575 361759

Trattoria Il Saraceno
via Mazzini, 6a
52100 Arezzo
phone +39 0575 27644

Oreficeria Carniani
via del Gavardello, 62
52100 Arezzo
phone +39 0575 381847

Oreficeria Garzi
via del Maspino, 30
52100 Arezzo
phone +39 0575 984341

carrara

Azienda di Promozione Turistica (APT)
lungomare Vespucci, 24
57037 Marina di Massa (Massa)
phone +39 0585 240046
fax +39 0585 869015
apt@massacarrara.turismo.toscana.it
www.turismo.toscana.it

Hotel Carrara
via E. Petacchi, 21
località Avenza
54033 Carrara (Massa)
phone +39 0585 52371
fax +39 0585 50344
info@hotelcarrara.it
www.hotelcarrara.it

Hotel Cavalieri del Mare
viale Verdi, 23
frazione Ronchi
54100 Marina di Massa
phone +39 0585 868010
fax +39 0585 868015

Hotel Mediterraneo
via Genova, 2h
54033 Marina di Carrara (Massa)
phone/fax +39 0585 785222

Ristorante Ninan
via L. Bartolini, 3
54033 Carrara (Massa)
phone +39 0585 74741

Ristorante Venanzio
piazza Palestro, 3
località Colonnata
54033 Carrara (Massa)
phone +39 0585 758062

Lardo di Colonnata da Marino Giannarelli
piazza Rosselli, 11
località Codena di Carrara
54033 Carrara (Massa)
phone +39 0585 777329

Carlo Nicoli Studio di Scultura
piazza XXVIII Aprile, 8/e
54033 Carrara (Massa)
phone +39 0585 70079

cortona

Informazioni Turistiche
via Nazionale, 70
52044 Cortona (Arezzo)
phone +39 0575 630352
fax +39 0575 630656

Hotel Villa Marsili
viale C. Battisti, 13
52044 Cortona (Arezzo)
phone +39 0575 605199
fax +39 0575 605618
villamarsili@abitarelastoria.it

Relais Il Falconiere
località San Martino, 370
52044 Cortona (Arezzo)
phone +39 0575 612679
fax +39 0575 612927
info@ilfalconiere.it
www.ilfalconiere.it

Hotel Oasi Neumann
via delle Contesse, 1
52044 Cortona (Arezzo)
phone +39 0575 630354
fax +39 0575 630354
oasi@oasineumann.com

Hotel San Michele
via Guelfa, 15
52044 Cortona (Arezzo)
phone +39 0575 604348
fax +39 0575 630147
info@hotelsanmichele.net
www.hotelsanmichele.net

Ristorante Tonino
piazza G. Garibaldi, 1
52044 Cortona (Arezzo)
phone +39 0575 630500

Taverna Pane e Vino
piazza Luca Signorelli, 27
52044 Cortona (Arezzo)
phone +39 0575 631010
taverna@pane-vino.it
www.pane-vino.it

Ceramica L'Etruria
piazza Luca Signorelli, 21
52044 Cortona (Arezzo)
phone +39 0575 62575

Il Cocciaio
via Benedetti 24
52044 Cortona (Arezzo)
phone +39 0575 605294

grosseto

Azienda di Promozione Turistica (APT)
viale Monterosa, 206
58100 Grosseto
phone +39 0564 462611
fax +39 0564 454606
aptgrosseto@grosseto.turismo.toscana.it
www.grosseto.turismo.toscana.it

Grand Hotel Bastiani
piazza Gioberti, 64
58100 Grosseto
phone +39 0564 20047
fax +39 0564 29321

Hotel della Fortezza
piazza Cairoli, 5
58018 Sorano (Grosseto)
phone +39 0564 632010
fax +39 0564 633209
fortezzahotel@tin.it
www.fortezzahotel.it

Albergo Ristorante La Taverna Etrusca
piazza del Pretorio, 16
58010 Sovana (Grosseto)
phone +39 0564 616183
fax +39 0564 614193

Hotel Granduca
via Senese, 170
58100 Grosseto
phone +39 0564 453833
fax +39 0564 453843
info@hotelgranduca.com
www.hotelgranduca.com

Ristorante Canapone
piazza Dante, 3
58100 Grosseto
phone +39 0564 24546

Ristorante Lorena
via Mameli, 23
58100 Grosseto
phone +39 0564 22695

Ristorante Terzo Cerchio
piazza Castello, 2
58040 Istia d'Ombrone (Grosseto)
phone +39 0564 409235

Tartufi - Brezzi Oliviero e Figlio
via Orcagna, 56
58100 Grosseto
phone +39 0564 408937
info@tartufotaste.it
www.tartufotaste.it

Cantina Cooperativa di Pitigliano
via N. Ciacci, 974
58017 Pitigliano (Grosseto)
phone +39 0564 616133
fax +39 0564 616142
info@cantinadipitigliano.it
www.cantinadipitigliano.it

Il Riccio (leather goods)
via D. Chiesa, 36
58100 Grosseto
phone +39 0564 417593

isola d'elba

Informazioni Turistiche
Calata Italia, 26
57037 Portoferraio (Livorno)
phone +39 0565 914671
fax +39 0565 916350
info@aptelba.it
www.arcipelago.turismo.toscana.it

Hotel Hermitage
località La Biodola
57037 Portoferraio (Livorno)
phone +39 0565 974811
fax +39 0565 969984

Hotel Airone del Parco e delle Terme
San Giovanni
57037 Portoferraio (Livorno)
phone +39 0565 929111
fax +39 0565 917484
info@hotelairone.info / www.hotelairone.info

Hotel Park Napoleone
San Martino
57037 Portoferraio (Livorno)
phone +39 0565 911111
fax +39 0565 917836
info@parkhotelnapoleone.com

Ristorante Capo Nord
La Fenicia, 69
località Marciana Marina
57037 Portoferraio (Livorno)
phone +39 0565 996983

Ristorante Publius
piazza XX Settembre, 6/7
località Marciana Marina
frazione Poggio
57037 Portoferraio (Livorno)
phone +39 0565 99208

Ristorante Stella Marina
banchina Alto Fondale
57037 Portoferraio (Livorno)
phone +39 0565 915983

lucca

Azienda di Promozione Turistica (APT)
piazza Guidiccioni, 2
55100 Lucca
phone +39 0583 91991
fax +39 0583 490766
aptlucca@lucca.turismo.toscana.it
www.lucca.turismo.toscana.it

Villa Orlando
via delle Ville, 641
55018 Segromigno in Monte (Lucca)
phone/fax +39 0583 928001
giotti76@fastwebnet.it
golo@galactica.it

Villa Mansi
località Colli, 1
55064 Monsagrati (Lucca)
phone/fax +39 0583 385840
info@villamansi.com
www.villamansi.com

Hotel Villa La Principessa
via Nuova per Pisa, 1616
frazione Massa Pisana
55100 Lucca
phone +39 0583 370037
fax +39 0583 379136
info@hotelprincipessa.com
www.hotelprincipessa.com

Ristorante La Mora
via Sesto di Moriano, 1748
località Ponte a Moriano
55100 Lucca
phone +39 0583 406402

Ristorante La Buca di Sant'Antonio
via della Cervia, 1/3
55100 Lucca
phone +39 0583 55881

Bottega di Prospero
via Santa Lucia, 13
55100 Lucca
info@drogheriaprospero.com
www.drogheriaprospero.com

Antico Caffè delle Mura
piazzale Vittorio Emanuele, 2
55100 Lucca
phone +39 0583 47962

Cafè Caselli Di Simo
via Fillungo, 58
55100 Lucca
phone +39 0583 496234

montepulciano

Azienda di Promozione Turistica (APT)
via di Città, 43
53100 Siena
phone +39 0577 42209
fax +39 0577 281041
aptsiena@siena.turismo.toscana.it
www.siena.toscana.it

Hotel Borgo Trerose
località I Palazzi, 5
53045 Valiano di Montepulciano (Siena)
phone +39 0578 72491
fax +39 0578 724227

Hotel Il Borghetto
borgo Buio, 7
53045 Montepulciano (Siena)
phone +39 0578 757535
fax +39 0578 757354

Ristorante La Grotta
località San Biagio, 15
53045 Montepulciano (Siena)
phone +39 0578 757607

Ristorante Diva e Maceo
via di Gracciano nel Corso, 90/92
53045 Montepulciano (Siena)
phone +39 0578 716951

Antico Caffè Poliziano
via Voltaia nel Corso, 27/29
53045 Montepulciano (Siena)
phone +39 0578 758615
caffepoliziano@libero.it

Caseificio Cugusi
Statale per Pienza - via della Boccia, 8
53045 Montepulciano (Siena)
phone +39 0578 757558

Enoteca Oinochoe
via Voltaia nel Corso, 82
53045 Montepulciano (Siena)
phone +39 0578 757524

Frantoio Sociale di Montepulciano
via di Martiena, 2
53045 Montepulciano (Siena)
phone +39 0578 758732

pienza

Informazioni Turistiche
corso del Rossellino, 59
53026 Pienza (Siena)
phone +39 0578 749071

Hotel L'Olmo
Podere Ommio, 27
località Monticchiello
53026 Pienza (Siena)
phone +39 0578 755133
fax +39 0578 755124
flindo@tin.it

Hotel Il Chiostro di Pienza
corso del Rossellino, 26
53026 Pienza (Siena)
phone +39 0578 748400
fax +39 0578 748440
ilchiostrodipienza@virgilio.it
www.relaisilchiostrodipienza.com

Ristorante Taverna di Moranda
via di Mezzo, 17
località Monticchiello
53026 Pienza (Siena)
phone +39 0578 755050

Trattoria Latte di Luna
via San Carlo, 2/4
53026 Pienza (Siena)
phone +39 0578 748606

Caseificio Azienda Agricola San Polo
Podere San Polo, 1
53026 Trequanda (Siena)
phone +39 0577 665321

Cornucopia del Club delle Fattorie
piazza Martiri della Libertà, 2
53026 Pienza (Siena)
phone +39 0578 748150

pietrasanta

Informazioni Turistiche
via Donizetti, 14
55045 Marina di Pietrasanta (Lucca)
phone +39 0584 20331

Albergo Pietrasanta
via G. Garibaldi, 35
55045 Pietrasanta (Lucca)
phone +39 0584 793726
fax +39 0584 793728
a.pietrasanta@versilia.toscana.it

Hotel Palagi
piazza Carducci, 23
55045 Pietrasanta (Lucca)
phone +39 0584 70249
fax +39 0584 71198

Ristorante Enoteca Marcucci
via G. Garibaldi, 40
55045 Pietrasanta (Lucca)
phone +39 0584 791962

Osteria alla Giudea
via Padre Eugenio Barsanti, 4
55045 Pietrasanta (Lucca)
phone +39 0584 71514

Laboratorio Sculture Cervietti
via Sant'Agostino, 53
55045 Pietrasanta (Lucca)
phone +39 0584 790925

pisa

Azienda di Promozione Turistica (APT)
piazza Vittorio Emanuele, 14
56124 Pisa
phone +39 050 42291
fax +39 050 929764
info@pisa.turismo.toscana.it
www.pisa.turismo.toscana.it

Grand Hotel Duomo
via Santa Maria, 94
56100 Pisa
phone +39 050 561894
fax +39 050 560418
hotelduomo@csinfo.it

Hotel Royal Victoria
lungarno Pacinotti, 12
56100 Pisa
phone +39 050 940111
fax +39 050 940180
ryh@csinfo.it

Ristorante A Casa Mia
via Provinciale Vicarese, 10
località Ghezzano
56100 Pisa
phone +39 050 879265

Osteria dei Cavalieri
via San Frediano, 16
56100 Pisa
phone +39 050 580858

Trattoria Salza
borgo Stretto, 46
56100 Pisa
phone +39 050 580244

san gimignano

Informazioni Turistiche
piazza Duomo, 1
53037 San Gimignano (Siena)
phone +39 0577 940008
fax +39 0577 940903

Hotel Monteriggioni
via I Maggio, 4
53037 San Gimignano (Siena)
phone +39 0577 3050.09
fax +39 0577 305011

Hotel L'Antico Pozzo
via San Matteo, 87
53037 San Gimignano (Siena)
phone +39 0577 942014
fax +39 0577 942117
info@anticopozzo.com
www.anticopozzo.com

Relais Santa Chiara
via Matteotti, 15
53037 San Gimignano (Siena)
phone +39 0577 940701
fax +39 0577 942096
rsc@rsc.it
www.rsc.it

Osteria Antiche Terre Rosse
località San Donato, 12
53037 San Gimignano (Siena)
phone +39 0577 940540

Ristorante Bel Soggiorno
via San Giovanni, 91
53037 San Gimignano (Siena)
phone +39 0577 940375

Azienda Agricola San Quirico
località Pancole, 39
53037 San Gimignano (Siena)
phone +39 0577 955007
fax +39 0577 955149
az.agr.sanquirico@libero.it

Associazione Il Croco
via delle Fonti, 3/a
53037 San Gimignano (Siena)

Enoteca Il Castello
via del Castello, 20
53037 San Gimignano (Siena)
phone/fax +39 0577 940878
ricast@tin.it

Osteria delle Catene
via Nonenardi, 18
53037 San Gimignano (Siena)
phone/fax +39 0577 941966

siena

Azienda di Promozione Turistica (APT)
via di Città, 43
53100 Siena
phone +39 0577 42209
fax +39 0577 281041
aptsiena@siena.turismo.toscana.it
www.siena.toscana.it

Grand Hotel Continental
via Banchi di Sopra, 85
53030 Siena
phone +39 0577 44204
fax +39 0577 49020
info@charmingonline.net
www.grandhotelcontinentalsiena.com

Relais la Suvera
via della Suvera
località Pievescola
53030 Casale d'Elsa (Siena)
phone +39 0577 960300
fax +39 0577 960220
reservations@lasuvera.it

Hotel Certosa di Maggiano
strada di Certosa, 82–86
53030 Siena
phone +39 0577 288180
fax +39 0577 288189
rcertosa@relaischateaux.fr

Antica Trattoria Botteganova
strada Chiantigiana, 29
53030 Siena
phone +39 0577 284230
info@anticatrattoriabotteganova.it
www.anticatrattoriabotteganova.it

Ristorante Osteria Le Logge
via del Porrione, 33
53030 Siena
phone +39 0577 48013

Trattoria da Gano
via Pantaneto, 146
53030 Siena
phone +39 0577 221294

Antica Drogheria Manganelli
via di Città, 71–73
53030 Siena

La Nuova Pasticceria
piazzale Maestri del Lavoro, 9
53100 Siena
phone +39 0577 41319

volterra

Informazioni Turistiche
via G. Turazza, 2
56048 Volterra (Pisa)
phone +39 0588 86150
info@volterratur.it
www.volterratur.it

Hotel San Lino
via San Lino, 26
56048 Volterra (Pisa)
phone +39 0588 85250
fax +39 0588 80620
info@hotelsanlino.com
www.hotelsanlino.com

Hotel Villa Nencini
borgo Santo Stefano, 55
56048 Volterra (Pisa)
phone +39 0588 86386
fax +39 0588 80601

Hotel Villa Rioddi
località Rioddi
56048 Volterra (Pisa)
phone +39 0588 88053
fax +39 0588 88074

Ristorante Il Vecchio Mulino
via del Molino
frazione Saline di Volterra
56048 Volterra (Pisa)
phone +39 0588 44060

Enoteca del Duca
via del Castello, 2
56048 Volterra (Pisa)
phone +39 0588 81510

Ristorante Etruria
piazza dei Priori, 6–8
56048 Volterra (Pisa)
phone/fax +39 0588 86064

Pasticcerie Migliorini
via Gramsci, 21
56048 Volterra (Pisa)
phone/fax +39 0588 86446

Alabastri Bessi
via Turazza, 1–3
56048 Volterra (Pisa)
phone/fax +39 0588 88538
www.bessialabastro.com

Soc. Coop. Artieri Alabastro
via Pisana, 28
56048 Volterra (Pisa)
phone +39 0588 87590
artieri.a@tin.it
www.artierialabastro.it

UMBRIA

assisi

Servizio Turistico Territoriale
piazza del Comune, 12
06081 Assisi (Perugia)
phone +39 075 812450
fax +39 075 813727
info@iat.assisi.pg.it

Hotel Le Silve
località Armenzano
06081 Assisi (Perugia)
phone +39 075 8019000
fax +39 075 8019005
info@lesilve.it
www.lesilve.it

Hotel San Francesco
via San Francesco, 48
06081 Assisi (Perugia)
phone +39 075 812281
fax +39 075 816237

Hotel Santa Maria degli Ancillotti
località Sterpeto, 42
06081 Assisi (Perugia)
phone +39 075 8039764
fax +39 075 8039764
pavone@edison.it

Locanda dei Cavalieri
via G. Matteotti, 47
località Petrignano
06081 Assisi (Perugia)
phone +39 075 8030011

Ristorante La Fortezza
piazza del Comune, 2/b
06081 Assisi (Perugia)
phone +39 075 812418

**Ricami e Ceramiche
di Pinchi Giuliana**
via Fontebella, 40/a
06081 Assisi (Perugia)
phone +39 075 813502

gubbio

Informazioni Turistiche
via Ansidei, 32
06024 Gubbio (Perugia)
phone +39 075 9220693
fax +39 075 9273409
info@iat.gubbio.pg.it

Hotel Bosone Palace
via XX Settembre, 22
06024 Gubbio (Perugia)
phone +39 075 9220688
fax +39 075 9220552
mencarelli@mencarelli group.com

Hotel Castello di Petroia
località Petroia
06024 Gubbio (Perugia)
phone +39 075 920287
fax +39 075 920108
castello.petroia@infoservice.it

Hotel Relais Ducale
via Galeotti, 19
06024 Gubbio (Perugia)
phone +39 075 9220157
fax +39 075 9220159

Hotel Ristorante Villa Montegranelli
località Monteluiano
06024 Gubbio (Perugia)
phone +39 075 9220185
fax +39 075 9273372
villamontegranellihotel@paginesi.it
www.villamontegranellihotel.it

Ristorante La Fornace di Mastro Giorgio
via Mastro Giorgio, 2
06024 Gubbio (Perugia)
phone +39 075 9221836

Ristorante ai Cappuccini
via Tifernate
06024 Gubbio (Perugia)
phone +39 075 9234

Ghiottonerie Egubine
via Mastro Giorgio
06024 Gubbio (Perugia)

Ceramiche Rampini
via L. Da Vinci, 92
06024 Gubbio (Perugia)
phone +39 075 9272963

Artigianato Ferro Artistico
via U. Baldassini, 22
06024 Gubbio (Perugia)
phone +39 075 9273079

orvieto

Servizio Turistico Territoriale
piazza Duomo, 24
05018 Orvieto (Terni)
phone +39 0763 341911
fax +39 0763 344433
info@iat.orvieto.tr.it
www.iat.orvieto.tr.it

Hotel La Badia
località La Badia, 8
frazione Orvieto Scalo
05018 Orvieto (Terni)
phone +39 0763 301959
fax +39 0763 305396

Hotel Palazzo Piccolomini
piazza Ranieri, 36
05018 Orvieto (Terni)
phone +39 0763 341743
fax +39 0763 391046
piccolomini.hotel@orvienet.it
www.hotelpiccolomini.it

Albergo Filippeschi
via Filippeschi, 19
05018 Orvieto (Terni)
phone +39 0763 343275

Ristorante Osteria dell'Angelo
piazza XXIX Marzo, 8
05018 Orvieto (Terni)
phone +39 0763 341805

Trattoria Il Giglio d'Oro
piazza Duomo, 8
05018 Orvieto (Terni)
phone +39 0763 341903

Azienda Vinicola Tenuta Le Velette
località Le Velette, 23
05018 Orvieto (Terni)
phone +39 0763 29090
www.levelette.it

Enoteca La Loggia
corso Cavour, 135
05018 Orvieto (Terni)

Gastronomia Carraro
corso Cavour, 10
05018 Orvieto (Terni)

Ceramicarte
via Duomo, 42
05018 Orvieto (Terni)
phone +39 0763 341394

Moretti Merletti (handmade lace and dolls)
via Duomo, 55
05018 Orvieto (Terni)
phone +39 0763 41714

Pozzo della Cava
via della Cava, 28
05018 Orvieto (Terni)
phone +39 0763 342373
fax +39 0763 341029
info@pozzodellacava.it
www.pozzodellacava.it

perugia

Servizio Turistico Territoriale
via Mazzini, 6
06100 Perugia
phone +39 075 5728937
fax +39 075 5739386
info@iat.perugia.it

Castello dell'Oscano
strada della Forcella, 37
località Cenerente
06070 Perugia
phone +39 075 584371
fax +39 075 690666
info@oscano.it
www.oscano.com

Hotel Brufani Palace
piazza Italia, 12
06100 Perugia
phone +39 075 5732541
fax +39 075 5720210
brufani@tin.it
www.brufanipalace.com

Hotel Palazzo Terranova
località Ronti Morra
06010 Perugia
phone +39 075 8570083
fax +39 075 8570014
sarah@palazzoterranova.com
www.palazzoterranova.com

Hotel Ristorante Giò Arte e Vini
via R. D'Andreotto, 19
06100 Perugia
phone +39 075 5731100
hotelgio@interbusiness.it
www.hotelgio.it

Relais Ristorante San Clemente
località Bosco
06080 Perugia
phone +39 075 5915100

Frantoio Giovanni Batta
via San Girolamo, 127
06100 Perugia

Pasticceria Sandri
corso Vannucci, 32
06100 Perugia

spoleto

Servizio Turistico Territoriale IAT
piazza della Libertà, 7
06049 Spoleto (Perugia)
phone +39 0743 49890
fax +39 0743 46241
info@iat.spoleto.pg.it

Hotel Vecchio Mulino
via del Tempio, 34
06042 Campello sul Clitunno (Perugia)
phone +39 0743 521122
fax +39 0743 275097
vecchiomolino@perugiaonline.com

Hotel San Luca
via Interna delle Mura, 21
06049 Spoleto (Perugia)
phone +39 0743 223399
fax +39 0743 223800

Villa Milani
località Colle Attivoli, 4
06049 Spoleto (Perugia)
phone +39 0743 225056
fax +39 0743 49824
villamilani@abitarelastoria.it

Ristorante Il Capanno
località Terrecola, 6
06049 Spoleto (Perugia)
phone +39 0743 54119
info@ilcapannoristorante.it
www.ilcapannoristorante.it

Ristorante Il Tartufo
piazza Garibaldi, 24
06049 Spoleto (Perugia)
phone +39 0743 40236

Maria Teresa Tardioli (amphorae, vases)
corso Mazzini, 66
06049 Spoleto (Perugia)

Tessitura di Lucilla de Angelis
via Lascaris, 3
06049 Spoleto (Perugia)
phone +39 0743 221735

todi

Servizio Turistico Territoriale
piazza Umberto I, 6
06059 Todi (Perugia)
phone +39 075 8943395
fax +39 075 8942406
info@iat.todi.pg.it

Relais Todini
frazione Collevalenza (Cervara)
06050 Todi (Perugia)
phone +39 075 887521
fax +39 075 887182
relais@relaistodini.com
www.relaistodini.com

Villa La Palazzetta
frazione Asproli, 23
06059 Todi (Perugia)
phone +39 075 8853219
fax +39 075 8853358
0758853360@iol.it

Trattoria La Mulinella
località Pontenaia, 29
frazione Vasciano
06059 Todi (Perugia)
phone +39 075 8944779

Old Time (antiques)
via G. Mazzini, 26
06059 Todi (Perugia)
phone +39 075 8942501

MARCHE

ancona

Azienda di Promozione Turistica Regionale (APTR)
via Thaon de Revel, 4
60100 Ancona
phone +39 071 3589902
fax +39 071 801454
aptrr@regione.marche.it
servizio.turismo@regione.marche.it
www.le-marche.com/italia/marche

Hotel Ristorante Fortino Napoleonico
via Poggio, 166
località Portonovo
60100 Ancona
phone +39 071 801450
fax +39 071 801454
fortino@fastnet.it

Hotel Emilia
via Collina di Portonovo, 149a
60100 Ancona
phone +39 071 801145
fax +39 071 801330
info@hotelemilia.com
www.hotelemilia.com

Ristorante Al Rosso Agontano
via Marconi, 3
60100 Ancona
phone +39 071 2075279
fax +39 071 54050
agontan@libero.it
www.alrossoagontano.it

Ristorante Il Laghetto
via Portonovo, 11
località Portonovo
60100 Ancona
phone +39 071 801183

Osteria Strabacco
via Oberdan, 2
60100 Ancona
phone +39 071 54213

Trattoria Carloni
via Flaminia, 247
località Torrette
60100 Ancona
phone +39 071 888239

Nostalgie (lace)
corso Amendola, 12
60100 Ancona
phone +39 071 2073103

Hotel Monteconero
via Monte Conero, 26
60020 Sirolo (Ancona)
phone +39 071 9330592
fax +39 071 9330365
info@hotelmonteconero.it
www.hotelmonteconero.it

Ristorante Locanda Rocco
via Torrione, 1
60020 Sirolo (Ancona)
phone/fax +39 071 9330558
locandarocco@abitarelastoria.it

ascoli piceno

Ufficio di Informazione e Accoglienza Turistica (IAT)
Palazzo dei Capitani - piazza del Popolo
63100 Ascoli Piceno
phone +39 0736 253045
fax +39 0736 252391
iat.ascolipiceno@regione.marche.it

Hotel Villa Seghetti Panichi
via San Pancrazio, 1
63031 Castel di Lama (Ascoli Piceno)
phone +39 0736 812552
fax +39 0736 814528
info@seghettipanichi.it / ww.seghettipanichi.it

Hotel Il Pennile
via G. Spalvieri, 13
63100 Ascoli Piceno
phone +39 0736 41645
fax +39 0736 342755

Ristorante Castel di Luco
località Castel di Luco
63040 Acquasanta Terme (Ascoli Piceno)
phone/fax +39 0736 802319
luco@abitarelastoria.it

Ristorante Gallo d'Oro
corso Vittorio Emanuele, 13
63100 Ascoli Piceno
phone +39 0736 253520

Azienda Agricola Ottaviani
via San Cristoforo
63021 Amandola (Ascoli Piceno)
phone +39 0736 847401

loreto

Informazioni Turistiche
via G. Solari, 3
60025 Loreto (Ancona)
phone +39 071 970276
fax +39 071 970020
iat.loreto@regione.marche.it

Albergo Ristorante La Vecchia Fattoria
via Manzoni, 19
60025 Loreto (Ancona)
phone +39 071 978976
fax +39 071 978962

Hotel Ristorante Pellegrino e Pace
piazza della Madonna, 52
60025 Loreto (Ancona)
phone +39 071 977106
fax +39 071 978252
info@pellegrinopace.it

Fisarmoniche Castagnari
via Risorgimento, 77
62019 Recanati (Macerata)
phone +39 071 7574294
info@castagnari.com
www.castagnari.com

Fisarmoniche Serenellini L. & C.
via Brecce, 52/a
60025 Loreto (Ancona)
phone +39 071 978172

urbino

Informazioni Turistiche
piazza Rinascimento, 1
61029 Urbino (Pesaro Urbino)
phone +39 0722 22788
fax +39 0722 2441
iat.urbino@regione.marche.it

Hotel Bonconte
via delle Mura, 28
61029 Urbino (Pesaro Urbino)
phone +39 0722 2463
fax +39 0722 4782
info@viphotels.it

Hotel Mamiani
via Bernini, 6
61029 Urbino (Pesaro Urbino)
phone +39 0722 322309
fax +39 0722 327742
info@hotelmamiani.it / www.hotelmamiani.it

Ristorante Da Bruno
via Colonna, 36
località Trasanni-Cesane
61029 Urbino (Pesaro Urbino)
phone +39 0722 340289

Ristorante L'Angolo Divino
via Sant'Andrea, 12
61029 Urbino (Pesaro Urbino)
phone +39 0722 327559

Casa del Formaggio
via G. Mazzini, 47
61029 Urbino (Pesaro Urbino)
phone +39 0722 4035

LAZIO

anagni

Azienda di Promozione Turistica (APT)
via Aldo Moro, 465
03100 Frosinone
phone +39 0775 83381
fax +39 0775 833837
info@apt.frosinone.it / www.apt.frosinone.it

Hotel Ristorante Villa La Floridiana
via Casilina km 63,700
03012 Anagni (Frosinone)
phone +39 0775 769960
fax +39 0775 774527

Grand Hotel Palazzo della Fonte
via dei Villini, 7
03014 Fiuggi (Frosinone)
phone +39 0775 5081
fax +39 0775 506752
palazzo@mclink.it

Ristorante Lo Schiaffo
via Vittorio Emanuele, 270
03012 Anagni (Frosinone)
phone +39 0775 739148

La Torre al Centro Storico
piazza Trento e Trieste, 29
03014 Fiuggi (Frosinone)
phone +39 0775 515382
www.ristorantelatorre.biz

Pasticceria Gelateria Antichi Sapori
via Cavour, 2
03012 Anagni (Frosinone)
phone +39 0775 727978

Tarsie Turri
via Vittorio Emanuele, 291
03012 Anagni (Frosinone)
phone +39 0775 726978

tarquinia

Informazioni Turistiche
piazza Cavour, 1
01016 Tarquinia (Viterbo)
phone +39 0766 856384
fax +39 0766 840479

Hotel Tarconte
via della Tuscia, 19
01016 Tarquinia (Viterbo)
phone +39 0766 856141
fax +39 0766 856585

Hotel Torre del Sole
via Manica Lunga
località Marina Velca
01016 Tarquinia (Viterbo)
phone +39 0766 812242
fax +39 0766 812041

Hotel Ristorante Velcamare
via degli Argonauti, 1
località Tarquinia Lido
01016 Tarquinia (Viterbo)
phone +39 0766 864380
fax +39 0766 864024
pompei@nonel.etruria.net

Ristorante Arcadia
via Mazzini, 6
01016 Tarquinia (Viterbo)
phone +39 0766 855501

Omero Bordo (etruscan art)
via della Ripa, 3
01016 Tarquinia (Viterbo)
phone +39 0766 855175

Ceramiche Marco Bocchio
via Giotto
01016 Tarquinia (Viterbo)
phone +39 0766 842674

Todini Sculture
via Roma, 1
01016 Tarquinia (Viterbo)
phone +39 0766 858294

tivoli

Informazioni Turistiche
piazza G. Garibaldi
00019 Tivoli (Rome)
phone +39 0774 334522
fax +39 0774 331294

Hotel Torre Sant'Angelo
via Quintilio Varo
00019 Tivoli (Rome)
phone +39 0774 332533
fax +39 0774 332533

Hotel Adriano
via Villa Adriana, 194
00019 Tivoli (Rome)
phone +39 0774 382235
fax +39 0774 535122
info@hoteladriano.it
www.hoteladriano.it

Ristorante Antica Hostaria de' Carrettieri
via D. Giuliani, 55
00019 Tivoli (Rome)
phone +39 0774 330159

Ristorante Antica Osteria del Borgo
via San Valerio, 3
00019 Tivoli (Rome)
phone +39 0774 313420

Terme Acque Albule
via Nazionale Tiburtina km 22,700
00011 Bagni di Tivoli (Rome)
phone +39 0774 371007
fax +39 0774 375085
info@termediroma.org / www.siriohotel.net

Lavorazione Rame e Ottone Giuseppe Cialone
via Varo Quintilio, 36/b
Strada Marcellina, 2
00019 Tivoli (Rome)
phone +39 0774 313662

tuscania

Ufficio Informazioni
piazza San Carluccio, 5
01100 Viterbo
phone +39 0761 304795
fax +39 0761 220957

Hotel Ristorante Al Gallo
via del Gallo, 22
01017 Tuscania (Viterbo)
phone +39 0761 443388
fax +39 0761 443628

Hotel Royal
piazza Dante Alighieri, 8
01023 Bolsena (Viterbo)
phone +39 0761 797048
fax +39 0761 796000
ati@bolsenahotel.it / www.bolsenahotel.it

Locanda di Mirandolina
via del Pozzo Bianco, 40–42
01017 Tuscania (Viterbo)
phone/fax +39 0761 436595
info@mirandolina.it / www.mirandolina.it

Ristorante Da Picchietto
via di Porta Fiorentina, 15
01023 Bolsena (Viterbo)
phone +39 0761 799158

Ristorante Dante
via Nazionale, 2
01027 Montefiascone (Viterbo)
phone +39 0761 826015

Terracotta di Marcello Barlozzini
via Martana, 4
01017 Tuscania (Viterbo)
phone +39 0761 434386

viterbo

Ufficio Informazioni
piazza San Carluccio, 5
01100 Viterbo
phone +39 0761 304795
fax +39 0761 220957

Hotel Salus e delle Terme
via Tuscanese, 28
01100 Viterbo
phone +39 0761 3581
fax +39 0761 354262

Nibbio Hotel
piazzale Gramsci, 31
01100 Viterbo
phone +39 0761 326514
fax +39 0761 321808
hotelnibbio@libero.it

Balletti Park Hotel
via Umbria, 2
01030 San Martino al Cimino (Viterbo)
phone +39 0761 3771
fax +39 0761 379496
info@balletti.com
www.balletti.com

B&B Farinella
via Capodistria, 14
località La Quercia
01100 Viterbo
phone/fax +39 0761 304784
giopi@isa.it

Ristorante Da Pino
via Abate Lamberto, 2–4
località San Martino al Cimino
01100 Viterbo
phone +39 0761 379242

Ristorante La Zaffera
piazza San Carluccio, 7
01100 Viterbo
phone +39 0761 344265
info@lazaffera.it
www.zaffera.it

Ristorante Tre Re
via Macel Gattesco, 3
01100 Viterbo
phone +39 0761 304619

Trattoria Il Richiastro
via dela Marrocca, 16
01100 Viterbo
phone +39 0761 228009

Enoteca La Torre
via della Torre, 5
01100 Viterbo
phone +39 0761 226467

Gelateria Chiodi
via Roma, 32
01100 Viterbo
phone +39 0761 304705

Ferro Battuto Deco
strada Fornaci
01031 Bagnaia (Viterbo)
phone +39 0761 289622

**Lavorazione Fibra di Canapa
di Mario Matteucci**
strada Case Nuove, 3/h
01030 Tobia (Viterbo)
phone +39 0761 378753

ABRUZZO AND MOLISE

l'aquila

**Ufficio di Informazione e di Accoglienza
Turistica (IAT)**
piazza Santa Maria di Paganica, 5
67100 L'Aquila
phone +39 0862 410808, fax +39 0862 65442
www.regione.abruzzo.it

Albergo Diffuso
67020 Santo Stefano di Sessanio (L'Aquila)
phone +39 0862 8999116
info@sextantio.it / www.sextantio.it

Hotel Duomo
via Dragonetti, 10
67100 L'Aquila
phone +39 0862 410893
fax +39 0862 413058

Ristorante Elodia
strada statale 17 bis del Gran Sasso, 37
frazione Camarda
67100 L'Aquila
phone +39 0862 606219

Ristorante La Conca Antica Posta
via G. Caldora, 12
67100 L'Aquila
phone +39 0862 405211

L'anfora di Anna Ciccani
via Patini, 25
67100 L'Aquila
phone +39 0862 414449

Le Mani d'Oro (lace)
corso Vittorio Emanuele, 23
67100 L'Aquila
phone +39 0862 410971

**Lavorazione Rame e Ottone
di Raimondo Tiberio**
strada statale 17 bis
67100 L'Aquila
phone +39 0862 316827

ortona

Informazioni Turistiche
piazza della Repubblica, 9
66026 Ortona (Chieti)
phone +39 085 9063841
fax +39 085 9063882

Hotel Ideale
via G. Garibaldi, 65
66026 Ortona (Chieti)
phone +39 085 9063735
fax +39 085 9066153

Ristorante Al Vecchio Teatro
largo Ripetta, 7
66026 Ortona (Chieti)
phone +39 085 9064495

Ristorante Il Sestante
via Marina, 72
66026 Ortona (Chieti)
phone +39 085 9061878

Ristorante Miramare
largo Farnese, 15
66026 Ortona
phone +39 085 906656

Azienda Agricola Agriverde
via Monte Noneella, 118
66026 Ortona (Chieti)

SOUTHERN ITALY AND THE
ISLANDS

CAMPANIA

amalfi

Informazioni Turistiche
corso Repubbliche Marinare, 19–21
84011 Amalfi (Salerno)
phone +39 089 871107
fax +39 089 872619

Hotel Luna & Torre Saracena
via P. Comite, 33
84011 Amalfi (Salerno)
phone +39 089 871002
fax +39 089 871333

Albergo Rufolo
via San Francesco, 1
84010 Ravello (Salerno)
phone +39 089 857133
info@hotelrufolo.it
www.hotelrufolo.it

Hotel Villa Cimbrone
via Santa Chiara, 26
84010 Ravello (Salerno)
phone +39 089 857459
fax +39 089 857777
info@villacimbrone.it
www.villacimbrone.it

Hotel Palumbo
via San Giovanni del Toro, 15
84010 Ravello (Salerno)
phone +39 089 857244
fax +39 089 858133
palumbo@amalfinet.it

Ristorante Palazzo della Marra
via della Marra, 7
84010 Ravello (Salerno)
phone +39 089 858302

Antichi Sapori di Amalfi
via Supportico Ferrara, 4
piazza Duomo, 39
84011 Amalfi (Salerno)
phone +39 089 872303

Cartiera Amatruda
via delle Cartiere
84011 Amalfi (Salerno)
phone +39 089 871315

capri

**Azienda Autonoma di Soggiorno e Turismo
(AAST)**
piazzetta I. Cerio, 11
80073 Capri (Naples)
phone +39 081 8370424
fax +39 081 8370918
tourinfo@mbox.caprinet.it
touristoffice@capri.it

Palace Hotel
via Capodimonte, 2b
80071 Anacapri (Naples)
phone +39 081 8373800
fax +39 081 8373191
www.capripalace.com

Hotel La Scalinatella
via Tragara, 8
80073 Capri (Naples)
phone +39 081 8370633
fax +39 081 8378291

Ristorante Quisi
via Camerelle, 2
80073 Capri (Naples)
phone +39 081 8370788

Ristorante La Capannina
via Le Botteghe, 12 bis
80073 Capri (Naples)
phone +39 081 8370732

Cooperativa Agricola La Caprense
via Provinciale Marina Grande, 203
80073 Capri (Naples)
phone +39 081 8377124

Limoncello di Capri
via Roma, 79
80073 Capri (Naples)
phone +39 081 8375561

Dulcis in Fundo
via Trieste e Trento, 8
80071 Anacapri (Naples)
phone/+39 081 8371384

caserta

Ente Provinciale per il Turismo (EPT)
Palazzo Reale
81100 Caserta
phone +39 0823 322233
fax +39 0823 326300
ept@casertaturismo.com
www.casertaturismo.com

Hotel Europa
via Roma, 19
81100 Caserta
phone/fax +39 0823 325400
www.hoteleuropacaserta.it

Hotel Belvedere
via Nazionale Sannitica, 87
località Vaccheria - San Leucio
81100 Caserta
phone +39 0823 304925
fax +39 0823 485328

Ristorante Le Colonne
via Nazionale Appia, 7–13
81100 Caserta
phone +39 0823 467494

Leucio
via Panoramica, San Leucio
81100 Caserta
phone +39 0823 301241

Caseificio La Baronia
via Ferrarecce, 23
81100 Caserta
phone +39 0823 353657
labaronia@labaronia.com
www.labaronia.com

La Nuova Orchidea (ceramics)
via Vittorio Emanuele, 12
80026 Casoria (Naples)
phone +39 081 7587584

I Borboni Arte di Capodimonte (porcelain)
via G. Amato, 10–12
80026 Casoria (Naples)
phone +39 081 7587648

La Capodimonte Artistica
via Vittorio Emanuele, 50
80026 Casoria (Naples)
phone +39 0817 576336

ischia

**Azienda Autonoma di Soggiorno e Turismo
(AAST)**
corso Colonna, 108
80077 Ischia (Naples)
phone +39 081 5074211
fax +39 081 5074230
aacs@metis.it
www.ischionline.it/tourism

Hotel Regina Isabella
piazza Santa Restituta
frazione Lacco Ameno
80077 Ischia (Naples)
phone +39 081 994322
fax +39 081 990190
info@reginaisabella.it / www.reginaisabella.it

Hotel Terme Mare Blu
via Pontano, 44
80077 Ischia (Naples)
phone +39 081 982555
fax +39 081 982938
mareblu@metis.it

Ristorante Il Melograno
via G. Mazzella, 110
frazione Forio
80077 Ischia (Naples)
phone +39 081 998450

Ristorante Umberto a Mare
via Soccorso, 2
frazione Forio
80077 Ischia (Naples)
phone +39 081 997171

Trattoria Il Focolare
via Cretajo al Crocifisso, 4
frazione Barano d'Ischia
80077 Ischia (Naples)
phone +39 081 902944

pompeii - herculaneum

Informazioni Turistiche
via Sacra, 1
80045 Pompeii (Naples)
phone +39 081 8507255
fax +39 081 8632401

Hotel Noneuri
via Acquasalsa, 20
80045 Pompeii (Naples)
phone +39 081 8562716
fax +39 081 8562716
noneuri@uniserv.uniplan.it

Hotel Forum
via Roma, 99
80045 Pompeii (Naples)
phone +39 081 8501170
fax +39 081 8506132
info@hotelforum.it
www.hotelforum.it

Ristorante Il Principe
piazza B. Longo, 8
80045 Pompeii (Naples)
phone +39 081 8505566

Ristorante President
piazza Schettini, 12–13
80045 Pompeii (Naples)
phone +39 081 8505566

Coralli e Cammei da Giovanni Apa
via E. De Nicola, 1
80059 Torre del Greco (Naples)
phone +39 081 8811155

Coralli e Cammei da Biagio Piscopo
corso Resina, 318
80056 Herculaneum (Naples)
phone/fax +39 081 7322736

Arte & Pasta dei Giovani Pastai
via Brancaccio, 75/a
località Boscoreale
80045 Pompeii (Naples)
phone +39 081 8594976
info@arteepasta.it

Metafora (lace)
via Dogana, 29
80056 Herculaneum (Naples)
phone +39 081 7321464

sorrento

Informazioni Turistiche
via De Noneo, 35
80067 Sorrento (Naples)
phone +39 081 8074033
fax +39 081 8773397

Grand Hotel Excelsior Vittoria
piazza Tasso, 34
80067 Sorrento (Naples)
phone +39 081 8071044
fax +39 081 8771206
exvitt@exvitt.it
www.exvitt.it

Grand Hotel Parco dei Principi
via Rota, 1
80067 Sorrento (Naples)
phone +39 081 8784644
fax +39 081 8783786
info@grandhotelparcodeiprincipi.it

Grand Hotel Riviera
via A. Califano, 22a
80067 Sorrento (Naples)
phone +39 081 8072011
fax +39 081 8772100
info@hotelriviera.com
www.hotelriviera.com

Hotel Palazzo Murat
via dei Mulini, 23
84017 Positano (Salerno)
phone +39 089 875177
fax +39 089 811419
info@palazzomurat.it
www.palazzomurat.it

Hotel Ristorante Le Sirenuse
via C. Colombo, 30
84017 Positano (Salerno)
phone +39 089 875066
fax +39 089 811798
info@sirenuse.it
www.sirenuse.it

Ristorante Caruso
via Sant'Antonino, 12
80067 Sorrento (Naples)
phone +39 081 807356
info@ristorantemuseocaruso.com
www.ristorantemuseocaruso.com

Ristorante L'Antica Trattoria
via P. Reginaldo Giuliani, 33
80067 Sorrento (Naples)
phone +39 081 8781082

Ristorante Le Tre Sorelle
via del Brigantino, 23
84017 Positano (Salerno)
phone +39 089 875452

Museo Correale di Terranova
via Correale, 50
80067 Sorrento (Naples)
phone +39 081 8781846

Museobottega della Tarsia Lignea
via San Nicola, 28
80067 Sorrento (Naples)
phone +39 081 8771942

Enoteca I Sapori di Positano
via dei Mulini, 6
84017 Positano (Salerno)
phone +39 081 811116

Fabbrica Liquori Limonoro
via san Cesareo, 52
80067 Sorrento (Naples)
phone +39 081 8072782

Pasticceria La Zagara
via dei Mulini, 10
84017 Positano (Salerno)

PUGLIA

alberobello

Azienda di Promozione Turistica (APT)
piazza Moro, 31/a
70122 Bari
phone +39 080 5242361
fax +39 080 5242329
aptbari@pugliaturismo.com
www.pugliaturismo.com

Hotel Astoria
viale Bari, 11
70011 Alberobello (Bari)
phone +39 080 4323320
fax +39 080 4321290

Hotel Il Melograno
contrada Torricella, 345
70043 Monopoli (Bari)
phone +39 080 6909030
fax +39 080 747908
melograno@melograno.com
www.melograno.com

Hotel dei Trulli
via Cadore, 32
70011 Alberobello (Bari)
phone +39 080 4323555
fax +39 080 4323560
hoteldeitrulli@inmedia.it

Ristorante Il Poeta Contadino
via Indipendenza, 21
70011 Alberobello (Bari)
phone +39 080 4321917

Ristorante Trullo d'Oro
via F. Cavallotti, 27
70011 Alberobello (Bari)
phone +39 080 4323909

Trattoria La Cantina
vicolo Lippolis, 9
70011 Alberobello (Bari)
phone +39 080 4323473

Impronte Ceramiche d'Arte
viale Putignani, 83
70011 Alberobello (Bari)
phone +39 080 4325988
improntecer@libero.it

Ricami di Maria Vinci
via Monte San Marco, 5
70011 Alberobello (Bari)
phone +39 080 4321244

Oro dei Trulli
via Monte San Michele, 7
70011 Alberobello (Bari)
phone +39 080 4323610

bari

Azienda di Promozione Turistica (APT)
piazza Moro, 33/a
70122 Bari
phone +39 080 5242361
fax +39 080 5242329
aptbari@pugliaturismo.com
www.pugliaturismo.com

Palace Hotel
via Lombardi, 13
70100 Bari
phone +39 080 5216551
fax +39 080 5211499
palaceh@tin.it

Sheraton Nicolaus Hotel
via Cardinale A. Ciasca, 9
70100 Bari
phone +39 080 5042626
fax +39 080 55042058
gmdirezione@sheratonnicolausbari.com
www.sheratonicolausbari.com/ita/home.htm

Ristorante Alberosole
corso Vittorio Emanuele, 13
70100 Bari
phone +39 080 5235446

Ristorante La Pignata
corso Vittorio Emanuele, 173
70100 Bari
phone +39 080 5232481

Monastero delle Benedettine Olivetane
(typical sweets, almond paste, amaretti cookies)
via Provinciale per Bitetto, 50
70027 Palo del Colle (Bari)
phone +39 080 626096

Stellargenti (silversmith)
strada Rurale Pantaleo, 6
70100 Bari
phone +39 080 5494050

gallipoli

Azienda di Promozione Turistica (APT)
via Monte San Michele
73100 Lecce
phone +39 0832 314117
fax +39 0832 310238
aptlecce@pugliaturismo.com
www.pugliaturismo.com

Hotel Joli Park
piazza Salento, 2
73014 Gallipoli (Lecce)
phone/fax +39 0833 263321
atcaroli@tin.it

Hotel Al Pescatore
riviera C. Colombo, 39
73014 Gallipoli (Lecce)
phone/fax +39 0833 263656

Hotel Palazzo del Corso
corso Roma, 145
73014 Gallipoli (Lecce)
phone +39 0833 264040
fax +39 0833 265052

Hotel Ecoresort Le Sirene
litoranea Gallipoli - Santa Maria di Leuca
73014 Gallipoli (Lecce)
phone +39 0833 202536
fax +39 0833 202539

Ristorante La Puritate
via Sant'Elia, 18
73014 Gallipoli (Lecce)
phone +39 0833 264205

Trattoria Da Olga
viale Bovio, 2
73014 Gallipoli (Lecce)
phone +39 0833 261982

Pasticceria Alda di Provenzano
via Aldo Moro, 154
località Tuglie
73014 Gallipoli (Lecce)
phone +39 0833 598168

lecce

Azienda di Promozione Turistica (APT)
via Monte San Michele
73100 Lecce
phone +39 0832 314117
fax +39 0832 310238
aptlecce@pugliaturismo.com
www.pugliaturismo.com

Patria Palace Hotel
piazzetta Riccardi, 13
73100 Lecce
phone +39 0832 245111
fax +39 0832 245002
info@patriapalacelecce.com
www.patriapalacelecce.com/ita/home.htm

Hotel Zenit
via Adriatica - Complesso Gridi
73100 Lecce
phone +39 0832 493421
fax +39 0832 493433

Ristorante I Tre Moschettieri
via Paisiello, 9a
73100 Lecce
phone +39 0832 308484

Ristorante Guido
viale XXV Luglio, 14
73100 Lecce
phone +39 0832 305868

Trattoria Le Zie
via Col. A. Costadura, 19
73100 Lecce
phone +39 0832 245178

Pasticceria La Cotognata Leccese
viale Marconi, 51
73100 Lecce
phone +39 0832 302800

Pasticceria Franchini
via San Lazzaro, 34
73100 Lecce
phone +39 0832 343882

Artefare
via Vittorio Emanuele, 14
73100 Lecce
phone/fax +39 0832 240629
info@artefare.it / www.artefare.it

Creazioni in Cartapesta di Piero Quarta
via Trieste, 7
73010 Lequile (Lecce)
phone +39 0832 634528

otranto

Informazioni Turistiche
lungomare Kennedy
73028 Otranto (Lecce)
phone +39 0836 801436

Hotel Degli Haethey
via F. Sforza, 33
73028 Otranto (Lecce)
phone +39 0836 801548
fax +39 0836 801576
info@hoteldeglihaethey.com
www.hoteldeglihaethey.com

Agriturismo Tenuta Torre Pinta
via delle Memorie
73028 Otranto (Lecce)
phone/fax +39 0836 428358
torrepinta@nonel.clio.it

Ristorante Da Sergio
corso Garibaldi, 9
73028 Otranto (Lecce)
phone +39 0836 801408

Trattoria Zia Fernanda
via XXV Aprile, 1
73028 Otranto (Lecce)
phone +39 0836 801884

Frammenti Arte Musiva
via Melorio, 2
73028 Otranto (Lecce)

L'Ago del Ricamo
corso Garibaldi, 41
73028 Otranto (Lecce)

BASILICATA

maratea

Azienda di Promozione Turistica (APT)
piazza del Gesù, 32
85046 Maratea (Potenza)
phone +39 0973 876908
fax +39 0973 877464

Locanda delle Donne Monache
via C. Mazzei, 4
85046 Maratea (Potenza)
phone +39 0973 877487
fax +39 0973 877687
locdonnemonache@crossiwinds.net

Hotel Santavenere
via Santavenere
località Fiumicello
85046 Maratea (Potenza)
phone +39 0973 876910
fax +39 0973 877654

Hotel Villa Cheta Elite
via Timpone, 46
località Acquafredda
85046 Maratea (Potenza)
phone +39 0973 878134
fax +39 0973 878135
villacheta@labnet.it

Ristorante Taverna Rovita
via Rovita, 13
85046 Maratea (Potenza)
phone +39 0973 876588

Enoteca La Farmacia dei Sani
via Cavour, 10
85046 Maratea (Potenza)
phone +39 0973 876148

Azienda di Promozione Turistica (APT)
via De Viti De Marco, 9
75100 Matera
phone +39 0835 331983
fax +39 0835 333452
presidiomatera@aptbasilicata.it

Sassi Hotel
via San Giovanni Vecchio, 89
75100 Matera
phone +39 0835 331009
fax +39 0835 333733
hotelsassi@virgilio.it
www.hotelsassi.it

Hotel Del Campo
via Lucrezio angolo via Gravina
75100 Matera
phone +39 0835 388844
fax +39 0835 388757
hoteldelcampo@intelnett.com
www.hoteldelcampo.com

Ristorante Le Botteghe
piazza San Pietro Barisano, 22
75100 Matera
phone +39 0835 344072

Trattoria Lucana
via Lucana, 48
75100 Matera
phone +39 0835 336117

Arte Decorativa
via San Francesco, 15
75100 Matera
phone +39 0835 334206

Il Bottegaccio
via Madonna dell'Idris, 10
75100 Matera
phone +39 0835 311158

Orizzonti (ceramics)
via delle Beccherie, 27
75100 Matera
phone +39 0835 333019

CALABRIA

cosenza

Azienda di Promozione Turistica (APT)
corso Mazzini, 92
87100 Cosenza
phone +39 0984 27304

Hotel Centrale
via dei Tigrai, 3
87100 Cosenza
phone +39 0984 75750
fax +39 0984 73681
h.centrale@tin.it

Hotel Royal
via Molinella, 24/e
87100 Cosenza
phone +39 0984 412165
fax +39 0984 412461
royal@tin.it

Trattoria Da Giocondo
via Piave, 53
87100 Cosenza
phone +39 0984 29810

Gioielleria Pertichini
via Roma, 173
87055 San Giovanni in Fiore (Cosenza)
phone +39 0984 970465
gioiellipertichini@libero.it

crotone

Azienda di Promozione Turistica (APT)
via Torino, 148
88900 Crotone
phone +39 0962 23185
fax +39 0962 26700

Hotel Costa Tiziana
via per Capocolonna
88900 Crotone
phone +39 0962 25601
fax +39 0962 21427
info@costatiziana.it
www.costatiziana.it

Hotel Helios
via per Capocolonna
località San Leonardo
88900 Crotone
phone/fax +39 0962 27997

Ristorante Casa di Rosa
viale C. Colombo, 117
88900 Crotone
phone +39 0962 21946

Ristorante Da Ercole
viale Gramsci, 122
88900 Crotone
phone +39 0962 901425

Consorzio Orafi Magna Grecia
via Torino, 119/b
88900 Crotone
phone +39 0962 29050

tropea

Azienda di Promozione Turistica (APT)
via Forgiari - Galleria Vecchio
89900 Vibo Valentia
phone +39 0963 42008
fax +39 0963 44318

Albergo La Pineta
via Marina del Vescovado, 150
89861 Tropea (Vibo Valentia)
phone +39 0963 61700
fax +39 0963 62265

Hotel Terrazza sul Mare
zona Croce
89861 Tropea (Vibo Valentia)
phone/fax +39 0963 61020

Ristorante Pimm's
corso Vittorio Emanuele, 60 (largo Migliarese)
89861 Tropea (Vibo Valentia)
phone +39 0963 666105

Azienda Agricola Torre Galli
contrada San Rocco fondo Moccina, 1
località Drapia
89861 Tropea (Vibo Valentia)
phone +39 0963 67254

SICILY

agrigento

**Agenzia Autonoma Provinciale
per l'Incremento Turistico (AAP)**
viale della Vittoria, 255
92100 Agrigento
phone +39 0922 401352
fax +39 0922 25185
aapitag@libero.it
www.agrigentoweb.it

Hotel Della Valle
via U. La Malfa, 3
92100 Agrigento
phone +39 0922 26966
fax +39 0922 26412
jollyvalle@asinform.it

Hotel Dioscuri Bay Palace
lungomare Falcone e Borsellino, 1
località San Leone
92100 Agrigento
phone +39 0922 406111
fax +39 0922 411297
dioscuri@framon-hotels.com

Hotel Villa Athena
passeggiata Archeologica, 33
92100 Agrigento
phone +39 0922 596288
fax +39 0922 402180
villaathena@hotelvillaathena.com
www.athenahotels.com

Ristorante Leon d'Oro
viale Emporium, 102
località San Leone
92100 Agrigento
phone +39 0922 414400

Trattoria dei Templi
via Panoramica dei Templi, 15
92100 Agrigento
phone +39 0922 403110

Antichi Sapori Gastronomia
via C. Battisti, 20
92100 Agrigento
phone +39 0922 554585

catania

**Agenzia Autonoma Provinciale
per l'Incremento Turistico (AAP)**
via Cimarosa, 12
95124 Catania
phone +39 095 7306211
apt@apt.catania.it
www.apt.catania.it

Hotel Central Palace
via Etnea, 218
95100 Catania
phone +39 095 325344
fax +39 095 7158939

Palazzo Biscari
via Museo Biscari, 16
piazza Duca di Genova, 22
95100 Catania
phone +39 095 321818
fax +39 095 7152508
palazzobiscari@interfree.it
www.palazzobiscari.com

Ristorante Il Carato
via Vittorio Emanuele, 81
95100 Catania
phone +39 095 7159247

Ristorante La Siciliana
viale Marco Polo, 52/a
95100 Catania
phone +39 095 376400

CILDA (wine, oil, dried fruit, candied flowers)
viale Vittorio Veneto, 174/b
95100 Catania
phone +39 095 393610

**Lavorazione Pietra Lavica
di Armando Gelsomino**
via Fondo Romeo, 15/b
95121 Catania
phone +39 095 206334

erice

Ufficio Informazioni
piazzale Funivia
phone +39 0923 565055
91016 Erice (Trapani)
phone +39 0923 869388
fax +39 0923 869544

Hotel Elimo
via Vittorio Emanuele, 75
91016 Erice (Trapani)
phone +39 0923 869377
fax +39 0923 869252
elimoh@comeg.it

Hotel Ristorante Moderno
via Vittorio Emanuele, 63
91016 Erice (Trapani)
phone +39 0923 869300
fax +39 0923 869139
modernoh@tin.it

Ristorante Monte San Giuliano
vicolo San Rocco, 7
91016 Erice (Trapani)
phone +39 0923 869595

Caffè e Pasticceria Maria Grammatico
via Vittorio Emanuele, 4–14
91016 Erice (Trapani)
phone +39 0923 869390

Ceramica Ericina
contrada Fontanarossa
91016 Erice (Trapani)
phone +39 0923 869040

Tessitura Tappeti di Francesca Vanio
via Conte Pepoli, 55
91016 Erice (Trapani)
phone +39 0923 869049

isole eolie

Informazioni Turistiche
corso Vittorio Emanuele, 202–204–231
98055 Lipari (Messina)
phone +39 090 9880095
fax +39 090 9811190
aasteolie@netnet.it
infoaast@netnet.it
www.netnet.it/aasteolie

Hotel Ericusa
via Perciato
98050 Alicudi (Messina)
phone +39 090 9889902

Trattoria La Canna
via Rosa, 43
98050 Filicudi
phone +39 090 9889956

Hotel Villa Meligunis
via Marte, 7
98055 Lipari (Messina)
phone +39 090 9812426
fax +39 090 9880149
info@villameligunis.it / www.villameligunis.it

Ristorante 'E Pulera
via Diana, 67
98055 Lipari (Messina)
phone +39 090 9811158

Hotel Raya Residence
via San Pietro, 1
98050 Panarea (Messina)
phone +39 090 983013
fax +39 090 983103
info@hotelraya.it / www.hotelraya.it

Ristorante da Pina a Cala Junco
via San Pietro, 3
98050 Panarea (Messina)
phone +39 090 983032

Hotel Bellavista
via Risorgimento, 8
località Santa Marina
98050 Salina (Messina)
phone +39 090 9843009

Hotel Signum
via Scalo, 15
località Malfa
98050 Salina (Messina)
phone +39 090 9844222
fax +39 090 9844102
salina@hotelsignum.it / www.hotelsignum.it

Ristorante Da Franco
via Belvedere, 8
località Santa Marina
98050 Salina (Messina)
phone +39 090 9843287

Ristorante Portobello
via Bianchi, 1
località Santa Marina
98050 Salina (Messina)
phone +39 090 9843125

Hotel La Sciara
via Domenico Cincotta
98050 Stromboli (Messina)
phone +39 090 986004

Ristorante Ai Gechi
via Salina, 12
98050 Stromboli (Messina)
phone +39 090 986213

Hotel Arcipelago
località Vulcanello
98050 Vulcano (Messina)
phone +39 090 9852002
fax +39 090 9852154
info@hotelarcipelago.it
www.hotelarcipelago.it

noto

Informazioni Turistiche
piazzale XXVI Maggio, Villetta Ercole
96017 Noto (Syracuse)
phone/fax +39 0931 836744

Hotel Club Helios
viale Lido
località Noto Marina
96017 Noto (Syracuse)
phone +39 0931 812366
fax +39 0931 812378

Hotel Villa Mediterranea
viale Lido, 1
località Noto Marina
96017 Noto (Syracuse)
phone/fax +39 0931 812330

Ristorante Neas
via Pirri, 30
96017 Noto (Syracuse)
phone +39 0931 573538

Trattoria del Carmine
via Ducezio, 1a
96017 Noto (Syracuse)
phone +39 0931 838705

Pasticceria Mandolfiore
via Ducezio, 2
96017 Noto (Syracuse)
phone +39 0931 836615

piazza armerina

Informazioni Turistiche
via Cavour, 1
94015 Piazza Armerina (Enna)
phone +39 0935 680201
fax +39 0935 684565

Hotel Mosaici da Battiato
contrada Paratore, 8 (bivio mosaici)
94015 Piazza Armerina (Enna)
phone/fax +39 0935 685453

Park Hotel Paradiso
contrada Ramaldo
94015 Piazza Armerina (Enna)
phone +39 0935 680841
fax +39 0935 683391
info@parkhotelparadiso.it
www.parkhotelparadiso.it

Ristorante Al Fogher
Statale 117 bis - contrada Bellia
(intersection for Aidone)
94015 Piazza Armerina (Enna)
phone +39 0935 684123

Trattoria La Ruota
contrada Paratore
94015 Piazza Armerina (Enna)
phone +39 0935 680542

syracuse

Azienda Provinciale Turismo APT
via San Sebastiano, 43
96100 Syracuse
phone +39 0931 481200
fax +39 0931 67803

Hotel Gutkowski
lungomare Vittorini, 26
96100 Syracuse
phone +39 0931 465861
fax +39 0931 480505
info@guthophone.it

Grand Hotel
viale Mazzini, 12
96100 Syracuse
phone +39 0931 464600
fax +39 0931 464611
info@grandhotelsr.it / www.grandhotelsr.it

Hotel Holiday Inn Siracusa
viale Teracati, 30
96100 Syracuse
phone +39 0931 440111
fax +39 0931 67015
vacation: none

Ristorante Darsena
riva Garibaldi, 6
96100 Syracuse
phone +39 0931 66522

Ristorante Minosse
via Mirabella, 6
96100 Syracuse
phone +39 0931 66366
ristorante.minosse@tin.it

Vetrate Artistiche Giuseppe Santoro
via Maestranza, 76
96100 Syracuse
phone +39 0931 463649

taormina

Informazioni Turistiche
c/o Palazzo Corvaja - piazza Santa Caterina
98039 Taormina (Messina)
phone +39 0942 23243
fax +39 0942 24941
aast@taormina-ol.it / www.taormina-ol.it

San Domenico Palace
piazza San Domenico, 5
phone +39 0942 23701
fax +39 0942 625506
98039 Taormina (Messina)
san-domenico@thi.it / www.thi.it

Hotel Villa Ducale
via Leonardo da Vinci, 60
98039 Taormina (Messina)
phone +39 0942 28153
fax +39 0942 28710
villaducale@tao.it

Ristorante Al Duomo
vico Ebrei, 11
98039 Taormina (Messina)
phone +39 0942 625656

Ristorante Maffei's
via San Domenico De Guzman, 1
98039 Taormina (Messina)
phone +39 0942 24055

Ristorante Il Ficodindia
via Appiano, 14
località Mazzeo
98039 Letojanni (Messina)
phone +39 0942 36301

Specialità Etna
corso Umberto I, 112
98039 Taormina (Messina)

trapani

Ufficio Informazioni
piazzetta Saturno
91100 Trapani
phone +39 0923 29000
fax +39 0923 24001
apttp@nonel.cinet.it
www.apt.trapani.it

Crystal Hotel
piazza Umberto, 1
91100 Trapani
phone +39 0923 20000
fax +39 0923 25555

Ristorante Taverna Paradiso
lungomare Dante Alighieri, 22
91100 Trapani
phone +39 0923 22303

Trattoria Bettina
via San Cristoforo, 7
91100 Trapani
phone +39 0923 20050

Marsala da Florio
via Florio, 1
91025 Marsala (Trapani)
phone +39 0923 781111

Pasticceria '900 di Filingeri
via Fardella, 84/86
91100 Trapani
phone +39 0923 22502

SARDINIA

alghero

Informazioni Turistiche
piazza Portaterra, 9
07041 Alghero (Sassari)
phone +39 079 979054
fax +39 079 974881

Hotel El Faro
località Porto Conte
07041 Alghero (Sassari)
phone +39 079 942010
fax +39 079 942030

Rina Hotel
via delle Baleari, 34
07041 Alghero (Sassari)
phone +39 079 984240
fax +39 079 984297
info@bluhotels.it
www.bluhotels.it

Hotel Villa Las Tronas
lungomare Valencia, 1
07041 Alghero (Sassari)
phone +39 079 981818
fax +39 079 981044
info@hotelvillalastronas.it
www.hotelvillalastronas.it

Ristorante La Lepanto
via C. Alberto 135
07041 Alghero (Sassari)
phone +39 079 979116

Ristorante Santa Tecla
via Roma, 48
07041 Alghero (Sassari)
phone +39 079 983311

Ristorante Al Tuguri
via Noneorca, 113
07041 Alghero (Sassari)
phone +39 079 976772

Bar Milese
via Garibaldi, 11
07041 Alghero (Sassari)
phone +39 079 952419

Atelier Orafo F.lli Marogna
piazza Civica, 34
07041 Alghero (Sassari)
phone +39 079 984814

Botarfish (dried tuna roe)
via Sanzio, 28
07041 Alghero (Sassari)
phone +39 079 951390

oristano

Ente Provinciale per il Turismo (EPT)
via Cagliari, 278
09170 Oristano
phone +39 0783 74191
fax +39 0783 302518
enteturismo.oristano@tiscalinet.it

Hotel CaMa
via Vittorio Veneto, 119
09170 Oristano
phone +39 0783 74374
fax +39 0783 74375

Hotel Mistral Due
via XX Settembre
09170 Oristano
phone/fax +39 0783 210389
hmistral@tiscalinet.it

Ristorante Cocco & Dessì
via Tirso, 31
09170 Oristano
phone +39 0783 300720

Ristorante Il Faro
via Bellini, 25
09170 Oristano
phone +39 0783 70002

Bottarga Spanu
via G. Carducci, 20
09072 Cabras (Oristano)
phone +39 0783 391161

Cooperativa Pescatori e Molluschiltori
via Cima, 9
09072 Cabras (Oristano)
phone +39 0783 290848

porto cervo

Ente Provinciale per il Turismo (EPT)
viale Caprera, 36
07100 Sassari
phone +39 079 299544
fax +39 079 299415

Hotel Cala di Volpe
località Cala di Volpe
07020 Porto Cervo (Sassari)
phone +39 0789 976111
fax +39 0789 976617
caladivolpe@luxurycollection.com
www.costasmeraldaresort.com

Hotel Romazzino
località Romazzino Costa Smeralda, 1a
07020 Porto Cervo (Sassari)
phone +39 0789 977111
fax +39 0789 96258
romazzino@luxurycollection.com
www.costasmeraldaresort.com

Gastronomia Belvedere
località Abbiadoro
07020 Porto Cervo (Sassari)
phone +39 0789 96501

SUGGESTED READINGS

ART AND ARCHITECTURE

Alberti, Leon Battista. *On Painting.* Trans. Cecil Grayson. New York: Penguin Books, 1991.

Basile, Giuseppe. *Giotto: The Frescoes of the Scrovegni Chapel, Padua.* Milan: Skira, 2003.

Bertelli, Carlo. *Piero della Francesca: The Legend of the True Cross in the Church of San Francesco in Arezzo.* Milan: Skira, 2001.

Brown, David Allen, Giulio Bora, Maria T. Fiorio, and Pietro C. Marani. *The Legacy of Leonardo: Painters in Lombardy, 1480–1530.* Milan: Skira, 1999.

Cunaccia, Cesare. *Magnificent Italian Villas and Palaces.* New York: Rizzoli International Publications, 2004.

Toledano, Ralph, and Jack Basehart. *Italian Splendor: Great Palaces, Castles, and Villas.* Reprint, New York: Rizzoli International Publications, 2004.

Vasari, Giorgio. *The Lives of the Artists.* Ed. and trans. George Bull. 2 vols. Harmondsworth, UK: Penguin Books, 1987.

CULTURE

Bugialli, Giuliano. *Foods of Sicily and Sardinia and the Smaller Islands.* New York: Rizzoli International Publications, 2003.

McBride, Simone, and Elizabeth Helman. *Private Tuscany.* New York: Rizzoli International Publications, 1999.

Morelli, Laura. *Made in Italy: A Shopper's Guide to the Best of Italian Tradition.* New York: Universe Publishing, 2003.

LITERATURE

Alighieri, Dante. *The Divine Comedy.* Trans. John D. Sinclair. 3 vols. London: Bodley Head, 1948.

Boccaccio, Giovanni. *The Decameron.* Trans. G. H. McWilliam. 2nd ed. London: Penguin Books, 1995.

De Voragine, Jacobus. *The Golden Legend: Readings on the Saints.* Trans. William Granger Ryan. 2 vols. Princeton, NJ: Princeton University Press, 1995.

King, Ross. *Brunelleschi's Dome: The Story of the Great Cathedral in Florence.* London: Pimlico, 2001.

——. *Michelangelo and the Pope's Ceiling.* New York: Penguin Books, 2003.

TRAVEL

Gatti, Claudio, and John Moretti. *Rome in Detail: A Sophisticated Traveler's Guide.* New York: Rizzoli International Publications, 2003.

Gatti, Claudio, and Fred Plotkin. *Florence in Detail: A Guide for the Expert Traveler.* New York: Rizzoli International Publications, 2003.

Hurst, Kelly F. *Italian Country Hideaways: Vacationing in Tuscany and Umbria's Most Unforgettable Private Villas, Castles, and Estates.* New York: Universe Publishing, 1999.

PHOTO CREDITS

First published in the United States of America in 2014
by Rizzoli International Publications, Inc.
300 Park Avenue South
New York, NY 10010
www.rizzoliusa.com

© 2004 RCS Libri Spa, Milan

Production: Colophon srl, Venice, Italy

Editorial Direction: Andrea Grandese

Editor: Rosanna Alberti

Design Concept: Stephen Fay

English Translation: Judith Goodman

Editor (English Edition): Ilaria Fusina

Copyeditor (English Edition): Julie Di Filippo

2014 2015 2016 2017 / 10 9 8 7 6 5 4 3 2 1

ISBN: 978-0-8478-4294-0

Library of Congress Control Number: 2013954122

Printed in Italy